The Art of the Poor

*The Aesthetic Material Culture of the
Lower Classes in Europe, 1300–1600*

Edited by
Rembrandt Duits

BLOOMSBURY ACADEMIC

LONDON · NEW YORK · OXFORD · NEW DELHI · SYDNEY

BLOOMSBURY ACADEMIC
Bloomsbury Publishing Plc
50 Bedford Square, London, WC1B 3DP, UK
1385 Broadway, New York, NY 10018, USA
29 Earlsfort Terrace, Dublin 2, Ireland

BLOOMSBURY, BLOOMSBURY ACADEMIC and the Diana logo are trademarks of
Bloomsbury Publishing Plc

First published in Great Britain 2020
This paperback edition published in 2022

Cover image: 'The Big Market' by Jacopo Bassano (ca 1510-1592).
Photo by DeAgostini/Getty Images

A catalogue record for this book is available from the British Library.

Library of Congress Cataloging-in-Publication Data
Names: Duits, Rembrandt, editor.
Title: The art of the poor: the aesthetic material culture of the lower classes in Europe,
1300-1600 / edited by Rembrandt Duits.
Description: London; New York: Bloomsbury Academic, 2020. | Includes
bibliographical references and index.
Identifiers: LCCN 2020025146 (print) | LCCN 2020025147 (ebook) | ISBN 9781788316750
(hardback) | ISBN 9781786736239 (ebook) | ISBN 9781786726179 (epub)
Subjects: LCSH: Arts and the poor—Europe—History—To 1500. | Arts and the
poor—Europe—History—16th century. | Material culture—Europe—History—To 1500. |
Material culture—Europe—History—16th century.
Classification: LCC NX180.S6 A737 2020 (print) | LCC NX180.S6 (ebook) |
DDC 701/.03–dc23
LC record available at https://lccn.loc.gov/2020025146
LC ebook record available at https://lccn.loc.gov/2020025147

ISBN: HB: 978-1-7883-1675-0
PB: 978-1-3502-1457-6
ePDF: 978-1-7867-3623-9
eBook: 978-1-7867-2617-9

Typeset by Deanta Global Publishing Services, Chennai, India

To find out more about our authors and books visit www.bloomsbury.com and
sign up for our newsletters.

The Art of the Poor

To Angeliki and Anna-Ritsa,
The riches of my life

Contents

Illustrations

Maps

Figures

Tables

Contributors

Joanne W. Anderson is Reader in History of Art at the University of Aberdeen, UK. She is the author of *Moving with the Magdalen: Late Medieval Art and Devotion in the Alps* (2019).

Ruth Atherton is Lecturer in History at the University of South Wales, UK.

Roger Blench is an independent scholar who obtained his PhD from the University of Cambridge, UK. He is the chief research officer of the Kay Williamson Educational Foundation and an academic visitor of the McDonald Institute for Archaeological Research at the University of Cambridge.

Samuel Cohn is Professor of Medieval History at the University of Glasgow, UK. He is the author of *Epidemics: Hate and Compassion from the Plague of Athens to AIDS* (2018), *Popular Protest in Late Medieval English Towns* (2013) and *Cultures of Plague: Medical Thinking at the End of the Renaissance* (2010), among others.

Rembrandt Duits is Deputy Curator for the Photographic Collection at The Warburg Institute, School of Advanced Studies, University of London, UK. He is the author of *Gold Brocade and Renaissance Painting: A Study in Material Culture* (2008), and co-editor of *Images of the Pagan Gods* (2009) and *Byzantine Art and Renaissance Europe* (2013, with Angeliki Lymberopoulou).

Anne-Clothilde Dumargne is a PhD candidate in Medieval History at the University of Versailles Saint-Quentin-en-Yvelines, France.

Paula Hohti Erichsen is Associate Professor of History of Art and Culture at Aalto University, Finland. She is the author of *Artisans, Objects, and Everyday Life in Renaissance Italy* (2020).

Clarisse Evrard has achieved her PhD degree in Art History at the University of Lille – École du Louvre, France.

Shannon Gilmore-Kuziow is Associate Research Fellow at the Australian Catholic University, Australia.

Meriel Jeater is Curator at the Museum of London, UK.

M. A. Katritzky is Barbara Wilkes Research Fellow in Theatre Studies and Director, The Centre for Research into Gender and Otherness in the Humanities, at The Open University, UK. Publications include: *Transnational Connections in Early Modern Theatre* (2020, co-edited with Pavel Drabek); *Healing, Performance and Ceremony in the Writings of Three Early Modern Physicians* (2012); *Women, Medicine and Theatre, 1500–1750* (2007); and *The Art of Commedia* (2006).

Angeliki Lymberopoulou is Senior Lecturer in Art History at The Open University, UK. She is the author of *The Church of the Archangel Michael at Kavalariana* (2009) and editor of *Images of the Byzantine World* (2011) and *Cross-Cultural Interactions between Byzantium and the West, 1204–1669* (2018).

Tom Nichols is Reader in History of Art at the University of Glasgow, UK. He is the author of *Giorgione's Ambiguity* (2020); *Renaissance Art in Venice* (2016); and *Titian and the End of the Venetian Renaissance* (2013); among others.

Jacqui Pearce is Senior Finds Specialist in Post-Roman Ceramics at MOLA (Museum of London Archaeology), UK.

Thomas Schweigert is a PhD candidate in Art History at the University of Wisconsin-Madison, United States.

Anne-Kristine Sindvald Larsen is a PhD candidate in the Department of Art at Aalto University, Finland.

Lucinda Timmermans is Junior Curator of Metalwork and Decorative Arts at the Rijkmuseum, Amsterdam, The Netherlands.

Preface

If in a distant – and distinctly undesirable – future all Western art museums and all copies of Giorgio Vasari's *Vite* . . . and of Karel van Mander's *Levens* . . . were destroyed, and all that was left of Europe from the period of the late Middle Ages and the Renaissance were a record of urban archaeology, would we then say that Europe during this historical era did not have art? It is highly unlikely, as there is hardly any culture across the globe and in world history to which we do not attribute at least some form of art. Of course, the notion of 'art' as we understand it in the twenty-first century is a Western construct of relatively recent date, and our descendants in that terrifying future might no longer have it, or no longer apply the term in the same way as we do. But if they still speak of art in a sense similar to ours, and were to organize an exhibition of the art of the late Middle Ages and the Renaissance, they might be more inclined than we are today to include not just the few shards of up-market *maiolica* that the archaeological record would yield but a wider range of forms of pottery and other media. They would effectively display a much fairer cross section of the historical society of the period than can be found in our current art collections and surveys of Art History, which define art and its development almost entirely in terms of a small group of works produced for the richest people of the time.

It has long been my wish to present a narrative of the art history of the period 1300–1600 that would be more inclusive, not just of the greater bandwidth of artistic media that has already entered our understanding of the period in recent decades but also of all layers of society – similar to what we might do if we were to take an anthropological approach to an alien culture that has not saddled us with its own self-promoted values. I first advocated such an approach in an essay in a course book for the Open University in 2007, and have attempted to teach it to successive cohorts of MA students at the Warburg Institute over the years. My project took on a more ambitious shape when I organized the conference *The Art of the Poor in the Late Middle Ages and Renaissance*, held at the Warburg Institute on 14–15 June 2018. The present volume is the deposit of the knowledge and insights put forward at that ephemeral gathering. It is my hope that the conference and its proceedings will provide an impetus for what I believe has the potential to grow into a new field within art history.

The conference was made possible by the generous financial support of the John Coffin Fund of the University of London. I am grateful to The Warburg Institute for facilitating the conference and in particular to the Institute's erstwhile administrator Jane Ferguson, without whose hard work the event would never have materialized. I thank Michelle O'Malley, Tom Nichols and, last but not least, my wife Angeliki Lymberopoulou for chairing conference sessions. My former PhD student, now friend, Lorenza Gay kindly volunteered to be conference assistant and helped to make the

two days run smoothly. I would also like to thank Tom Stottor, former editor at I.B. Tauris, for believing in this project as a book topic before the conference was even held. Once I.B. Tauris was absorbed into Bloomsbury, Tom's initial confidence was shared by Bloomsbury's Joanna Godfrey and Olivia Dellow, and more recently Rhodri Mogford and Laura Reeves. I have been fortunate in working with such highly professional editorial teams.

Introduction

Did the poor have art?

Rembrandt Duits

Poverty has its whims and shows of taste, as wealth has.

Charles Dickens, *Barnaby Rudge*

Not long before his death in 1929, the art and cultural historian Aby Warburg stated that he had become convinced 'that primitive man, no matter where on earth, produces a fundamental equivalent for that which in so-called high culture is understood as an aesthetic event'.[1] Warburg's solemnly worded observation chimes distantly with the ideas of modern anthropology. The anthropologist Donald Brown, for instance, includes aesthetics in a list of 'universals' of human culture – traits that appear in all human societies around the globe.[2] It is probably fair to say, however, that in Western art history, aesthetics are rarely studied evenly across populations. The surviving physical evidence of much of art history is skewed towards elite production and consumption, and the argument can be made that the narratives and vocabulary of art history have reinforced this bias, equating a narrow band of elite works with a 'high art' that is often considered normative for the collective tastes of past cultures.

For the period of the Late Middle Ages and the Renaissance, it is undoubtedly true that we know rather a lot about the tastes and preferences of what Warburg called 'high culture', represented by the art patronage of a small group of rich and powerful people, but still comparatively little about the tastes, preferences and art of almost everyone else. Yet, as this volume will seek to demonstrate, this is one case in which an absence of knowledge should not be mistaken for knowledge of an absence. The late Middle Ages and Renaissance may in fact be the first period in Western history to provide us with ample surviving physical and documentary evidence to reconstruct an art market beyond that of the elite production for nobles and wealthy religious institutions, encompassing virtually all social strata. Moreover, the study of such a broader art market is particularly relevant for this particular era, which gave rise to the first narratives of art history and contributed much to our modern understanding of what constitutes 'art' in the narrower sense that art history tends to describe.

There has of course been a sporadic interest in the art of the 'common people' of this era. Already in the late nineteenth century, the socialist and champion of the Arts and Crafts movement, William Morris, presented an idealized picture of the medieval village craftsman and his artistic output, positing that 'the throne of the great

Plantagenet, or the great Valois, was no more daintily carved than the seat of the village mass-john, or the chest of the yeoman's good-wife.'[3] Morris's views were echoed by others, such as Charles Hutchinson, director of the Art Institute of Chicago, who, in an address at the opening of the Cleveland Museum of Art in 1916, argued emphatically for a non-elitist vision of art: 'Art is not destined for a small and privileged class. Art is democratic. It is of the people and for the people.'[4]

Yet, as we learn from the chapter by Jacqui Pearce in this volume, Morris's contemporary, the chemist and ceramics expert Sir Arthur Church, called late English medieval pottery produced for ordinary households a 'rude' art, and the later expert Robert Lockhart Hobson, a contemporary of Hutchinson, spoke of 'uncouth objects' unlikely to 'have found a place at the tables of the rich and noble'.[5] We may be inclined to condemn such opinions as snobbish today, but they are reflected in the fact that examples of the same medieval pottery are exhibited in the 'archaeological' collection of the Museum of London, while the artefacts we find in dedicated art museums, and which are hailed in surveys and tourist guides as the great masterpieces of art history, predominantly derive from the patronage of the 'rich and noble'. Significantly, the poor as a subject in the art of the Renaissance rich have been studied much more than the actual art of the poor.[6]

The question of whether poorer people even had art in the late Middle Ages and the Renaissance has in recent decades been met with a range of answers – from an emphatic, if rhetorical, 'no', to a cautious 'maybe', to an optimistic 'there might be more than you would think'.[7] Even publications that acknowledge that there was an art of the poor tend to regard it as separate from the art of the rich, adhering perhaps inadvertently to Pierre Bourdieu's principle of social distinction in suggesting a fundamental divide between a self-fashioned elite and the underprivileged masses.[8] Virginia Nixon states that 'textual records and the quantity and variety of surviving objects make it clear that large numbers of paintings, sculptures and prints were made expressly to be sold to people in lower income strata', but proceeds to qualify these works as a 'popular art' that was technically crude and iconographically simplified compared to the art of the elite, in line with contemporary elite assumptions about the poor being uneducated.[9]

The present volume, based on a conference held at The Warburg Institute in London in June 2018, will take a different approach. It will positively seek to confirm the existence of an art of the poor, or at least of the 'non-elites', in the period that established the conventions of the art of the rich in the Western world. It will show that the study of the art of the poor can be a separate field within art history, dealing with its own range of primary sources, materials of manufacture and methods of production and marketing. It will, however, not set apart the art of the poor as essentially distinct from the art of the rich, but argue instead that both were part of the same continuum within material culture – a continuum of artefacts that were adorned and valued beyond the merely functional, and were deliberately made with a potential for aesthetic appreciation.

Before outlining the structure of the volume, this introduction will attempt to answer three basic questions:

- Who were the poor?
- What was art? (or rather, how should we define 'art' in order to speak constructively about an art of the poor?)
- Why does the art of the poor matter?

Together, the answers to these three questions will provide an essential framework for the discussion that is to follow, defining the parameters of the new field that is the study of the art of the poor and providing the motivation for this expansion of the traditional discipline of art history.

Who were the poor? Poverty is a reality to those who are poor and a mere idea to those who are not. Where the line between poor and not-poor is drawn is in a sense arbitrary, depending on methods of measurement and the perceptions of the people involved. Modern, broadly accepted analyses of the proportion of poverty in society are underpinned by an array of statistics and abundant documentation, but these go back perhaps some 200 years;[10] it is not surprising that, as noted by several authors in this volume, historians engaging with the subject of poverty in the late Middle Ages and Renaissance have put an emphasis on the relativity of poverty and the difficulties of making precise distinctions between poor and non-poor.[11]

Medieval and Renaissance societies in Europe had their own understanding of 'the poor', referring mostly to categories of people who were in want of financial assistance for their mere day-to-day subsistence – those who depended on institutions such as almshouses and were the beneficiaries of the so-called Poor Laws that were introduced in Elizabethan England.[12] Historians and historical anthropologists discussing poverty tend to adhere to this historical understanding of the term, although they have also adopted a range of modern concepts to facilitate analysis, such as the 'structural poor' (e.g. those with a disability that prevented them from working), the 'episodic poor' or 'crisis poor' (e.g. those who were impoverished as the result of a poor harvest or an arbitrary fluctuation in the job market) and the 'life-cycle poor' (e.g. those who fell into poverty owing to old age).

The present volume, too, will work with modern concepts of 'the poor'. Compared to the familiar historical picture, however, it will greatly expand the segment of the population included in its scope. It will, in fact, focus not so much on those who were acutely destitute (although they will be part of the story, for example in the chapter by Shannon Gilmore-Kuziow), but on the social strata of peasants, unskilled and skilled labourers, small-time and occasionally even middle-bracket artisans – in short, on those who did not have the financial means to commission or purchase the works of art that have entered the accepted canon of art history. A working definition of this broader social group might be 'non-elites', although, as will be discussed later, modern interpretations of the notion of poverty certainly permit us to qualify them with the less clinical-sounding phrase 'the poor'.

The United Nations institution, UNESCO, provides three different criteria by which to measure poverty:[13]

1) *Absolute poverty.* This is measured against a so-called poverty line, an income level below which people lack the most basic needs for subsistence. For example, the World Bank currently draws an international poverty line (for what it defines as 'extreme poverty') of $1.90 per day.[14]

2) *Relative poverty.* This is measured as a percentage of income in a circumscribed geographical area, mostly in affluent societies where the percentage of people in absolute poverty is comparatively low. Britain, for instance, has defined a relative poverty standard of 60 per cent of median income, meaning that at the time of writing, just over 20 per cent of people in the UK are living in relative poverty.[15]

3) *Social exclusion.* This is measured not in financial terms, but by the degree to which individuals or groups are disadvantaged in their access to the benefits of the prevailing culture, such as education or health care. Importantly, this form of impoverishment can be the result not just of restricted financial resources but also of factors of social discrimination, involving issues such as age, gender or belonging to an ethnic minority.

These UNESCO criteria, while designed for the modern world, can be applied historically, as can be demonstrated using the case study of Renaissance Florence, a city state for which we have a relatively rich vein of published historical evidence for the period between 1300 and 1600:

1) *Absolute poverty.* Officials of the Florentine tax office, the *catasto*, employed their own poverty line, set at an income of 14 florins per year during the fifteenth century.[16] This was the line below which a person was expected to struggle with subsistence (individually, let alone in support of a family). Over the course of the fifteenth century, the income of an unskilled worker in Florence appears to have ranged from well above this level around 1400 to barely above it around 1500.[17] David Herlihy and Christiane Klapisch-Zuber famously studied the wealth distribution of Florence and its territories based on the assessment of taxable assets of Florence and its territories produced by the *catasto* officials in 1427. Their analysis was presented as a Lorenz curve projecting percentage of total assets against percentage of the total population (Figure 0.1).[18] The curve suggests that perhaps 40 per cent of households may have been hovering around this bread line (the *catasto* recorded no taxable wealth for ca. 40 per cent of households, meaning these households generated enough income to subsist but not to produce surplus wealth).[19] It is important to note that the very poorest of society, for example, those reduced to a life of begging or other forms of social dependency, were not included in the *catasto* assessment, which was based only on households (Figure 0.2). The 40 per cent on the poverty line is likely to have included peasants in the Florentine *contado* and unskilled labourers, many of whom would also have worked seasonally on the fields (Figure 0.3). It is important to note that they would have been able to support themselves and their families during a good year of full employment, but could easily have fallen into destitution in times of crisis; as Tom Nichols observes in his chapter in this volume, which deals with the distinction between the structurally poor and crisis poor. The limited financial means of the 40 per cent of households living around the poverty line might suggest that they can be excluded from any discourse on art history. Yet, as Meriel Jeater demonstrates in her chapter, objects such as pilgrims' badges were within the financial reach of even unskilled workers, and may have been specifically manufactured for this market. Peasants engaged in the collective commissioning of village churches and their decoration, as discussed in the chapters by Angeliki Lymberopoulou and Joanne Anderson. And the chapter by Shannon Emily Gilmore-Kuziow shows how even the destitute could form part of the target audience of a miraculous image in a religious cult site.

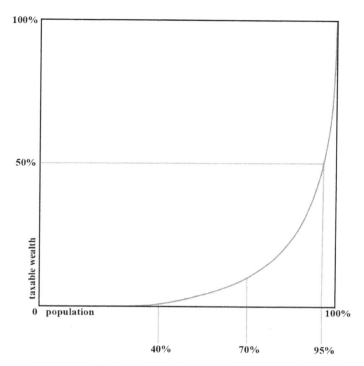

Figure 0.1 Lorenz curve of the division of wealth in Florence according to the *catasto* of 1427. After D. Herlihy and C. Klapisch-Zuber, *Les Toscans et leurs familles*, 250–1.

2) *Relative poverty*. As Renaissance Florence was an affluent society in its day, the criterion of relative poverty is relevant. If we use the standard as defined for modern Britain (60 per cent of median income), we can estimate that about 70 per cent of people in Florence and its territories lived in relative poverty (Figure 0.1).[20] This group would have included a large base of skilled workers whose income was up to twice that of unskilled workers, but who nonetheless lived on short-term job contracts and were therefore significantly exposed to fluctuations in the economy.[21] They were the foremen on construction sites (Figure 0.3) and the main workforce of the textile industry – people such as the late fourteenth-century wool carders Chimento Noldini, Giusto di Luca Petrini, Luca di Filippo and Bardo di Piero, the wool beater Salvatore di Francesco, and the burler Giovanni di Baldo with his wife Monna Jacopa, all of whom appear in contemporary legal documents published by Gene Brucker.[22] They are not normally associated with art patronage, and yet we will encounter representatives of their ranks throughout this volume: the Aretine greengrocer who bequeathed money for paintings for the altar of his confraternity, referred to by Samuel Cohn; the members of a minor confraternity who commissioned a painting by Carpaccio in Venice, discussed by Thomas Schweigert; and the Danish journeyman brewer Pouell Pedersen, whose modest wardrobe inventory

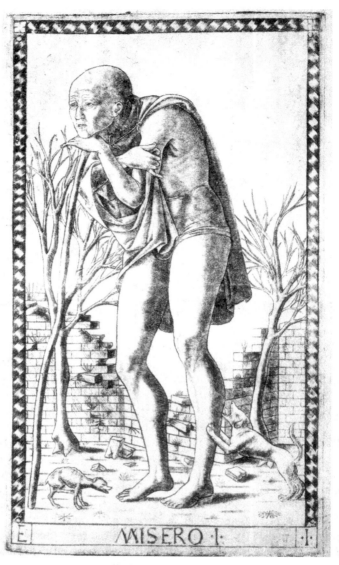

Figure 0.2 North-Italian, *Beggar*, from the set of playing cards known as *Tarocchi*, engraving, late fifteenth century. Photo out of copyright (The Warburg Institute, Photographic Collection).

is analysed by Anne-Kristine Sindvald Larsen. They may have formed part of the intended market for certain manufacturing industries, such as the London decorated pottery presented by Jacqui Pearce. They may have owned, and played, some of the popular musical instruments that are the subject of the chapter by Roger Blench. And they would have grasped the pun displayed on

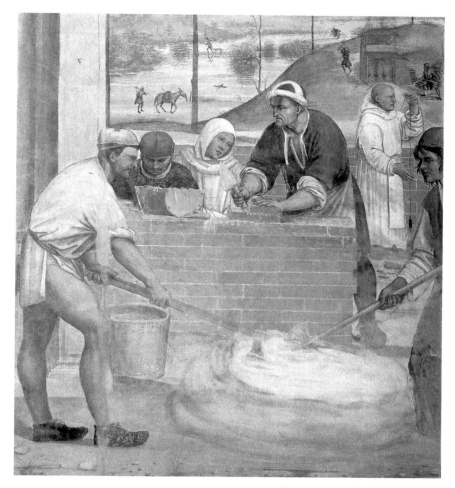

Figure 0.3 Giovanni Antonio Bazzi, known as Il Sodoma, Builders on the construction site of a new monastery: unskilled workers mixing mortar (foreground) and a master laying bricks (background), fresco, early sixteenth century, Abbey of Monteoliveto Maggiore, Great Cloister. Photo out of copyright (The Warburg Institute, Photographic Collection).

the door of the town holding cell for drunks and other minor social offenders, mentioned by M. A. Katritzky.

3) *Social exclusion.* This volume will not deal systematically with forms of social exclusion resulting from discrimination, although repeated examples will be given from the ranks of at least one social group whose lives were impoverished by both law and the conventions of society: women – from the woman donating 70 kilograms of salt to finance the building of her village church in Venetian Crete, discussed by Angeliki Lymberopoulou, to the widow from Southampton owning seven brass candlesticks, referred to by Anne-Clothilde

Dumargne. In terms of social exclusion based on economic status, it is worth noting that in fifteenth-century Florence, 50 per cent of all economic assets were in the hands of just 5 per cent of households (Figure 0.1).[23] It is probably safe to argue that the full benefits that Florentine society had to offer in terms of education, health care, political representation and cultural participation were accessible only to this top 5 per cent, and that conversely, up to 95 per cent of the population was subject to a degree of social exclusion. To this we may also add a form of retrospective social exclusion. Art-historical discourse tends to focus on a range of aesthetic objects generated mainly by the top 5 per cent of richest people. The discipline of art history has developed its own socially excluding vocabulary for works that do not belong to this top 5 per cent league: 'craftsman-like'; 'derivative'; 'minor'; 'crude'; 'coarse'; 'primitive'; 'regional'; 'provincial', to name but a few. Extending the definition of 'the poor' to all of those who have been treated poorly by art history would include the upper echelons of artisans, such as the Italian tailors whose own sense of fashion is analysed in the chapter by Paula Hohti (Figure 0.4). This social stratum, to which, in fact, most of the famous Renaissance painters and sculptors would have belonged, was not poor by purely economic standards, yet it deserves to be considered as part of this initial exploration of the art of the poor. They were among the owners of the mass-produced maiolica now hidden away in museum storage, discussed by Clarisse Evrard; the cast-iron firebacks presented by Lucinda Timmermans; the brass candlesticks whose social status is examined by Anne-Clothilde Dumargne, and the catechism prints whose iconographical variants are analysed by Ruth Atherton – none of them objects that would be likely to grace the pages of a regular survey of Renaissance art history.

A final point to make is that wherever we draw the border between 'poor' and 'not-poor', it was always a permeable boundary. People fell into poverty, such as the Florentine Barone di Cose, who found himself living in the city's debtor's prison in 1393; given the size of his debt of 79 florins, he is likely to have been a man of modest substance at some point.[24] Upward mobility, on the other hand, is evident in the case of several renowned Florentine Renaissance artists. Antonio and Piero Benci, for instance, became famous under the name of the profession of their father, a poulterer, or Pollaiuolo.[25] And the son of the tanner Mariano di Vanni has become known to us as Sandro Botticelli.[26] Both the Pollaiuolo brothers and Botticelli ended up working for the pope in Rome, the most prestigious patron of Renaissance Italy. The social background of these masters alone is a reason to take an interest in the question whether the poor had art.

What was art? Whether we can say that the poor of the late Middle Ages and the Renaissance had art depends partly on how we define 'art' – a concept, needless to say, that is even more protean than that of 'the poor'. The Renaissance itself has bequeathed to us a framework that still guides the Western understanding of art and art history today, centred on painting, sculpture and architecture, and specifically on the 'most excellent' representatives of these three media.[27] Over the past century, the validity of

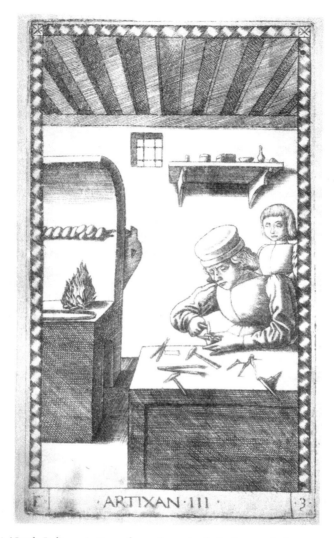

Figure 0.4 North-Italian, *Artisan*, from the set of playing cards known as *Tarocchi*, engraving, late fifteenth century. Photo out of copyright (The Warburg Institute, Photographic Collection).

the framework has been questioned. Charles Hutchinson, already cited earlier, wrote in 1916:

> At the present time when we use the word Art it is generally understood that we refer to painting, sculpture or architecture. This limited use of the word is unfortunate, since it has in a large measure led unthinking people to look upon Art as something apart from daily life.

The last thirty years have seen surveys of Renaissance art that remain largely within the traditional framework, but also ones that have explored different avenues.[28] There have been vocal critics of the framework, such as Marina Belozerskaya, who has argued for a different paradigm of 'art' for the grand princely courts of the period, revolving around media such as tapestry and goldsmith's work.[29] There has been an impact of material culture studies, as exemplified by the 2006 exhibition *At Home in Renaissance Italy* at the Victoria & Albert Museum, which displayed a broad array of luxury artefacts from households in Renaissance Florence and Venice.[30] And there have been anthropological approaches that have largely left the issue of 'art' aside and have looked instead at objects and images from a functional perspective, especially in the area of devotion.[31]

In the present context, it is worth noting that both the traditional framework and most of the alternatives that have been proposed for it are socially exclusive. Of the three media of the traditional framework, painting was materially the least expensive. Yet, in fifteenth-century Florence, even a small triptych made for a nun by Neri di Bicci (one of the lesser masters of the Quattrocento by modern standards despite his commercial success at the time) cost 4 florins – a challenging expenditure for someone living on the poverty line of 14 florins per year.[32] The bias of the framework towards the 'most excellent' masters pushes the art history it describes even more firmly into the realm of elite patronage. Belozerskaya's court art paradigm expands the range of media, but is by nature the very opposite of an art of the poor. The exhibition *At Home in Renaissance Italy* was more socially inclusive than the traditional framework, for example, by giving ample room to the material culture of women. Nonetheless, it contained only a few pieces of visual evidence (e.g. a painting by Vincenzo Campi that in itself was a work for an upmarket patron) revealing something of the material culture of the economically less privileged.[33] Only the functional anthropological approach has been fully inclusive of low-cost artefacts such as pilgrims' badges, treating them as religious images equivalent to paintings and manuscript illuminations, but it has done so by selecting objects according to a particular historical purpose and ignoring, at least to a degree, the aspect of their aesthetic appreciation.

The aim of the present volume is to argue instead for an art history that is fully inclusive. The volume will focus on the poorer segments of late medieval and Renaissance society as outlined earlier, seeking to sketch the contours of their rather neglected art history, but at the same time, it will attempt to break free of the conceptual 'ghetto' of an art of the poor that stood apart from, or was merely derivative of the 'real' art of the rich. It will examine both the arts of the traditional Renaissance framework and a broader array of material culture. It will attempt to open up a new field within art history – a field that perhaps even more than art history in general has overlaps with other disciplines, such as urban archaeology and historical anthropology. Yet, it will be distinct from those other disciplines in singling out artefacts exclusively for the fact that they were made with a degree of artifice, however modest, and may have been enjoyed because of it, regardless of their other functions. The evidence of aesthetic appreciation is of course particularly pertinent for those areas of material culture furthest removed from the established modern notion of 'art' (even the simplest painting can probably lay claim to the denominator 'art' more easily than the most luxurious pilgrim's badge);

various authors will discuss how even among categories of unostentatious or ostensibly purely functional objects there are signs of an aesthetic role of the artefacts (e.g. Jeater on pilgrims' badges; Sindvald Larsen on lower-class costume; Pearce on basic pottery; and Dumargne on brass candlesticks).

Why does the art of the poor matter? Or, to put it rhetorically, why study pilgrims' souvenirs when we could be immersing ourselves in the intellectual and aesthetic pleasures offered by Michelangelo? There are at least three compelling answers to this question, which will be introduced here based on three paintings by Pieter Brueghel the Elder – the Renaissance master who is perhaps more than any other associated with the depiction of the poor, but who does not otherwise figure in the pages of this volume.[34]

1) The *Netherlandish Proverbs* of 1559, now in the Gemäldegalerie in Berlin.[35] Among the numerous characters that populate this panel is a rich man wearing a voided-velvet cloak died in an expensive shade of crimson; he is balancing a globe on his up-turned thumb, personifying the proverb 'the world is spinning on his thumb', that is he has all the advantages (Figure 0.5). Brueghel has given him a position of prominence in the composition, slightly off-centre in the foreground. It gives the sense that the rest of the world, less privileged than he, revolves around him like the globe turning on his thumb. Directly next to the rich man is a poor devil crawling through a globe, or 'stooping to make his way in the world'. Famously, the painting also contains an inn sign that symbolizes the world turned on its head, possibly a subtle comment by Brueghel on the social relations of his time. Be that as it may, the rich man is surrounded by around twenty other foreground figures, which make him a neat representative of the 5 per cent of people who owned 50 per cent of all economic assets in urbanized societies of the time.

 Of all the characters in the painting, the rich man was surely one of the few who could have afforded to commission a painting from Pieter Brueghel.[36] Doing

Figure 0.5 Pieter Breughel the Elder, *Netherlandish Proverbs* (detail: rich man surrounded by poor people), 1559, oil on panel, Berlin, Gemäldegalerie. Image in the public domain.

so would, among other things, have confirmed his exceptional social status, not just in terms of the wealth required to purchase such a luxury item but also in terms of the even greater wealth spent on the education needed to appreciate one of Brueghel's unique and clever pieces.[37] The fact that Brueghel's painting is now in a public museum is part of a process of democratization, in the modern Western world, of art forms that were once the exclusive domain of the rich.[38] It could be argued, however, that this process of democratization has been one-sided and in a sense still propagates the myth of the superiority of the rich man's tastes; it has not yet extended to allowing the tastes of the less privileged from the past to have a place in the museum alongside those of the rich. Completing this part of the democratization would fulfil a social and moral obligation towards the 95 per cent of society who did not belong to the elite, the forgotten people of the past. It would enhance both our understanding of the past and spice up the menu of its aesthetic heritage. We do not have to subscribe to Morris's exultation of the 'humble craftsman' to enjoy much of the art that is the subject of this volume – the iconographic and stylistic richness of murals in village churches on Crete or in the Swiss Alps that may have been the only paintings a villager from these regions ever saw, the inventive late medieval English pottery of which the Museum of London has such a fine collection, the subtle sophistication of sixteenth-century German catechism prints or the wit of a word-and-image pun that even Shakespeare thought good enough to be introduced into a play.

2) The *Peasant Dance*, painted around 1569 and now in the Kunsthistorisches Museum in Vienna. In the top-right corner of this panel, we see, somewhat inconspicuously, a framed image of the Virgin and Child nailed to a tree as a modest religious tabernacle, to which a posy of flowers has been offered, placed in a clay jug hanging underneath it (Figure 0.6). According to a popular interpretation, the peasants, in their eagerness to join the village *fête*, are ignoring religion as represented by this religious shrine, although other readings have also been put forward.[39] The meaning of the detail aside, it is interesting that Brueghel has rendered the devotional image as a woodcut, with the figures outlined in black contours within a rectangular black border and a devotional text printed underneath; the artist has been meticulous in depicting the schematic hand-colouring of the woodcut in transparent water colours. Evidently, Brueghel, whose knowledge of rural material culture appears to have been extensive, considered such a woodcut an appropriate medium for a tree shrine in a Flemish village.[40]

There can be no doubt that in the sixteenth-century Netherlands, there was a market for woodcuts that were affordable to people with small purses. In early sixteenth-century Antwerp, for example, the confraternity of Onze-Lieve-Vrouwe-Lof produced black-and-white devotional prints for the sum of 0.1 Brabant denier a piece.[41] Even if sold at a 400 per cent profit margin, these would have fallen well within the purchasing power of both skilled builders, whose average daily wage was 10–14 deniers at the time, and unskilled workers on building sites, who earned around 8 deniers per day.[42] The medium of woodblock printing aimed at the mass-reproduction of images in inexpensive materials,

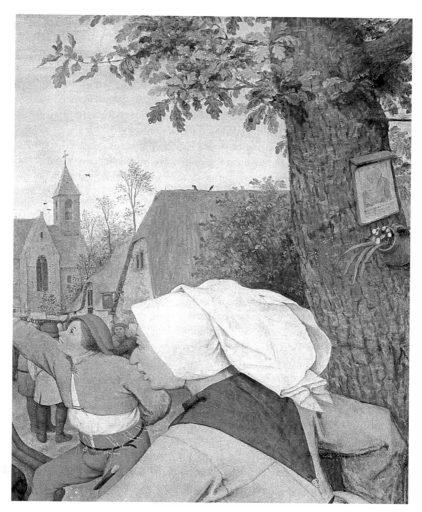

Figure 0.6 Pieter Breughel the Elder, *Peasant Dance* (detail including the small tree shrine in the top-right corner of the painting), 1569, oil on panel, Vienna, Kunsthistorisches Museum. Image in the public domain.

ink and paper, was inherently suitable for production for the poor, even if much more technically elaborate and iconographically sophisticated upmarket woodcuts also existed at the time.[43]

Historians of printing have cautioned us against the oft-made assumption that the single-leaf woodcut in fact started its existence in the fifteenth century as an art form for 'simple folk'.[44] It is plausible, however, that the earliest religious woodcuts fulfilled a function analogous to that of pilgrim souvenirs, which were equally mass-manufactured and accessible to a broad segment of the population, as discussed by Meriel Jeater in this volume. Prints that may have

been designed deliberately as items for a collectors' market appear only later in the fifteenth century. Printing as a medium may have undergone a process of upward social mobility, possibly again in analogy with pilgrim souvenirs. Similar upward mobility may have occurred in ceramics, again a reproductive industry that developed an appeal to a higher market segment only with the introduction of tin-glazing during the fifteenth century, as shown by Jacqui Pearce in this volume, and perhaps also in glass, a medium that saw repetitively produced basic pieces in the fourteenth century followed by an upmarket production in Venice in the fifteenth century.[45] Such an upward mobility of media contradicts the widely held notion that art forms of the poor were invariably derivative of those of the rich. It would mean that art forms of the poor could have a direct impact on art forms of the rich, which would certainly be a reason for taking the art of the poor seriously.

3) The *Peasant Wedding* of 1567, also in the Kunsthistorisches Museum in Vienna. In the lower left corner of the master's most famous work, we see a basket full of glazed clay mugs; a young man dressed in black has taken one out and is filling it with ale from a larger jug (Figure 0.7). It has been observed that this detail is one of the many in Brueghel's paintings that 'painstakingly describe the material life of everyday things', and that the artist here 'carefully articulates the grooved indentations and variegated colors of the assortment of drinking jugs held in the basket at the bottom left'.[46] The existence of such clay drinking mugs, with a moulded foot, a handle, a belly and a narrower neck, and a green or brown glazing, is confirmed by a range of similar items in the Museum of London. Interestingly, the examples in the Museum of London are local English wares, some of which are dated two to three centuries before Brueghel's painting.[47] Clearly, this was a type of manufacture that existed across a larger stretch of north-west Europe over a long period of time. The example indicates that an art history of the poor does not necessarily conform to the same patterns as the more familiar art history of the rich, which has a well-defined geography, with clear distinctions between particular centres of production and their hinterland, and an established chronology in which artefacts are often datable to a precise decade if not a particular year. The alternative parameters of the art history of the poor are reflected in the present volume, which deliberately covers a longer period, from the thirteenth to the early eighteenth centuries, a wide geographical area that includes most of Europe, and regions that in regular art history would be considered 'provincial' or peripheral, such as Crete or the Swiss Alps.

The more important issue, however, is whether a glazed clay beer mug, however marketable perhaps even if reproduced today, deserves a place in a study on the history of art. Was such a mug simply a functional item of material culture, or would its shape and the colour of its glazing have made it into one of the few possessions of a poor household that might have given their owners a modicum of aesthetic pleasure? Such speculations are raised above the level of the merely theoretical when we learn that a young man visiting a Basel fair around the middle of the sixteenth century experienced carved wooden biscuit moulds sold in a market stall as, in his own words, 'works of art', and spent time

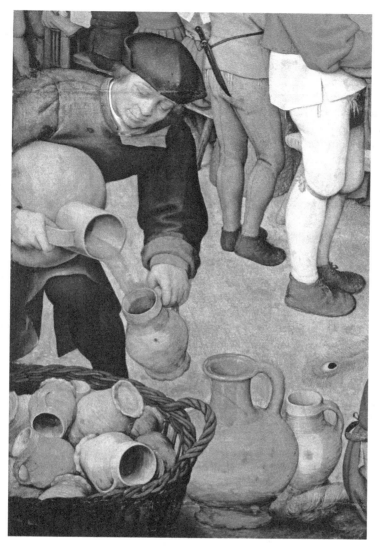

Figure 0.7 Pieter Breughel the Elder, *Peasant Wedding* (detail: man pouring ale into mugs), 1567, oil on panel, Vienna, Kunsthistorisches Museum. Image in the public domain.

lingering at the stall in order to admire them.[48] Debating whether such objects as beer mugs and biscuit moulds should be incorporated in the discourse of the history of art forces us to rethink, on a fundamental level, where within general material culture we want to draw the boundary of a category of artefacts that were made to have a form of aesthetic appeal and to which we are willing to apply the label 'art'. Considering such objects as 'art' has the potential to bring our discussion of Western art closer in line with how we view many non-Western

artistic traditions. Few would object, after all, to seeing a clay vessel of modest shape and colour included in, say, an exhibition on the indigenous art of the Americas. The fact that it sparks such philosophical enquiries into the very nature of 'art' and the remit of art history is another eminent reason to study the art of the poor.

The chapters in this volume, based on a selection of the papers delivered at the aforementioned 2018 Warburg Institute conference, do not follow a single consistent academic approach. They instead present a range of methods, including archival statistics (Cohn; Dumargne); source text interpretation (Lymberopoulou); surveys of evidence (Sindvald Larsen; Blench; Evrard); cultural-historical analysis (Gilmore-Kuziow; Hohti; Katritzky); pure art history (Nichols; Schweigert); iconographical interpretation (Atherton); object-based history (Jeater; Pearce; Timmermans); theory (Anderson); and combinations of the above. It is a deliberate choice not to force the first exploration of the field of the art history of the poor into a single methodological straightjacket but to examine instead what contributions different techniques of research and interpretation can make. Similarly, the contributors are from different backgrounds, including history (Cohn; Atherton), anthropology (Blench), archaeology (Jeater; Pearce), material culture studies (Dumargne; Evrard; Timmermans), costume history (Hohti; Sindvald Larsen), art history (Anderson; Gilmore-Kuziow; Lymberopoulou; Nichols; Schweigert) and history of literature (Katritzky). Most contributors are university based, but three are museum curators (Jeater; Pearce; Timmermans), which is especially important as a lot of knowledge essential to the new field is object-based and held at museum collections of urban archaeology and material culture.

The chapters are arranged according to several broad thematic divisions. The first two deal with evidence for the world of the poor and their art: documentary (Cohn) and visual (Nichols). Then follow three contributions on painting – one on panel painting (Schweigert) and two on murals (Lymberopoulou; Anderson); the latter two also cover the theme of 'regional' art, crucial in the context of the art of the poor as the classic dichotomy of centre and periphery is often one between concentrations of wealth at courts and cities and the relative poverty of provinces. Two transitional chapters deal with objects of devotion: painting (Gilmore-Kuziow) and pilgrim souvenirs (Jeater). They lead to a section on broader material culture, divided according to media: costume (Sindvald Larsen; Hohti); musical instruments (Blench); ceramics (Pearce; Evrard); and metal work (Dumargne; Timmermans). The volume concludes with two chapters that revolve around iconography in print culture (Evrard) and mixed media (Katritzky). There is no arrangement based on geography or chronology, except that thematic sections follow a chronological order where appropriate, and the final essay is also the one dealing with comparatively the most recent material, dating from the early seventeenth to the early eighteenth centuries.

The first chapter, by Sam Cohn, discusses documentary evidence for the art of the poor, highlighting the importance of such evidence for the study of art forms the physical remnants of which have largely disappeared. Based on wills, Cohn shows that in late medieval Tuscany, non-elites not merely purchased ready-made paintings and art-objects, but actively commissioned artwork, including entire funerary chapels

in parish churches. Cohn demonstrates that this market of non-elite commissions peaked in the decades immediately following the Black Death, when the decimation of the population brought about a redistribution of wealth as labour became a scarcer and therefore more expensive commodity. The trend buckled, however, after 1375; Cohn argues that this was the result of a deliberate effort by elites to maintain social distinctions.

Tom Nichols deals with visual evidence regarding the Renaissance poor and their world, which largely consists of representations of the poor made for the elite. Nichols argues that poor people depicted in the works of one of the well-known painters of rustic life of the later sixteenth century, Jacopo Bassano, were indeed viewed through the eyes of the upper classes. They were presented either as the victims of temporary hardship that were deserving of charity or as staffage that added a touch of charm to rural landscapes. Bassano masked the harsh reality of times of destitution, showing the poor in small numbers as the focus of the charitable efforts of the rich. Similarly, he depicted the poverty of peasants as a colourful feature of the countryside, where the real focus was on the herds of animals that demonstrated the wealth of landowners.

Thomas Schweigert turns our attention to a painting that was commissioned by the lower-class people from a minor confraternity in Venice. Schweigert points out that among the nine paintings by Carpaccio that decorate the ground-floor room of the present building of the Scuola degli Schiavoni in Venice, one stands out as an anomaly in terms of its artistic execution: *Saint Tryphon Tames the Basilisk*, which art historians have treated as a the poor relative of the cycle. In fact, Schweigert argues, the nine works were part of two different commissions – one of eight works by the rich Knights Hospitaller, and one single work by the poor confraternity of the Schiavoni, representatives of the Venetian dominion of Albania Veneta on the Dalmatian coast, who ordered the painting of Saint Tryphon, their patron saint.

Angeliki Lymberopoulou continues along the lines of painting and collective commissions, and also introduces the theme of regional and, in this case, insular art as associated with relative poverty. Lymberopoulou discusses cycles of wall painting found in numerous small village churches on Crete dating from the fourteenth and fifteenth centuries, when Crete was a Venetian dominion. Inscriptions indicate that many of the churches and their decorations were communal commissions by groups of villagers, or occasionally even the entire village. These inscriptions, as Lymberopoulou shows, functioned as ledgers, with names recorded in the order of pledged contributions, and sometimes names added in a different hand after the closure of the initial ledger. Contributions were made in money, but also in kind, including olive trees and plots of land that may have financed the upkeep of the church.

Joanne Anderson elaborates further on the regional theme. Using the example of the Alpine bishopric of Chur during the fourteenth century, Anderson questions the assumption that small villages represent poverty next to the wealth of a cathedral city. Using the concept of 'relationality', she argues that poverty should be measured not merely on a relative scale, but in terms of the world that contemporary people would have related to. Anderson compares the cathedral of Chur, a regional centre of some 1,300 inhabitants, to the small churches of Dusch and Stuls/Stugl, villages of diminishing size at increasing distances from Chur. While the latter were not

remotely on the same scale as the cathedral, within the local world of the villagers, they stood for wealth rather than poverty, and their paintings should be assessed on those terms rather than dismissed as 'regional' or 'rural' art in a framework determined by twentieth-century connoisseurship.

Shannon Gilmore-Kuziow discusses a public painting that was appropriated by the poor as an object of devotion. The cult of Santa Maria delle Carceri in Prato centred on a fresco of the Virgin and Child Enthroned on the outside wall of a former debtor's prison: the fresco was recorded to have started performing miracles from July 1484; the cult was sanctioned by a papal bull from September of that year; and the painting was enshrined within a dedicated church in 1485. Gilmore-Kuziow points to a number of factors that contributed to the cult becoming particularly attractive to the poor from the city and the surrounding countryside, including the fact that Prato's principal relic, the sacred girdle of the Virgin, had become an exclusive cult object for the elite, controlled, like the city itself, by the Medici family from Florence.

Meriel Jeater, in the first of the three contributions by museum curators, shifts the focus to the broader material culture of devotion. She presents an overview of forms and functions of pilgrims' badges based on the extensive collection of the Museum of London. The base metal souvenirs sold at religious shrines were a form of devotional imagery accessible to a wide segment of the population. They were made of cheap metal alloys (mostly lead and tin in varying proportions) and mass-produced in reusable moulds that allowed for the simultaneous manufacture of multiple identical badges. They were sold in tens or even hundreds of thousands of copies per year at popular cult sites, at prices of a penny apiece, affordable even to ordinary workers. Many have been found in medieval landfill shoring up the old wooden quays of the River Thames, suggesting they were not treated as valuable items. Yet, they display a variation of in form and quality, which indicates that their aesthetic aspect mattered to prospective buyers.

Anne-Kristine Sindvald Larsen takes us into the territory of secular material culture, specifically costume. She assesses the evidence that is available for the rarely studied dress of the lower ranks of artisans, for example, bakers, barbers, blacksmiths and butchers, in trading towns in sixteenth- and seventeenth-century Denmark, with particular attention to Helsingør (Elsinore). She presents examples of relevant inventories, representations of dress, archaeological finds of actual clothing, sumptuary legislation, court cases documented in so-called town books, accounts by foreign travellers visiting Denmark, and personal documents, such as the rare diary that describes the lives of two generations from a butcher family from Helsingør. Each type of evidence has its advantages and limitations; in combination, however, the different sources present a rich and rounded picture of the style and cultural significance of costume among ordinary manufacturers and traders in early modern Danish towns.

Paula Hohti follows the thread of artisanal costume, taking Giovanni Moroni's famous portrait of a tailor in the National Gallery in London as her point of departure. She argues against assumptions that artisans wore only functional clothing and were curbed in their sartorial self-expression by sumptuary laws, presenting evidence to show that the fine and fashionable clothes worn by Moroni's tailor (sometimes used to question whether the painting is a genuine portrait of an actual tailor) were in fact

representative of the upper tier of artisans in sixteenth-century Italy. Hohti points out that master tailors in particular gained in social status at this time, emphasizing the intellectual element of design in their creations, and engaging in mercantile activities, trading second-hand clothes and in clothing accessories.

Roger Blench discusses the material culture of entertainment, presenting a survey of the evidence regarding popular musical instruments and musical performance in late medieval Europe. As with most aspects of culture, the surviving sources and the research based on them are biased towards elites. There is, however, scattered evidence from various corners of Europe that allows us to reconstruct some of the popular instrumentarium and performance practices that existed across the continent in the period between 1000 and 1500 AD, including stone and wood carvings on the column capitals of religious and secular buildings and the bosses of church vaults, paintings such as those by Albertus Pictor in south Sweden and Bernard Notke in Tallin, archaeological finds and surviving instruments, surviving folklore traditions and texts ranging from the eleventh-century Catalan *Biblia de Rodes* to Praetorius's *De Organographia* of 1618.

Jacqui Pearce, in the second contribution by a museum curator, takes us from entertainment to entertaining, discussing glazed ceramic table wares from London potteries in the late Middle Ages, based on the collections of the Museum of London. Pearce distinguishes between functional pottery, for example, cooking pots, and wares that were meant to be presented on the table during meals; both, however, were produced by the same manufacturers (based at Woolwich, Kingston and Mill Green for the London area). Pearce argues that these decorative ceramics were a widely accessible alternative to the exclusive silver and pewter tablewares of the elites. Using jugs with animal patterns and in the shapes of animals and people as examples, Pearce shows how the introduction of technical innovations (glazing and the potter's wheel) in pottery manufacture during the twelfth century was the impetus for a surge of inventiveness in design during the thirteenth and early fourteenth centuries, brought to an end abruptly by the Black Death.

Clarisse Evrard continues on the theme of ceramics as an alternative to silverware, examining sixteenth-century Italian maiolica – not the well-known high-end production by artists such as Nicolà da Urbino or Xanto Avelli, but simpler, mass-produced items that tend to fall outside of the scope of regular maiolica studies and are often kept in storage by museums. Evrard asks if such items could be classified as the lower-class equivalent of the precious-metal tablewares of the elites. The scant visual evidence regarding the use of maiolica is inconclusive, but inventories demonstrate that even the maiolica found in the households of the rich was often relatively inexpensive, and that small numbers of jugs and basins specifically described as 'di maiolica' could be found in poor houses. Using Virginia Nixon's definition of 'popular art', Evrard demonstrates that a range of surviving examples of maiolica adheres to the characteristics of this category, for example, in the repeated reproduction of a simple design.

Anne-Clothilde Dumargne shifts the discussion to metal ware, surveying the evidence for the presence of copper-alloy candlesticks in regional England from the fourteenth to the seventeenth centuries. Dumargne makes a distinction between

pricket candlesticks, which have the candle mounted on a spike, and socket candlesticks, which have the candle inserted in a socket. The former were more suitable for exclusive beeswax candles, mainly used in a liturgical context, the latter for softer but less expensive tallow candles, the introduction of which enabled the widespread use of candles in the domestic sphere from the fourteenth century onwards. Yet, not all households contained candlesticks, and they were not systematically included in lists of essential household goods. Their presence does not seem reflective of the relative wealth of households. Their value was mainly determined by their weight in metal, suggesting that they sometimes functioned as a modest store of capital.

Lucinda Timmermans, in the third and last contribution by a museum curator, stays with metal wares, presenting a brief overview of cast-iron firebacks in the collection of the Rijksmuseum in Amsterdam. Such firebacks were mounted in fireplaces to protect the wall from the heat of the flames and project the warmth forward into the room. They were popular in the Netherlands in the seventeenth century, although Timmermans also refers to examples from Germany and France. Their production was international, too; even though there is a tendency to speak of 'Dutch' firebacks, they were actually manufactured in iron foundries in Germany and perhaps Sweden. Their production was related to that of iron stove panels. Yet, whereas a cast-iron stove was a relatively exclusive item, the use of firebacks appears to have been widespread, ranging from farms to governmental and charitable institutions. And while stove panels were decorated with religious scenes, firebacks had their own iconographical tradition, often related to contemporary political events.

Ruth Atherton takes us to the medium of print, discussing woodcuts in post-Reformation catechisms – books of religious instruction for the laity, which were produced in various degrees of sophistication for audiences of differing levels of education and literacy. Atherton points to recent research showing that woodcut illustrations in sixteenth-century books can contain messages of their own that can supplement, or even deviate from, the text. Authorial control over book illustrations was limited; woodcuts could be added on the instigation of the publisher or printer. The same images could be reused in different contexts and thus given different interpretations. In the post-Reformation era, printmaking artists could work for both Catholic and Protestant publications. Atherton argues, moreover, that iconography could reflect local social concerns in the city of publication. She also presents two case studies demonstrating what she calls the 'versatility and ambiguity' of woodcut illustrations in their application on either side of the religious divide.

M. A. Katritzky concludes the volume with a discussion of a popular joke that is referenced in Shakespeare's *Twelfth Night*, and was disseminated in prints and reproduced in other media across Western Europe from the late sixteenth century onwards. The joke in question combines image and text: the image showing any number of fools and the caption referring in the first-person plural to that same number of fools plus one, thus adding the spectator as an extra fool (e.g. an image of two fools captioned 'we three'). Katritzky traces this jest across examples as diverse as a stone relief on a holding cell for petty criminals in a town in Bavaria, a sixteenth-century German biscuit mould, friendship albums, popular poetry and prints. She demonstrates that the tradition was so successful that sometimes even images that

were not part of it were co-opted, for example, a genre painting by Carracci or a French medieval woodcarving.

Altogether, the sixteen chapters present evidence for and examples of art forms that were accessible to a range of non-elite audiences, from unskilled workers to artisans. They draw the outlines of a potential new field in art history and indicate directions of research within it. Most importantly, they demonstrate that this new field is a lively and productive area of academic investigation, and thus advocate the further study of art of the poor. They show how much the study of the art of the poor would enrich the traditionally elitist discipline of art history and make it clear that despite entrenched prejudices about what constitutes 'high art', the art of the poor should never be thought of as poor art.

Material culture without objects

Artisan artistic commissions in early Renaissance Italy

Samuel Cohn

Increasingly, scientists employing skills beyond documentary analysis are the ones making fundamental historical breakthroughs. As I write, geneticists, physical anthropologists and evolutionary biologists are rewriting the Columbian exchange between the 'New' and 'Old Worlds'. With DNA analysis and genome sequencing a new landscape of epidemic history in the pre-Columbian New World is being discovered, contesting assumptions about the New World health before Old World diseases invaded. No longer will the pre-Columbian New World be seen in the pristine light as some have previously imagined.[1] No documents or even present archaeological findings chart these earlier epidemic contours. Instead, phylogenetic reconstructions pinpointing mutant genes are the keys for mapping this past, and objects – skeletal remains – provide the primary sources.

Art history, of course, has always been object-based. In a reversal of what is now occurring in science-based history, this chapter will contend that the contours of some subjects in art history are, however, imperceptible merely from the study of surviving objects and can be reconstructed only through the analysis of surviving historical documents. Such is the case with much of the art history of those beneath the upper echelons of the elites, at least before the sixteenth century. One such area concerns the art non-elites purchased and displayed in their homes. The mapping of these contours of consumption rests overwhelmingly on documents, principally inventories. As with phylogenetic family trees of pathogens for disease history, research on these documents over the past forty years has transformed our notions of the trends and patterns of consumption among artisans, workers and even peasants. Yet for the ownership and display of paintings, prints and other forms of decorative art in households beneath the horizons of elites, much remains to be done.[2]

Another world even more dimly lit by surviving objects regards artistic patronage by artisans, labourers and peasants in the late Middle Ages and Renaissance. Evidence of artisans' commissions comes almost exclusively from one source: last wills and testaments, scattered through notarial books and parchments kept by churches, monasteries, hospitals and occasionally in family archives. Such works of art were

commissioned mainly for parish churches and monasteries. A rare exception was a commission by a blacksmith from the Mugello, north of Florence: on his deathbed he bequeathed 14 lire to adorn his bed with an image 'in the likeness of the majesty of God' that it be given to the hospital of Borgo San Lorenzo to care for the poor.[3] Other commissions for painted or carved figures could cost less, as with a candleholder left by a disenfranchised Florentine woolworker to the hospital of Santa Maria Nuova, which he ordered 'painted and inscribed' with his coats of arms, even though this carder possessed no family name.[4]

The goals of these artisan commissions for embossed candlestick holders, embroidered figures for priestly vestments, panel and wall paintings, and wax figures that could cost less than a florin were not just for salvation. As with pious bequests from elites, those of humble testators expressed desires for remembrance and prestige in this world as in the next. These patrons demanded to be painted 'in their very likeness' (*ad similitudinem*) and alongside images of deceased family members. Such was a testamentary commission by a blacksmith living in the Aretine hill town, Bibbiena. His modest testament was devoted to one bequest alone: a panel to be painted of the Virgin and Child with St John the Evangelist on one side, and Mary Magdalene and St Anthony, on the other, to be hung close to his grave in the friary of the Blessed Mary. The blacksmith's instructions went further: on one side, the artist was to paint the blacksmith kneeling at the Virgin's feet and, on the other, his deceased father. For neighbours and future generations not to miss the point, the blacksmith commanded the artist to label the figures: 'Here lies Montagne the blacksmith; there, Pasquino, his father.'[5]

Other artisan commissions could supply more details as with one from an Aretine greengrocer (*ortolanus*) in his will of 1371. For a mere 4 lire,[6] he commissioned narratives (*ystorie*) of the Holy Ghost to be placed above the altar of his confraternity, probably as the *predella* of an existing painting.[7] At the beginning of the fifteenth century, a man identified only by a single patronymic from the mountain village of Cerreto, northeast of Spoleto, exceeded the simple call for a burial portrait at the feet of the Virgin. He ordered 'the figure of Saint George with [his name] above his head, the Virgin Mary and child in her arms', and the testator's father kneeling at her feet, holding a trumpet in one hand and in the other, flying a flag bearing the arms of the Orlandi family.[8] Why the Orlandi's arms were to be inscribed is not explained. Might the commissioner or his father have been a dependant of this Perugian noble family?[9] In the histories of Renaissance portraiture, art historians have yet to evaluate or even recognize this fourteenth-century chapter of donor paintings commissioned in large part, at least in Tuscany and Umbria, by non-elites in their last wills and testaments for spiritual and temporal recognition.

Yet despite their occupations and social status, these testators cannot easily be classified as the poor. Several cases show the economic heights to which artisans could ascend after the Black Death, illustrating shifts in the supply and demand for labour and the new possibilities to purchase landed property.[10] In 1361 an Aretine ironmonger left the entirety of his residual estate to build a chapel in that city's Augustinian church,[11] and in 1416 a cobbler from Vinci, who earlier had worked in the poorer parishes *sopr'Arno* on Florence's periphery, left 50 florins to construct a chapel to commemorate his remains in his native village. Further, he ordered it to be adorned with a panel painting,

depicting the Virgin and 'the Blessed Saints John the Baptist, the Apostle Paul, Michael the Archangel and Anthony'.[12] Even though 50 florins was at the lowest end of amounts to finance the building of a chapel even in village churches as seen in my samples, the cobbler's expenditure was twenty times larger than the average amount artisans spent on commissioning burial paintings alone. The cobbler, however, had not overreached the possibilities for post–Black Death artisans or their spouses. In 1390, the wife of a belt-maker commissioned a chapel to be constructed in the ancient Aretine abbey of Santa Fiora.[13] In 1411, the widow of a tanner ordered the building of a chapel in Perugia's friary of Monte Morciano.[14] And in 1348, the Aretine widow of a weaver (in Tuscany, usually a disenfranchised worker without rights of citizenship) sold all her possessions for one pious bequest, the construction of a chapel in Arezzo's Santa Maria in Gradibus.[15]

To explain the rise of the artisan patron, my argument hinges on economics, the shift in wealth spurred by the demographic catastrophe of plagues from 1348 through the Renaissance. As we shall see, the relationship is not what we might have expected. Over sixty years ago, Emmanuel Le Roy Ladurie showed that the Black Death reversed a long-term economic pattern of the rich getting richer and the poor poorer in the south of France.[16] Since then, historians have shown that Black Death demographics spawned similar economic trajectories for labourers and artisans in other parts of Europe.[17] Yet only recently has it emerged just how universal and unusual the post–Black Death century, ca. 1375 to 1475, was in economic history, not only across Europe but into the Near East, and from the thirteenth century to the present.[18] No other century has shown such a marked deviation from a generally steady timeline of ever-increasing inequality.[19]

However, artisans' artistic commissions found in my sample of 2,879 testaments, drawn from archives in five cities and their *contadi* or regional hinterlands – Arezzo, Assisi, Florence, Perugia and Pisa – do not suddenly increase during the post–Black Death century of increasing prosperity and equality.[20] Instead, the relation between artisan commissions and economic well-being was more nearly inversely correlated. Their commissions rose through the first half of the fourteenth century and peaked with the Black Death in 1348. Then, when the economies of Tuscany and Umbria reversed gears around 1375, with textile production rebounding, conditions beginning to improve in the countryside, and the growth of new luxury goods,[21] artisan commissions declined sharply and by the opening decades of the Quattrocento had almost disappeared (Figure 1.1 and Tables 1.1 and 1.2).[22] Between 1401 and 1425, across all five city states, only two artisan commissioners appear in my samples. When we turn to testamentary commissions of a grey area of non-elites (neither identified as peasants, workers or artisans nor by elite occupations, titles or family names), the significance of the changes post-1375 becomes more striking. From the Black Death until 1376, the percentages of artistic commissions to ecclesiastical institutions made by these testators, probably the middling sorts or shopkeepers, continued rising. However, when prosperity and equality began to rise, their commissions dipped as steeply as those ordered by peasants or artisans (Figure 1.2 and Tables 1.1 and 1.2).[23]

The early Renaissance did not, however, mark a general decline in artistic commissions to churches, hospitals and monasteries. For elites – identified by family names, titles of nobility, and upper-guild professions – the last fifty years of our analysis, 1376 to 1425, registered instead a sharp rise in their commissions, showing

Figure 1.1 Chart: Testamentary Commissions 1276–1425: Elites and Commoners (see also note 22 of Chapter 1). Copyright: author.

Table 1.1 Artistic Commissioners by City State 1276–1425 (see also notes 22 and 23)

City States	Testaments	Commissions	Elites	Commoners	Grey Area (Non-elites)
Arezzo	616	112	61	21	30
Assisi	258	18	2	2	14
Florence	647	94	49	13	32
Perugia	574	59	22	12	25
Pisa	784	70	31	13	26
Total	2879	353	165	61	127

Table 1.2 Artistic Commissions by City State 1276–1425 (see also notes 22 and 23)

City State	Testaments	Commissions	Elites	Commoners	Grey Area (Non-elites)
Arezzo	616	165	99	25	41
Assisi	258	24	4	2	18
Florence	647	127	71	16	40
Perugia	574	69	27	12	30
Pisa	784	97	48	11	38
Total	2879	487	249	66	172

a decisive dominance over the ecclesiastic art market. Effectively, their contributions eliminated peasants, artisans and shopkeepers from earlier patronage and their ability to commemorate themselves and their ancestors visually in ecclesiastical spaces.

The price of art was one of the levers that created this scissors-like graphic that opened the gap between elites, on the one hand, and commoners and non-elites more generally. By the beginning of the fifteenth century, the price for ecclesiastical commissions skyrocketed, rising nine times over what it had averaged during the previous generation

Figure 1.2 Chart: Testamentary Commissions 1276–1425: Elites, Commoners and an undefined Mixed Group (see also note 22). Copyright: author.

and a fantastic twenty-six times over what it fetched in the 1360s, despite the period, 1375–1475, being deflationary as far as basic commodities can be measured.[24] These prices, however, do not reflect an increase in what individual paintings of comparable materials, dimensions and prestige of the artists might have registered.[25] Rather, a complex of items now had become necessary to gain artistic space in ecclesiastical buildings. After 1375, chances of leaving lasting memorials in churches rested on large donations for constructing burial chapels that included bequests of silver chalices, priestly vestments, altars, sculpted monumental tombs, elaborate fresco cycles and livings for priests to sing perpetual masses. A structural change in the possibilities of commissioning explains the price rise. Single gifts of inexpensive panel paintings, not a part of such grandiose chapel complexes, had virtually disappeared no matter who the donor happened to be.

This early Renaissance reversal in non-elites as potential art patrons reflects another post-plague scenario. Not only in Florence after the defeat of the Ciompi and minor guildsmen in January 1382, but across other regions of Europe, a paradox emerged: as artisans' real wages continued to increase for a century after 1375, their political status declined: oligarchic elites, supported by kings and landed aristocrats, successfully attacked artisan guild liberties and in Italy their rights to serve in large legislative assemblies.[26] Their loss of power to commission works in ecclesiastic spaces to memorialize their places of burial and their ancestors with sculpted figures or painted panels reflects another dimension to their general decline in status during the Renaissance.[27] Here, I hypothesize that the political elites with the cooperation of the Church were able to confront the threatening rise of economic equality brought on by the new demographic realities by creating new inequalities in the political and cultural spheres.

To substantiate this hypothesis, the geographical and temporal dimensions of these testamentary samples must be extended. In addition, we would be able to ask new questions such as how non-elites reacted to this closure of their possibilities to commission art. At least three alternative pathways may have arisen: (1) commissions

for sacred art for homes and shops may have increased as suggested in Neri di Bicci's accounts;[28] (2) a turn to cheaper and more ephemeral votive offerings, which increased through the fifteenth century (however, these were usually purchased, ready-made, from artists' shops and rarely, if ever, commissioned by artisans);[29] and (3) the pooling of funds through artisan guilds or religious confraternities to commission more costly altarpieces.[30] To date, no one has plotted the course of any of these trends, or connected them to artisan losses during the post–Black Death century. Moreover, did these trends differ regionally, and, if so, what were the reasons?

In conclusion, the fourteenth century extended artisan and even peasant patronage of chapels, altars and paintings. This art patronage, however, was short-lived, and by the fifteenth century it had virtually disappeared, not because of a decline in their material well-being but for the opposite. The abrupt change in the supply and demand for labour sparked by the Black Death and successive plagues drove elites to engineer new non-economic means to preserve and extend their status and privileges. One arena of this elite reaction, yet to be studied, was art patronage. In the opening years of the fifteenth century, magnate families such as Florence's Frescobaldi and wealthy merchants such as Arezzo's Bracci offered hundreds, even thousands, of florins to build complex burial chapels, embellished with expensive fresco cycles, but only if churches agreed to prevent others from impinging on these spaces or even the view of them with competing artistic commissions.[31] Such were the demands of a 'Probus Vir' in Florence in 1417. His founding and decoration of a chapel in Santo Spirito for his family tomb with sculpted coats of arms, paintings, stained glass and livings for priests were conditional on the friars' promising that no banners, plates, arms or paintings would be accepted that would block the view of his chapel from as far away as the church's organ.[32] The new demands of these early fifteenth-century merchant elites suggest that the whitewashing of church interiors and stripping of cheap column paintings, plates and burial monuments that artisans had earlier commissioned to preserve their own memories had begun well before Cosimo I's and Giorgio Vasari's transfiguration of Florence's ecclesiastic interiors in the mid-sixteenth century to conform to what they believed were the aesthetics of ancient Greek temples.[33] As early as 1429 the Commune of Florence imposed a tax on families who possessed chapels and tombs in churches for the purposes of ornamenting and whitewashing church walls.[34] Two decades later, Leon Batista Alberti in *De re aedificatoria* expressed similar doctrines for a new Renaissance ecclesiastic aesthetic. For him, 'the walls of the ideal church interior' should be predominantly white.[35] At the same time, Pope Pius II in his *Commentaries* commanded: 'No one shall deface the whiteness of the walls and the columns. No one shall draw pictures. No one shall hang up pictures. No one shall erect more chapels and altars than there are at present'; and according to Henk van Os, the evidence from Sienese church interiors shows that Pius's desires were being carried out.[36]

From surviving objects in museums and private collections, the contours of artisan art patronage remain hidden from history. Few of these artisan commissions survive, and certainly not enough to chart trends over time or place. In contrast to present discoveries of pre-Columbian epidemics in the New World that possess no traces in documentary history, the reverse is true here: documents alone can bring to light this artisan material heritage.

Poverty in the paintings of Jacopo Bassano

The crisis poor and the structural poor

Tom Nichols

Jacopo Bassano (ca. 1510–92) introduced a calculatedly humble tone in his paintings, often featuring impoverished social types who had not previously been granted much attention in the heroic or idealizing imagery of Renaissance art. Although Bassano spent time in the workshop of Bonifazio de'Pitati in Venice, he subsequently made his career in the small regional town of Bassano del Grappa. His rural location may have encouraged him to develop a homely or rustic style that was carefully differentiated from the more lavish productions of contemporary painters in nearby Venice, such as Titian and Paolo Veronese. Against these metropolitan masters' classicizing richness (*richezza*), Bassano offered pictorial directness and simplicity. Despite this distinction, a closer analysis suggests that Bassano's approach was sophisticated enough. He carefully mediated his imagery of poverty, avoiding too direct a representation of the harsh realities of material want in his time. When depicting scenes of saintly almsgiving, he typically set the scene in the town, and promoted the poor and sick as ideal models of 'sacred poverty' (*sancta povertà*) whose plight offered opportunities for charity among respectable citizens. In those paintings which he set in the countryside, often featuring trenchant depictions of peasants tending their animals, he was careful to offset the indications of material lack or need, making their poverty appear as picturesque, and as a somehow inevitable and justified part of the ongoing circumstances of everyday life.

The well-known distinction of social and economic historians between the 'crisis' poor and the 'structural' poor in sixteenth-century Europe proves very useful when interpreting Bassano's differing approaches.[1] When almsgiving or assistance to the poor becomes the explicit theme of the painting, then Bassano depicts 'crisis poor' ravaged by disease, whose fallen bodies lie about in the street in a state of extreme physical distress. They are shown as physically disabled by their sickness and unable to work, and perhaps also as displaced, insofar as they appear to have only recently arrived in a setting implied as urban. The potentially destabilizing effect of these desperate refugees is, however, offset by the suggestion that the charitable ministrations of pious townsfolk, powerfully supported by the miraculous intervention of divine or divinely

inspired actors, will provide them with sufficient restitution. Even as such works demand an empathetic charitable response from the viewer, they also restore a sense of the underlying efficacy of the social and divine orders in the relief of the poor within the supportive context of the city. On the other hand, when Bassano depicts the 'structural' poverty of peasants in the countryside, the indications of material want or lack are not allowed to disturb the quotidian run of things and demand no intervention, divine or otherwise. Poverty in this context operates as a formative or constituent element of the scene depicted, and is embedded within imagery that suggests the ongoing functionality and productivity of the rural world.[2]

Peasant and beggar were two aspects of one social identity in sixteenth-century Italy, and Bassano often used a similar reclining figure for his depiction of both types.[3] In times of war, disease and famine, rural populations flocked in great numbers to towns and cities, where many peasants quickly became beggars, or succumbed to the ravages of disease. One eyewitness in Vicenza in 1528, at a time of failed harvests, famine and sickness, noted this terrifying invasion from the countryside in very expressive terms. Luigi da Porto complained that you could 'give alms to 200 and as many more appear again', and that 'you cannot walk down the street or stop in a square or church without multitudes surrounding you to beg for charity'. And then there was the nightmare of their physical appearance: 'you see hunger written in their faces, their eyes like gem-less rings, and the wretchedness of their bodies with skin shaped only by bones'.[4]

Jacopo Bassano, from nearby Bassano del Grappa, may well have experienced this frightening level of social deprivation at first hand. When, during another particularly savage outbreak of the bubonic plague in 1575, he was commissioned to paint the High altarpiece for the church of San Rocco in Vicenza, he certainly reflected the challenges generated by the sick poor invading the city (Figure 2.1).[5] But he was also careful to suggest that the problems these desperate sufferers presented were being actively and successfully addressed. While the sick are very carefully represented in his painting, they do not, in the way that Da Porto had noted, dangerously outnumber those who attempt to help them. Six committed helpers are shown ministering to the needs of just four main representatives of the sick crowded into the foreground, and still more attend another group of sufferers in the middle distance. While Bassano's inclusion of a background landscape might indicate the country origin of these desperate immigrants, there remains the impression that they have come to the right place, and that they are receiving effective help. A pleading mother points out her dying baby to St Roch, the great pilgrim healer of the plague-stricken, who responds by raising his hand in blessing. Meanwhile a *monatto* – the plague official who removes the bodies of the sick to secure public health or safety – bends close to the child's body, perhaps to check whether he still breathes. Such figures remain heavily clothed in contrast to the naked or semi-naked sick to suggest their difference from those whom they attend. They are not yet infected, even if their immediate physical proximity to the diseased bodies might imply that they are at some risk of becoming so. And this voluntary proximity is also a sure sign of their selfless heroism in the service to the sick, or in their attempt to protect the wider public from the dangers of contagion. The charitable ministrations of these contemporary townsfolk, both male and female, directly relate

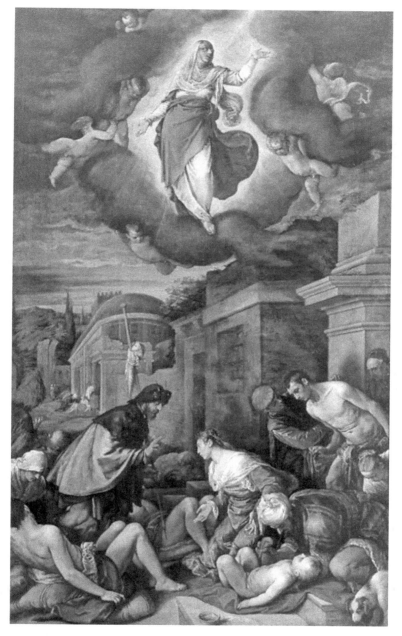

Figure 2.1 Jacopo Bassano, *St Roch Healing Plague Victims*, ca. 1575, oil on canvas, 350 × 210 cm. Pinacoteca di Brera, Milan. Image in the Public Domain.

them to the divinely inspired figure of the saint and to the supernatural Mother of God who appears in the heavens, and whose forms and gestures they partially mimic.

The carefully constructed nature of Bassano's altarpiece indicates again the mediated sense that his work gives of the desperate social realities it alludes to. We can illuminate this aspect further by noting the way in which Bassano modelled the bodies of his plague victims on certain well-known and revered artistic models from both recent Renaissance and classical art. In taking this approach, he followed the lead of other painters of the Venetian school when called upon to depict the sick poor in their religious paintings. In a depiction of *St Roch Healing the Plague-Stricken* of 1549 for the Venetian church of San Rocco, Jacopo Tintoretto had shown the saint working his miracles in a contemporary plague hospital, or *lazaretto*, and based certain of the bodies of the inmates on well-known antique and Renaissance sculptures. Paolo Veronese had followed suit in a more recent altarpiece of ca. 1566 featuring *St Barnabas Healing the Sick* with the mere touch of his Bible for a church in nearby Verona.[6] Like Tintoretto and Veronese before him, Bassano reshaped the 'fallen' bodies of the sick poor with reference to artistic exempla such as the late antique sculpture known as the *Falling Gaul*, then on display in the Grimani Collection in Venice, or Michelangelo's renowned monumental sculptures in the Medici Chapel, which he would have known from statuettes and reproductive prints.

The use of such artistic sources undoubtedly granted Bassano's figures a new kind of aesthetic value and significance. On one level, Bassano's reclining nude bodies are presented as beautified formal exempla, highlighted by the chiaroscuro arrangement at the lower centre foreground, and serve to demonstrate the painter's very considerable artistic skills in their illusionistic representation. The complex foreshortened arrangement of their limbs offers further opportunity for a self-conscious display of the overcoming of artistic *difficoltà*. Shown as idealized nudes, the sick poor take on a new visual importance that connects them to the central artistic principles of the Italian Renaissance. But such an approach enhances rather than undermines the significance of these figures as moral emblems of the Counter-Reformation. Their nudity not only indicates worldly vulnerability (*nuditas temporalis*) but also serves as a guarantor of their spiritual probity and deservingness. As Cesare Ripa explained in his *Iconologia* of 1593, nudity served as a potent symbol of 'Truth'.[7] In the famous passage in the Gospel of St Matthew defining the seven Acts of Mercy, Christ dramatically uses the first person to explain his identity with the deserving poor: 'I was naked and you clothed Me.'[8] To this extent, the bodies of the plague-stricken featured in Bassano's altarpiece are also sacralized, transformed into shining symbols of the suffering of God Himself while on earth.

They are shown in close proximity to a line of building facades, structures that suggest the built environment of a city street. A close relationship between the architectural fabric of the city and the indigent poor or sick had, in fact, a long history in visual art. Their abject figures often appear on city gates or those of charitable institutions or take on a still more prominent position in the foreground of representations of the ideal cityscape.[9] The depiction of the ruined body of the *povero* in the proximity of pristine architecture in such imagery might serve to highlight the city's perfection and material wealth by way of contrast. The city naturally attracts and perhaps

even requires the presence of the poor in order to demonstrate its *richezza*. Yet the intimate connection of wealth with poverty in the urban context could also have less oppressive or hierarchical connotations. For the city's surplus wealth is justified or redeemed precisely by its ethical readiness to protect the masses of destitute who flow towards it, taking shelter around its comforting portals. If the waif-like vulnerable body of the poor man is contrasted with the physical solidity of the city's architecture in earlier representations, then in Bassano's altarpiece the roles of these two essential visual components seem to be reversed: or each element takes on something of the other's identity. As substantial monumentalized nudes, Bassano's sick poor become 'architectural', and easily overpower, in a visual sense, the darkened buildings before which they have gathered. These structures have in turn become fragile, seeming more like shadowy supports to the shining forms featured in the foreground. If the bodies of the poor are made newly heroic with reference to *all'antica* canons of aesthetic beauty, then the buildings now appear dilapidated, as if they had absorbed the human ruins sprawling before them.

The once splendid buildings of the city, monuments to cultural achievement, now retreat from centre stage, taking on a secondary role, functioning as visual supports to the more developed imagery of the destitute. Their pointedly classical appearance might symbolize the futility of the old pagan order in the face of the all-powerful Christian drama of death and redemption enacted nearby. Such symbolic connotations aside, however, Bassano includes a more literal reference to contemporary reality. The lozenge-shaped building in the middle distance directly recalls Andrea Palladio's so-called Basilica (Palazzo della Ragione) at the centre of Vicenza, begun in 1549 (Figure 2.2).[10] It might be tempting to interpret the depiction of this building, painted in ghostly shorthand, and with another group of the destitute sick in its immediate vicinity, as a veiled Reformist critique of Palladio's courtly classicism. But the 'Basilica', in reality the town hall of Vicenza, the seat of local government, was already a famous and revered marker of place. Given the incorporation of this building in a scene of efficacious charitable intervention, it is more likely intended as a means of identifying Vicenza as a locus of good works and active piety. As the High altarpiece of the church of San Rocco, Bassano's painting served as a demonstration of Vicentine charity, while at the same time indicating the town's fidelity to its political overlords in Venice, where the cult of St Roch had especially flourished since the *translatio* of his relics there in 1485.[11]

However notionally Bassano's perspectival line of buildings in the St Roch altarpiece represents sixteenth-century Vicenza, we can take it that the extremes of want and suffering – and its practical and spiritual relief – are imagined in an environment that is essentially urban and institutional. In the many paintings that Bassano set in the countryside, typically featuring contemporary-looking peasants and animals in landscapes, many indications of poverty are also present (Figures 2.3–2.5). But rather than drawing attention to this material lack as the defining feature of the scene, or one that required special attention or charitable intervention, Bassano presented it as integral: as an identifying feature of the rural world that served to distinguish it from the wealth or *richezza* of the city. Rural peasants were, almost by definition, 'poor', at least when compared to wealthy citizens of the town, and to this extent their

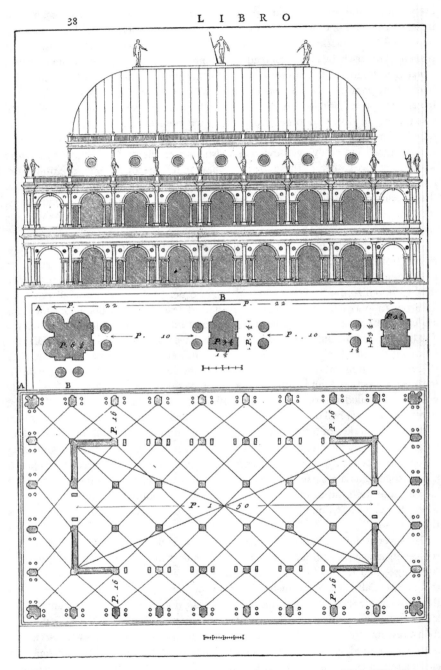

Figure 2.2 Woodcut illustration from Andrea Palladio, *I Quattro Libri dell'Archittetura* (Venice, Domenico de'Franceschi, 1570; reprint 1767), 38. Photo of copyright (Warburg Institute Photographic Collection).

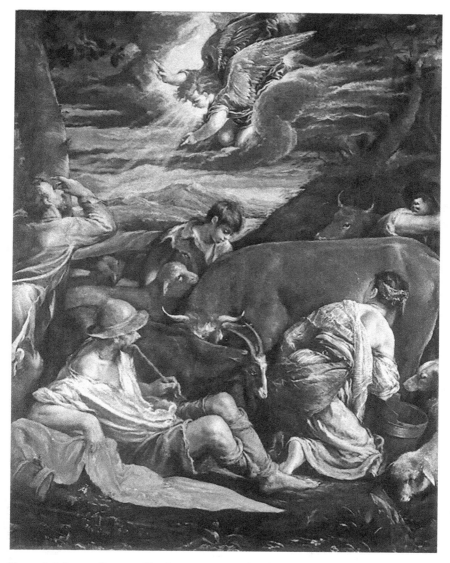

Figure 2.3 Jacopo Bassano, *The Annunciation to the Shepherds*, ca. 1559–60, oil on canvas, 106 × 83 cm. National Gallery of Art, Washington, DC. Image in the public domain.

poverty was familiar enough. They were inured to an ongoing life of hardship, and not only in times of social or economic crisis. But their poverty was not seen as a social problem or issue, and was not linked to sickness or disease, to mass migration and the crisis situation this might engender. To this extent, peasant poverty was understood as an inbuilt aspect of a fixed cultural identity. In these circumstances, the depiction of peasants had, on the one hand, to indicate material lack, while, on the other, making

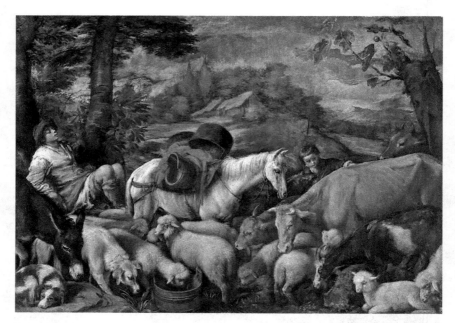

Figure 2.4 Jacopo Bassano, *The Sleeping Shepherd*, ca. 1568, oil on canvas, 99.5 × 137.5 cm. Szépmüvészeti Museum, Budapest. Photo: Museum of Fine Arts ©Dénes Józsa.

this appear as unexceptional or unproblematic. In Bassano's rural paintings, it appears as an acceptable part of everyday peasant existence that does not illicit thoughts of philanthropic or miraculous intervention on the part of the non-poor viewer. In this visual context, poverty is hidden in plain sight, operating as a kind of buried sign whose potentially disturbing meaning is carefully mitigated or dissipated. If poverty was to be represented as the unproblematic but defining social condition of country life, then its potentially negative aspects needed to be offset by the inclusion of other visual elements that suggested that this rural domain was a locus of positive cultural values such as hard work, deserved leisure, sensual pleasure, spiritual responsiveness and (most contradictory of all) material plenitude.

In the Vicenza altarpiece, a semi-naked plague-victim lies at the foreground left with his knees raised, his form mirrored by others among the sick poor nearby (Figure 2.1). This figure type had previously been employed by Bassano for a peasant shepherd in his rural paintings (Figures 2.3 and 2.4). The overlap between these two social identities and artistic forms is suggestive enough. In the San Rocco figure minor variations to the form, such as the more passive posture – he lies rather than sits or rests – and his complete lack of activity secures the idea of an abject 'plague-victim' approaching physical death, but also the possibility of spiritual redemption. As the peasant shepherd, the figure is more self-possessed, his body relaxed but physically strong. In the Annunciation of the Shepherds, he ruminates (perhaps a little like the animals nearby), while chewing on a thin twig, a symbol of poverty that has precedents

in a number of earlier depictions of peasants.[12] If, in the San Rocco painting, the figure is largely naked, except for the swath of drapery across his body, the peasant shepherd is clothed in his everyday garb. But this attire nonetheless strongly signals his poverty: it is made of the coarsest cloth and is badly ripped or torn, falling away from his body to expose bony knees and shoulders.

He abstractedly caresses a piece of luscious fine cloth which offers an immediate contrast to the roughness of his own garb. The presence of this drapery seems wholly out of sync, given the setting of the scene in the humble and impoverished world of the peasants. Fluidly painted using the realgar orange pigment that had become so popular among leading painters in the wealthy metropolis of Venice in the sixteenth century, its shape elegantly echoes that of the peasant's reclining form. Is this unexplained drapery, we might ask, a kind of visual tag included as a marker of the high-ranking viewer's more cosmopolitan culture? In other rural works, Bassano often included similar markers of the urban taste for visual *richezza*, which typically serve to ameliorate the indications of abject poverty given elsewhere in the image.[13]

If the object that the shepherd holds signals his material want in accordance with an established iconographic tradition, its precise identity remains open to question. It might be taken as the kind of reed pipe beloved of the musical shepherds of Arcadia in fashionable high-culture traditions of Virgilian pastoral poetry.[14] The visual equivocation between twig and Arcadian pipe might also acknowledge the 'higher' culture of a metropolitan patron or viewer, translating the impoverished scene to accommodate his sophisticated cultural interests. Equally important in this regard, and with the further implication that the patron of this work might have been a country landowner, is the suggestion of productive animal plenitude. The social deprivation implied by the peasant's ragged clothing is countermanded by the careful attention Bassano gives to the soft or smooth surfaces and textures of the animals' skin and fur, its visual attractiveness hinting at the future conversion of such livestock into lucrative meat, dairy products, clothing and leather goods. The way in which these particular animal bodies are cut by the frame suggests that we view just a cross section of much larger and extensive 'herds' and that those depicted are merely representative of a teeming rural world. The peasants' bodies are not quite reduced to mere adjuncts or accessories to those of the animals, but there is nonetheless the sense that these latter are of equal or even greater importance.

The prominence allowed to farm animals in the *Annunciation* is typical of Bassano's depictions of the rural scene more generally. In this kind of painting, their meticulously painted but also dynamic bodies appear about to sweep the peasants away on a tide of non-human energy (Figures 2.4 and 2.5). Such physical proximities, overlaps and occlusions indicate that the usual hierarchy in Renaissance art between human and animal is under threat. And it is very telling in this regard that the earliest collectors and connoisseurs of Bassano's rural paintings consistently emphasize his depiction of animals at the expense of the peasants shown tending them. The Spanish ambassador in Venice, Guzmán de Silva, for example, purchased a work showing *Abraham's Departure for Canaan* (ca. 1574–5, Madrid, Museo del Prado) for King Philip II of Spain, and wrote to his master on 21 January 1574, extolling Bassano's paintings of 'nature, animals and other things', making no mention of the peasants that also feature

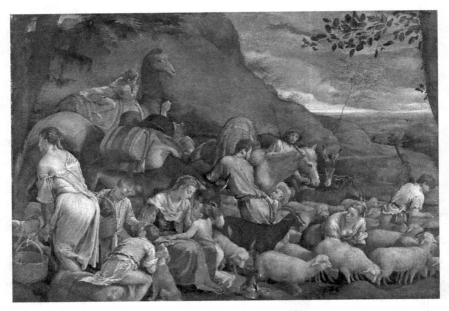

Figure 2.5 Jacopo Bassano, *The Journey of Jacob*, ca. 1561, oil on canvas, 129.4 × 184.2 cm. The Royal Collection/HM Queen Elizabeth II, London. Image in the public domain.

in his works.[15] The sixteenth-century Florentine writers Giorgio Vasari and Raffaello Borghini were similarly coy regarding Bassano's peasants, excluding them from consideration in their brief comments on the artist. Bassano, Vasari tells us, specialized in 'little things and paintings of animals of all sorts', while Borghini notes that he painted 'natural landscapes and especially animals, and various household furnishings [*masserizie della casa*]'.[16]

Such early accounts suggest that the peasants in Bassano's rural paintings were deemed to be of much less significance than other components of the country scene, such as landscapes, household objects and (most important) animals. But this viewing habit or preference was to some extent anticipated and encouraged by the painter himself, who often allowed the forms of his peasants to be dominated by these other visual elements, burying them in vast landscapes or crowding the picture space with animals.[17] In these works, Bassano's careful depiction of the sleek and healthy bodies of livestock serves to offset the indications of material deprivation expressed by the human inhabitants of the countryside. This must reflect Bassano's attempt to accommodate the predilections of his early patrons and audiences: not primarily the peasants of his local area around Bassano del Grappa, as has sometimes been assumed, but rather members of the patrician and *cittadini* elites of Venice.[18] The early owners of such works were typically from wealthy metropolitan families, whose farming interests on the *terra ferma* had intensified following the decline of trade in the Eastern Mediterranean, and who were far more interested in the potential profits to be had from animal produce than they were in an accurate or extended depiction of the peasantry.[19] Less than 20 per

cent of the Republic's *terra ferma* was given over to livestock farming in the sixteenth century, reflecting in part the availability of cheaply imported meat from Hungary.[20] But the Venetian overlords in the region may nonetheless have sought to encourage farming with animals at the expense of the more traditional practice of crop rotation, perhaps reflecting their position as absentee landowners, whose primary concern was with profits to be made on the urban market, rather than with feeding the poor in the countryside. Bassano's special emphasis on farm animals rather than peasants in his rural paintings may reflect these capitalistic patrician predilections.

The patron of the *Annunciation to the Shepherds* is unknown, but many aspects of the painting indicate that it was made for a sophisticated, non-peasant, non-local and probably urban (but perhaps also landowning) client. The small-scale and ultra-modern Venetian-style painterly handling, with its subtle chiaroscuro effect, suggests as much. The figure of the foreground peasant self-consciously recalls recent *all'antica* examples revered in the dominant artistic centres of Venice and Florence, and thereby acknowledges the refined tastes of the knowing mid-Cinquecento art connoisseur. Perhaps, one can go further, and admit the somewhat fraught or contradictory quality of the depiction of the kneeling milkmaid to the right, who, while busy at her work, shares something of the sensuousness of the reclining male peasant. Like his form, hers is based on an earlier work of art by a revered Renaissance master invented in the city, rather than on direct observation from nature in the countryside. She recalls a figure in a well-known print after Titian which Bassano probably owned (Figure 2.6). But Bassano makes her noticeably younger and more attractive: she provocatively thrusts her backside towards us and allows her shawl to fall away enticingly from her shoulder as she bends to milk the cow's udders. Similarly enticing young women feature to the left and right in Bassano's *Jacob's Journey* (Figure 2.5). Such country milkmaids were destined to a somewhat notorious future history in visual imagery made for the consumption of urban male audiences (e.g. in the burgeoning tradition of so-called street *cris*).[21] Bassano's carefully posed figures might again accommodate the predilections of the Venice-based gentleman landowner: a voyeuristic outsider to peasant life, alive to its carnal or generative opportunities, but also with a particular interest in its economic productivity.

Bassano generates a particularly intense sense of dawning spiritual realization in the *Annunciation to the Shepherds*, despite the rather secular associations allowed by the male peasant's *all'antica* pastoralism and the milkmaid's sexual availability. A number of the protagonists, perhaps including the milkmaid herself, have already noticed and responded to the angel's heavenly call. Even the dreamy reclining figure seems to dwell inwardly on the possibility of redemption initiated by the recent birth of Christ. The reforming bishop of Verona, Agostino Valier, had recently proclaimed that the lives of the peasants in the Veneto could serve as models of an 'honest, honourable and pleasurable' life, polemically contradicting the more usual judgement of such types as villainous and despicable low-life.[22] This kind of idea would have legitimated Bassano's overwhelmingly positive depiction of peasant life. It also served to establish such rural imagery as the pious equivalent to the scenes of spiritual redemption shown in the urban context. If the city's surplus wealth, supported by the pious actions of charitable citizens and the sympathetic interventions of divine actors, would always prove adequate to the succour of the poor in the towns and cities, then in the countryside

Figure 2.6 Nicoló Boldrini after Titian, *Landscape with a Milkmaid*, ca. 1535–40, woodcut, 37 × 53 cm. Metropolitan Museum, New York. Image in the public domain.

poverty was, in analogous fashion, allied to the age-old ideal of Christian humility that was being consciously revived under the impact of the Counter-Reformation. But however fitting and apposite such spiritualizing associations might then have then appeared, they also served to justify the existing social and economic status quo, rather than addressing the underlying causes of periodic social crises in towns, or the ongoing grinding poverty of the countryside.

Bassano's rural paintings cannot, then, be properly understood as genuine or independent cultural products of the country poor themselves. In these works, we certainly find an 'art of poverty', but not a genuine 'art of the poor', as the theme of this book so pertinently asks us to seek out and consider. In Bassano's San Rocco altarpiece, as also in his scenes of peasant life, it is the social distinctions, economic interests, aesthetic predilections and religious imperatives of the non-poor that remain defining. Whether Bassano painted plague and charity in the town, or the defining but appealing poverty of the peasants in the countryside, his art accommodated and further promoted the categories and values held by socially distanced and economically elevated patrons and viewing audiences. Bassano was quickly understood to be at his most artistically innovative in his depictions of the rural scene. But while such images certainly widened the social purview offered by Italian Renaissance art, their ideological and colonizing aspects might also indicate the diminishing power of the very cultural domain that Bassano now represented. Bassano's new visual focus on the countryside might paradoxically reflect a new advance for the abstracted urban and non-local values of early modernity. The new level of cultural inclusion that Bassano's

paintings appear to allow to the 'ordinary people' of the countryside might actually be indicative of the familiar cultural process by which the rural world is folded into the urban, pictured as the passive object of its projection and desire. But at the same time, this was also a victory of the persuasive and all-powerful alluring visual image, with its special, though always questionable habit of smoothing away the realities and contradictions of history.

The 'slipshod' nature of Carpaccio's *St Tryphon Tames the Basilisk*

A painting for a poor confraternity

Thomas Schweigert

Patricia Fortini Brown's book on narrative painting in Renaissance Venice refers to the 'Age of Carpaccio'.[1] The high point of this era may be the nine paintings still in situ at the Scuola degli Schiavoni, from the first decade of the *Cinquecento*.[2] These are conventionally divided into a gospel cycle, comprising the *Calling of Matthew* and the *Agony in the Garden*, and Saint George and Saint Jerome cycles, consisting of three paintings each and often described as based on Jacobus de Voragine's *Legenda Aurea*.[3] This division, however, leaves a 'cycle' of a single painting, *Saint Tryphon Tames the Basilisk* (Figure 3.1). A plausible textual source for this work is the vita of Tryphon from a manuscript in the Marciana Library, one of whose miniatures has also been proposed as the visual source for the Carpaccio painting, although the manuscript may have only been in Venice since the nineteenth century.[4] It was produced in 1466 in Cattaro (present-day Kotor, Montenegro), in what was then *Albania Veneta*, home to the *Schiavoni* and, from around 1420, part of the Venetian maritime empire, the *Stato da Mar*.[5] Tryphon has been the patron saint and protector of Cattaro/Kotor since the translation of his relics in 809 to then Acruvium under the Christian emperor Nikephoros I. By long tradition, Tryphon was martyred around 250, under the pagan emperor Decius in Nicaea, and, except for anomalies such as Cattaro/Kotor, and Bari and Venice in Italy, he is today an essentially Eastern Orthodox saint.[6]

It is not only the iconography that makes the *Saint Tryphon Tames the Basilisk* stand out. The painting is evidently not of the same quality of execution as the other masterpieces at the Scuola degli Schiavoni. Vittorio Sgarbi has called it 'slipshod . . . the most pedestrian of the [nine] paintings'.[7] In comparing *Saint Tryphon* to the *Return of the Ambassadors* from Carpaccio's Saint Ursula cycle, done for the Scuola di Sant'Orsola in the last decade of the Quattrocento and now in the Gallerie dell'Accademia, Fortini Brown notes the similar composition of the *Saint Tryphon*, but considers the latter work merely derivative, linear and static.[8] The workshop is often implicated in the production of this inferior work, but this begs the question of why Carpaccio's worst painting is found among some of his best ones. Here, I would like to argue that the

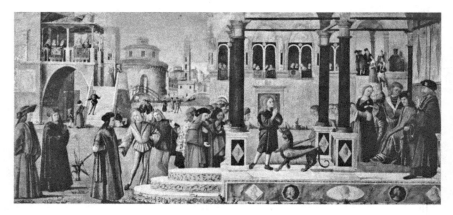

Figure 3.1 Vittore Carpaccio, *Saint Tryphon Tames the Basilisk*, 1507, oil on canvas, 141 × 300 cm, Venice, Scuola Dalmata dei Ss. Giorgio e Trifone. Image in the public domain.

answer lies in the patronage of the works, and specifically a difference in patronage between the eight high-quality paintings in the Scuola degli Schiavoni and the *Saint Tryphon*. This difference was not merely one of names but also one of social class and wealth. In fact, the poor *Saint Tryphon* may have been judged somewhat unfairly as a product of lower-class patronage that through a quirk of history has ended up among a set of upmarket pictures.

It appears to be a common (mis)conception that because Carpaccio's nine paintings are presently in a building referred to as the Scuola degli Schiavoni, the *Schiavoni* were the patrons of all of them. It should be noted, however, that neither is a *scuola* a building, nor did the Scuola degli Schiavoni control the building in which the *scuola* is presently housed at the time the paintings were made (Figure 3.2). In Venice, a *scuola*, or confraternity, was a legal person or corporation; there were six *Scuole Grandi* but numerous *scuole piccole*, like the Scuola degli Schiavoni, and not every one of these always had a building with its name attached to it.[9] With a few notable exceptions, including the Scuola degli Schiavoni, Napoleon liquidated all the *scuole* in Venice, looting much of the art, though some of the buildings are still standing; the former Scuola Grande della Carità now houses the museum, Gallerie dell'Accademia.[10]

During the fifteenth century, the building in which the current Scuola degli Schiavoni is housed was a hospice within the compound of the Venetian Priory of the Order of Knights of the Hospital of Saint John of Jerusalem – the crusading Knights Hospitaller.[11] In the early Cinquecento, the Scuola degli Schiavoni had, at best, condominium in this building along with one other *scuola*, that of John the Baptist, and, of course, the Knights Hospitaller themselves, whose prior at the time no doubt considered his Order as the proprietor.

The entity which became the Knights Hospitaller was operating a hospice for pilgrims in Jerusalem when the First Crusade arrived in 1099. With the rout of the Crusaders by the Mamluk Sultanate in the later thirteenth century, the Hospitallers headquartered on Rhodes beginning in 1306. The Hospitallers inherited Templar property, including the Venetian priory (although this is disputed[12]), when the Templars were suppressed in

Figure 3.2 Scuola Dalmata dei Ss. Giorgio e Trifone ('Scuola degli Schiavoni'), former Hospice of St Catherine, thirteenth century, renovated ca. 1551. Image in the public domain.

1307. The Hospitallers survived the Ottoman assault on Rhodes in 1480, led by no less than Sultan Mehmed II *Fatih*, the conqueror (of Constantinople but also of Scutari). They were driven off in 1522 by Sultan Suleyman I, the Magnificent, eventually being granted Malta by the Holy Roman Emperor Charles V in 1530.

Jacopo de' Barbari's 1500 woodcut map of Venice shows the compound of the Venetian Priory of the Knights Hospitaller with its three main buildings (Figure 3.3):[13] Saint Catherine's Hospice, named for Saint Catherine of Alexandria, a common

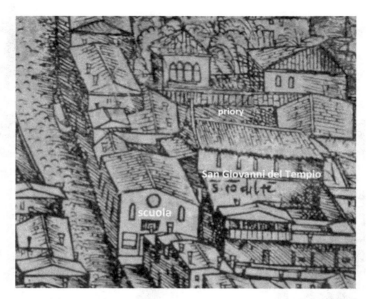

Figure 3.3 Jacopo de'Barbari, *Map of Venice* (detail: Grand Priory of the Knights of St. John of Jerusalem), 1500, woodcut. Image in the public domain.

patroness of hospices; the Church of San Giovanni del Tempio, named for John the Baptist, patron saint of the Hospitallers, with the addition 'del Tempio' suggesting that this may have originally been a Templar property, but, in any event, a reference to Jerusalem; and the headquarters building, with convent and cloister. The buildings exist today, different only because of subsequent renovations. After a long hiatus, the church and headquarters are once again the property of the Sovereign Military Order of Malta, successor to the Knights Hospitaller.

In the Church of San Giovanni del Tempio, after a long absence, is the *Baptism of Christ* by (the workshop of) Giovanni Bellini (Figure 3.4). This work, like Carpaccio's paintings in the nearby former hospice, is from the first decade of the *Cinquecento*.[14] It shows, kneeling on the left, the donor: the then Prior of the local Hospitallers, Sebastiano Michiel, a member of the patrician Michiel family who, uncharacteristically for a Venetian, became a Crusader. He is in Hospitaller garb with the distinctive square cross. Guido Perocco has noted the similarity in appearance between Michiel and the man standing behind the Matthew figure in the *Calling of Matthew*.[15] Perocco also found a correspondence between the coats of arms visible in the *Calling of Matthew* and the *Agony in the Garden*, and the Michiel family coat of arms, strengthening his conclusion that Sebastiano Michiel had commissioned these two paintings.[16] That the Prior of the Knights Hospitaller was the patron of two paintings located in a building on the grounds of the Priory should come as no surprise. What is surprising is not just that many have ignored Perocco's proposal concerning Hospitaller patronage but that Perocco himself considered the *Schiavoni* to have commissioned the rest of the paintings in the current *scuola*.

Figure 3.4 Giovanni Bellini and workshop, *Baptism of Christ* (detail: *Donor portrait of Sebastiano Michiel*, first decade of the sixteenth century), oil on canvas, 216 × 199 cm, Venice, Chiesa di San Giovanni Battista del Tempio. Photo out of copyright (The Warburg Institute, Photographic Collection).

I agree with Perocco concerning Michiel's patronage of the gospel cycle, but I would extend it to the Saint George and Saint Jerome cycles, excluding only the *Saint Tryphon*. All these paintings together were moved from the first floor of the hospice to the ground floor during the renovations of 1551, where they remain in a new arrangement. Considering a variety of factors as well as subject matter, Molmenti and Ludwig conjectured the original order in their valuable, if dated, work on Carpaccio.[17] They make no mention of Hospitaller patronage (considering the *Schiavoni* to have been the patrons) and advance no theory of a single narrative cycle, but their suggested arrangement underlies and informs my reading.

On the first floor, there was an altar on the interior of the facade wall, and the sequence begins on the left side – the *cornu evangelii* where the gospel reading takes place – with the *Calling of Matthew*. The painting, then, may evoke the *Gospel of Matthew*, but, reading from left to right, this would also make Michiel the first figure depicted in the whole cycle, befitting his role as the patron and intellectual author. On the right side of the altar, in the *cornu epistolae*, is the *Agony in the Garden* with

Jesus and the three sleeping disciples – Peter, James and John – to whom epistles are attributed. In his monograph on Carpaccio, Vittorio Sgarbi considers the *Agony in the Garden* an 'underrated masterpiece' and a 'homage to the narrative tradition of Padua', a reference to Andrea Mantegna.[18] That assessment is difficult to appreciate when viewing the painting in its current setting, where Christ is kneeling, dunce-like, in a corner, staring at the intersection of two walls. In its original setting, as proposed by Molmenti and Ludwig, Jesus would be facing in the direction of the centre of the altar, towards the altarpiece and perhaps even a representation of his own coming Crucifixion; his upward gaze would be directed to the portal window that, in the daytime, illuminated the space.

If one imagines turning to the right from facing the altar on the front wall, one finds the third and longest painting in Molmenti and Ludwig's arrangement, *Saint George and the Dragon*. It stands alone on the long wall on the canal side, illuminated by its two windows. This seems out of sequence, as the back wall has the three paintings of the Jerome cycle, ending with what Molmenti and Ludwig thought was *Saint Jerome in His Study*, now identified instead as *Saint Augustine's Vision of Saint Jerome*.[19] On the other long wall, the George cycle takes up again with the *Triumph of Saint George* and the *Baptism of the Selenites*. Molmenti and Ludwig then place the *Saint Tryphon* 'last and least', as if they did not know what else to do with it. In this recreated arrangement, the paintings transcend being isolated canvases, becoming inter-referential, in dialog with each other and the space they occupy.

In fact, the eight paintings, which I believe were commissioned by Michiel, could be read as a single narrative cycle of Crusade propaganda. The Gospel of Matthew starts with the genealogy of Christ, tracing Jesus's lineage back to King David, who first established Jerusalem as the capital of Judea.[20] In the *Agony in the Garden*, on the other hand, quite unlike in Mantegna's prototype for this painting, Jerusalem is shrouded in darkness.[21] In the *Triumph of Saint George* (Figure 3.5), the Saint George figure could be a youthful, idealized version of Sebastiano Michiel, with the long flowing hair (by all accounts, Michiel was rather vain). He stands in front of what could be interpreted as the Dome of the Rock, on Temple Mount in Jerusalem, about to behead the vanquished

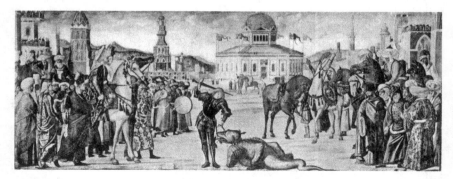

Figure 3.5 Vittore Carpaccio, *Triumph of Saint George*, ca. 1504–07, oil on canvas, 141 × 360 cm, Venice, Scuola Dalmata dei Ss. Giorgio e Trifone. Photo out of copyright (The Warburg Institute, Photographic Collection).

dragon. On the left (George's right) is the Mamluk sultan, on horseback, surrounded by an entourage of his personal mamluks, an identification based on their respective headgear.[22] The drums and fifes of the mamluks are military, the drum and bugle corps used to time the assault, bolster morale and terrify the opponent. This, then, appears to be the military-administrative branch of the Islamic state that was the Mamluk Sultanate, ruling the Near East since 1260, when it drove the Crusaders into the sea, forcing the Hospitallers to resettle on Rhodes.[23] On the right (George's left), there is a preponderance of turbans, and so this is the legal-religious branch of the Islamic state, the *Ulama*. Here would be the caliph, the heads of the four legal schools of Sunni Islam, and select qadis.[24] Augusto Gentili has argued that the dragon slain by Saint George represents 'the Turks';[25] I think that it represents Islam itself, and this fantasy Crusade victory over Islam is not a victory over the Ottomans but over the Mamluk Sultanate. Ironically, within a decade after this painting, in 1517, the Mamluk Sultanate would indeed be conquered, but by Ottoman imperialism, and large parts of the Arab world, created by Islamic conquest in the seventh century, would endure four centuries under the 'Turkish yoke'.

Mounted on the facade of the former Hospitaller hospice are two stacked relief carvings (Figure 3.6).[26] The top relief, by an unknown sculptor from around 1450,

Figure 3.6 Anonymous Venetian sculptor, *Virgin and Child with Saint John the Baptist and Saint Catherine and Donor*, mid-fifteenth century; Pietro da Salò, Saint George slaying the dragon, ca. 1551; relief carvings on the facade of the *Scuola Dalmata dei Ss. Giorgio e Trifone*. Image in the public domain.

shows Saint John the Baptist presenting a kneeling donor to the Virgin and Child, with, on the other side, Saint Catherine, with her left hand on her torture wheel and in her right a martyr's palm. The bottom relief, done a century later by Pietro da Salò as part of the 1551 renovation of the building, represents *Saint George and the Dragon*. It was in the mid-sixteenth century, at the time of the renovations and the *Saint George* relief, that the de facto control of the building seems to have passed from the Hospitallers – now based on Malta – to the Scuola degli Schiavoni, one of whose patron saints was George.[27]

The present-day successor of the Scuola degli Schiavoni, the Scuola Dalmata dei Ss. Giorgio e Trifone now owns this building which, however, is not the actual *scuola* but, technically, a church. George and Tryphon are the patron saints of the confraternity, and Dalmatia has been the traditional geographic origin of the members, particularly southern Dalmatia, below Ragusa, in the coastal region of what is today Montenegro, where the Republic of Venice only secured its hold on Cattaro and the *Bocche di Cattaro* in 1420. This home to the seafaring *Schiavoni*, as these South Slavs were called, somewhat pejoratively, by the Venetians, was part of the larger province of *Albania Veneta* in the Venetian maritime empire. By 1479, Ottoman conquests, particularly of Scutari,[28] had left a rump *Albania Veneta* whose main town was now Cattaro. The Venetian acquisition of their homeland, followed by partial Ottoman conquest, was the context for the formation of the confraternity, the Scuola degli Schiavoni, recognized by the Venetian state in 1451. The membership would have increased subsequently as 'ethnic minority' refugee immigrants (South Slavs as well as Albanians and Greeks who had their own *scuole*) flooded into Venice fleeing the Ottoman onslaught.

From its inception, the Scuola degli Schiavoni was associated with the Hospitaller Priory in Venice, originally having only the use of a side altar in the Church of San Giovanni del Tempio for its devotional practices.[29] At the first meeting and election of officials, members of the council of the confraternity included 'a greengrocer, a seller in the piazza, a goldsmith, a cabinet maker, two tailors, a bricklayer, and a shoemaker'.[30] These men were the elite of the brethren, with some permanency of residence in Venice. Other sources suggest that the rank and file consisted of rowers on galleys, the backbone of the naval power of Venice and its maritime trade.[31]

By 1500, with the Hospitaller hospice no longer active, there was condominium in the former hospice building between the Priory and two *scuole* – the Scuola degli Schiavoni and a smaller one devoted to Saint John the Baptist. The *Schiavoni* had use rights to some part of the first floor where the Carpaccio paintings were originally installed. A legal dispute over property rights on the first floor between Michiel and the *Scuola* began in 1502, also the earliest known date of any of the paintings.[32] The exact details are unknown, but it is presumed that the dispute somehow involved the paintings themselves. Michiel, a Venetian patrician, appears to have simply disregarded the ruling of the Venetian court which favoured the immigrant Slavs, whom he would have considered *popolani* at best. Michiel died in 1534, having been Prior of the Hospitallers for some four decades, and he was succeeded by a non-Venetian, the then pope's nephew.

As part of the 1551 renovations of the former hospice, now under the control of the Scuola degli Schiavoni, Carpaccio's paintings were removed to the ground floor, and

the new first-floor ceiling was painted, including many depictions of Saint Tryphon. Perocco devotes the last twenty pages of his invaluable book on Carpaccio in the Scuola degli Schiavoni to the 'other works in the *Scuola*'.[33] Most of the paintings mentioned are anonymous, but two named painters are Andrea Vassilacchi (1556–1629) and Andrea Vicentino (1542–1617), both active after the *Schiavoni* had taken control of the building. Vassilacchi (nick-named *l'Aliense*, the alien) was a Greek immigrant to Venice from Milos and a member of the Scuola dei Greci.[34] A pupil of Veronese, he made a living as a painter, including working on the restoration of the Doge's Palace after the fire of 1577. Vicentino (from Vicenza) also worked in the Doge's Palace, where his most notable work is *The Crusaders Conquering the City of Zara*.[35] It was he (or his workshop) which was commissioned to paint the first-floor ceiling of the Scuola degli Schiavoni building. These two, then, are the most prominent painters to have carried out commissions for the Scuola degli Schiavoni after 1551.

Additional commissions of the *Schiavoni* still extant are two side panels – all that remains – from the altarpiece of the Scuola in its original home, the Church of San Giovanni del Tempio. It is attributed to an anonymous painter from the 'School of Antonio Vivarini'.[36] There are also various seventeenth-century works, including 'votive paintings' in the staircase of the Scuola building (which Perocci classifies as 'occasional works, of little artistic value'), another anonymous painting ('of small artistic value') and one attributed to the 'School of Sebastiano Ricci'.[37] From the eighteenth century, there is the work of an 'anonymous 18th-century painter, John the Baptist Preaching, with the name and portrait of Giovanni Barich', and a 'votive painting of one of the brethren [Marko Ivanovich], commemorating a naval battle in the Gulf of Patras which took place in 1751', in the 'style of Francesco Fontebasso'.[38]

In light of this record, it could be argued that the workshop painting of *Saint Tryphon Tames the Basilisk*, so anomalous among the other Carpaccio masterpieces in the current Scuola building, was in fact the only contribution by the Scuola degli Schiavoni to the Age of Carpaccio. This scene from the *vita* of their patron saint (impossible to have been commissioned by anyone *but* the *Schiavoni*) would have been ordered at a time when, in the early sixteenth century, the *Scuola* was claiming its rights to (part of) the first floor of the defunct Hospitaller hospice building. An extension of this argument would be that the painting, despite its relative lack of artistic merit, gains in interest as a product of poor man's patronage. It was the misfortune of the work to end up among and be constantly negatively compared to a cycle of paintings commissioned by a much wealthier client of Carpaccio's. In the context of a re-evaluation of the art of the poor, however, *Saint Tryphon Tames the Basilisk* perhaps deserves a second chance.

'... κέ παντός του λαου τοῦ χορίου τ(ης) Μάζας...'

Communal patronage of church decoration in rural Venetian Crete[1]

Angeliki Lymberopoulou

The small church dedicated to Saint Nicholas in the village of Maza, in the former province of Apokoronas, in the prefecture of Chania, western Crete (Map 4.1), is dated 1325/6, meaning it was built and decorated during the period in which Crete was a Venetian dominion (1211–1669). As such, it is one of the ca. 850 churches surviving on the island (in various states of conservation) that were either built or renovated in this era, mostly between the late thirteenth and early fifteenth centuries. The church is the product of a collective donation by the villagers of Maza, as recorded in the dedicatory inscription. The earliest known example of this type of collective patronage in Greece is documented in an eleventh-century inscription from the Peloponnese (Map 4.2).[2] On Crete, there are a substantial number of these collective commissions, registered in inscriptions, which involved large groups of people and even whole villages.[3] This chapter explores the social and economic nature of this art of the poor.

Crete came under the rule of Venice in the aftermath of the Fourth Crusade, which culminated in the conquest of Constantinople by the Crusaders and the subsequent dismemberment of the Byzantine Empire. In 1204, Venice bought Crete and other former Byzantine territories from the Crusader, Boniface Marquis de Montferrat, for 1,000 marks of silver.[4] It was not until 1211 that the Venetians managed to establish an administration on Crete, but their government of the dominion would last until 1669. The Venetians undoubtedly benefitted from this calculated transaction (it can safely be said that their 1,000 marks of silver was money well spent), but, judging by the many Orthodox churches that date from this period, the native Cretan population also took advantage of the prosperity brought by Venetian trade in some of the island's popular agricultural products, such as cheese, wheat and wine.[5]

The small dimensions of the church at Maza (6.67 × 4.30 m) are typical for Cretan rural church architecture, which largely consists of single nave, barrel-vaulted churches, with the capacity of accommodating no more than the community of a small

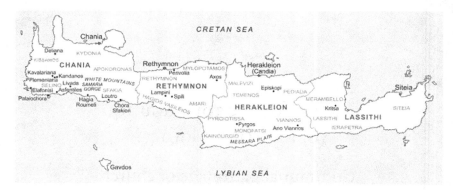

Map 4.1 Crete. Copyright: Angeliki Lymberopoulou and Rembrandt Duits.

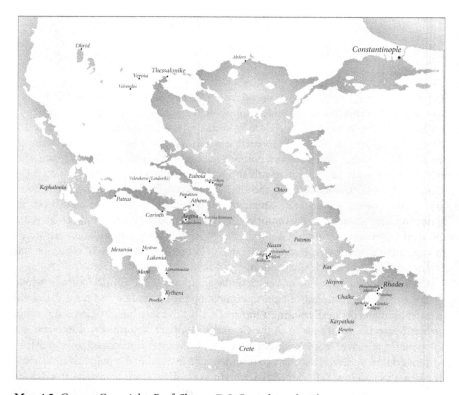

Map 4.2 Greece. Copyright: Prof. Sharon E. J. Gerstel, used with permission.

village. They are invariably carefully oriented, with their sanctuary pointing east, and in most cases decorated with wall paintings adhering to the Orthodox tradition in their iconography and style.[6] As mentioned earlier, the church at Maza is dedicated to Saint Nicholas, one of the more important intercessors for the salvation of the soul in the Orthodox Church, second only to the Virgin and Saint John the Baptist. An image

of Saint Nicholas is placed prominently on the north wall of the church (Figure 4.1),[7] and he is also referred to in the dedicatory inscription, situated on the west wall.

This inscription, while laconic, provides us with a wealth of information: it gives us the year in which the church was decorated, 1325/6; the painter who was commissioned with this task, Ioannis Pagomenos,[8] one of the most prolific fourteenth-century Cretan painters active in this part of the island; and it tells us who paid Pagomenos for his troubles – Demetrios Sarakinopoulos and Konstantinos Raptis funded one-half, while Konstantinos Sarakinopoulos (almost certainly a relative of Demetrios),[9] Georgios Mavromatis, the priest Michael and the whole of the village of Maza put up the money

Figure 4.1 Ioannis Pagomenos, *Saint Nicholas*, 1325/6, wall painting, Maza (Apokoronas, Chania), Church of Saint Nicholas, north wall. Photo: author.

for the rest (Figure 4.2).[10] The latter piece of information makes it clear that certain inhabitants of the village had deeper pockets than others, but equally that the whole village chipped in to erect and decorate a church dedicated to their chosen patron saint. Maza presents us with one of the most concise examples of a collective donation with a defined division of the amount spent by the donors.[11] Several other commissions of the painter Ioannis Pagomenos offer further case studies of such collective donations, allowing us to define their parameters with greater clarity.

For example, in the Church of Saint George in the village of Komitades, in Sfakia, also in the prefecture of Chania (Map 4.1), dated 1313/14, the inscription on the west wall appears to name every single individual and family who contributed a more substantial amount towards the decoration of the church (Figure 4.3).[12] It ends by mentioning an anonymous collective of people, in a manner similar to that encountered in Maza, but without explicitly stating that it is the 'whole of the village' (as in Maza). It seems, however, that at the last minute, a woman and her children still made a larger contribution, and it was deemed appropriate for their names to be included in the inscription – where they appear after the 'Amen' and before the painter's signature. A similar 'mishap' occurred while drawing up the lengthy inscription in the Church of Saint George in the village of Anydroi, in Selino, again in the prefecture of Chania (Map 4.1), dated 1323 (Figure 4.5).[13]

It is amusing to entertain the possibility that the painter actually learnt from this experience and changed his tactics when dealing with his next set of his patrons, those who paid him to decorate the Church of the Virgin in the village of Kakodiki, once more in Selino (Map 4.1), dated 1331/2. The dedicatory inscription on the

Figure 4.2 Ioannis Pagomenos, *Dedicatory Inscription*, 1325/6, wall painting, Maza (Apokoronas, Chania), Church of Saint Nicholas, west wall. Photo: author.

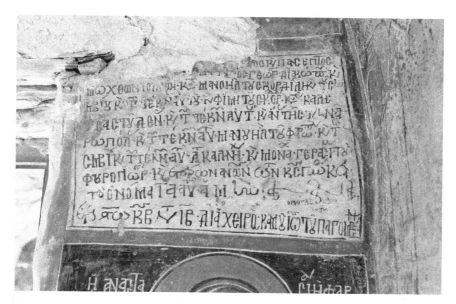

Figure 4.3 Ioannis Pagomenos, *Dedicatory Inscription*, 1313/14, wall paintings, Komitades (Sfakia, Chania), Church of Saint George, west wall. Photo: author.

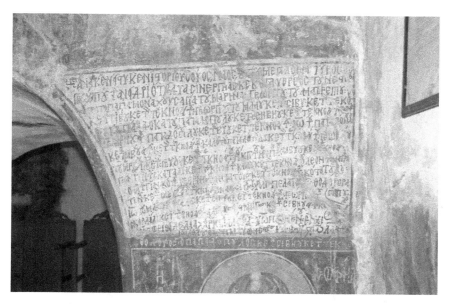

Figure 4.4 Ioannis Pagomenos, *Dedicatory Inscription*, 1323, wall paintings, Anydroi (Selino, Chania), Church of Saint George, south wall. Photo: author.

west wall of this church is lengthy, naming a large section of the village's inhabitants (Figure 4.5).[14] According to palaeographical evidence, at least three different hands can be identified in the text, one in majuscule script, found at the beginning and the end of the inscription, and at least two more in miniscule. It appears that the handwriting in the majuscule script deliberately left space in the middle of the inscription to be filled with names of further donors after the first group of contributors was recorded (avoiding thus the awkward insertion of names as an afterthought found at Komitades and Anydroi).[15]

It is interesting to note that, as Sharon Gerstel has pointed out, these lengthy inscriptions mentioning every donor's name, when read out loud, are reminiscent of the services priests hold to the present day in the Orthodox Church to commemorate the names of the deceased within a community.[16] Gerstel's argument is persuasive, since it was one of the best ways for donors to ensure commemoration in eternity and to remain the recipients of prayers for the salvation of their soul. On Crete, we encounter inscriptions where the long list of donors' names concludes with the invocation 'may they be remembered in eternity'.[17] When the congregation is mentioned collectively, as in Maza, remembrance is entrusted to the priest mentioned just before the anonymous group, who can make the names of his flock known to God (the priest himself in this case is halfway between being named and maintaining anonymity, as only his first name, Michael, is recorded).

The recording of names in these inscriptions does not follow an alphabetical order and in general seems to be random. A protopapas (priest) is often mentioned first,

Figure 4.5 Ioannis Pagomenos, *Dedicatory Inscription*, 1331/2, wall paintings, Kakodiki (Selino, Chania), Church of the Virgin, west wall. Photo: author.

primarily because he would have been responsible for obtaining permission from the authorities for building and/or decorating the church,[18] but this is definitively not the rule (as mentioned earlier, the priest Michael is recorded just before the anonymous villagers at Maza). This (uncertain) principle aside, there is no other apparent hierarchy, for example according to the size of the donors' contributions. The surviving evidence would suggest that people were simply recorded in the order in which they came forth to make their donations. Interestingly, two inscriptions recorded by Sophia Kalopissi-Verti in Mesa Mani in the Peloponnese, one in the Church of Hagioi Anargyroi in the village of Kepoula (Map 4.2), dated 1265,[19] and another in the Church of the Archangel Michael in the village of Polemitas (Map 4.2), dated 1278,[20] seem to double as ledgers in which the amount of money spent per sponsor is duly noted. In both cases, the records are neither in an alphabetical order nor relate to the relative size of the donations.

More specifically, at Polemitas, the inscription is written in miniscule characters that become smaller in the second part of the text. In total, over thirty donors with their families are mentioned in the first part of the inscription. Donations are listed in the second part; they include fields of various dimensions, olive trees (in one instance half an olive tree) and vegetable plots. This would suggest that these were not just incidental gifts but provisions for the upkeep of the church.[21] At Kepoula, all recorded contributing donors are male; their contributions add up to a total of 14.5 gold coins. The largest contribution, 8 gold coins, was made by Helias, the *anagnostis* and *nomikos* (a lector in the church and the village notary).[22] One donor contributed 1.5 gold coins; four donors contributed 1 gold coin each; one donor contributed 0.5 gold coin; and two donors contributed 0.25 of a gold coin each.

Painting on wall and panel was a medium less expensive than other forms of artistic production (e.g. Byzantine mosaics) in the Late Middle Ages and in the Renaissance. As such, it is not surprising that it was the preferred medium for collective commissions in small, rural communities of moderate means. The cost of 14.5 gold coins for the decoration of a church (even a tiny church: Kepoula measures 3.95 × 2.43 m) was by no means a large sum of money for an artistic project. On the other hand, it was not negligible. In 1343, the Byzantine imperial debt to Venice amounted to 30,000 gold ducats; thus, 14.5 gold coins may have represented 0.05 per cent of the national debt of a state.[23]

The structure of the donations for the churches at Mesa Mani is comparable to that of donations encountered in rural Crete. For example, at Kepoula, the donor Helias contributed more than half of the total amount towards the decoration of the church (8 out of 14.5 gold coins), with the rest of the donations being much smaller by comparison, ranging between a quarter of a coin and one-and-a-half coins. This appears to echo the division of the sponsorship recorded in the dedicatory inscription at Maza, where two named donors paid for half of the church, and a group of named donors and the whole of the village made smaller contributions. The inscription at Polemitas could perhaps offer an insight into the pattern of sponsorship encountered at Kakodiki. It is possible that the additional names recorded in a different hand in the middle of the inscription at Kakodiki were of those who offered contributions for the upkeep of the church. Leaving property and land to a church, as recorded at

Polemitas, is also attested in other Cretan churches, for example at Apano Floria, in Selino (Map 4.1), where the inscription in the Church of the Holy Fathers, dated 1470, also mentions bequests of bees, vineyards and arable land.[24]

Giuseppe Gerola, the seminal scholar of the study of Cretan churches in the early twentieth century, claimed that the countless small churches on the island were a product of religious fanaticism. Despite making a heroic effort to catalogue a great number of the churches in a four-volume publication, he considered them 'poor', 'insignificant' and 'inadequate for their purpose', comparing them negatively to the 'beautiful' custom of the Latin (Roman Catholic) West to place on street corners and at crossroads either a crucifix or a tabernacle.[25] The fact that Gerola thought the Orthodox village churches comparable to this Roman Catholic tradition of road markers is interesting in itself, and reflects the different attitudes between Orthodoxy and Catholicism regarding worshipping practices. Even Gerola, however, seems to have been aware that Venetian Roman Catholic colonists who resided in the Cretan countryside during the fourteenth century did not share his opinion – at least not regarding the inadequacy of the edifices for religious purposes.[26]

Owing to the shortage of Latin priests in the Cretan provinces, Venetian Roman Catholics were left with no other option than to attend Orthodox services. At least two Venetian decrees, one in 1349 and another in 1405, were issued attempting to counteract this practice, thereby indirectly confirming its existence.[27] It is also highly likely that some of the Venetian colonists contributed towards the building and/or renovation and decoration of their local churches. Indirect evidence to this effect is provided by more than one inscription from the island describing the donation for a particular church as exclusively Orthodox. For example, at Hagia Eirini, Church of the Saviour, dated 1357/8, and at Prines, Church of the Holy Apostles, dated to the fourteenth century (both Selino – Map 4.1), it is specifically noted that the donors of these particular churches were Orthodox.[28] The inscription at Kapetaniana, Church of the Archangel Michael (Monofatsi – Map 4.1), dated ca. 1430, mentions 'Christians of the same dogma'; this is undoubtedly a reference to Orthodox Christians, since the first name recorded here is that of the Orthodox monk Matthew.[29]

The need to announce explicitly the Orthodox 'purity' of the donors in these few inscriptions suggests that not all rural churches were built and decorated exclusively with donations from the Orthodox congregation. Indeed, certain Western elements included in the iconographic programmes in a number of Cretan churches would indicate a familiarity with Western traditions; perhaps they were sometimes commissioned and paid for by Roman Catholic members of the congregation. One of the better-known examples of Western iconography on the island is the representation of Saint Bartholomew holding his flayed skin over his shoulder (Figure 4.6), which follows the Western tradition of his martyrdom, since according to the Orthodox Church, he was crucified.[30]

The exclusion of and effective discrimination against any group of people who were not of the Orthodox persuasion is a reminder that pockets of hostility between the two religiously different groups of inhabitants were never completely eradicated on Venetian Crete. Mutual suspicion, rooted in small but significant differences in the interpretation of Christian dogma, remained a source of division in society. Overall,

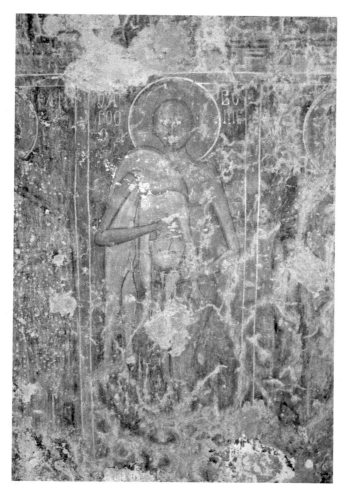

Figure 4.6 Cretan, *Saint Bartholomew Carrying His Flayed Skin over His Shoulders*, 1381–91, wall painting, Drys (Selino, Chania), Church of the Holy Apostles. Photo: author.

however, the interaction between the Greek Orthodox and the Venetian Roman Catholics on the island appears to have been a positive cultural dialogue, as reflected in numerous artefacts.[31] Without a doubt, a primary factor to facilitate this dialogue was commerce, conducted in the language that knows neither borders nor cultural boundaries: money.

The dedicatory inscriptions at Mesa Mani make it explicit that the building and/or renovating and decorating of a church cost non-negligible sums of money. Evidently, the flurry of church building and decorating activity in rural Crete during the fourteenth and fifteenth centuries means that these rural communities were prospering. The Venetian presence and the trade they introduced in regional Crete stimulated the local economy. Western rule enhancing economic growth in former Byzantine

territories is attested also in other areas. For example, on Rhodes under the Knights Hospitaller (1309–1523), artistic activity among the Orthodox population of the island was boosted (Map 4.2).[32] The main difference between Rhodes and Crete is that from rural Rhodes, there is only one single inscription that testifies to the communal commission of a church.[33] Possibly, individuals or specific families benefitted more than communities from the wealth generated by the Knights Hospitaller on Rhodes. By contrast, on Crete, the wealth generated by Venetian trade appears to have been more democratically divided.

This is noticeable, for example, in the far-flung mountainous region of Selino in the south-western corner of Crete (Map 4.1). Selino has the largest density of churches compared to the other nineteen provinces of Crete (1 church per 2.83 km²).[34] Scholars have sought to explain this out of the mountainous landscape of the area, which rendered travel difficult, and made it easier for every small community to have its own church. Apart from the fact that travel in general was challenging in the fourteenth and fifteenth centuries, the mountainous landscape is characteristic for the whole of Crete; it is not exclusive to the Selino area. In fact, the neighbouring region of Sfakia is equally (if not more) mountainous. Sfakia (Map 4.1) is the province with the lowest density of churches in the prefecture of Chania (1 per 17.98 km²) and one of the lowest densities on Crete; only in the eastern prefecture of Lassithi (Map 4.1), there are two regions with fewer churches per square kilometre than in Sfakia (Merambello, with 1 church per 18.28 km², and Lassithi, which has no churches).

Both the area of Sfakia and the area of Lassithi were systematically depopulated by the Venetians because they were considered hotbeds of revolutionary activity against their government.[35] The plateau of Lassithi in particular was the last stronghold of the Saint Titus rebellion, probably the most dangerous uprising Venice had to face during its rule over the island, between 1363 and 1367.[36] Venice managed to defeat the rebellion and also to make an example out of its victory: the Lassithi plateau was to be turned into a desert, where nobody was to live or work, and whoever dared to either sow seed or take animals to pasture there would have his foot cut off and lose his herd.[37] We do not know whether this decree was ever fully implemented. Yet, the absence of churches here may well have been owing simply to an absence of population.

In general, the Venetians appear to have treated Crete as agricultural land and a source of certain raw materials. The three basic products of Cretan agriculture the Venetians consumed and traded were wheat, wine and cheese. Wheat was grown in the plains of Kissamos in the Chania area, and in Pediada in the prefecture of Herakleion (Map 4.1). The most famous Cretan wine was cultivated in the province of Malevizi, also situated in Herakleion (Map 4.1), and was exported to many places in Europe at the time (it was known as Malmsey in England).[38] Cheese was produced in various regions, and the shipping of cheese from Chania to the capital Candia (the modern-day city of Herakleion) is documented.[39]

A crucial raw material that the Venetians harvested on Crete was wood for building and shipbuilding. The main forests were situated in the mountains of the southern provinces of the island, especially the White Mountains, which form a natural border between the areas of Selino and Sfakia. The economic advantages of cheese production and wood harvest must have been shared in equal measure by Selino and other elevated

southern regions, but it is important to point out that Selino may well have been the first part of the south-western coast the Venetians brought under their control. They built a fortress on the coast of Selino, at Palaiochora, as early as 1282, while the fortress of neighbouring Sfakia, which, as mentioned earlier, was regarded by the Venetian authorities as a seditious region, was erected only a century later, in 1374.[40] Inscriptions in churches testify to further raw materials that were traded. For example, in the Church of Prophet Elijah at Avdouliana, Selino (Map 4.1), dated to the fourteenth century, the female donor Anthousa Parthalopoula gave 70 kilograms of salt towards the building of the church.[41] The inscription provides evidence that trading in salt was an activity in which working-class women participated already before the sixteenth century, when it became rather popular among female entrepreneurs.[42]

All in all, it is clear that the rural communities of Venetian Crete profited from their dealings with the Venetians. Ordinary Cretans invested some of the modest excess wealth which this trade generated into the creation of art and architecture that served the religious needs of their community. This is mostly evident in the prefecture of Chania, where, as we have seen, communities of all shapes and sizes came together to sponsor church building and decoration – from a cluster of families within one village, to an entire village, to even a cluster of villages (called tourma),[43] as in the case of the Church of Saint Paraskevi at Kitiros, Selino (Map 4.1), dated 1372/3.[44] The Cretan collective church commissions, aiming at the salvation of their sponsors' souls,[45] constitute a sponsorship with a difference. From the perspective of art history, social history and the history of religion, the evidence that the resulting churches provide is every bit as glamorous as that of the well-known and globally admired Byzantine monuments elsewhere,[46] and as magnificent as the landscape in which they are located.

Next to Chur we are still poor

Art and the relationality of poverty in the Rhaetian Alps

Joanne W. Anderson

Poverty is relative in both concept and reality. As argued by Michel Mollat, the challenge for the historian is to reconcile the idea of poverty with the shifting social realities of the condition in all their complexities.[1] They might approach the topic philologically, economically, socially and biologically in order to understand what might constitute the status of poverty in concrete and abstract terms: the poor as a distinctive social group, the circumstances that bring that group or its constituent individuals into that condition and the ways in which they are rationalized by others, the most elevated nomenclature in the late medieval period being *pauper Christi*, or Christ's poor – those who were defined as both a spiritual mission and a paradigm of gospel virtue by the mendicant orders and their associated tertiary charitable organizations from the late thirteenth century onwards.[2] Art History has its own terms for poverty, referring to certain forms of artistic production as poor or low art, native, naive or child-like, vernacular, folksy, simplistic, crude, all pejorative labels that are the result of a restrictive connoisseurial perspective. This chapter, as indeed the volume, raises instead the question of art or imagery that was commissioned for or viewed by the less well off in the very spaces or environments in which they lived their lives, and how such imagery related to a wider context.[3]

Specifically this chapter will explore the relations between those artworks produced for the prosperous bishopric seat of Chur in the Rhaetian Alps (Switzerland) and those produced for the small yet numerous chapels or churches that populated its expansive, largely rural diocese – art that falls largely out of the connoisseurial canon and to which some of the above-mentioned pejorative labels could be applied from a traditional art-historical point of view. In examining the relations between Chur and its outlying districts, I will work with the concept of 'relationality' rather than Mollat's relativity to indicate that poverty was not just a relative concept in abstract, absolute terms, but should be regarded as a framework of local relationships that defined the world that people knew, thus allowing us to quantify and qualify artistic production in a comparative yet connected way that is vital in the Alps.[4] In critical terms, the chapter

operates between two types of space within this locality, the urban and the rural, space necessarily having a relational value with a wider context.[5] Given that urban and rural patrons in this geographic area generally used the same artists or their workshops, what role do the migratory working practices of these artists and workshops play, and if so how does that alter our definition and understanding of art for the less privileged in remote places? Is it always in relation to Chur?

During the late medieval period, the bishopric of Chur – founded in 451 by Bishop Asinio from the Roman province of *Raetia Curiensis* and becoming a princely bishopric from 1170 – encompassed the city of Chur, the Engadine valley and the Vinshgau, corresponding roughly to the modern-day canton of the Swiss Grisons (Map 5.1). The city's aspect was captured by the printing press in the mid-sixteenth century: in Johannes Stumpf's *Chronik* it was depicted fortified by its walls and towers, while in Sebastian Münster's *Cosmographie*, the focus was placed on the prince-bishop's court (*Hof*): a modest citadel that gave prestige and symbolic weight to the office and the city.[6] Inevitably, there are no comparable views for the rural territories outside of those walls at the time, only maps indicating the numerous small settlements as part of territorial claims. This has implications for our understanding of what constituted poverty, given that remoteness can sometimes be equated with depravation, often for justifiable reasons. These localities fell under the jurisdiction of the prince-bishop and the castles of the feudal lords, but this power relationship did not necessarily translate into one of relative wealth – a lord's castle denoted position and power but did not always reflect material abundance, including artistic works. Some settlements,

Map 5.1 Swiss Grisons with case study locations indicated. © author.

however, were proximate to monastic houses, for example, the Premonstratensians at Churwalden Abbey, whose altarpieces, wall paintings, sculpture, glass and metalwork were plentiful in relation to surrounding parish churches and chapels.

In what follows, I will focus on ecclesiastical edifices in three localities, the relationality of which can be considered representative of the wider networks in the Rhaetian Alps: the Cathedral of Heilige Mariä Himmelfahrt (St Mary of the Assumption), dedicated in 1272, in Chur; the Chapel of St Maria Magdalena in Dusch in the Domleschg valley; and the Church of St Johannes in Stuls/Stugl in the Albula valley.[7] The balance is weighted to the rural, specifically two small settlements at increasing distances from Chur, yet at the same time situated in proximity to other 'larger' centres with their churches and imagery. This approach helps us to determine poverty in the mountains: can art in the main centre of a region be taken as the principle measure of value, and does art in remote places reflect greater poverty?

Across rural and urban locales, such as the three studied here, there was a broad social spectrum: clergy and religious orders, nobility (high and low), craftsmen and women, merchants, travellers, labourers, peasants and beggars.[8] The Rhaetian Alps are noted for their communal constitution from the fourteenth century, drawn up as part of alliance-forming strategies to limit the power of the non-elected elite.[9] Its communities had a good level of autonomy in terms of political development, although they were still subject to the administration of larger institutional structures. For example, in Dusch in the upper Domleschg valley, the chapel of St Maria Magdalena fell under the jurisdiction of the Premonstratensian Abbey of Churwalden from 1208 (at 12.9 miles distance, nearly 7 hours on foot), an institution which itself benefitted from the largesse of the local noble family of Vaz up until the mid-fourteenth century.

Canons regulars from the abbey are represented in the fresco cycle with scenes from the life of Mary Magdalen inside the little chapel in Dusch, suggesting that they played a crucial role in commissioning the Waltensburg Master and workshop, the dominant artist in the area at the time. Aesthetically, the paintings are refined and colourful, with the lively border pattern giving the impression of a luxury tapestry that has unfurled upon the wall leading up to the apse with its own decorative programme. The Magdalen cycle substituted for the continual presence of an officiating canon and served the local populace, as well as passing travellers as suggested by the contemporaneous fresco of St Christopher bearing the Christ Child on the exterior wall facing down the valley (Figure 5.1).[10]

The involvement of the abbey, however, does not exclude contribution in kind from the residents of the house and farm of Dusch – this could be up to twenty people depending on the size and structural type of the buildings, documented in this locality as a possession of the abbey since 1208.[11] They would have paid an annual tithe, probably in the form of natural goods from working the land or animal husbandry (*Alpwirtschaft*) – the latter involving mainly cattle for breeding or dairy production, with six to eight cows being a marker of prosperity.[12] This implies a relational social hierarchy and distribution of wealth, but one that nonetheless gave them a stake in the chapel and its paintings. The poorer, and most likely seasonal, labourers would have been worse off financially, but the paintings addressed their spiritual needs too. The scenes of Mary Magdalen preaching to the rulers of Marseille

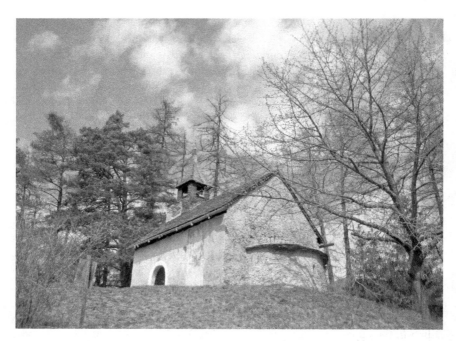

Figure 5.1 Waltensburg Master and workshop (attributed), *St Christopher Carrying the Christ Child*, ca. 1350, exterior fresco, Dusch, St. Maria Magdalena. Photo: author.

in their castle and the detail of the Magdalen receiving a basket of baked Eucharistic wafers from an angel during her wilderness retreat show the saint's spiritual action in contrasting situations reflecting wealth and poverty (Figures 5.2 and 5.3). While the volume and variation of imagery are less than what might be seen in Chur around 12.8 miles away, 5 hours by foot (by going down to and along the valley floor), for its size and location, St Maria Magdalena in Dusch offered visual riches for its less affluent community.

The tiny church of St Johannes (now the Reformed Church) in Stuls/Stugl (over 26 miles from Chur, 10 hours by foot) further problematizes the correlations between location, distance and scale (Figure 5.4).[13] It is first noted as a possession of the Chur Cathedral Chapter in the mid-thirteenth century, indicating an historic link between this more distant locale and the bishopric centre.[14] Stuls/Stugl is a linear hamlet that sits high above the Albula valley (1551 m) and the larger settlement of Bergün/Bravuogn, with its parish church replete with fresco decoration. The chapel in Stuls/Stugl commands an impressive territorial view – similar to the chapel in Dusch and akin to the castles in this region. Its own visibility in the landscape signals its function as a spiritual refuge for locals and passers-by frequenting the often-treacherous mountain pathways. Inside, there are impressive frescoes dating from ca. 1360–70, including the Baptism of Christ, the Last Supper, five scenes from the Passion of Christ, the Death of the Virgin, Christ in a Mandorla with the four Evangelists, four Church Fathers and possibly the Adoration of the Kings (Figure 5.5).[15] On the wall outside, facing inwards to the village,

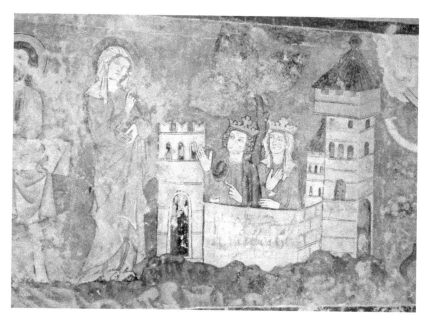

Figure 5.2 Waltensburg Master and workshop (attributed), *Mary Magdalen Preaching to the Rulers of Marseille*, ca. 1350, interior fresco, Dusch, St. Maria Magdalena. Photo: author.

Figure 5.3 Waltensburg Master and workshop (attributed), *Mary Magdalen in the Wilderness*, ca. 1350, interior fresco, Dusch, St. Maria Magdalena. Photo: author.

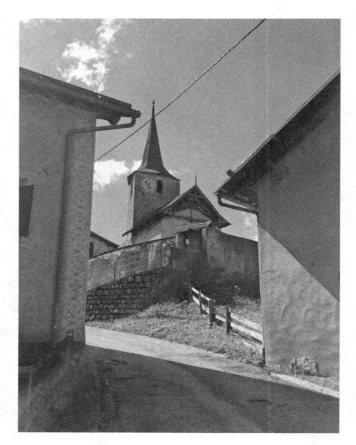

Figure 5.4 Exterior view of Stuls/Stugl, St Johannes. Photo: author.

are the remnants of frescoes of Sts Christopher and John the Baptist (ca. 1310–20), and St George rescuing the princess from the dragon (ca. 1360–70) (Figure 5.6).

We can ask ourselves how much surplus wealth was required to commission a series of fresco paintings in this locale across two decorative campaigns.[16] Historians have noted that Alpine communities across the mountain arc acted communally for the good of their churches, particularly within parishes, contributing (willingly or not) to the upkeep of buildings and their adornment, including paintings.[17] In the pre-Alpine diocese of Trento, poverty was cited as an obstacle for the men of the parish of Volano when asked to contribute to the cost of restoring the parish church, but their appeal was ignored and the work enforced on pain of excommunication.[18] Nothing is known about the production of the paintings in Stuls/Stugl. In 1579, Stuls/Stugl was documented to have sixty-eight inhabitants, a relatively large number; the demographics may have been similar in the fourteenth century, although the capacity of the church would indicate a number closer to twenty to twenty-five.[19] Stuls/Stugl was principally a farming village (grain and hay, cattle breeding and dairy production) so the ability to

Figure 5.5 Anonymous workshop, *Scenes from the Passion of Christ*, ca. 1360–70, interior fresco, Stuls/Stugl, St. Johannes. Photo: author.

raise some funds must be assumed, although this would have been conditional to the annual yields, with residents varying in terms of their material wealth. In this context, it is challenging to draw the poverty line. A labourer in the village may have been poor next to a priest living on a community-raised benefice in Bergün/Bravuogn, but, nevertheless, remained well off next to an itinerant beggar living off alms.[20]

This locality was poor in relation to Chur by the simple fact of its size and the profession of its inhabitants, but, evidently, it could afford art that was more than proportionate to its size and situation. There was only one church to serve this village; its imagery would have been accessible to all in terms of subject matter, and is free from markers of individual identity or sponsorship (unlike in Dusch). The closest alternatives for worship were the church of St Nikolaus in Latsch (founded 1154), a 20-minute walk along the pathway at the same elevation, or the parish church in Bergün/Bravuogn down on the valley floor. However, given that St Nikolaus was never adorned with paintings, relationality is with the larger church in Bergün/Bravuogn and its fresco programme. In the late fourteenth century, Stuls/Stugl was still a filial church of

Figure 5.6 Anonymous workshop, *St George and the Dragon*, ca. 1360–70, exterior fresco, Stuls/Stugl, St. Johannes. Photo: author.

Bergün/Bravuogn but in terms of scale and quantity of artworks it could not be classed as poorer, again it was proportionate. Moreover, the remote location did not deter a travelling workshop (perhaps from Tyrol) from taking on the job and providing a resplendent devotional space for the community, one that saved them from descending to the parish church in Bergün/Bravuogn on a regular basis.[21] Yet next to Chur, they remained poor when it came to the scale and quantity of art.

Chur enjoyed a more densely concentrated population including clergy, religious orders (specifically the Premonstratensians and Dominicans), craftsmen and women, farmers, construction workers, servants, merchants, traders and probably pilgrims.[22] It was also a place for the most vulnerable in society who were seeking shelter and alms – a hospital passed from St Martin to the convent of St Luzi (1154) was given the charge of looking after the poor and other marginalized groups.[23] Chur was a major trading city since Roman times given its proximity to important Alpine passes that linked the Mediterranean south with Northern Europe. Its markets were protected by the city walls and civic statutes, encouraging the generation of wealth and disposable income.[24] From the high to late Middle Ages, the city used its land for grain, gardens and vineyards, all tradable commodities.

In the thirteenth century, Chur had around 1,300 residents.[25] The fourteenth century saw civil unrest due to multiple fires ravaging the city, and with the political powers

Figure 5.7 Anonymous workshop, main portal (detail), polychromed stone, Chur, Cathedral of Heilige Mariä Himmelfahrt. Photo: author.

wielded by the prince-bishop (held since 1299, including control of government and the nearby Alpine passes for the Holy Roman emperor) and the Habsburg House then challenged by the newly formed Gotteshausbund from 1367. Instability characterizes this period, yet the city remained the dominant regional centre and place of exchange. Both rich and poor were subject to the same relationality as those who lived in rural locations; they mixed within the confines of the walls, looking upon and praying before the same devotional imagery in public ecclesiastical sites.

The cathedral (founded 1151, consecrated 1272), located within the bishop's court, provides the most significant relational example to the rural cases discussed earlier. Its devotional art addressed everyone in the largest and most accessible space in the city. Inside and out, a density of imagery in the form of wall paintings, sculpted altarpieces and sculptures, glass windows, metalwork and textiles were visible and accessible that was simply on a scale not possible in rural parish churches and chapels. The tympanum decoration of the main portal offered a striking first impression with its brightly polychromed and patterned archivolts (Figure 5.7). The innermost archivolt bears two painted kneeling, secular male supplicants bearing a votive banner declaring the prayer: *MATER VIRGO PIA NOBIS SUCCURREM* . . . On the exterior east end, a fragmentary large-scale frescoed Crucifixion is visible, making it clear that the principles of building decoration applied here were similar to those of countryside churches thus levelling the differences on approach but not quantity.

The wall paintings inside, also produced during the thirteenth and fourteenth centuries, include a giant St Christopher (fragmentary) on the inner right façade offering protection to those leaving the sacred precinct, scenes of the Adoration of

the Magi, the Crucifixion and the Last Judgement bearing a family's coat of arms in the baptistery chapel situated in the western nave (Figure 5.8).[26] Fragments of other decoration are visible elsewhere in the nave, particularly around architectural altars, indicating that a much richer visual programme was at one time in existence on the walls. A number of these works were painted (most likely) by the same master and workshop responsible for those in St Maria Magdalena in Dusch and other regional locations (notably in Waltensburg and Rhäzüns), namely the Waltensburg Master. This model of artistic migration suggests a lack of discrimination between urban and rural localities, and with that a certain levelling of economic variances.

As noted earlier, it is easy to characterize the Alps as regional or rural and thus as poor, but the reality was that it played host to rich bishoprics and abbeys that held and filtered (some) wealth down through the parishes. In this geographic locality, valleys were zones of productivity with skills being distributed across the nearby territories. This included artworks commissioned for the most impressive and modest ecclesiastical buildings. One artist and his large workshop might service all localities bringing a form of equivalence to the local visual culture.

In Chur, with its larger population and greater concentration of wealth, there was potential for a high turnover of art, by which I mean the addition of new imagery or the renewal of older programmes. By contrast, in rural Dusch and Stuls/Stugl, opportunities for renewal were more limited in terms of both patronal agency and available artistic skill (demand and supply). Simply put, the rural village or hamlet in the Alps had to wait for a patron or patrons to bring in a master artist and his workshop

Figure 5.8 Waltensburg Master and workshop (attributed), *Adoration of the Magi, Crucifixion, and Last Judgement*, interior fresco, Chur, Cathedral of Heilige Mariä Himmelfahrt, Baptistery Chapel. Photo: author.

to decorate the local church (sometimes in addition to secular/domestic jobs that no longer survive), or it had to wait for such practitioners to pass through the territory as part of their seasonal migration work pattern.[27] The rural case studies of this chapter indicate two types of artistic migration.

The Waltensburg Master, whose workshop painted in Dusch in the Domleschg valley around 1350, travelled into the region via Zürich. Most likely, he originally came from the Bodensee region. He worked in many locations in the Rhaetian Alps, including Rhäzüns, Zillis, Churwalden, Waltensburg and Chur, dominating the regional visual culture. Although trained in the elegant style of the Codex Manesse produced for the fourteenth-century court in Zürich, he found an outlet in more 'marginal' territories, and a further extension of his enterprise through his workshop. It evidences one type of migratory practice of artists who supplied wall paintings for mountain communities in that the Waltensburg Master travelled into a vast yet defined territory, built up a workshop and worked the valleys systematically: each small settlement offering the potential for the diffusion of style and iconography. This was a great leveller independent of the economic status of the patron, whether they were an individual or a collective.

A second type of migration is in evidence in the church of St Johannes in Stuls/ Stugl in the Albula valley. The exterior and interior paintings, dated 1360–70, suggest the influence of the Italian Venetan style, most likely transmitted via the regional centre of Bozen, then in the County of Tyrol.[28] The responsible workshop probably came from that town, having travelled into the region using the Albula Pass; today, the journey would take up to at least two days on foot assuming that pathways and climatic conditions were favourable. This suggests a passing-through type of migration, whereby a seasonal workshop would meet the demands of a specific parish or valley based on availability.[29] It would explain why such a small church, situated off the principle route down the valley, would attract such a high calibre, hybrid style workshop. An urban centre might offer such a workshop the most promising prospects, in the form of larger well-paid jobs, but the multiplicity of smaller rural settlements also each provided work, shelter, food and some income, vital in a peasant and artisanal economy.[30]

The multiplicity of locations and potential work opportunities for migratory artistic workshops in the Rhaetian Alps challenges the traditional binary model of 'centre and periphery'. In this regionally and valley-driven ecology, what is central or peripheral is dependent upon people's access, time, resources and perspective on where they live. Both Dusch and Stuls/Stugl were significantly poorer than Chur, but in relation to one another the picture is different. They both possessed a small painted church by a skilled artistic workshop that served their immediate needs and those of passing travellers. The decision to have their churches painted in the way they did appears to have been an attempt to assert their status in relation to other centres such as Bergün/Bravuogn. In this system of multiplicities, art was mobilized in the forging of a community's own status. For Stuls/Stugl in relation to Bergün/Bravuogn, a larger settlement with a painted church and houses, the relationality is contingent upon whether the residents of Stuls/Stugl would have viewed their church as poorer when taking into consideration the size of the building and the extent of the visual programmes. Did they necessarily

see themselves as impoverished, or rather the opposite, having acquired the services of an 'outsider' workshop disseminating a more modern style?

In 1979, Carlo Ginzburg and Enrico Castelnuovo upended the outward flow of skills/wealth/values bound up with the centre–periphery model, suggesting that a pushback by peripheral localities was possible.[31] But in the case of the Alps, the pushback was more diffused. Each locality most likely determined its status in relation to more proximate points of reference. The fact that they often hired the same artistic workshops as the major centre and neighbouring communities advocates for regional networks of centres. This accords with the recent analysis of Yoshihisa Hattori, who has argued for the autonomous interaction of valley communities (village and valley) in the formation of territorial or regional states, with the Grisons singled out as a striking example of the significance of individual village communities and their propensity for 'assertive action'.[32]

To conclude, in his *Geschichte der Bildenden Künste der Schweiz* of 1876, Johann Rudolf Rahn wrote that there was no art in the mountains during the Middle Ages.[33] Alpine art, in Rahn's eyes, was mediocre, as the Alps were just a meeting place where everybody mixed, thus not developing an autochthonous style. Rahn's nineteenth-century emphasis on style may no longer carry the same weight today, but there is still a lingering perception that a 'peripheral' region populated by peasants can have produced little of distinction, resonating with Michel Mollat's observation that the word 'poor' moved from being an adjective to a noun, from a quality to a condition. This chapter has sought to prove that the art of the Rhaetian Alps, its producers and beholders were part of a relational framework, in which status was not measured in absolute terms but in close relation to the environment that people related to. The art was not poor; it was simply reflective of specific geographic, economic and cultural factors, and deserves re-evaluation within a broader art history.

6

Miracles in the margins

The miraculous image of
Santa Maria delle Carceri in Prato

Shannon Gilmore-Kuziow

On 6 July 1484, in the Tuscan town of Prato, a young boy named Jacopino witnessed a fresco of the Virgin Mary miraculously come to life.[1] The *Madonna and Child with Saints Leonard and Stephen*, otherwise known as *Santa Maria delle Carceri*, was painted in the fourteenth century on the exterior entrance wall of Prato's prison – decommissioned by the time of the miracle in 1484 (Figure 6.1).[2] According to Jacopino, the Virgin in the fresco opened her arms and beckoned the poor and exhausted masses to her image. Pilgrims from the surrounding countryside answered her call and journeyed to the prison's crumbling ruins to receive relief from their physical and spiritual troubles. In the early years of the cult, many people gathering before the prison were artisans, labourers and inhabitants of Tuscan agrarian communities. This chapter therefore investigates two interconnected and less studied aspects of the cult: the devotional significance of the image's location on the prison and the ways in which the cult identified with and attracted the more humble social groups.[3]

Since the Commune of Prato owned the prison on which the image was painted, a papal bull issued in September 1484 provided the Commune with sole patronage rights over the cult. Most importantly, the bull specifically barred any parish or 'local ecclesiastical' interference, effectively denying any rights to Carlo de' Medici, the illegitimate son of Cosimo de' Medici and the provost of Prato's main church, the *pieve* of Santo Stefano.[4] As part of the Florentine territory, Prato was under the control of the Medici family at the time when the cult of *Santa Maria delle Carceri* was founded, and F. W. Kent posits that the Commune supported the image cult in the hopes of creating a feeling of community that was bruised by Lorenzo de' Medici's reception of authority over Prato's local governmental reforms in 1475.[5] The Medici had also penetrated the town's religious life, since Carlo's clerical post granted him a certain degree of influence over the activities and income of Prato's sacred sites;[6] furthermore, as provost of the *pieve*, Carlo possessed partial custody of the Virgin's belt, the illustrious relic housed in Santo Stefano, the cult of which (established before 1255) had caused the town's communal identity to become permanently intertwined with that of the Virgin.[7] By the

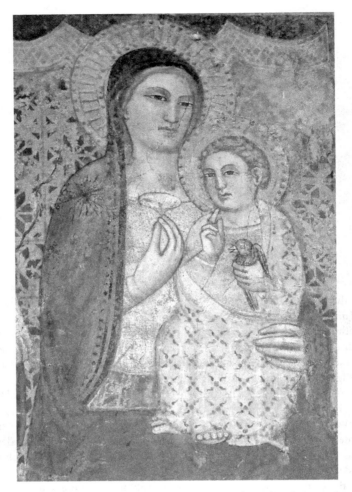

Figure 6.1 Anonymous Tuscan, *Madonna and Child Enthroned with Saints Leonard and Stephen* ('*Santa Maria delle Carceri*') (detail: fourteenth century, fresco, Prato, Basilica of Santa Maria delle Carceri). Courtesy of the Parrocchia di Santa Maria delle Carceri, Diocesi di Prato.

fifteenth century, the social elite enjoyed intimate physical access to the belt and the cult's public rituals emphasized the intercessory power of the ecclesiastical hierarchy. I suggest that the new local cult of *Santa Maria delle Carceri* worked to alter the identity of the Commune's protectress – the Virgin of Prato – by making her responsive to a wider demographic.

The sources that best illuminate the devotional atmosphere surrounding *Santa Maria delle Carceri* include two miracle books and one poem. The first miracle book, Codex 86 in the Biblioteca Roncioniana in Prato, likely dates to the late 1480s and is a transcription of several sources.[8] In 1505, local magistrate Giuliano Guizzelmi

compiled a second compendium of miracles that contains some of the same stories found in Codex 86, although it likely draws on another source, possibly Lorenzo degli Olbizi's poem *Miracoli della Vergine delle Carceri*, which was published during the first two years of the cult.[9] Codex 86 differs from the other two sources in that it recounts Carlo's various attempts to seize control of the miraculous image. According to the author of Codex 86, on 26 May 1485, the foundation ceremony was held for the new church that was being built to enshrine the fresco. For the occasion, Carlo and the Commune organized a procession that commenced at Carlo's *pieve* of Santo Stefano; upon arriving at the miraculous image, Carlo's vicar placed the crucifix of Santo Stefano into the church's foundations:

> immediately after the said cross was placed, all of the people threw stones [in the foundations], and they did not want to have much patience when the said [vicar of Santo Stefano], the *gonfaloniere*, and the Eight Priors threw them in: the people wanted this to demonstrate that they were the patrons, and not any other person, just as the [papal] bulls said.[10]

The people were not only aware of Carlo's ploy to usurp the ceremony and the site, but their willingness to retaliate with their 'lack of patience' exhibited their own collective claim on the cult.

As is evident from this act of resistance during the ritual, the *popolo* strongly identified with the miraculous image of *Santa Maria delle Carceri*. This is not to say that the image failed to appeal to the more prominent members of society; the numerous silver votive offerings and lavish donations of vestments listed in the church's inventories from the late fifteenth century prove that the image attracted affluent and illustrious devotees.[11] Artisans, labourers and the people living in the countryside, however, represented the driving force behind the cult. Research by Cecelia Hewlett on Codex 86 and Guizzelmi's book has revealed that the 'overwhelming majority' of the people amassing outside the prison were from small Tuscan agrarian communities.[12] A closer examination of the individual miracle stories offers a more nuanced understanding of the devotees and their hardships that moved them to seek comfort at the shrine. Together, the two sources list a total of approximately 230 stories, 83 of which provide information that allows for a rough determination of the supplicants' socio-economic status.[13] The majority of these eighty-three accounts indicates the devotees' professions, or those of their immediate family, and some of the stories even explicitly state whether a supplicant was rich, poor or in debt. According to my interpretation of the data, fifty-one of the eighty-three stories (61 per cent) tell of artisans, millers, labourers, servants, mendicant friars, minor clergymen and even a couple of gypsies. Only two of the artisans belonged to a major guild, while the rest were members of various minor guilds and included tailors, bakers, a shoemaker and a blacksmith. The remaining thirty-two stories (39 per cent) concern devotees who appeared to be wealthy or financially secure.

The miracle stories associated with the image give us glimpses into the desperate situations that labourers and small-time artisans frequently encountered in fifteenth-century Tuscany. The Virgin delivered supplicants from indebtedness and other forms

of economic hardship. Other miracle stories speak to the physical dangers of manual labour, describing the various accidents and illnesses that befell people while working: examples include a construction worker who tumbled into the foundations of a building, a farmworker whose eye was punctured by a sickle and a young girl who contracted a fever after falling asleep in a rain-drenched field where she was harvesting grain.[14]

Like most miracle shrines, the blind and the lame flocked to *Santa Maria delle Carceri* in the hopes of receiving a cure. Throughout the miracle stories, we find many instances of infirmities that incapacitated the afflicted and likely hindered them from making a living. One German man was paralysed for many months and distressed because 'he earned money with his arms in order to live'. Without success, he turned to doctors and medicinal remedies and finally, in desperation, vowed to *Santa Maria delle Carceri* and 'was liberated and healthy'.[15] In both Guizzelmi's text and Codex 86, the formula for recording the miracles received by individuals at the shrine frequently ended with the phrase, 'he or she was liberated'.[16] This recurrent phrase suggests that miracles were perceived as having an emancipatory role, particularly when the afflicted were either facing imminent death or suffering from a chronic medical condition. The concept of deliverance through miraculous intervention was made even more potent by the fact that it was occurring in a former place of captivity. Indeed, I propose that the miraculous image's location on the prison shaped the cult's devotional identity, making it into a locus where devotees held captive by the hardships of poverty and infirmity could find release. The trope of liberation from prison exists in the literature surrounding the cult; in his poem, degli Olbizi employs carceral imagery, albeit to express spiritual, rather than physical, redemption: 'Jesus . . . / . . . you wanted for your goodness, / only to extract us from the dark prison'.[17]

Prior to the Commune's decision to abandon it, sometime around 1470, the prison in Prato held debtors and the mentally ill.[18] Italian prisons burdened their inmates with the cost of their imprisonment and typically allowed prisoners few employment opportunities.[19] Below the fresco of *Santa Maria delle Carceri*, too, there is an inscription referring to the inmates' payment of an annual tax to the jail, reminding viewers of the system of fees that condemned impoverished individuals to an indefinite period of captivity.[20] Guy Geltner notes that these practices ultimately penalized less affluent social groups, such as 'day labourers and artisans', who entered prison and lost access to regular income.[21] As they accumulated further debt, their hopes of obtaining speedy release were dashed, so that impoverished inmates became dependent on charitable organizations, on the clemency of local communes or on divine intervention.[22] The early devotees of *Santa Maria delle Carceri* could have related to the former occupants of Prato's prison, since they too understood how quickly one's misfortunes could lead to poverty. Furthermore, the miracle stories commonly noted that the miraculous image represented a last-ditch effort on the part of the devotees, for whom earthly medicine had proved ineffective. Like the desperate debtors once held indefinitely inside the prison, the infirm and ill supplicants who visited the miraculous image were left to rely on outside help, in this case supernatural aid. The prison ruins themselves suggested freedom from bondage: Guizzelmi states that the Commune had deemed the prison structure obsolete because its state of disrepair had allowed for the regular escape of its inmates.[23]

Following the prison's abandonment, it was left vacant and eventually succumbed to ruin. According to Guizzelmi, a mound of dirt, weeds and thorns stood adjacent to the prison and collected 'all superfluous and ugly things of this said Town', and the entire precinct was left untended 'so that few people ever passed through that place'.[24] Located just south of the crumbling prison was another desolate area: the prison stood near one of the main city gates, which led one to the Porta a Corte neighbourhood, a district originally situated outside the boundaries of the historic city centre.[25] The Porta a Corte was the most indigent neighbourhood in an already impoverished town. According to the tax records of 1487, approximately 73 per cent of the families living inside the town of Prato and its suburbs were either poor or completely destitute.[26] The situation in the Corte district was even direr, since the majority of its inhabitants were unskilled labourers and salaried farmworkers, 88 per cent of whom were experiencing economic hardship.[27] The neighbourhood had only two shops, and presumably failed to attract many people living outside its limits.[28] The advent of the new miraculous image cult likely enlivened the district as multitudes streamed inside Prato's city gates to pay homage to the Virgin at the prison. The pilgrims would have accessed the shrine through both the Porta a Corte gate and the Porta a Capodiponte, located east of the oratory. The image's location proved ideal for less affluent members of society, situated at the threshold of the poor urban neighbourhood and near two main city gates that made it conveniently accessible for people living in the country.

The sweeping piazza surrounding the church today obscures the overgrown, isolated field where the prison was once located. Although not readily apparent to modern-day visitors unacquainted with the church, the ignoble origins of the cult were well known and even appreciated by devotees, and evidence of the prison's importance to the cult's supporters can be found within the walls of the church enshrining the image. In May 1485, a committee appointed by the Commune chose architect Giuliano da Maiano's design for the church, since it followed the Commune's stipulations that the oratory preserve both the prison's subterranean cells and the wall bearing the fresco.[29] During October of that same year, the Medici family placed their stamp of possession on the image when Lorenzo de' Medici substituted Giuliano da Maiano with Giuliano da Sangallo as the church's principal architect;[30] Sangallo's sanctuary, however, still preserves the local prison structure within its walls – indeed, the dedication of Sangallo's Basilica of *Santa Maria delle Carceri* recalls the cult's humble roots (Figure 6.2). The significance of the cult's origins is further attested to by the coat of arms of the works committee, which shows an image of a barred prison window (Figure 6.3). The resultant continuity evident in the site deepened the fresco's local ties, inhibiting its complete usurpation by the Medici.

Beyond the appeal of the prison as a miracle site, there was the attraction of the image itself. This was not the only image adorning the jail. The miraculous image appears adjacent to a *Crucifixion*, the iconography of which is quite formulaic (Figure 6.4). Painted in the vestibule of the prison is a fresco of the *Madonna of Humility* (Figure 6.5). This latter image became more difficult to access once the prison was closed and presents the Virgin in a humble fashion; by comparison, one of the attractions of *Santa Maria delle Carceri* as a cult image lies perhaps in the contrast between the lofty presentation of the Virgin and Child enthroned and the

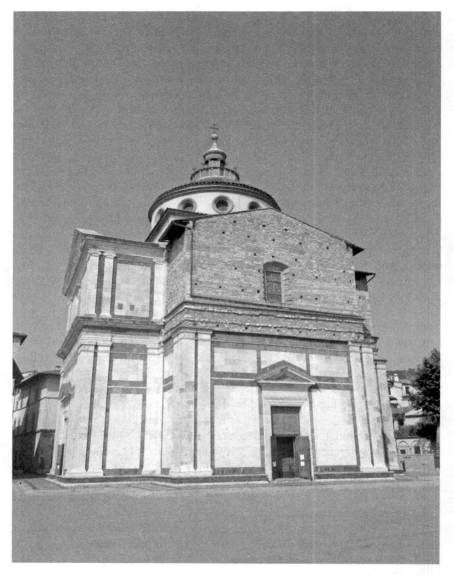

Figure 6.2 Giuliano da Sangallo, *Basilica of Santa Maria delle Carceri*, begun 1485–6, Prato. Photo: author.

humility displayed in the first recorded miracle. According to the boy, Jacopino, the Virgin ventured down from her throne. The author of Codex 86 states: '[The Virgin] descended . . . having visibly removed herself [from the wall] and adored [her son] for us praying and placing her very saintly son on the ground in this vile place of the Carcere.'[31] Jacopino's vision recalls imagery found in paintings of the *Nativity* that depict Christ lying upon rough, unpaved surfaces set within the countryside; such

Figure 6.3 Bernardo Buontalenti (design) and Giovanni Sacchi (execution), balustrade enclosing the presbytery, detail showing the coat of arms of the Opera of Santa Maria delle Carceri, 1588–9, marble, Prato, Basilica of Santa Maria delle Carceri. Courtesy of the Parrocchia di Santa Maria delle Carceri, Diocesi di Prato.

scenes emphasize the abasement of the Incarnation, when Christ descended from the heights of heaven and a purely divine form to the humility of earth and a human body.[32]

Following the adoration of the Child, the author of Codex 86 adds that 'in that place, the pious Mother Virgin Mary, with her hand of grace opened and stretched out

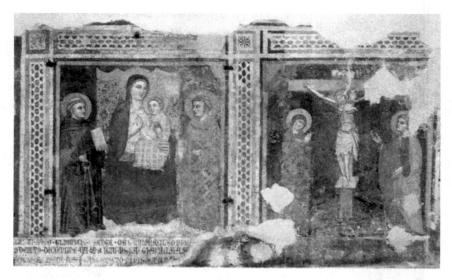

Figure 6.4 Anonymous Tuscan, *Madonna and Child Enthroned with Saints Leonard and Stephen*, and *Crucifixion*, fourteenth century, fresco, Prato, Basilica of Santa Maria delle Carceri. Courtesy of the Parrocchia di Santa Maria delle Carceri, Diocesi di Prato.

to the needy, and her arms of Mercy stretched out to the poor, [was] saying: "Come to me all of you who are tired and I will save you".[33] This description closely recalls *Madonna della Misericordia* images, which depict Mary extending both arms outwards, so as to shelter supplicants beneath her billowing mantle.[34] Renaissance hospitals and confraternities frequently took the name of *Madonna della Misericordia*, or simply *Misericordia*, which described the charitable activities with which they concerned themselves. The governors of Prato's hospitals, the Ospedale della Misericordia and the Ospedale del Dolce, participated in the administration of the *Carceri* cult.[35] Prior to the cult's establishment, the Misericordia hospital already had close ties to the original prison building, since its institutional duties included providing food for impoverished inmates.[36] Furthermore, the types of people seeking aid at Prato's Misericordia hospital bore a striking resemblance to the devotees listed in *Santa Maria delle Carceri's* miracle stories: both the hospital and the image attracted the poor.[37] By forging connections to Prato's hospitals and to the *Madonna della Misericordia*, *Santa Maria delle Carceri* reinforced its role as a place where the needy could seek out shelter and relief.

Prior to the founding of the *Carceri* cult, religious activity in Prato typically converged on the opposite side of town at the *pieve* of Santo Stefano, where the relic of the Virgin's belt is housed. In 1493, Giuliano Guizzelmi completed a miracle book for the relic cult.[38] His manuscript covers a period of roughly 300 years but only records 31 stories, most of which concern the upper echelons of society. The information Guizzelmi provided allowed me to determine the social status of fifteen protagonists, twelve of whom were affluent, with several boasting influential political positions or important relations, including an Alberti count, the sister of the cardinal of Prato, the duchess of Calabria and the wife of a marquis.[39] The relic certainly also attracted the

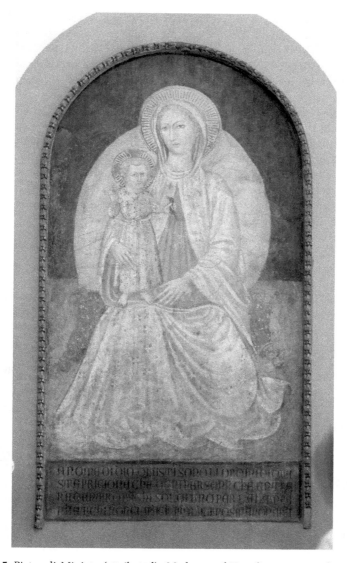

Figure 6.5 Pietro di Miniato (attributed), *Madonna of Humility*, ca. 1425, fresco, Prato, Basilica of Santa Maria delle Carceri. Courtesy of the Parrocchia di Santa Maria delle Carceri, Diocesi di Prato.

lower classes. Presumably, the miracles found in Guizzelmi's book, many of which he copied from earlier texts, were carefully selected and the inclusion of illustrious figures legitimized the miracles and also lent the cult an aura of prestige.[40]

The highlighting of more elite members of society speaks to the hierarchical structure of the cult itself, control of which was divided between the Commune of Prato and the provost of Santo Stefano, with the Commune having the larger degree of power

over the cult's income and management.[41] Given Prato's subjugation to the Florentine state, however, the City of Florence and the Medici increasingly required the local government to grant prominent Florentine citizens and visiting dignitaries access to private presentations of the relic, which was located inside the altar of a gated chapel in Santo Stefano.[42] Although surviving documentation makes it difficult to ascertain who could enter the chapel on a daily basis, physical access was likely strictly monitored, and even visual access to the relic required permission from civic authorities.[43] The general public, therefore, had to await the annual presentation ceremonies to catch a glimpse of the girdle. Communal officials initiated the ostension rituals and flanked the provost (or his vicar) as he displayed the belt from three locations in the *pieve*, the last of which was the pulpit on the church's facade (Figure 6.6).[44] At the climax of the ritual, the people in the piazza received the Virgin's divine grace, the source of which, however, remained physically elevated outside their reach and clutched in the hands of the provost, Carlo de' Medici.[45]

In the first years of the *Carceri* cult, the works committee promoted a miraculous site that offered the people less mediated access to a sacred object.[46] The church's first inventory (1488–94) records the presence of veils to conceal the image, and it is plausible that, like most miraculous images, the fresco was covered in the days following the founding miracle;[47] even so, Codex 86 documents fifty transfigurations that the uncovered image enacted before many witnesses between the years 1484 and

Figure 6.6 The bishop of Prato displaying the Sacred Belt of the Virgin from the pulpit on the facade of the Cathedral of Santo Stefano during a modern-day ostentation ceremony. Courtesy of Alexandra Korey / arttrav.com.

1487.[48] On 23 October 1484, for instance, the Virgin 'turned her eyes and changed colour' in a sanctuary packed by the *popolo*, who were attending the offices being said by the Company of San Girolamo.[49] Although clerics were present, laypeople led this particular ritual before the exposed image, just as they did every Saturday night, when local confraternities said the offices before the fresco.[50] The miracle compilations additionally record at least four instances in which individuals seeking cures gained access to the gated altar situated before the image.[51] Three of these four devotees granted entry into the sacred precinct were ordinary people from small towns or localities in the Tuscan countryside. Although unveiling the image and unlatching the altar gate undoubtedly required the consent of an official at the shrine, the peoples' visual and physical access to the image in the early years was more frequent, more spontaneous and even more intimate in nature, than their devotional experience of the Virgin's belt.

Despite the advent of the new cult, the Chapel of the Sacred Belt remained a significant pilgrimage destination. With the miraculous image, the city's religious focus did not so much shift, as adjust to include the periphery into the central area. As Robert Maniura has observed, a direct correlation was drawn between the two sacred sites, particularly when individual recipients of the Virgin's miracles processed from the prison to the Chapel of the Sacred Belt.[52] Thus, the centre and the edges of the city were connected through the devotional dialogue exchanged among the two Marian cults. The *Madonna delle Carceri* did not oppose the relic cult; rather, the miraculous image succeeded in altering the local religious fabric by reworking the Virgin of Prato's identity, making her more accessible and less elite.

Santa Maria delle Carceri stands not on its own, but represents one of several miracle-working images that identified with, attracted and served the needs of less privileged social groups;[53] as such, the fresco provides us with insight into the ways in which a sacred image can become a locus of empowerment. The image's success largely relied on the peoples' ability to embed the cult in a marginal location associated with desperate members of society. When the founding legend physically lowered the Virgin into that vile place, the elitist overtones of the queenly image were neutralized and her devotees recognized her as a merciful advocate for the helpless and the needy. While the image did not escape appropriation by the Medici family, the fact that it initially offered a more direct access to a sacred Marian object provided the people and the Commune with a small pocket of religious independence.

The art of popular piety

Pilgrim souvenirs from the Museum of London collection

Meriel Jeater

From the twelfth to the sixteenth centuries, pilgrims could buy cheap, mass-produced, base metal souvenirs during their visits to major shrines in England and on the continent. These tiny, portable objects, mostly in the form of either holy water bottles (*ampullae*) that were hung around the neck or badges that were pinned or sewn onto clothing, had the power to protect their wearers and to heal the sick, as well as being proof of a pious journey. Though some can be crude, many were carefully made in intricate moulds with iconography echoing that of illuminated manuscripts, paintings and stained glass. Imagery on the bottles and badges depicted holy relics and activities from shrines, the lives of the saints, and scenes of their martyrdoms.

Until the development of woodcuts in the fifteenth century, pilgrim souvenirs were the only form of truly mass-produced art in the medieval period. Indeed, pilgrim souvenirs were featured in a major exhibition on the origins of printmaking at the National Gallery of Art, Washington in 2005, as an earlier example of 'devotional objects reproduced on a massive scale'.[1] Richard Marks includes them in his study of medieval English devotional images alongside other forms such as wall paintings, statues, woodcuts, books of hours and jewellery.[2] There are certainly more pilgrim souvenirs surviving today than any other type of medieval image.[3] As tiny, portable artworks that people could take home, pilgrim souvenirs are worthy of study by art historians. Evidence suggests that these items were cheap, within the budget of most members of society, and could be considered as a form of art for the poor.

The Museum of London has an extensive collection of pilgrim souvenirs, representing the cults of saints from across England and Europe, often in beautiful detail. This chapter aims to show a range of the souvenir makers' art, look at who bought the items, and discuss their value, both to their original owners and researchers today. It will focus on base metal pilgrim souvenirs, though examples exist of souvenirs in other media, such as gold, silver, parchment, paper and fabric. The precious-metal and non-metal items survive in far fewer numbers, and there is only a very small selection in the Museum of London collection.

The Museum of London has over 1,000 pilgrim souvenirs in its collection. The collection has come from two main sources: chance finds by members of the public (particularly metal-detectorists searching the foreshore of the River Thames at low tide) and professional archaeological excavations. Although finds of pilgrim souvenirs from the Thames have been recorded since the nineteenth century, most have been found by foreshore searchers, known as 'mudlarks', during the last forty years. Around 800 souvenirs have entered the museum collection via this method. Well over 1,000 more have been reported to the museum by their finders but have stayed in private hands. Many are now recorded on the Portable Antiquities Scheme database.[4] Archaeological excavations, particularly on sites next to the Thames, have produced over 300 souvenirs. Most of these sites were dug in the 1970s and 1980s during a period of large-scale building development, but excavations continue today and new pilgrim souvenirs come to light all the time. The riverside archaeological finds currently represent cults from 39 places in Britain and 109 locations in Europe.[5]

The evidence from riverside excavations is especially useful for discussion of pilgrim souvenirs as art for the poor because it gives us some context for these objects. Examples are commonly found among earth deposited during the construction of medieval quaysides. Between the mid-twelfth to mid-fifteenth centuries, land was reclaimed from the River Thames by building a series of wooden revetments to create quaysides or wharves along the banks, which were infilled with large quantities of domestic rubbish, possibly brought from municipal dumps known as 'laystalls'.[6] Rubbish was also thrown directly into the Thames, possibly disposed by local residents living in riverside tenements.[7] These deposits are a rich source of well-preserved medieval objects.

Dendrochronology (tree-ring dating) of the timber revetments, combined with evidence from coins, has been used to date objects in the associated dumps of rubbish.[8] The pilgrim souvenirs are mixed in with all kinds of everyday objects. The fact that these religious items ended up being disposed among other household waste provides further evidence for their low cost, mass-production and widespread consumption by people of modest incomes. It seems that once their religious purpose was fulfilled, souvenirs were considered to be disposable knick-knacks, valued in a similar way as the other items found with them.[9] Nearly 2,000 mass-produced base metal dress accessories[10] were found alongside pilgrim souvenirs on these excavations, suggesting a consumer culture for cheap products in the capital.[11]

Tens of thousands of medieval pilgrim souvenirs have been found in Britain and Europe since the nineteenth century.[12] These represent probably millions of badges that were once in circulation.[13] Most were made from lead–tin alloy and cast in moulds which could be reused many times. X-ray fluorescence analysis has shown that around two-thirds of badges have a metal composition of approximately 60 per cent tin and 40 per cent lead. This mixture reduces the melting point to only 183 degrees Celsius, lower than the melting points of the individual metals, and allows the metal to turn from liquid back to solid very quickly (a few seconds according to modern experiments).[14] Thus, thousands of items could be made in a day.[15]

Moulds for making souvenirs survive. Most were made from stone, such as the cache of thirteenth-century moulds found at Magdeburg.[16] We have a small number

in the museum's collection, including a stone mould for casting pendants of the Virgin Mary[17] and another, made from cuttlefish bone, used for casting crowned 'M' mounts,[18] presumed to be in honour of the Virgin (although crowned 'M' motifs were also used by members of ruling families, such as Margaret of York[19]) (Figure 7.1). Cuttlefish bone is very easy to carve and objects could be pressed into the soft bone to create shapes for casting duplicates. It is uncertain how many times a cuttlefish bone mould could be used before it became damaged (a modern metalworker experimenting with medieval techniques felt such moulds would have a limited life span[20]), though there are ways of preparing the mould to increase its heat resistance.[21]

It should also be noted that the Museum of London example is a multiple mould, designed to make several mounts at once, thus increasing the speed of the casting process and presumably lowering the cost of the finished product. Stone moulds for making multiple badges have also been found, such as the mould for casting badges of the uncanonized saint John Schorn, discovered near his shrine at North Marston[22] and now in the Ashmolean Museum collection.[23] The carvers of the moulds would have been the artists in this process. They created designs that were simple enough to convey immediate messages about the saints that were represented but also detailed enough to show the necessary iconography of the cult.

Records survive from several late medieval shrines indicating how many badges may have been sold. In 1492, at Altötting, 130,000 badges were sold to pilgrims visiting a statue of the Virgin. In 1519, a short-lived cult grew up in Regensburg, around a miracle-working altarpiece to the Virgin and Child. In the second year of trading, 109,198 pewter badges and 9,763 silver badges were sold.[24] In 1481, 25,000 pilgrim

Figure 7.1 English, cuttlefish bone mould for making multiple mounts in the form of crowned 'M's, fifteenth century, London, Museum of London © Museum of London.

signs were made in Orviedo in Spain for the *Perdonanza*, the religious festival where attendees could receive plenary indulgences.[25] The priest of the church of Our Lady in Bollezeele, northern France, claimed, in 1483, that the church had been paid for by proceeds from pilgrim souvenir sales and offerings to the shrine there.[26] These continental shrines were not the most famous; therefore at higher status shrines, such as that of Thomas Becket in Canterbury Cathedral, the most important shrine in England, many more badges could have been sold each year.

The price of pilgrim souvenirs varied according to their materials and presumably also according to the quality of craftsmanship involved in making them. Ascertaining their cost is difficult as there are few surviving records. In 1393, the pilgrim souvenir makers at Mont Saint Michel successfully petitioned King Charles VI not to tax their sales as their income was so low. Their lead and pewter products were sold for farthings and pennies.[27] In 1504, in Paris, a dozen 'leaden' badges could be purchased for one sous (a shilling).[28] In 1466, 130,000 badges were sold at the monastery of St Maria at Einseideln in Switzerland in fourteen days, at a cost of two pfennigs each.[29] The Duchess of Norfolk spent one-and-a-half pence on badges and amulets at the shrine of Our Lady of Walsingham in 1481, showing that even high-status pilgrims bought cheap souvenirs.[30]

Assuming that the price of a badge of average quality was around a penny, how affordable was that for the ordinary person? In 1481, labourers working on the building of a new castle at Kirby Muxloe in Leicestershire were earning 3 to 4 pence per day, so for them, a penny pilgrim souvenir was worth a third to a quarter of their day's wages. Craftsmen on the same site were earning a day-rate of 6 pence and overseers earned 8 pence.[31] In terms of other commodities, in the fifteenth century, basic ceramic vessels cost around a quarter to half a penny,[32] a bed sheet 4 pence[33] or a pair of shoes 4 pence,[34] a day's wages for a labourer at Kirby Muxloe. These price comparisons indicate that while pilgrim souvenirs were not perhaps cheap enough to be considered an everyday purchase, they were not beyond the budget of those on limited wages. Embarking on a pilgrimage was not an everyday activity in any case, so pilgrims may have expected to pay more for their souvenirs than for less meaningful objects.

We know little about the individuals who bought the cheapest souvenirs. There are a few mentions, in the literature from the time, of fictional characters buying souvenirs, and passing references to souvenir ownership are made in miracle stories. In the fifteenth-century anonymous continuation of Chaucer's *Canterbury Tales*, known as *The Tale of Beryn*, the pilgrims go to buy 'signs' after they have visited Thomas Becket's shrine, but the Miller and the Pardoner steal some.[35] In an early fifteenth-century illustration of the *Canterbury Tales* from the Ellesmere MS, the Pardoner wears a 'vernicle', a pilgrim souvenir from the shrine of St Veronica in Rome, on his hat: the image of Christ's face, painted on fabric or parchment.[36] The palmer (professional pilgrim) described in William Langland's fourteenth-century poem, *The Vision of Piers Plowman*, is covered in souvenirs: 'A hundred ampulles were placed upon his hat, tokens of Sinai, and shells of Galicia, and many a cross and keys-of-Rome on his cloak, and the vernicle in front so that men should know and see by his tokens whom he had sought.'[37] A similarly satirical work by Desiderius Erasmus describes a pilgrim who is 'covered with scallop shells, stuck all over with figures of lead and tin'.[38]

There are 712 miracles collected in *The Miracles of St Thomas of Canterbury*, written in the 1170s, and 54 of these contain references to *ampullae*, the lead–tin alloy holy water bottles bought by pilgrims.[39] The people who experienced miracles associated with *ampullae* or 'Canterbury water' (presumably contained in *ampullae*) are from a wide range of backgrounds and include monks, priests, shoemakers, knights and their family members brewers and metalworkers. Often their wealth and status are not clear, but sometimes poverty is explicitly mentioned, for example in the case of a poor pilgrim whose money was stolen, only to find it miraculously restored inside their 'phial' some days later.[40]

Even among the lead–tin alloy pilgrim souvenirs there are clear variations in quality, suggesting that a range of prices was available and that pilgrims of different incomes were catered for. The Museum of London has some very fine examples of *ampullae* from Thomas Becket's shrine at Canterbury. These would originally have contained holy water supposedly tinged with Becket's blood, which was thought to be a cure for all kinds of health issues. Its efficacy is proclaimed around the frame of the ampulla featured here (Figure 7.2),[41] with Latin lettering: 'O[P]TIMVS EGRORVM MEDICVS FIT TOMA BONOR[VM]' (Thomas is the best doctor of the worthy sick). On the front is a high-relief figure of Becket in archbishop's vestments and on the reverse is a depiction of his martyrdom. Though the image is naive in style, it includes a lot of detail and decorative elements, indicating that the creators were trying to make the item as attractive as possible to tempt purchasers.

The most common fourteenth- and fifteenth-century Canterbury badges are those that depict the gold reliquary bust of Becket, one of the shrine's major relics.[42] There are many different styles of bust badge; in some the bust is surrounded by a complex architectural frame, perhaps to suggest the chapel where the reliquary stood, while others depict the bust alone (Figure 7.3 left).[43] These badges appear to be depicting the real reliquary, rather than a generic bishop's head, as most have distinctive almond-shaped

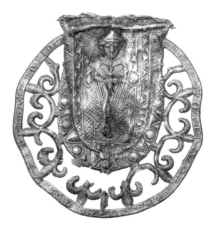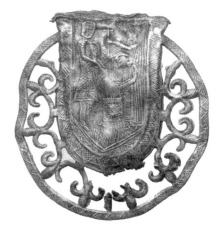

Figure 7.2 English, lead–tin alloy ampulla from the shrine of St Thomas Becket at Canterbury, thirteenth century, London, Museum of London © Museum of London.

eyes and a cleft chin.[44] Other badges were very crude (Figure 7.3 right[45]), lacking almost any detail or lettering, and with Becket reduced to a rather odd, almost inhuman, appearance. They also lack any lettering. Presumably a range of badges was available for different budgets, but also reflecting the differing artistic skills of the makers.

Another clear indication of the variation in quality are the badges depicting Thomas Becket's martyrdom. The complexity of the design and the skill required to carve the mould and cast the badge was much greater on some compared to others (Figure 7.4).[46] The metal composition has been analysed on both the detailed badges and the simpler versions, revealing that the simpler types have a higher lead content.[47] Lead was generally cheaper than tin in the medieval period,[48] so it makes sense that badges displaying lower quality craftsmanship would also be made more cheaply. Many badges have serious imperfections and casting flaws, but were still purchased. One Becket martyrdom badge in the Museum of London collection has a line going across the centre, showing that it was made in a cracked mould.[49] This suggests that here was a trade in imperfect badges or in cheaper 'seconds'. The badge with the mould scar, while not finely decorated, is still detailed enough to include two bears' heads on the shield of one of the knights, indicating that he is Reginald FitzUrse.[50]

All of these badges depict the essential elements of the martyrdom scene, as shown in other more expensive media, such as illuminated manuscripts. A late twelfth-century miniature from the British Library is remarkably similar to the detailed badge on the left in Figure 7.4.[51] An early mid-fifteenth-century badge showing the martyrdom of St Alban represents him sinking to his knees having been beheaded.[52] The martyrdom scene is the same in the thirteenth-century *Life of St Alban* by Matthew Paris.[53] There were also similar images on display in the church of St Alban's Abbey,[54] which presumably influenced the design of the souvenirs sold there.

Some souvenirs were very fine indeed, such as a badge from the shrine of the Virgin at Canterbury, known as Our Lady Undercroft (Figure 7.5 left).[55] The exquisite detail of the badge, the complexity of the mould needed to produce the delicate openwork design and the graceful quality of the drapery on the figures are all exceptional. It is probably the

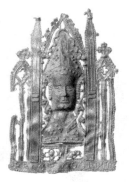 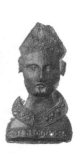

Figure 7.3 English, lead–tin alloy souvenir badges from Canterbury depicting the gold reliquary bust of Thomas Becket, fourteenth to fifteenth centuries, London, Museum of London © Museum of London.

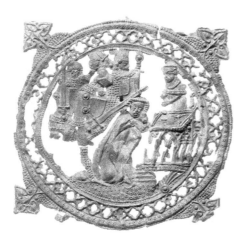
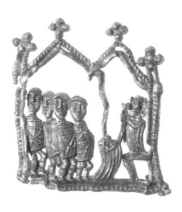

Figure 7.4 English, two badges depicting the martyrdom of Thomas Becket (the right-hand, simpler badge was made with a cheaper metal alloy), mid–late fourteenth century, Private Collection, and London, Museum of London © Museum of London.

work of a master craftsperson.[56] There are also tabs on the side to hold a coloured backing, which would have made the badge even more striking. At the opposite end of the scale are the extremely crude badges of the Virgin and Child on a crescent moon, which are possibly from the shrine at Willesden in west London (Figure 7.5 centre). This shrine was briefly very popular in the late fifteenth and early sixteenth centuries, and it has been suggested that the large number of 'crescent moon' Virgin badges found in London may relate to its cult.[57] These badges have a high lead content[58] and are so schematic that on some examples the identity of the figures is almost completely obscured.

Some base metal souvenirs are imitations of gold objects, such as the badges of King Henry VI made in the style of gold coins. Real coins were sometimes turned into amulets by piercing them with a hole, but the Museum of London has several lead–alloy versions decorated with the figure of the king standing on a ship with legends such as 'HENRICUS DEI GRA REX ANG'.[59] One example is very low quality, and the legend has been replaced with simple cross-hatching.[60] However, the owner was keen to keep wearing the badge even after the pin had snapped off, as they drilled three sewing holes into it.[61]

In the late fifteenth century, badges made from thin stamped brass foil began to appear, imitating the look of gold.[62] Stamped brass foil badges are often more detailed than the lead–tin alloy versions, and, while being fairly simple, they incorporate all the essential elements of religious scenes that are well-known in other art forms. An example is a badge from the museum's collection, possibly bought at the shrine of Our Lady of Walsingham (Figure 7.5 right). The badge depicts the Annunciation, and when compared to scenes from illuminated manuscripts of the period, such as the *New Bedford Hours* of ca. 1465,[63] the badge is very similar, if simplified. Gabriel's kneeling pose and the drapery over his knee shown on the badge is almost identical to the painted version in the *Hours*.

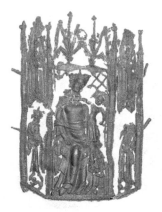

Figure 7.5 English, pilgrim badges depicting the Virgin Mary, from (left to right) Canterbury, Willesden (possibly), and Walsingham, late fourteenth to early sixteenth centuries, London, Museum of London © Museum of London.

Understanding the long-term value of pilgrim souvenirs to the medieval people that owned them is difficult as the ways in which the items were treated varies. Some badges appear to have been kept as devotional aids, such as an ampulla in the museum's collection which was a souvenir from the shrine of the Holy Rood at Bromholm.[64] When found, the ampulla was nailed to a piece of board, suggesting that the owner may have displayed it somewhere at home as an amulet.[65] Two badges, one from Wilsnack and the other from Blomberg, were found attached to a house-shaped piece of wood in Amsterdam in 1973.[66] Both badges were from shrines associated with Eucharist miracles, and it is suggested that the board was intended to be displayed at home as a focus for prayer and for household protection.

Large badges bought as souvenirs, such as the badge of Our Lady Undercroft, Canterbury (Figure 7.5 left), or openwork plaques, could also have been used for acts of private worship.[67] One such plaque is a gilded souvenir of Thomas of Lancaster (Figure 7.6 left), described as 'a remarkable survival of a piece of both religious and political art'.[68] This fine example is of higher quality than other parallels and depicts four scenes leading to the death of Thomas of Lancaster, the rebel baron who was executed in 1322. Miracles soon followed and three shrines were established, including one at St Paul's Cathedral in London.[69]

Accounts exist of elite individuals keeping even simple lead–alloy badges for ongoing acts of devotion.[70] Charlotte of Savoy, wife of King Louis XI, kept many 'lead signs' in a purse of red and white satin, according to an inventory of her belongings drawn up after her death in 1483. Louis XI himself had a hat covered in 'images' which were mostly lead or tin. The owner of a purse of eighteen florins found in Silvacane Abbey, France, is unknown, but it also contained a badge of Our Lady from Saintes-Maries-de-la-Mer, suggesting that the owner carried their badge with them on a daily basis.

Images of Christ, the Virgin, saints and relics were perceived to have great power, which would encourage people to retain them for private devotion. David Areford writes that 'a copy was seen as no less efficacious or meaningful than an original depiction'.[71]

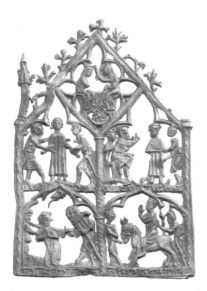
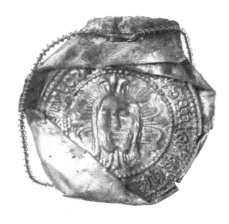

Figure 7.6 English, lead–alloy openwork panel showing Thomas of Lancaster, mid–late fourteenth century; copper-alloy reliquary box featuring a souvenir of the Veronica in Rome, mid-fifteenth century, London, Museum of London. Photo: Andy Chopping © MOLA (left); © Museum of London (right).

This was especially true for images of the Veronica in Rome – the veil of St Veronica miraculously imprinted with Christ's face. According to a late fourteenth-century pilgrims' guidebook, foreign pilgrims could buy indulgences of 12,000 years when the Veronica was on display,[72] but they could also receive large indulgences by praying in front of an image of it.[73] Such images were immensely popular and mass-produced as tiny paintings and as metal souvenirs. One of the latter in the museum's collection was fashioned into one side of a circular box which may originally have held a relic (Figure 7.6 right).[74] It is made from a stamped sheet of copper alloy and has Christ's face in the centre, surrounded by the words '*Salve san[c]te facies nostris rede[m]ptori[s]*' (Hail, the holy face of our redeemer): the first line of a popular prayer composed in ca. 1330.[75]

Some pilgrim badges were sewn into the pages of prayer books, though these, of course, were a method of preservation that only the wealthy could afford.[76] The badges tend to be at the higher end of the market, in silver, gold or gilded. Some books of hours survive with their badges in situ, such as a fine mid-fifteenth-century example in the collection of the National Library of the Netherlands, produced in Bruges.[77] In other books, only the impressions of badges survive.[78] This fifteenth-century practice was popular enough that some manuscript illuminators painted images of pilgrim souvenirs onto pages in a *trompe l'oeil* effect.[79] The badges sewn into prayer books are usually stamped from thin sheet metal, rather than cast, which made them delicate and vulnerable to damage (Figure 7.5 right, for a copper-alloy example). Keeping them in prayer books was the ideal way to protect them and retain them for personal devotion after the pilgrimage was over.[80] For example, the *Grandes Heures* of Duke Philip the

Good include badges of saints next to prayers to those same saints, thus providing suitable images when reading the text.[81]

There are also examples of medieval people who were buried with their souvenirs, retaining them for eternity, such as a man in Norfolk, whose skeleton had an ampulla next to it,[82] or a man buried with two Italian pilgrim souvenirs at the hospital of St Giles in North Yorkshire.[83] Badges were also impressed into moulds when casting church bells, apparently to give the bells extra powers to ward off evil with their noise.[84] A bell dating to the 1480s in the collection of the Statens Historiska Museum in Stockholm has an impression of a pilgrim badge from the shrine of the Three Kings at Cologne,[85] which is very similar to a badge in the Museum of London collection.[86] Both the impression and the London badge depict the Magi travelling to Bethlehem, on horseback, with a star above them.

However long souvenirs were kept or used after pilgrimage, we must not forget the thousands of badges, including the Cologne example mentioned earlier, that ended up in the rubbish. The badges are found among the general detritus of medieval life in the Thames or on excavations. Some of these will be accidental losses, such as badges falling into the river when pilgrims climbed in and out of boats, but we must conclude that base metal pilgrim souvenirs were cheap and disposable. It was important that they represented the essential elements or relics of their associated cult and that they were attractive enough to encourage purchasers, but it is not clear for how long souvenirs retained their spiritual value once a pilgrimage was over or after their owners had passed away. One badge of Henry VI, found in a late fifteenth-century rubbish dump,[87] must have been lost or thrown away fairly soon after its purchase, as his cult only began in the 1470s.

Regardless of their worth in the past, pilgrim souvenirs are valuable for modern researchers. They tell us about popular piety in the medieval period, the different shrines that pilgrims travelled to, and the distances that they travelled. They reveal information about manufacturing processes, materials and trade. Pilgrim souvenirs can also tell us about art and architecture that no longer exists, such as Thomas Becket's shrine in Canterbury, which was demolished in 1538. Pilgrim badges that depict the shrine, including a very fine complete example in the Museum of London collection,[88] give key information about its appearance.[89]

Pilgrim souvenirs demonstrate the growing access that lay society had to religious art and artefacts in the late medieval period, and the sorts of art that was available for the masses: cheap items that circulated in their millions around Britain and Europe in the Middle Ages. Annemarieke Willemsen describes base metal mounts in the form of love symbols or religious images as 'Mass produced and inexpensive late-medieval "bling-bling"', commenting that they, and the more expensive precious-metal versions 'appear in the body language of rich and poor alike, not because the poor were imitating the rich, but because the themes were dominant in the daily life of all social strata'.[90] Pilgrim badges are very similar: designed to be worn and made from a variety of materials from precious metals to cheaper alloys. As such, they represent the religious and aesthetic aspirations of people from all levels of society and are as worthy of study as the most expensive art produced for elites.

Artisans and dress in Denmark, 1550–1650

A preliminary exploration

Anne-Kristine Sindvald Larsen

In 1581, an inventory was made up to divide the property of the smith Pouil after his wife, Kirstinne, had died.[1] Before her death, Kirstinne had arranged for some of her belongings to go to her daughter Seigne, including 'some silver wares, buckles and spoons'.[2] The inventory further specified that Seigne could keep Kirstinne's clothes and the chest they were stored in.[3] This is a valuable example of the transmission of clothing and accessories, because it relates to ordinary artisans, a social group often overlooked by dress historians in favour of the elites.[4] One issue that challenges the study of ordinary people's dress is that the lives and possessions of this group are often poorly documented. Only a few studies, in the European context, have concentrated on the culture and dress of ordinary people. In Scandinavia, no one has conducted a detailed study of the clothing of people at artisanal levels, such as the shoemakers, butchers, bakers, tailors and barbers living in Danish trading towns.[5] This chapter will introduce and discuss the range of sources that are available for the study of dress among artisans and shopkeepers in Denmark in the period 1550–1650, including inventories, town court books, sumptuary laws, travel accounts, personal accounts and tracts, as well as visual culture and extant garments. It will demonstrate that a cross-examination of different types of evidence can provide a clearer understanding of how artisans dressed and the meanings they attributed to clothing in the early modern period.

The discussion will focus on the Kingdom of Denmark, which, in this period, contained around 100 towns with small populations of only a few hundred people (Figure 8.1). The larger towns included Viborg, Ribe, Aarhus (Århus), Odense, Roskilde, Elsinore (Helsingør), Aalborg, Malmoe (Malmø) and the capital Copenhagen (København).[6] Despite the small size of the towns, Denmark was already part of a global commercial network by the end of the seventeenth century. Copenhagen, Malmoe, Elsinore and Elsingburg (Helsingborg) in particular were thriving centres of trade, where both everyday goods and luxuries circulated among a wide range of consumers.[7] The sources presented in this chapter are mainly from the trading town of Elsinore, but examples from other towns will be included.

A key source for the study of dress are probate and post-mortem inventories – lists of personal property and possessions drawn up after a person died.[8] Probate inventories

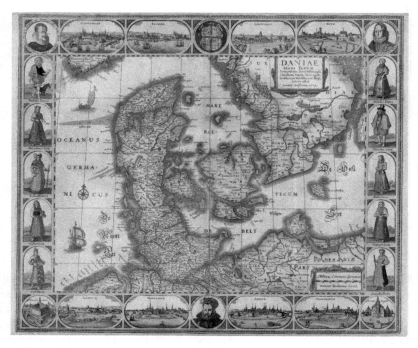

Figure 8.1 Johannes Janssonius and Nicolaus J. Piscator, *Map of Denmark*, 1629–30, engraving, Copenhagen, Royal Library of Denmark, KBK 1111-0-1629/3. Image in the public domain.

survive in Denmark from the sixteenth and early seventeenth centuries, from towns such as Elsinore, Malmoe, Randers, Kalundborg, Odense, Ribe, Vordingborg, Køge and Nakskov.[9] The records used here are from Elsinore, and represent all layers of society, including people from the artisanal level. The purpose of inventories, which were legal documents, was to ensure that the heirs received the share of the estate that was rightfully theirs. When a person died, the home would be sealed, and a number of appraisers would be appointed by the town to value the property and household goods.[10] Although post-mortem inventories are the most common type, inventories were sometimes drawn up for other reasons as well. For example, on 5 March 1596, the bailiff and the town clerk of Elsinore, together with two burghers, gathered in the house where the goods of tailor Jens Skreders were kept. The reason for their inventory of his estate was not because he had died, but because he had 'escaped, having stabbed and killed' tanner Jørren.[11]

Inventories are useful sources because they not only illustrate the kind of clothing that people kept in their home but also provide further information about what fabrics the clothes were made of, the colours they had, what condition they were in and how valuable they were. The documents, moreover, often give insight into the owner of the clothes, informing us about family relations, occupation and where the owner lived.[12] For example, the inventory of the deceased brewer journeyman Pouell Pedersen, dated

27 May 1630, shows that he had lived and worked in Elsinore (Figure 8.2). His clothing and fabrics included 'One dark brown fustian attire with two lines of embroidered trimmings'; 'one pair of black breeches of [woollen] cloth with three rows of trimmings, one fustian jacket and one pair of multi-coloured kersey breeches'.[13] In addition, his wardrobe included two hats (one of them old), one lined cap, an old nightcap, a pair of blue stockings, a pair of white hose, a pair of gloves, a new brush to dust off his clothing and thirty-five silver buttons.[14] He also owned items made of linen, including 'two old shirts and two pairs of linen hose, together with three old pleated ruffs'.[15] Furthermore the brewer possessed 3.5 ells (ca. 2.19 m) of kersey fabric, which was valued at 1 rigsdaler 8 skilling, and could be sewn up into a new garment.[16]

For all their usefulness, inventories also present historians with challenges. In the first place, although inventory descriptions of dress often contain estimations of monetary value and terms that indicate the condition of the item, we cannot be sure when, how or in what state the items were originally acquired and how much they had cost. Secondly,

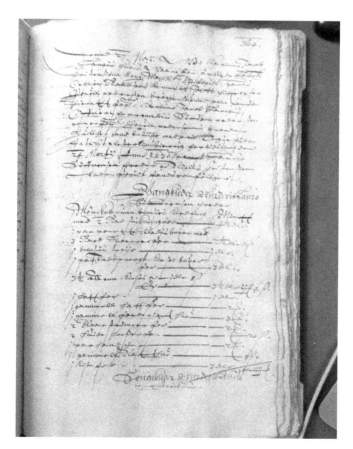

Figure 8.2 The brewer journeyman Pouell Pedersen's inventory, 27 May 1630, Helsingør byfoged, Helsingør Skifteprotokol p 364 r, Copenhagen, The National Archive of Denmark. Photo: author.

we must consider who compiled the inventory and the accuracy of that person's knowledge about the clothing recorded. This is especially important when we interpret the descriptions of clothing and translate terms from one language to another. Thirdly, we do not know what the garments looked like and how they differed from each other. Thus, while documentary sources such as inventories often provide lively descriptions of clothing worn by townspeople in the sixteenth and the seventeenth centuries, it is hard to picture the clothing without visual evidence and remaining objects. Therefore, to obtain a better sense of dress and fashion in the period, we must turn to visual evidence.

Although visual representations of artisanal groups are rare, some relevant paintings, prints and engravings survive. Other useful images include objects related to craft guilds. One such image is a stained-glass window, originally from the shoemakers' guild house in Odense (Figure 8.3).[17] The stained-glass window was presented to the

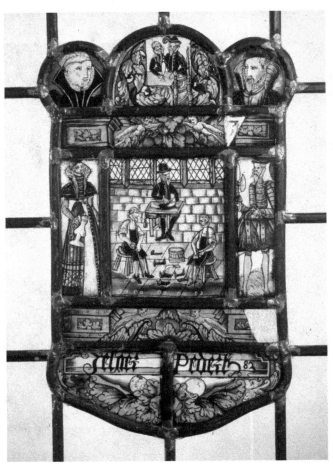

Figure 8.3 Danish, stained-glass window depicting a shoemaker's workshop, 1583, Odense, City Museums.

Shoemakers' Guild Hall in Odense in 1583, by the master shoemaker Jens Pedersen, and depicts a shoemaker's workshop with a journeyman and an apprentice, flanked by portraits of the master shoemaker Jens Pedersen and his wife. By comparing the image with documentary evidence, we can form an idea of the kind of clothing shoemakers wore in Denmark, and how garments were used to express hierarchies. In the workshop scene, the two workers are dressed in modest, white linen shirts, black aprons and pleated neck ruffs, whereas the master is depicted in relatively fine clothes, including a tight-fitting doublet and hose decorated with buttons, and what seems to be yellow lining, or a ribbon, alongside the buttons. He also wears black stockings, black shoes, white cuffs and a yellow ruff that matches the lining or trim on his doublet. On his head he wears a tall black hat.

In working with visual sources we must bear in mind that images were often idealized and they do not necessarily depict the actual clothes worn by the person portrayed – or worn in the context in which they are shown (e.g. a shoemaker may not have worn his finest clothes while at work in his shop). Therefore, a comparison with documentary evidence is needed. For example, according to an inventory from 1592, the shoemaker Steffen from the town of Kalundborg owned, among his clothing, a 'black leather doublet' and 'two [pairs of] breeches made of English [wool]', confirming, at least, that shoemakers did indeed own black clothing.[18] We also have to take into consideration who painted or commissioned the image. A master shoemaker commissioning a representation of himself and his workshop to be donated to the Shoemakers' Guild Hall in Odense, where it would have been seen by everyone passing by, would probably have wished to show himself and his family in a style of clothing that would present them in the most respectable way. A critical analysis of images, examined together with documentary evidence, gives us information on what artisans owned and what garments could have potentially looked like. Yet, while written and visual evidence can communicate, to a certain extent, what artisans owned and what garments looked like, it does not give us a sense of the quality and tactility of the fabrics, or how the garments were cut and constructed. To gain an understanding of these aspects, we must look at remaining objects from the time.

In general, it is almost impossible to link surviving garments in museum collections directly to images or written descriptions. Nonetheless, these actual items of clothing and fabric add a material layer to our understanding that may support the information given by the written and visual sources. Generally, textile evidence from the lower social orders is sparse, and little has survived. But the National Museum of Denmark and the Museum of Copenhagen host important collections of early modern archaeological textiles from Copenhagen (Figure 8.4). Many early textiles were discovered in the course of a metro excavation during 2011 and 2012, when more than 2,000 textile fragments, mainly of silk and wool, were excavated from a seventeenth-century moat that had surrounded Rådhuspladsen, the town hall square.[19] A study of 370 textile finds from Rådhuspladsen, carried out by the archaeologist Charlotte Rimstad, sheds light on the clothing of ordinary residents of Copenhagen in the seventeenth century. Although the clothing was found in the moat, making it impossible to connect the items to a specific neighbourhood or family, Rimstad's study shows that the textiles

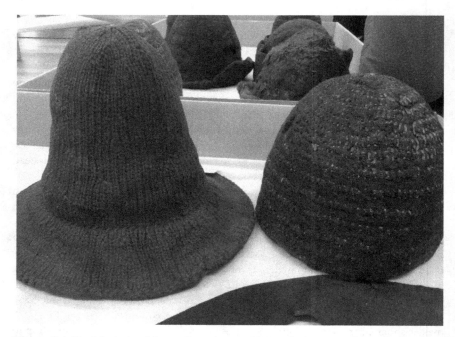

Figure 8.4 Danish, knitted hats, Copenhagen, National Museum of Denmark. Photo: Paula Hohti.

represent the kind of dress items worn and used by the broader population of early modern Copenhagen.[20]

As challenging as it may be, by including these material objects in the study of dress and connecting them with documentary and visual evidence, we come closer to understanding how the clothing of ordinary people was made and used, and what materials were employed to make various dress items, from skirts and jackets to ribbons and hats. Knowing what kinds of clothing ordinary artisans owned and what their garments may have looked like helps us to begin to ask broader questions about the meanings, attitudes towards and functions of clothing at the lower social levels.

Over the course of the sixteenth and seventeenth centuries, the nobility's desire to spend money on luxury goods and dress increased, especially on special occasions such as weddings, confinements and funerals. A similar trend can also be detected among town populations, engendering social competition. Sumptuary laws were designed to define and regulate appropriate levels of consumption according to social status and position in society, allowing the elite to distinguish themselves from commoners. The laws separated the lower orders from the higher ranks of society, and set apart the king and the nobility from the burghers through restrictions and privileges. Additionally, the laws were designed to enforce religious morals and to control the national and the household economy of ordinary people from being ruined by over-consumption.[21]

In December 1606, new legislation on dress and appearance was issued in Elsinore. In relation to wedding dresses, the laws contained instructions on how brides of high

and low status could adorn themselves. The bride or daughter of a mayor, council man or merchant could embellish herself with two gold necklaces and a piece of jewellery around her neck. In her hair, she could wear a string of pearls and a *garnidt*, a hair decoration that could be made out of fake hair.[22] By comparison, women from artisan families who were about to marry an artisan or a commoner were only allowed to wear one gold necklace and a string of pearls in their hair. [23] Of course, such sumptuary laws are not necessarily a reflection of the items the lower orders actually wore and owned. The legislation, however, gives an insight into a number of issues such as how the higher ranks of society perceived the status of artisans and small shopkeepers, what types of dress were considered appropriate for the lower ranks to use and wear, which clothing items and accessories were perceived as luxury and which attitudes existed towards novelties and new fashions. Crucially, the laws do not inform us as to whether or not people kept to the regulations, although the frequency with which new laws were issued or old ones restated can give an indication. The Swedish historian Eva Andersson has investigated the effects of sumptuary laws in Stockholm in this period, suggesting that most of the clothes owned by ordinary people were made of the materials that were permitted for their rank such as different wool and silk fabrics such as damask and satin. However Andersson found systematic breaches in the case of smaller items, such as caps and jackets made out of velvet, possession of which is regularly recorded in inventories from the lower tiers, despite being forbidden to these strata of society.[24]

Another source that highlights the role of clothing in society are town court books, which survive from several towns in Denmark and provide information about issues that were brought before the local court. Importantly, the books give an idea of the many other functions clothing and textiles had, besides being worn.[25] For example, in 1550, in Elsinore, Jørgen Henrichsen, a carpenter who was born in *Lybke*, stole a red piece of silk camlet worth 20 rigsdaler from the council man Henrick Moensen.[26] The theft occurred on the evening before Easter, and the thief later resold the fabric to a man called Anders, from the town of Landskrona. To be precise, Jørgen bartered the fabric in exchange for some wax. The source indicates that the town court sentenced Jørgen to death, but the people present at the town court begged Henrick, the original owner of the silk camlet, to spare his life sending him to prison instead.[27] This example illustrates the significant financial value of fabrics and clothing. Textiles were not just necessities, but they also represented a valuable part of people's private possessions that could be used to store wealth – so much so, in fact, that some would risk their lives to appropriate them illegally.[28]

Traveller accounts give us an idea of which aspects of Danish dress style stood out in the eyes of foreigners. There are several surviving accounts of travellers who visited Danish towns in the sixteenth and seventeenth centuries, in which we find evidence regarding clothing. Even though dress and appearance are not the main themes of the accounts, travellers occasionally commented on the people they met on their journeys, including observations on the fashion of their dress, or its individual components. The interest in foreign fashions is also apparent from costume books and descriptive accounts that were published in the same period, documenting the sartorial customs of urban and rural populations across Europe and in newly discovered parts of the world.[29]

In an account from 1593, the English gentleman Fynes Morrison comments broadly on the style of dress he encountered in Denmark:[30]

> Women as well married as unmarried, Noble and of inferiour condition, weare thinne bands about their neckes, yet not falling, but erected, with the upper bodies of their outward garment of velvet, but with short skirts, and going out of the house, they have the German custome to weare cloakes.[31]

An account by the Frenchman Charles Orgier, who visited in 1634, records his thoughts about the people of Elsinore. Orgier was the secretary to a French diplomat, and visited Denmark on the occasion of the wedding of Prince-Elect Christian to Magdalena Sybilla of Saxony.[32] Among other things, Orgier marvels about people's ability to acquire certain types of fabric that were not produced locally. On 12 August 1634, he wrote:

> Everywhere you see the finest linen, and I wondered how even in stalls of the Barbers I found fine and costly towels which artisans and day labourers use, though there is no abundance of flax and hemp in the country. In no other country have I seen such large and beautiful bed sheets as here.[33]

The visitors inform us on the type of dress that people wore out in public, and on how German style and culture affected the dress of Denmark.[34] More importantly, they indicate that working people could acquire fine imported linens, and that people of 'inferior condition' could wear the same style of clothes as the wealthier groups of society. This is confirmed by inventories from Elsinore. For example, the butcher Troels had 5 shirts, 5 ruffs, 2 handkerchiefs and 3 pillowcases. Moreover, he kept a pair of flax linen sheets, 8 pounds of flax yarn, and also 1 cloth, 1 pair of sheets and 21 pounds of the coarser quality of linen known as *blågarn* among his household linens.[35]

Personal accounts, such as diaries, and public pamphlets and tracts equally give us a picture of clothing habits and the mentality regarding dress. Diaries written by ordinary artisans or shopkeepers are extremely rare, but the diary of a butcher family from Elsinore describes the everyday life in the trading town from 1607 to 1677.[36] In the diary, there is no direct information about the dress of the diarists and their families, but in 1617, the father, Tue Jensen, writes about the birth of a child with an abnormal appearance. He describes a child 'with a peaked skull what looked like a half round circle similar to one of those metal threads they put in front of their forehead and through their ears', probably referring to a type of hairstyle or headdress worn by women.[37]

In 1625, another misshapen baby came into the world in the area of Mørkøv, outside of Copenhagen (Figure 8.5); this was commented upon by the local vicar Hans Nielsøn, who, in the pamphlet *Tragic Spectacles and Warnings* (*Sørglig Spectacel oc Vndertegn*), explained how the baby was born with:

> A high and wide bow of flesh, quite high and pointed . . . [like] the mourning hats raised with metal thread, and the other similar offensive caps that the female gender noble and ignoble, poor and rich wear, without thought or consideration towards the many signs that Gods uses every day to express His wrath.[38]

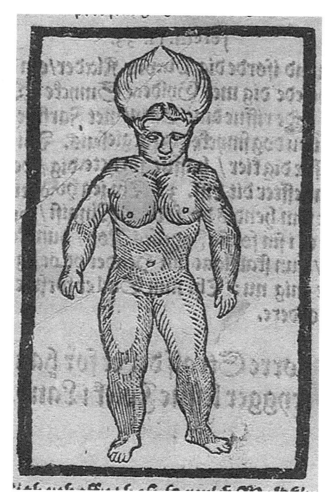

Figure 8.5 Misshapen baby from Mørkøv, from Hans Nielsøn, *Sørglig Spectacel oc Vndertegn*, woodcut, 1625, Copenhagen, Royal Library of Denmark. Image in the public domain.

According to the vicar, the child's deformity was a punishment for the mother having ignored God's word.[39] The commentaries by the butcher Tue Jensen and the vicar from Mørkøv place luxury dress in the centre of discussions about immorality. Even though the sources do not talk about the costumes of individuals directly, they nonetheless present ideas about dress and highlight the social, cultural and religious significance of clothing. They show how dress style was closely linked to religion and contemporary morals, and they highlight a connection between dress, body, religion and beliefs. Although we must consider that some of the accounts may be exaggerated or fictional, the sources may help to explain why people did, or did not, dress in a certain way.

Even though sources concerning the lives and appearance of ordinary artisans in Denmark from the sixteenth and seventeenth centuries are sparse, it is possible to study ordinary people's dress by cross-referencing documentary, visual and material evidence. Each category of sources on its own has different strengths and weaknesses, but used together they can provide an insight into the role of dress at different social levels and in various contexts, and will be a starting point for a more detailed study of dress among the lower levels of society in Denmark and elsewhere in Scandinavia and Europe.

The art of artisan fashions

Moroni's tailor and the changing culture of clothing in sixteenth-century Italy

Paula Hohti Erichsen

The portrait of a tailor, painted by Giovanni Moroni in the late 1560s, is the first known surviving portrait of a skilled craftsman engaged in manual labour (Figure 9.1).[1] The tailor is depicted in a self-confident pose, wearing a fine, pinked ivory doublet which is tied into his crimson red breeches, as well as a sword belt and a golden ring. This portrait is unique in the way it connects the tailor with the visual culture of the elites (Figure 9.2). It is fundamentally different from the usual depictions of artisans, such as the work scene in a print by Jost Amman, which shows a tailor at work in his workshop with apprentices sitting at the table stitching (Figure 9.3). In Moroni's portrait, by contrast, the tailor looks straight out at the spectator and seems to stand up for his dignity through his clothes and his pose.

Although Moroni was celebrated already in the seventeenth century for his striking ability to capture his sitters' looks, some scholars simply cannot believe that this is the picture of a real tailor.[2] Tailors were not poor, but their association with manual work meant that they occupied a relatively modest economic position in society. In Siena, on which most of my research is based, tailors were assessed in the city's tax records just a little above the average wealth of all the city's artisans, at 220 lire, while the level of wealth of their betters – the political governors, merchants, bankers and manufacturers who were the owners of substantial property and consumers of luxury goods – often amounted to several hundreds or even thousands of lire.[3] In addition to this sizeable economic gap, tailors, like other artisans, were socially and politically marginalized. Craftsmen and modestly prosperous traders did not have surnames, which were a precondition for full citizen rights and political office.[4] Would Moroni really paint someone working with his hands in sumptuous and costly clothes, some may ask, and are his crimson hose, belt, gold ring and silk doublet not too fine for a man of his social status?

In material culture scholarship, there is an underlying assumption that men and women at artisanal levels dressed primarily in functional and durable clothing that tied their roles to their work. The reason is not only that textiles and clothing were

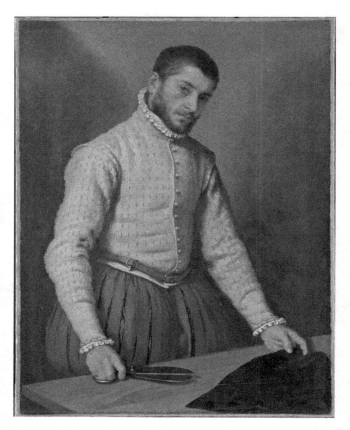

Figure 9.1 Giovanni Battista Moroni, *Tailor*, 1565–70, oil on canvas, London, The National Gallery. Reproduced by permission of The National Gallery.

costlier than any other category of household goods, including the 'high arts', but also that sumptuary laws, issued all over Italy and Europe, imposed strict social restrictions on dress. In the second-half of the sixteenth century, the Sienese commune, for example, issued several sets of new laws, in 1548, 1576, 1588 and 1594, to make sartorial distinctions more clearly visible in society.[5] The most elaborate materials, such as garments made of velvets and brocades, and delicate fashion novelties like thin silk veil, lace-trimmed and perfumed gloves, feathers in hats, gold belts, braid ornaments, perfume, velvet slippers and high platform shoes were reserved exclusively for the high-ranking citizens.[6] Special attention was paid to textiles and colours that were considered the most visible markers of elite status, such as the sumptuous black, crimson and purple (*pavonazzo*), all of which were associated with civic garments and, therefore, with power and authority.[7]

The laws were meant to be strict. In 1548, the local office *Quattro Censori*, the legislative body responsible for the enforcement of sumptuary legislation that year, ruled that all men and women should bring their garments into the office within thirty

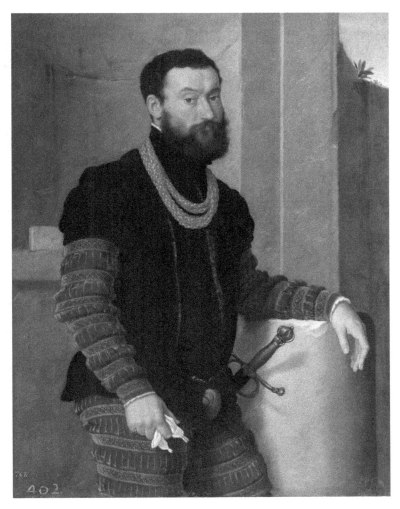

Figure 9.2 Giovanni Battista Moroni, *A Soldier*, ca. 1560, oil on canvas, Madrid, Museo del Prado. Photo: Alamy.

days of the publication of the law, and have them inspected. The notary recorded all items in the register, and once the owner had paid a fee of three *quattrini*, the officials marked the dress by attaching a lead seal to the hem of the garment. This gave the owner a permission to wear the dress for three years.[8] The *Quattro Censori* also established a system of controlling the appearance of citizens on a day-to-day basis, by encouraging all Sienese to record offences against sumptuary law. Anyone above twenty years old could anonymously report violations of sumptuary legislation, by placing a secret denunciation in the wooden box that was attached next to the Sienese Palazzo Pubblico on the central Piazza del Campo (Figure 9.4). If the offender was found guilty, s/he was given a heavy fine of 25 *scudi*.

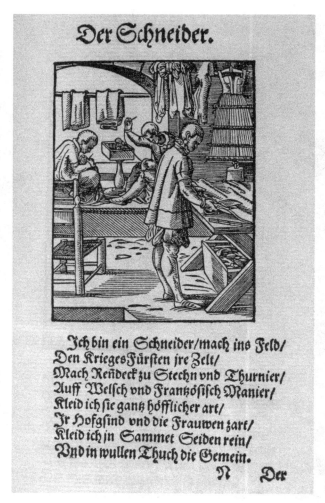

Der Schneider.

Jch bin ein Schneider/mach ins Feld/
Den KriegesFürsten jre Zelt/
Mach Renndeck zu Stechn vnd Thurnier/
Auff Welsch vnd Frantzösisch Manier/
Kleid ich sie gantz höfflicher art/
Jr Hofgsind vnd die Frauwen zart/
Kleid ich jn Sammet Seiden rein/
Vnd in wullen Thuch die Gemein.
 N Der

Figure 9.3 Jost Amman, *Tailor*, 1560, woodcut, nineteenth-century facsimile from Hirth, *Stände und Handwerker mit Versen von Hans Sachs* (Munich, 1884). Image: Wellcome Collection.

The emphasis on difference, exclusion and social control creates an image of striking visual and material differences between the dress of the ruling elites and that of the lower ranking ordinary Italians. This is reinforced by visual evidence, which regularly shows lower-class women in worn-out or patched clothes (Figure 9.5).[9] Yet, a close study of sumptuary regulations demonstrates that, although rules and regulations favoured the elites, the laws in reality allowed a great deal of flexibility and luxury in ordinary people's costumes, including the possibility to wear silk, which has been traditionally regarded as a sign of elite status and distinction. Evidence from Siena, for example, shows that, just like Moroni's tailor (Figure 9.1), the laws of 1548

Figure 9.4 Anonymous sumptuary law denunciation (*Denunzia*), 1548, Siena, Archivio di stato. Photo: author.

Figure 9.5 Domenico Ghirlandaio (workshop), *The Buonomini take inventory after the death of the head of a household* (detail: women in patched garments), late fifteenth century, fresco, Florence, San Martino del Vescovo. Image out of copyright (The Warburg Institute, Photographic Collection).

allowed ordinary men, including barbers, bakers, shoemakers, tailors and all common people below them, to complement their woollen breeches with doublets of silk. Their garments, furthermore, could be finished with silk buttons, silk and velvet trims, and belts that included a silver buckle, and on their heads, men could wear a beret that was made from real velvet.[10] Later in the century, in 1576, the statutes became even more flexible, and allowed especially the lower part of the male outfit to become more elaborate. This made it possible for artisans and other lower ranking citizens to complete their outfits with fancy breeches that were made from or lined with a range of coloured silks, such as damask, grosgrain, and satin, including silk died with precious crimson, and decorate their legwear, doublets and jerkins with slashing and pinking.[11]

Surviving sumptuary law registers from 1561 show that that male artisans had a particular taste for slashed clothing. Sienese men, from barbers to tailors, continuously obtained licences to wear paned or slashed taffeta–lined silk breeches that were decorated with silk trims and ribbons.[12] In 1576, the Sienese tailor Giovanbattista di Girolamo Fideli, for example, took two pairs of breeches that were forbidden by law to the office of the *Biccherna*, the chancellery of finance, in order to have them registered. These included two pairs of woollen breeches, white and black, the latter of which was paned and ornamented with decorative strips.[13]

The emphasis on the decorative character of the lower body connected male artisan fashions to the broader tastes of the period. Tuscan courtly male fashions in the sixteenth and seventeenth centuries showed that, young courtly men, like artisans, shared this taste, especially for colourful and ornamental slashed breeches, which were usually combined with much plainer silk doublets (Figure 9.2).[14] Furthermore, evidence demonstrates that Italian artisans continuously disrespected the sumptuary laws by wearing garments that were prohibited. The *Pratica segreta*, a wonderfully rich document recording prosecutions of dress in Florence at the start of the seventeenth century, shows that the state officials often caught artisans at taverns, market places, in the *piazza*, and at the entrance of the Duomo, for wearing ruffs that were too large, and jewellery that exceeded their allowance, and literally tore items that were prohibited from people's necks and arms.[15]

This excess of dress extended also to artisans' wives. In 1548, for example, the Sienese shoemaker Girolamo di Bartolomeo Salvestri appeared in before a court hearing that took place in the office of the *Quattro Censori*, on charges of breaking sumptuary laws, because his wife had worn an elaborate golden hairnet and a head frontal, both of which were forbidden to women of her social status. On 10 November of the same year, Girolamo was ordered to pay the crippling fine of 25 *scudi*.[16] In 1562, the same shoemaker returned to the office for clothing regulation in order to obtain a licence for some of his wife's prohibited garments. These included three fine purple and pink women's gowns, which were decorated with silk ribbons, and a pair of purple silk-lined sleeves.[17]

While this evidence suggests that class boundaries based on dress were never obvious or clear, these boundaries became further contested during the sixteenth century, as the markets were flooded by cheaper goods that were more adaptable to the increasing pace of change in dress fashions, such as light silk fabrics, gloves, hats, trims and silk buttons. These new trending items became essential parts of the fashionable

look and indicators of the wearer's rank. Mildly ostentatious materials, such as taffeta and tabby silks, embellished with elaborate surface decorations, such as applied braid and slashing, became acceptable even in public.[18] The lower prices of the new products that were on offer in the local shops made fashion much more accessible to the lower social groups. Shop records demonstrate that ready-made items, from woven ribbons and lace veil to light dress silks, were available, at varying prices and qualities, to a wide range of consumers in local fairs and markets. At the same time, cheaper imitations of the desired items, such as foiled gems, fake gold and false pearls, appeared on the market, and turned what had once been rare into familiar aspects of appearance.[19]

This context of intensified fashion change generated a new interest in fashion and appearance across social classes. One manifestation of this development is the first known book of fashion, studied in detail by historians Ulinka Rublack and Maria Hayward.[20] This collection of fashion plates consists of over 130 watercolour illustrations, commissioned between 1520 and 1560 by a German accountant named Matthäus Schwartz, who was the son of a wine merchant; the images record his appearance and dress at different stages of his life, up until he was sixty-three years old. In the colourful pages of this manuscript, we can see Schwartz posing in different styles of outfits, shown front and back. What is remarkable about this source, as Rublack notes, is not just the accountant's fascination with dress and changing fashions but also how he explored his clothing in relation to his body. His appearance is idealized in many images, and in one, he even recorded his waist measure – a mere sixty centimetres. Later on, it appears to have preoccupied him that he put on weight. At the age of twenty-nine, he had himself depicted nude, and wrote an inscription next to it stating, 'That was my real figure from behind, because I had become fat and large.'[21]

If Italian artisans felt similarly about their bodies and their clothing, it suggests a growing degree of intimacy in their relationship with clothing and fashion over the course of the sixteenth century. Artisan inventories from the second-half of the century confirm that bakers, barbers, shoemakers, tailors and others of their rank had a greater access to fashion than ever before. The number and variety of dress items and accessories among local urban artisans and tradesmen increased considerably during this period.[22] This changing social and cultural context of clothing may have inspired some artisan groups, such as tailors, to experiment with fashion, to explore their relationship with other people and the surrounding culture in new ways, and gain prominence through real and painted clothes.

This may have been particularly important for men such as Moroni's tailor (Figure 9.1), because the tailor's profession was an artisan occupation that was being redefined in the sixteenth century. Although tailoring continued to be associated with the mechanical trades, master tailors were eager to separate their profession from the purely artisanal craft status by associating themselves with the intellectual aspects of 'design'.[23] As Elizabeth Currie has shown, some tailors gained new prominence in society, assuming relatively powerful roles within the retail sector in the second-half of the sixteenth century, selling second-hand clothing as well as linings, sewing silks, buttons and braid, instead of merely collecting such items from merchants and mercers on behalf of their customers.[24] Such mercantile activities could translate into relative wealth and prosperity. One tailor in sixteenth-century Siena, Pietro Sarto Fideli (d.

1549), who lived next to the church of Sant'Onofrio in the neighbourhood of San Donato in the district of Kamollia, owned a share in a cloth shop that was located on the Piazza del Campo, the most central and prestigious location for a shop, which he ran in partnership with another tailor, Camillo di Biagio. His success in the trade is indicated by the fact that his taxable wealth was assessed at a level above that of the average artisan, at 300 lire, in 1548.[25]

Moroni's portrait suggests that his sitter was a master tailor at the higher end of the economic and professional scale. The black fabric in front of him that he is about to cut indicates that the clothes he made were for high-ranking clients, such as the gentlemen portrayed in Moroni's later portraits, all dressed in black and standing against broken, grey marble columns.[26] Although the tailor is depicted with scissors – the attribute of his craft – his dignified pose and relatively valuable clothing seem to suggest that he claims a new status and worthiness through this clothing. The artist has recorded the quality of the fabrics and various details of the construction of the garments with great precision, including the pinking of the cream-coloured silk doublet, the fine frills of lace that peek out at the collar and cuffs and the red tone of the breeches, which is so deep and rich that it could have been obtained only by dyeing the fabric with expensive red dyestuffs.

Even if Moroni's portrait were to be a fictional representation of a tailor, evidence suggests that this portrait was not the only one of its kind. The Venetian poet Pietro Aretino, for example, hinted at the fact that portraits gained popularity among artisans and traders in Venice in the sixteenth century. This development did not please him, as until then, only the upper classes had had their images painted, and the mere existence of a portrait had been a sign of high status. 'It is a disgrace of our age,' said Aretino, 'that it tolerates the painted portraits even of tailors and butchers.'[27] Research across artisan inventories in early modern Siena confirms that portraits begin to appear in artisan homes at the beginning of the seventeenth century. For example, the Sienese shoemaker Giovanni di Pavolo had a painted portrait of himself in the bedroom of his home in 1637.[28]

This gradual 'democratization' of portraits in the sixteenth century suggests that, whether Moroni's tailor was a real or a fictive image, artisans became more acutely aware of their appearance and the fashion they displayed themselves in during the second-half of the sixteenth century. Thus, Moroni's portrait stands for a revolutionary trend. The ability to express themselves not only through actual garments but also through painted clothes, provided a dramatic new way for men of artisanal rank to explore themselves and their status in relation to the surrounding world, to try out new roles and to communicate to others how they wanted to be seen, understood and remembered.

Identifying popular musical practice

Instruments and performance in the iconography and archaeology of the medieval and Renaissance period in Europe

Roger Blench

Using iconography as evidence for societal practice faces a common problem across the world, in that pictorial art is typically created by social or religious elites, and thus reflects their taste and practices. As with other categories of representation, musical instruments played by the elite, both secular and religious, are over-represented in the art of the Middle Ages and Renaissance.[1] Only with Michael Praetorius's *Syntagma Musicum*, and in particular part II, *De Organographia* (1618), do we get an overview of instruments at all levels of society (and the first acknowledgement of the music of non-European cultures). Nonetheless, insights into popular instruments can be gained from unexpected or marginal representations. For example, in a more egalitarian society such as Sweden, the church paintings of Albertus Pictor (1440–1507) show a wide range of popular instruments. Archaeology has begun to make an important contribution; a survey of finds of Jews' harps in medieval Europe suggests it may have been the single most popular instrument of the period, despite being rarely depicted in painting. Textual references are very limited, but the remarkable *Yconomica* of Konrad of Megenburg (ca. 1350) specifically links poverty to musical practice. Surviving folk traditions are another source of information; instruments such as the shawm remain widely played in folk contexts, despite having disappeared from the classical repertoire. This chapter aims to establish a popular instrumentarium for medieval Europe through an assessment of the available sources, to sum up what is known about performance practices and to suggest directions for future research.

Since at least the tenth century, religious buildings in Europe have been the locus of highly personal stone carving. Carvings in buildings from before this period seem to be more constrained, with only religious imagery permitted. Why the change occurred is unclear, but the fact is that when local carvers were let loose on both exteriors and interior capitals, these seem to have been a zone of tolerance, both for representing popular practice and images from a suppressed folk iconography deriving from spiritual

concepts older than the official church. The undercroft of Canterbury Cathedral (1070 AD onwards) has capitals with a variety of animals playing musical instruments, which are notably absent in more prominent locations in the same building (Figure 10.1).

Among such images, there are significant variations in the representation of musical practice in different places. For example, the rich repertoire of capitals in the cloister at Monreale in Sicily (ca. 1200 AD) includes both scenes of daily life and images from pre-Christian mythology, but not a single musical instrument. By contrast, the exterior of the Palazzo Ducale in Venice, which is characterized by images from different trades, as well as food processing, has numerous musical instruments, some played by angels, others by comically dressed characters, probably jester-musicians. The ground-floor arcade capitals belong to fourteenth and fifteenth centuries, although some have been replaced with nineteenth-century copies.

The well-preserved wooden bosses of Norwich Cathedral, created across the fourteenth century, include numerous scenes of ordinary life, and several of folk musicians (Figure 10.2).[2] The example reproduced here shows a boss in the east walk of the cloister, representing a shawm and a frame-drum, with costumes clearly intended to indicate these are popular entertainers. Another boss from the same period in the south walk of the cloister illustrates a rebec and a long trumpet. The status of the performers in this case is less clear, since the robes they wear may indicate clerical roles.

Medieval wall paintings are far more rarely preserved than carvings. Religious change and iconoclasm have encouraged destruction, particularly in England, and

Figure 10.1 English, carved capital in the undercroft of Canterbury Cathedral, late eleventh century. Photo: author.

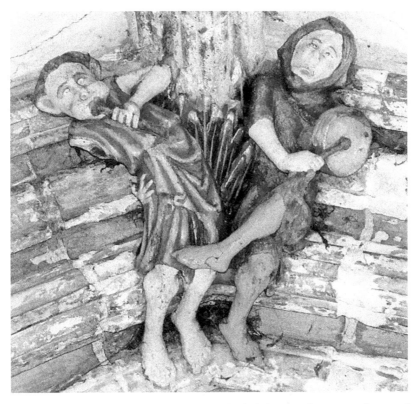

Figure 10.2 English, carved boss in Norwich Cathedral, fourteenth century. Photo: author.

paintings are often the victim of climate, fire and water damage. Perhaps the richest heritage of such paintings is preserved in Scandinavia, especially Sweden. The painted churches of Uppland remain in remarkable condition, all the more surprising given the contrast with their austere exteriors. One painter in particular, Albertus Pictor (ca. 1440–ca. 1507), was responsible (perhaps with apprentices) for nearly all the paintings which show scenes of daily life.[3] Albertus Pictor inspired the film director Ingmar Bergman and makes an appearance in the film, *The Seventh Seal* (1957); the famous scene of the knight playing chess with death is drawn directly from an Albertus Pictor painting in Täby Kyrka. Scenes of village life are mixed with more conventional religious representations in a quite unusual fashion, and can be contrasted with the equally well-preserved paintings in nearby Sigtuna, where no idiosyncratic representations occur anywhere in the church. Albertus Pictor makes it plain through the costumes that the musicians in his paintings are popular entertainers. Angels are shown playing more established church instruments such as the portative organ (although there is also one painting of a pig playing the organ).

Outside of Sweden, relevant paintings include works such as the fifteenth-century *Dance of Death* by Bernard Notke in the Nikolaikirche at Tallinn. This painting shows

the bagpipe, another instrument which clearly belongs to the folk tradition then as now (Figure 10.3). Its raucous sound and drone was highly suitable to accompany dancing but was unlikely to induce spiritual responses in the congregation, and it was thus always illustrated in secular contexts.

Music Archaeology is a rich tradition in Europe, and the oldest finds (flutes) date back to as far as 40,000 BP.[4] Scandinavia represents a particularly rich tradition, with numerous types of instruments preserved extremely well.[5] An increasing density of excavation and better identification of fragmentary instruments has meant that we can begin to make assertions about popular instruments with some confidence.

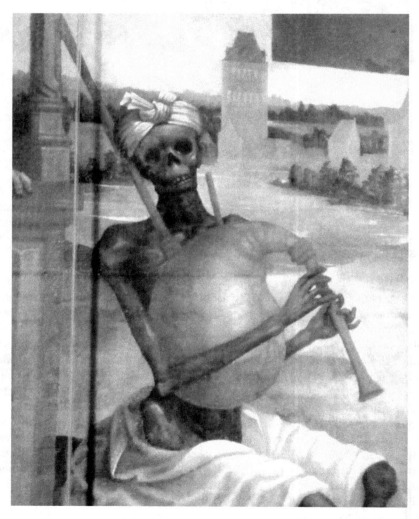

Figure 10.3 Bernard Notke, *Dance of Death* (detail), 1466, Tallinn, Nikolaikirche. Photo: author.

Preservation bias (taphonomy) affects the type of instruments which can be recovered, with bronze and metal more likely to be found than organic materials. Archaeology, however, has the advantage that it is not biased towards the instrumentarium of the elite. Despite being hardly depicted in painting, a survey of finds suggests the Jews' harp may have been the single most popular instrument in medieval Europe (Figure 10.4).[6] Far more surprising is a terracotta ocarina (Figure 10.5). Ocarinas with a duct-

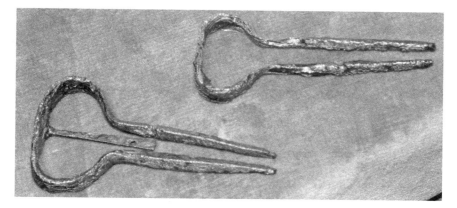

Figure 10.4 Jews' harps, Stockholm, Medeltidsmuseum. Photo: author.

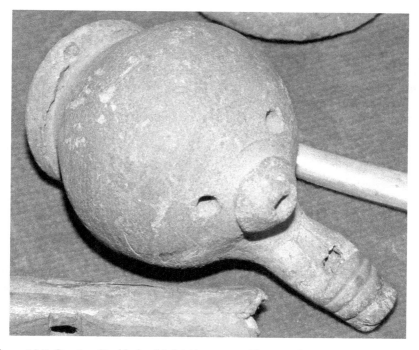

Figure 10.5 Ocarina, Stockholm, Medeltidsmuseum. Photo: author.

flute embouchure are widely found in modern European folk music, but are hardly reported in the archaeological literature and never depicted in iconography. More common everywhere is the bone flute. This type of flute, apparently with a notched embouchure, similar to those in South America, has been found in contexts dated as early as the Aurignacian (43,000–35,000 BP).[7] Until recently, such flutes were played by folk performers, for example on the Greek islands.[8]

Apart from archaeology, there are direct survivals: instruments preserved in elite houses or churches. Surviving medieval instruments are few in number, but those that remain provide valuable information about construction and appearance, although not social context.[9] A so far unique find is the three-holed end-blown horn made from a deer antler found in Thuringia and considered to be dating to the thirteenth century.[10] We cannot be certain of the embouchure, and it is possible that it was a bladder-pipe, but the weight of iconographic evidence points to a detachable cup mouthpiece. One of the most remarkable survivals is the Brian Boru harp, now owned by Trinity College, Dublin. Although the doubtful attribution to Brian Boru, High King of Ireland (941–1014), was dismissed long ago, its exact history is unclear. It is now generally considered to be fifteenth century. The harp is one of those instruments that seems to have crossed social barriers. Played for courtly ensembles, represented as the instrument of angels because of the spurious association with King David,[11] it was also played by travelling harpers, of whom Turlough O'Carolan (1670–1738) was the most famous, moving around Ireland in search of patrons.

Although textual references to non-elite musical performance are extremely sparse until the Renaissance, much earlier written texts with accompanying illustrations can provide valuable insights into performance practice. One of the most remarkable of these is the Catalan *Biblia de Rodes* (1010 onwards) now in the Bibliothèque nationale de France, Paris (lat. 6, III). Folio 64v shows an array of *ioculatores*, or popular entertainers, both juggling and swallowing swords, as well as a plausible ensemble of musical instruments including lyre, harp, portative, cymbals, double clarinet and horn (Figure 10.6). Christopher Page has drawn attention to the remarkable *Yconomica* of Konrad of Megenburg (ca. 1350), which is a guide to household management, not a musicological treatise.[12] Konrad distinguishes professional musicians from *ioculatores*, for whom 'ability exercised for gain is beggarly' ('*facultas lucri cupida mendica est*'), and notes rather scathingly that paupers must 'sweat at their instruments', developing musical skills 'because they are poor' ('*propter indigencias suas*'). The role of music in the quadrivium meant that high status was accorded music theory; consequently, the early texts, such as the *Micrologus* of Guido d'Arezzo (991/992–after 1033) hardly describe performance. In the *Musica getuscht und angezogen* by Sebastian Virdung (born ca. 1465–after 1511), some reference is made to non-elite practice. The *Musica instrumentalis deudsch* (1528 and 1545) of Martin Agricola (1486–1556) also includes references to popular instruments. Yet only in the volumes of Praetorius's *Syntagma Musicum* (specifically volume II, *De Organographia*, 1618) are images presented; the plate illustrated here shows some of these, including pellet and clapper-bells, gemshorns, hunting horns, timbrel, triangle, Jews' harp, glockenspiel, hurdy-gurdy, Hardanger fiddle and some type of viol (Figure. 10.7).

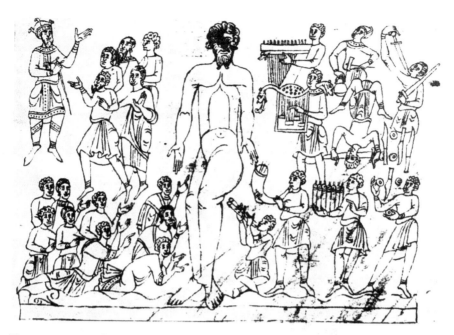

Figure 10.6 Varied musical instruments from the *Biblia de Rodes*, Catalan, after 1010, Bibliothèque nationale de France, Paris, lat. 6, III, fol. 64v. Image out of copyright (The Warburg Institute, Photographic Collection).

All across Europe, extant folk traditions can provide hints and sometimes surprising survivals which provide insight into medieval performance practice. In some regions, folk traditions pass through bottlenecks, losing their instruments and leaving only vocal music. England forms an example of such a bottleneck; the rich instrumentarium recorded in the iconography of the Middle Ages has completely disappeared. Partly, this may be the consequence of anti-musical attitudes of the Puritans during the seventeenth century, which caused church organs to be smashed and secular musical performance to be restricted to vocal music. When attitudes relaxed in the eighteenth century, instruments such as the violin, borrowed from the more classical, urban traditions were adopted in rural areas. The 'church bands', ad hoc ensembles used in churches in lieu of organs and memorialized in the novels of Thomas Hardy, represent the slow rebuilding of an instrumentarium in the English folk tradition.

In Catholic areas of Europe, where no prejudice against music existed, there are medieval instruments that survive in folk practice. Particularly striking is the *launeddas* of Sardinia, a triple-pipe or idioglot clarinet with two drone pipes.[13] It is a clear descendant of the classical *aulos*, and similar instruments also survive in Maghrebin folk culture. Images appear on tombstones in the British Isles in the eighth and ninth centuries, and there is a literary reference from the tenth century.[14] However the triple pipe has disappeared entirely from the European mainland, so the Sardinian instrument represents a striking survival which illuminates a tradition that was once present throughout Europe.

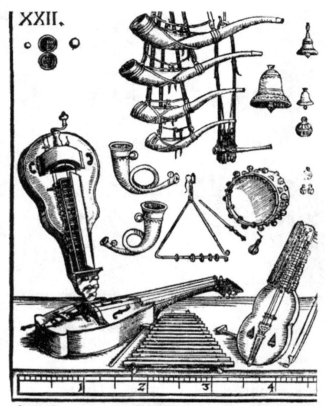

Figure 10.7 Varied musical instruments, from Praetorius's *Syntagma Musicum* (vol. 2, *De Organographia*, 1618). Image out of copyright (The Warburg Institute, Photographic Collection).

Another remarkable survival are the shawm and bagpipe ensembles which perform Christmas carols in Southern Italy, from the Marche southwards, and especially in Naples. The shawm, known as *piffaro* or *ciaramella*, is played together with a very large bagpipe, the *zampogna*, and players go from house to house asking for money. The shawm entered Europe during the twelfth century, brought back by the armies of the Crusaders, and rapidly became popular in many regions, partly because its loud volume made it ideal for accompanying dance. It was soon paired with the bagpipe, a possibly older instrument,[15] as ideal street instruments. These traditions largely disappeared when the shawm was developed into the classical oboe in the seventeenth century, but survives in Italy and parts of Eastern Europe.

A further intriguing instrument is the cog-rattle, familiar to English readers as the 'football rattle', a type of ratcheted wheel spun around on a handle, making a clacking

sound. Curiously, these first appear in the record in a sacred context, as they were played instead of bells during the *Paschal Triduum*, the three days before Easter Day. A remarkable example from the fourteenth century survives in the convent of Escaladieu, carved with religious iconography. A similar instrument is used in the Jewish tradition, the *ragger* or *gragger* (Yiddish: גראַגער). The *gragger* is used every time Haman's name is mentioned during the reading of the Megillah. Very large rattles are carried by masked figures in the Ecce Homo procession in Holy Week in Portugal. This instrument, which may at first sight appear to be entirely marginal, is clearly at the core of European tradition and neatly bridges the divide between secular traditions and folk religious practice.

Individual instruments can obviously be the subject of book-length monographs, so the existing evidence must be summarized. Overviews such as those by Munrow or Montagu provide essential resources.[16] Table 10.1 presents a list of the instruments which can be associated with popular culture, when they first appear, and what type of evidence is available. There are, of course, many more instruments found in medieval iconography, but their popular status is doubtful. Also, many images either appear only once or are hard to interpret.

Reconstructing other aspects of musical practice is significantly more difficult than establishing which musical instruments were played. A picture of bagpipes may not tell us much about their context of performance, unless the piper is accompanying dancing peasants. If animals are shown playing instruments, we can surmise the moral associations of an instrument, but not necessarily its social context. Images often do not show realistic ensembles; angel musicians are particularly unreliable in this respect. Again we can make inferences from manuscripts, and from folk practice. As mentioned earlier, treatises on music in the Middle Ages were largely theoretical and make little reference to performance. The earliest treatise on music in Europe, the *Micrologus* (1025 AD) of Guido d'Arezzo (991/992–after 1033) records the system of solmization developed to teach monks to remember Gregorian chant.

Broadly speaking, court music and religious music can be excluded from the popular category. Major manuscript song collections, such as the Cantigas de Santa Maria of Alfonso el Sabio (reigned 1252–84), which include a wealth of images concerning performance, consist entirely of praise-songs to the Virgin Mary, and must be used with care as they evidently represent elite practice. However, there are intriguing cases where popular practice leaks into the religious sphere. For example, the Carmina Burana manuscript (ca. 1230), found at Benediktbeuern, includes a *Missa Ludorum*, a remarkable popular parody of the Mass text, in which key spiritual terms are replaced by references to gambling. This was part of the once annual 'reversal' performances, where ordinary people mocked the solemnity of the monasteries. Table 10.2 lists the major popular genres of the period and some of the key manuscripts which provide texts.

One of the first writers to acknowledge the existence of dance songs was Johannes de Grocheio (Grocheo) (ca. 1255–ca. 1320), a Parisian musical theorist. His treatise *Ars musice* (ca. 1300) divides music into three categories:[17]

Musica vulgalis (popular music)
Mensurata (music using metrical rules; learned music)
Ecclesiastica (church music)

Table 10.1 Popular Instruments and Their First Appearance

Instrument	First Record	Type of Evidence
Idiophones		
Asses' jawbone	Seventeenth century	First depicted in an English miniature but still found widely in folk traditions across Europe.
Cog-rattle, ratchet	Fourteenth century (surviving example)	Still found widely in folk traditions across Europe, especially in Poland and neighbouring areas. Also used in churches and synagogues.
Castanets	Thirteenth century	Depicted in the 'Cantigas' manuscript. Probably never spread outside of Spain.
Triangle	Fourteenth century	Mersenne (1636) notes they were played by beggars, but medieval images show angelic performers.
Xylophone	1511	First shown in a Holbein engraving of 1523. Probably introduced by sailors from West Africa.
Membranophones		
Frame-drum	Seventeenth century	The Irish *bodhrán* strongly resembles North African frame-drums, such as the Moroccan *bender*. However, its use in Ireland can only be documented relatively late, and its widespread use only dates from the 1960s. In England, it was known as the 'riddle-drum' and developed from circular grain sieves.
Tambourine	Known from antiquity	Origin in the Near East and represented in classical antiquity, associated with popular ecstatic cults. Only surviving in folk culture along the southern edges of Europe. Unclear whether the tradition is continuous from antiquity to medieval period.
Friction-drum	1559(?)	Depicted in *The Battle between Carnival and Lent* by Pieter Bruegel the Elder (ca. 1559). Found widely in folk traditions. May be an introduction from Central Africa.
Chordophones		
Lyre	Tenth century	Known throughout the ancient Near East and in Classical Antiquity. Would have been the actual instrument played by King David, not the harp. The oldest known example in Europe (2300 BP) was excavated on the Isle of Skye in 2010. Existed in both plucked and bowed forms. A folk instrument around much of Europe, it disappeared as an accompaniment to song by the twelfth century. However, it survived into modern times in Wales (*crwd*) and Poland.
Hammer dulcimer	Fourteenth or early fifteenth century	Developed from plucked psalteries and the inspiration for the modern pianoforte. Although much represented in angelic orchestras, not found in secular traditions. Survives widely in folk traditions from Europe to China.[a]
Gittern	Thirteenth century	First represented in an anonymous manuscript from Avranches, Manche, France.[b] Disappears by the sixteenth century (or morphs into the early guitar).

Instrument	First Record	Type of Evidence
Hurdy-gurdy, symphony	Tenth(?)/Twelfth centuries	First described in the treatise *Quomodo organistrum construatur*, attributed to Abbot Odo of Cluny (d. 942). First represented in a stone carving on the Porta da Gloria, Santiago da Compostela. Instruments with a lute-like body survived in Western European folk traditions.
Psaltery	Twelfth to fifteenth century	Gorleston psalter (ca. 1310).
Vielle, fidel	Twelfth century	The seal of Bertan II, Count of Forcalquier, France, dated 1168, shows him playing a vielle. Develops into the viol family in the sixteenth century.
Rebec	Twelfth century	Early textual sources conflate references with the vielle. Survives in folk traditions in Eastern Europe and Greece.
Aerophones		
Transverse flute	Known from antiquity	Perhaps disappears and is then reintroduced from Byzantium in the twelfth century.[c] First depicted in Rudolf von Ems's *Weltchronik* (ca. 1255–70).
Duct-flute, recorder	Fourteenth century	At least eight duct-flutes have been recovered from fourteenth-century archaeological sites.[d] However, whistles operating with ducted embouchures are much older, and some references place them in Ireland in the seventh century. Pipe and tabor instruments are also usually duct-flutes. Disappears from the classical tradition in the eighteenth century until revived as a school instrument in the twentieth century.
Panpipe	Known from antiquity	Depicted on the Vače situla from Slovenia (fifth century BC) and in late Roman representations and then from the eleventh century onwards. Probably survived in folk traditions in the intervening period. Never widespread in Europe; it is occasionally played by angels. Survives in Eastern European folk traditions.
Ocarina	'Medieval'	At least one Neolithic example found at Runik in Kosovo. Modern-looking globular ocarinas of terracotta with duct-flute embouchures found in Sweden, probably derived from terracotta animal whistles found today in Eastern Europe.
Shawm	Twelfth century	Origin disputed. Known in classical antiquity, but medieval traditions in Western Europe date from the period of the Crusades.
Bagpipe	Known from antiquity	Assuming the identification of the *utricularius* played by the emperor Nero is accurate. First represented in medieval Europe in the 'Cantigas' manuscript, where several types are depicted. Mentioned in Chaucer (ca. 1380 AD).
Idioglot clarinet	Known from antiquity	Widely represented in Western Europe from the eight to the tenth centuries, then it appears to die out. The characteristic modern European form is the *launeddas* or Sardinian triple pipe and the Basque *alboka*.

(Continued)

The Art of the Poor

Table 10.1 (Continued)

Instrument	First Record	Type of Evidence
End-blown horn, cornetto	Eleventh century	Undercroft of Canterbury Cathedral. Survives in folk traditions, but disappears in Western Europe in the sixteenth century, except for the serpent (a bass cornetto).
Lamellophone		
Jews' harp	Early Eurasia	Extensive archaeological finds, but first represented in the fifteenth century. Never adopted into the European classical tradition, but continuously popular.

[a] Paul M. Gifford, *The Hammered Dulcimer: A History* (Lanham: The Scarecrow Press, 2001).
[b] L. Wright, 'The Medieval Gittern and Citole: A Case of Mistaken Identity', *The Galpin Society Journal* 30 (1977): 8–42.
[c] H. Hickmann, 'The Antique Cross-Flute', *Acta Musicologica* 24, no. 3/4 (1952): 108–12.
[d] Nicholas S. Lander, *Recorder Home Page: A Memento: The Medieval Recorder*, http://www.recorderhomepa ge.net/instruments/a-memento-the-medieval-recorder/ (accessed 18 May 2019).
[e] Canterbury Tales, General Prologue, lines 567–8: '*A baggepype wel coude he blowe and sowne/And ther-with-al he broghte us out of towne*'.

Table 10.2 Popular Genres and Key Manuscripts

Genre	Key Manuscripts
Dance songs	Llibre Vermell de Montsarrat
Lyric songs	Carmina Burana, Carmina Cantabrigensia
Secular amusement songs	Carmina Burana, Carmina Cantabrigensia
Instrumental dances	Paris, Bibliothèque nationale de France, fr. 844c British Library, Additional ms 29987

De Grocheio describes the *rotundellus*, the round dance with sung accompaniment, as popular in Paris.

One of the most precious survivals from the late Middle Ages is the Catalan *Llibre Vermell de Montsarrat* (compiled 1399), a collection of dance songs for pilgrims. The particular interest of this collection is that the compiler includes a description of performance:

> Because the pilgrims wish to sing and dance while they keep their watch at night in the church of the Blessed Mary of Montserrat, and also in the light of day; and in the church no songs should be sung unless they are chaste and pious, for that reason these songs that appear here have been written. And these should be used modestly, and take care that no one who keeps watch in prayer and contemplation is disturbed.[18]

The Latin text of the song *Mariam matrem virginem* is illustrated here (Figure 10.8). In addition, several songs are in the vernacular, including the motet *Imperayritz de la ciutat joyosa / Verges ses par misericordiosa* (fol. 25v), where Catalan and Latin texts are sung simultaneously. Remarkably, the tradition that gave birth to these dance songs still

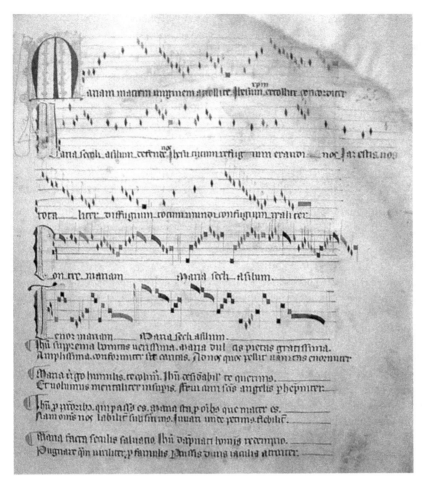

Figure 10.8 The Latin text of the song *Mariam matrem virginem* from the *Llibre Vermell de Montsarrat*, 1399, Barcelona, Monastery of Montserrat. Image in the public domain.

survives in Barcelona. On Sundays, *cobla* ensembles play in front of the cathedral in the Barrio Antiguo, while passers-by are encouraged to join in round dances, *sardanas*. The original *cobla* ensemble consisted of pipe and tabor, shawm and bagpipes, about as medieval a grouping as remains in modern Europe.

One of the most distinctive aspects of vocal music in southern Europe is the use of polyphony, the simultaneous sounding of multiple musical lines. Polyphony in the classical tradition developed from the *organum* pioneered by Pérotin in Paris in the twelfth century. By the time of Guillaume de Machaut (ca. 1300–77), it was fully developed; it has remained a basic compositional tool ever since. Across all of Northern Europe, the characteristic structural type is monophonic music. However, in southern Europe, folk polyphony persists, especially on the islands of the Mediterranean, quite

Table 10.3 Southern European Traditions of Vocal Polyphony

Place	Reference	Comment
Corsica	Macchiarella (2008)[a]	Records of *cunfraternitá* (singing brotherhoods) go back to the twelfth century, although the current style may be of fifteenth-century origin.
Sardinia	Macchiarella (2008)	
Sicily	Macchiarella (2008)	
Balkans	Ahmedaja and Haid (2008)[b]	This tradition spreads from Montenegro to Macedonia and Epirus.
Albania	Ahmedaja and Haid (2008)	Albanian migrants, such as the Arberesh in Southern Italy, have carried the polyphonic tradition with them.

[a] I. Macchiarella, 'Harmonizing on the Islands: Overview of the Multipart Singing by Chording in Sardinia, Corsica, and Sicily', in *European Voices: Multipart Singing on the Balkans and in the Mediterranean*, ed. A. Ahmedaja and Gerlinde Haid (Vienna: Böhlau Verlag, 2008), 103–58.
[b] A. Ahmedaja and Gerlinde Haid (eds), *European Voices: Multipart Singing on the Balkans and in the Mediterranean* (Vienna: Böhlau Verlag, 2008).

different from classical polyphony, which suggests it is both ancient and was once more widespread. Table 10.3 lists extant traditions of folk polyphony. Documentation for the antiquity of these traditions remains weak, although their distribution (and relatives further afield in Georgia and Armenia) suggests it is a type of singing that preceded the dominant monophony.

Iconography suggests that instrumental music, especially to accompany popular dancing, was widespread across Europe in the Middle Ages. However, the nature of the repertoire was such that it was rarely written down, or else the dance tunes survive as popular song-texts rather than as strictly instrumental forms. Yet, we know of many dance types such as the *estampie, saltarello, ductia, rota* and *nota*. Timothy McGee, who has presented the most recent overview of all existing manuscripts, counts some forty-seven dances, across twelve manuscripts, including one unique example in a Czech codex.[19] All of these are monophonic, except for some of the *ductia*, and none include indications for instrumentation. Clearly, these dance tunes represent a very rich popular tradition of which only fragments can now be recovered, strongly biased towards French and Italian examples.

To sum up, although in some ways the iconography of the Middle Ages and Renaissance would appear to be well-explored, the inventory of stone- and wood-carvings on religious buildings across Europe has barely begun. For no country has a comprehensive list been compiled of the existence, dates, state of preservation and interpretation of such carvings. Yet, they remain crucial to the reconstruction of daily life in a period when texts have little or nothing to say. Elite forms of iconography, such as painting, typically do not represent ordinary life, with a few exceptions. In the study of popular music and its performance in the late Middle Ages and the Renaissance, evidence from iconography can be supplemented with that from archaeological finds and still extant folk-music traditions. The systematic assessment of the available evidence, however, has only just begun, and if we want to better understand the contexts of music in the medieval period and its relationship with broader societal trends, much work remains to be done.

An art for everyman

The aspirations of the medieval potter

Jacqui Pearce

Ceramic vessels are a fundamental requirement of households at all levels of society. This is certainly true of a major city such as London, not only today but throughout history. In the medieval period, the range and number of vessels any family, individual or institution owned depended on their resources, as well as on their taste, personal preferences and circumstances. Except for those who were dispossessed and reduced to begging for their existence, the need for utensils in which to prepare and take food and drink was a given. Pottery was the most readily available, and one of the most affordable materials used for basic household needs over much of Britain during the Middle Ages, and especially so in the major towns and cities. This is confirmed by the considerable quantities of ceramic sherds recovered during archaeological excavations in London and other urban centres throughout England. This chapter is focused principally on the pottery made and used within the London region. It is illustrated by items in the collection of the Museum of London, derived in large measure from building sites within the city, collected on site by workmen from the late nineteenth and early twentieth centuries, and by controlled archaeological excavation since the Second World War.

Vessels for storing, preparing or cooking food remained strictly functional throughout the Middle Ages and into the early modern period. They were produced on a large scale and had a limited lifespan. There was no need for embellishment, which would only impair their use as utilitarian household items. So cooking pots, jars, plain bowls and dishes, and adaptations of these forms (e.g. with handles, feet and so on) displayed little obvious variation over time. During the medieval period, these were a fundamental component of the potter's repertoire, which is reflected in their frequency in excavated assemblages. There was little of 'art' in their creation, and however skilled the potter, however well-made his wares, those created for everyday use in food preparation remained as practical and useful as it was possible for their creator to make them.

A rather different picture emerges, however, when it comes to ceramic vessels made for the table. Again, a wide range of individual circumstances had to be catered for, and for many the notion of sitting down at table and serving drink from elaborately

decorated containers remained a distant prospect. Yet, it is in this area that the potter could more freely explore his own creative and artistic aspirations. Those at the upper levels of society would expect to be served from vessels of pewter, brass and silver, and could afford to set their tables with fine glass and only the best ceramics that money could buy. For those lower down the social scale, decorative ceramics made for the table could provide something approaching the quality and style of living that characterized the perceived status of their betters. And it is here that the potter could make a real contribution, by producing decorative, colourful and attractive vessels that were intended for display as much as for practical use.

Appreciation of the medieval potter's art has arrived rather late in the day. In 1884, Sir Arthur Church, a leading authority of the time, wrote: 'the chronology of these obscure vessels is not of much moment, considering how rude is the art they represent.'[1] Writing in 1910, R. L. Hobson, in his catalogue of ceramics in the collection of the British Museum, acknowledged that 'a few exceptional pieces' have survived, but was less than enthusiastic about the bulk of the museum's medieval wares: 'they consist chiefly of pitchers, jugs, and drinking pots of menial appearance; indeed it is unlikely that these uncouth objects could have found a place at the tables of the rich and noble in an age that produced such beautiful examples of metal work.'[2] By 1948, however, W. B. Honey could write, in his Foreword to Bernard Rackham's *Medieval English Pottery*, that the wares under discussion 'may be claimed, quite simply, as the most beautiful pottery ever made in England'.[3] Putting aside purely personal taste, this does seem to represent something of a step forward in aesthetic appreciation, reinforced by Rackham's own enthusiasm for the medieval potter's art, which he saw not only as the direct precursor of 'a great English industry of modern times' but also as 'pleasing to look at almost without exception; though designed for severely practical purposes and making no conscious claims to be regarded as things for aesthetic estimation, they have a dignity and beauty of form which are as a rule painfully lacking in the civilised teapots and covered dishes, gleaming white, smooth and gaudy, in our china shops'.[4]

Could this be seen as a genuine 'art of the poor'? The medieval pottery that can be viewed today in museum collections and in archaeologically excavated finds was created by artisans of no great status within society, and for people across the social spectrum. Rackham points this up further:

> the humble clay products of English potters would have been regarded alike by those who made them and by those for whose use they were made, as of small value from any point of view; fashioned for a useful purpose in a material almost everywhere easily obtainable, with no thought that they would be treasured solely for their beauty of artistic merit, they would be readily cast aside when their serviceability was impaired by breaking, or perhaps when, with changing social habits or fashion, they became outmoded in use or appearance.[5]

This raises an important point in relation to the ways in which those who purchased and used medieval pots viewed them aesthetically. In the London area, something of a ceramic revolution was taking place during the twelfth century, with the introduction of the potter's wheel and glazing. These two innovations together opened the way

for a greater emphasis on ceramic decoration, particularly on table wares, with jugs becoming the chief vehicle for artistic expression over much of lowland Britain.[6] In the local London-area industry, simple geometric patterns created in white slip represent the most decorative expression of the potter's art during the second half of the twelfth century.[7] And it is primarily in the ways that potters decorated their wares that they can be seen to be aspiring to appeal to the aesthetic tastes of their prospective purchasers.

The peak of medieval ceramic decoration took place in the thirteenth century, certainly in the London area. This was realized by that doyen of medieval pottery studies, G. C. Dunning, in his catalogue of ceramic wares in the collection of what is now the Museum of London: 'it is becoming increasingly clear that the finest products of the medieval potter belong almost exclusively to this time'.[8] It was a period of great invention and variety, often involving the use of elaborate ornamentation, with jugs remaining the principal choice for such artistic expressions. In all of the main ceramic industries serving London, a wide range of decorated table wares were produced alongside the more humble everyday forms for use in the kitchen, and it is in these that we see the many and varied influences at work on the potters' creativity.

The range and sources of these influences are of considerable interest. Medieval potters working in England were not of high social standing. They were artisans but not artists, and they were never regulated by the establishment of a guild, 'so the industry was largely without organization or cohesion', resulting in a strong regional character 'that gives it at once the charm of a peasant art'.[9] In London, there were city livery companies for brick makers and tile makers, and for clay pipe makers, but never for potters. Their work unregulated, they were free to follow their own course, and responded to market forces and the demand for more decorative wares by taking inspiration from the work of other potters and from vessels in other materials, drawing freely on the general artistic vocabulary of the world around them, interpreting it as best they could in their own medium and according to their own abilities.

In the thirteenth century, the variety of decorated wares was quite astonishing. In London, there were three main ceramic industries supplying the market with table wares (Figure 11.1): the local London-type ware industry, which was centred on kilns in Woolwich and probably other areas not as yet located;[10] Kingston-type ware, part of the Surrey whiteware tradition, with several known kilns excavated in Kingston upon Thames;[11] and Mill Green ware, made at kilns near Ingatestone in Essex.[12] All three industries produced a wide range of everyday cooking and serving vessels that would be used by people across the social spectrum. They also made a great variety of jugs, many of them decorated, and it is in these that the artistic aspirations of the craftsmen who made them can most clearly be seen.

The medieval potter had a wide range of techniques at his (or her) disposal, and in the London area the thirteenth and early fourteenth centuries saw these used by all the major potteries supplying the capital in a great surge of decorative exuberance that was not matched again until the advent of tin-glazing at the end of the sixteenth century. Viewed through modern eyes, many potteries produced vessels that are artistically satisfying despite an absence of decoration. In the eyes of those who made and used them, such considerations were doubtless important too, although practical concerns would also have played a part in dictating choice. In the same way, some of

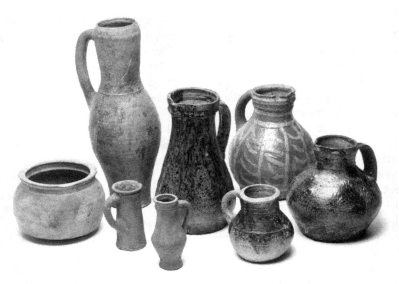

Figure 11.1 Pottery from the three main industries supplying London in the thirteenth century. From left to right: Kingston-type ware jar or cooking pot; London-type ware tulip-necked baluster jug (back) and drinking jugs (front); Mill Green ware conical jug; London-type ware rounded jug with white slip decoration (back); Kingston-type ware small rounded jug (front); and rounded jug with stamped boss decoration. London, Museum of London. Photo: Museum of London.

the more decorative pots would have carried an additional factor that would influence purchase – and that is the extra cost involved in both time and materials when applying decoration, which could become quite complex.

The pinnacle of decorative invention in the medieval potteries supplying London was reached in the middle of the thirteenth century and was largely over by the mid-fourteenth century. A wealth of decorative styles were employed within the London and Kingston industries in particular, with the latter most likely founded by potters trained in the former,[13] at first closely mirroring both techniques and styles, until diverging along different paths across successive generations. The most decorative wares employed the use of polychrome glazes and slips, applied embellishment, incised and combed patterns, stamped motifs and modelled plastic decoration. At their most elaborate, these vessels would have been relatively time-consuming to produce, as exemplified by illustrated examples of highly decorated London-type and Kingston-type ware jugs ornamented with combinations of most of these decorative techniques.[14]

These would originally have been colourful, eye-catching pieces, designed to make an impression at the table. They were, however, less costly than equivalent vessel forms made in metal and used by those in the upper echelons of society. By creating highly ornamental ceramics that represented the peak of their craft, potters were buying into a concept of 'art' that could be made available to a wider market than some of the more refined products of the silversmith and pewterer. Yet the influence of the one craft upon the other can be seen in a range of jugs made in Kingston-type ware that closely

imitate contemporaneous metal forms, as illustrated in illuminated manuscripts depicting high-level feasts and banquets.[15] These vessels carry minimal decoration and rely for their effect chiefly on shapes that carry a specific message. They may not have been intended for the poorest members of society, but they do represent a form of social emulation, an attempt to bring the standards, practices and stylistic preferences of the upper classes within the reach of those who were less well off.

One striking side-line of the thirteenth-century pottery industries supplying London was a range of zoomorphic and anthropomorphic jugs that reflect something of the exuberant playfulness that can be seen in manuscript marginalia. These were made in all three of the main industries centred on London, Kingston upon Thames and Mill Green, and reflect a wider tradition that can be seen in equally, or even more decorative table wares from around the country, exemplified by the elaborately embellished Scarborough and Nottingham knight jugs.[16] It is highly unlikely that the potters who made such vessels ever saw any of the illuminated manuscripts whose images they closely mirror, but their creations nevertheless partake of a wider decorative vocabulary that would have been visible to people at all levels of society, in the form of church carvings, wall paintings and a host of everyday objects made by various different craftsmen. The imagery and lore of the bestiary are apparent in a remarkable complete jug in London-type ware, decorated with applied rampant leopards (Figure 11.2),[17] and another vessel in Kingston-type ware with elaborate polychrome decoration including fanciful creatures in lozenge-shaped panels around the body.[18] These and other vessels of their kind have been executed with care and attention to detail, using a variety of decorative techniques that would have taken longer than usual to produce, certainly longer than the time required for making undecorated vessels. This would undoubtedly have been reflected in the cost to the purchaser, and it is possible that some of the more elaborate examples may have been special commissions from those with some degree of financial flexibility and aspirations to social status. In the eyes of those who created them and those for whom they were made, such pots can perhaps be said to represent a true art of and for the poor (if that term is accepted as referring to the mass of people not at the higher end of the social spectrum). Their aesthetic value has, unsurprisingly, transcended their own era, offering inspiration to twentieth-century studio potters such as Bernard Leach, and many others who have come after him.[19]

Further examples of social emulation involve the translation into ceramic form of whole animals – typically rams or horses – sometimes with a rider, made in imitation of metal aquamaniles used for handwashing at mealtimes and associated with the tables of the wealthy. Several such vessels have come down to us in Kingston-type ware,[20] and in London-type ware,[21] as well as from other industries around the country, such as the one centred on Scarborough.[22] Some are very crude and highlight the fact that these represent an attempt to reproduce, in an affordable medium, a custom associated with the tables of the well-to-do.

Human figures also appear in the thirteenth-century potter's art (and they can be found in later wares, albeit rarely). Rackham regarded these anthropomorphic vessels as 'show pieces made to prove the capability of their author, and not without a touch of conscious Rowlandsonian caricature'.[23] A wide range of skill can be seen in the way these figures are rendered, most frequently by the addition of moulded facial features

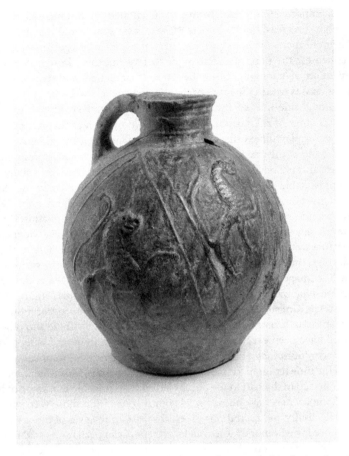

Figure 11.2 London-type ware large rounded jug with zoomorphic decoration, thirteenth century, London, Museum of London (site code PIC87 context [3058]). Photo: Museum of London.

to the rim of a jug (both large and in miniature forms), with arms and hands and sometimes also dress accessories applied, so that the entire jug assumes a human form (Figure 11.3).[24]

One of the more remarkable examples of this is a miniature jug from the early fourteenth century, in Kingston-type ware, with a naturalistic moulded head made as a representation of a king, with flowing hair, beard and crown (Figure 11.4).[25] A handful of examples are known, including one from the production site at Eden Street in Kingston upon Thames.[26] In each of them, the face was formed in the same mould – strikingly different from the usual type, which is usually rather crude, with applied, modelled nose and ears, incised mouth, beard and nostrils and stamped eyes. The mould for the royal head, probably that of Edward II, may well have been made for use with another medium, and was somehow acquired by the potter for reuse with

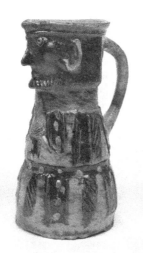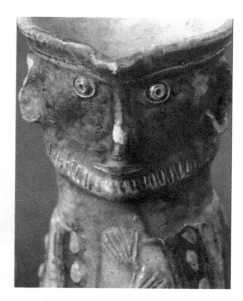

Figure 11.3 Kingston-type ware polychrome anthropomorphic conical jug, thirteenth century, London, Museum of London (Museum of London 5591). Photo: Museum of London.

his own materials. There is a distinct discrepancy between the quality of the moulded head and the clumsiness of the applied arms and incised fingers on the more complete examples. This serves to highlight ways in which the art of the potter can be related to that of other craftsmen. Potters working in the London area at a time when their art was at its most elaborate, and most self-consciously decorative, were creating a product that could not compete with the work of 'higher-end' artisans, but which did take inspiration from them, not only in the types of decoration employed but also in some of the more esoteric vessel forms and the social customs these represented.

Perhaps a less obvious feature of the medieval potter's art was his almost unconscious attention to technical detail on vessels that were otherwise plain or only simply decorated. This can be seen in the ways that jug handles and bases were finished, where technological necessity was freely exploited to decorative advantage. The more substantial handles of larger jug forms in all the main ceramic industries supplying London were thicker than the vessel walls to which they were attached, and this could result in problems relating to unequal shrinkage rates during firing. The solution was to stab or slash the handle in order to release excess water vapour. It was then a simple matter to make this a decorative feature of an otherwise plain vessel.[27] In a similar vein, the application of close-set thumbing around the base angle of vessels such as jugs was both decorative in appearance and at the same time practical, as it helped in reducing the points of contact between vessels as they were stacked in the kiln, so avoiding their becoming fused together by glaze during firing.[28] Such a combination of decorative functionality was in widespread circulation from the twelfth through to the fifteenth centuries, and is particularly well illustrated by the elaborately thumbed, slashed and

Figure 11.4 Moulded head from Kingston-type ware miniature anthropomorphic jug, thirteenth century, London, Museum of London (site code KEW98 context [3763]). Photo: Andy Chopping, copyright MOLA.

stabbed handles applied to the otherwise drab, undecorated and unglazed jugs made in the south Hertfordshire-type greyware industry (Figure 11.5).[29]

The trials and tribulations of the fourteenth century took their toll on the pottery industries of the London region, as across the country, and these are reflected in a distinct sea-change in attitudes towards decoration. The Black Death appears to have made a serious impact on the output of all the major potteries supplying the capital, and the net result was a move towards minimal decoration and a reduction of other time-consuming procedures, with a view to maximizing production and focusing on an altogether simpler and very practical range of vessels. This can be seen in the

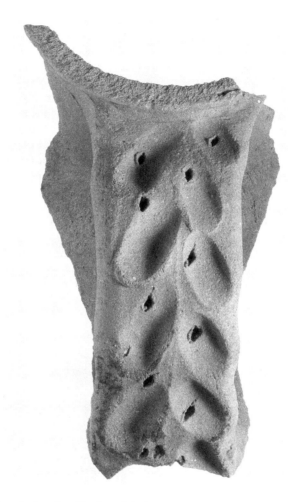

Figure 11.5 Thumbed and stabbed jug handle in south Hertfordshire-type greyware, ca. 1170–1350, London, Museum of London. Photo: Andy Chopping, copyright MOLA.

London-type, Kingston-type and Mill Green industries, all of which produced ranges of plain jugs,[30] in addition to essential kitchen wares, and tended to limit decoration to incised or combed bands or simple geometric designs executed in white slip.[31] These trends continued into the fifteenth century, with coarse Surrey-Hampshire border ware, made at kilns in the vicinity of Farnborough, and Cheam white ware now taking a major share in the London market.

The Farnborough-area kilns focused on a largely utilitarian output with little apparent interest in decorative embellishment, apart from the practical-decorative treatment of jug handles and bases noted above, and the occasional use of simple red slip painting.[32] There was some limited interest in simple slip-painted decoration among the Cheam potters, harking back to the stylistic preferences that typified late

twelfth-century London-type ware, and which were revisited in that industry in the late thirteenth and early fourteenth centuries. The slip-painted decoration that appears on fifteenth-century Cheam pottery, both whiteware and the later redwares made in the same kilns, is based on simple geometric designs that are executed with varying degrees of competence.[33] And this illustrates an important point – at its best, slip-painted late medieval Cheam pottery stands alongside some of the most beautiful ceramics created in this country, as lauded by W. B. Honey, but at its worst, it appears to represent little more than incompetent and incoherent daubing. What we can appreciate today as a satisfying and aesthetically appealing piece of pottery may not have been regarded as particularly special by those for whom it was originally made. What we would characterize as 'good' and 'bad' all share the same style and were very likely made in the same production centre by potters who knew each other but differed in their level of skill and 'artistic' gifts.

Whether or not the relative artistic merits of individual vessels were appreciated by those who purchased them must remain unknown. What we do know is that these various regional potteries supplying the London area in the late medieval period do not represent the most prestigious kinds of ceramic available to Londoners. At this time, high-quality pottery as a prestige item was relatively limited in circulation and came largely from overseas.[34] Imported continental wares had been entering the country since the early medieval period, but their status was variable, with a major

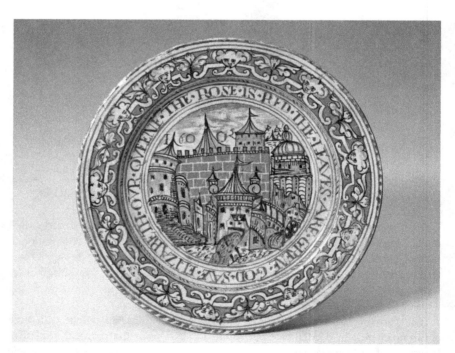

Figure 11.6 'The Rose is Red' delftware dish, dated 1600, and made in the Aldgate pothouse, London, Museum of London (C 84). Photo: Museum of London.

role taken by vessels used as containers of and adjuncts to other imported goods (such as high-quality Saintonge ware jugs accompanying the trade in wine from south-west France).[35] Ceramics that appear to have been considered 'desirable' in their own right consisted mainly of highly decorated forms in tin-glazed and other wares from Spain and Italy.[36]

In England, and more particularly the London area, changes in attitude regarding the status of pottery as an art form did not really begin to come about until the end of the sixteenth century, and are inextricably linked with the introduction of tin-glazing. The first successful tin-glaze or delftware pothouse in England was established in 1571 in Aldgate by potters from Antwerp,[37] opening the way for the production of items consciously designed as 'art', as in the unique 'Rose is Red' dish in the collection of the Museum of London (Figure 11.6). It is this major innovation that was to begin the process of transforming the place of pottery within the national consciousness, a process that was to culminate in the acquisition of major collections of fine porcelains and other ceramics by those wealthy and aristocratic members of society who, 500 years earlier, would have been demonstrating their status through the use of fine metal and glass vessels and not the wares produced by the humble potter, even at the height of his powers. Up to this point, the relatively low-status craft of the potter could be said to represent, at its best, a genuine and almost universally available form of art for everyman and not one that was designed for and limited to the few.

Italian tin-glazed ceramics

Silverware for poor people?

Clarisse Evrard

In a famous letter written in 1490, Lorenzo de' Medici told of the high esteem in which he held maiolica, comparing it to silverware: 'if the rarer an item is the more it should be held dear, I hold these vases very dear and I appreciate them as if they were made of silver, for being most excellent and rare, as I have said, and new to us beyond anything.'[1] Our image of Italian ceramics in the Renaissance is indeed that of luxurious productions, such as the well-known service made for Beatrice of Naples, wife of King Matthias Corvinus in Pesaro in the 1480s, or the *istoriati* for a villa of Isabella d'Este by Nicolà da Urbino. This image, however, is distorted by curatorial choices regarding the display in public collections. It is in fact inaccurate, as the majority of the ceramics kept in storage by museums is far removed from the exquisite plates by Francesco Xanto Avelli, Baldassare Manara or Giacomo Mancini.[2]

Numerous fragments of maiolica excavated in Italy show an iconography reduced to just one or two figures or a few ornaments.[3] Not everyone buying a maiolica plate had the latest substitute of a Perugino or a Raphael painting, or a decoration *a grottesca*, on their table or their wall. It is important to examine the market for and the social context of these modest works of art. The focus of this chapter is the social and cultural identity of the different clients of Italian tin-glazed earthenware. The exceptional ceramics for the elite aside, can the art of maiolica not also be described as the equivalent of silverware for people with lower incomes? And in that case, what does this art tell us about the tastes of the working classes? I will expand on these topics by looking at visual evidence, inventories and serial productions from the Deruta workshops in Umbria.

Of course, by asking the question whether non-luxurious maiolica can be classified as silverware for poor people, we are obliged to define also what we mean by 'poor'. The French historians Philippe Braunstein and Claude Gavard have explained the difficulty of establishing criteria to determine 'poverty' objectively and to define the notion of a class of 'commoners'.[4] Different factors provide different pictures; social, professional, fiscal and legal analyses of society all give us varying insights into which of its members were disadvantaged. From which level downward should we consider a household as

poor? It is often hard to draw the precise line. For these reasons, I will use a broad interpretation of the concept of 'lower classes', including a wide range of more modest households. I will seek to use visual and archival evidence to determine if maiolica was present in such households, the numbers in which it was present, and the significance it held among other household goods.

Images depicting Italian maiolica are inconclusive regarding the social classes that may have owned tin-glazed ceramics.[5] Prestigious religious and mythological paintings, with subjects such as the Marriage at Cana, the Last Supper, the Supper at Emmaus, the Wedding of Pirithous and Hippodamia, or the Banquet of Gods, often themselves the products of an elite environment, tend to present us with *credenze* stacked with objects of precious metal, reflecting the magnificence of the patron and the ceremonial character of the subject. An obvious example is the famous Banquet of the Gods by Giulio Romano on the south wall of the Chamber of Amor and Psyche in the Palazzo Te in Mantua, with its central splendid credenza full of silver and gold plates and jugs.[6] Paintings of less elevated social environments are in fact rare.

A few representations of maiolica can be found in paintings and manuscript decorations from the Renaissance. For instance, the fourteenth-century fresco of the Wedding at Cana in the Cappellone di San Nicola in the Basilica of Saint Nicholas at Tolentino shows servants handling tin-glazed jars with ornaments and zoomorphic motifs. A page from the well-known Book of Hours of Engelbert of Nassau, painted by the Master of Mary of Burgundy during the 1470s,[7] uses maiolic as marginal ornamentation. The fresco of Saint Jerome in his Study by Domenico Ghirlandaio in the church of Ognissanti in Florence, painted in 1480, includes two maiolica *albarelli* placed on a shelf of the saint's *studiolo*. Unfortunately, these images tell us little about the social context of maiolica ownership.

Documentary research, by comparison, has proven to be much more useful. The inventories that have been studied most extensively are of course those of powerful families. Scholars have emphasized the fantastic numbers of ceramics registered in the inventories of *palazzi* at the end of the fifteenth century, at a time when the production of and demand for maiolica began to expand in the context of the general development of markets for luxury goods in Italy.[8] These inventories, while pertaining to the rich, are nonetheless useful for our purpose in that they reveal the relatively low cost of ceramic objects, often listing only their number and type without further specifics, thus indicating that they may also have been accessible to less wealthy people.

The case of the Medici ceramics, studied by Marco Spallanzani,[9] can serve to illustrate this point. The Medici inventories reveal the consistently large numbers of maiolica bought by the Florentine family. For example, Clarice Strozzi, granddaughter of Lorenzo the Magnificent, purchased a maiolica service with 84 pieces at a price of 36 silver lire, equivalent to about 5 gold ducats, in 1517. Grand Duke Cosimo I ordered another service, consisting of 307 pieces, from the workshop of Leonardo Bettisi in Faenza in 1568.[10] An inventory kept in the Archivio di Stato di Firenze allows us to determine the content and the price of this set,[11] casting, incidentally, an interesting light on how maiolica were inventoried.[12] The descriptions give first of all the shape of each object (*piatto, tazza, bacino, scodella*, etc.), and sometimes also its function (*per lavare mane, per acqua, da frutte*, etc.). For a total of 307 ceramics, the Medici grand

duke paid about 250 lire, a modest price given the size of the set. These documents, in other words, demonstrate that maiolica was a fashionable craft, represented in ever larger numbers in the *Guardaroba* of the Medici family, but equally that it was not costly enough for items to be described individually with their iconography and the names of their makers. The relatively low prices suggest, moreover, that this was an industry with the potential to cater for a wider market.[13]

A source that may be able to confirm whether lower-class people did in fact own maiolica are the inventories of the so-called Magistrato dei Pupilli of Florence. This office produced post-mortem inventories and recorded the size of the inheritance of underage children without a guardian and widows whose husband had not left behind a will, regardless of their circumstances or social class. For my research, I have consulted the files of the *Magistrato dei pupilli avanti il Principato* from the period between the end of the fifteenth century and the 1530s, corresponding to the 'Golden Age' of maiolica. I will comment only briefly on the first results of my survey.[14] A first issue to raise concerns terminology: having read three *filze* of documents, I have found occasional qualifications such as *di terra* or *di maiolica*, but in most cases, the type of object is indicated, but the material of which it was made is not. Therefore, the information provided by these registers has to be assessed with care. It is possible, however, to confirm the presence of maiolica in several inventories of *pupilli* from a poor background. For instance, the inventory of an orphan dated to July 1516 lists a 'piatello di maiolica' and an 'orciolo di maiolica' (Figure 12.1).[15] Unfortunately, the precise level of wealth of this charge cannot be determined, but the fact that the inventory contains only a few objects indicates a modest background.

From the fifteen or so relevant documents that I had collected at the time of writing, we can conclude that, when maiolica is mentioned in lower classes inventories, it is invariably in small quantities – often just some plates, a wine-cooler or a drug jar or *albarello*. These small quantities of items described with the precise phrase 'di maiolica' may indicate that maiolica as a medium was not widely diffused among the lower classes. Yet, in those cases where ceramics identified as maiolica are registered, they seem to be taking the place of similar objects made of more valuable materials in richer households. This function of maiolica can be explained from the adaptability of the medium, which could be adjusted to the tastes and financial prowess of different social strata.

One of the appeals of the maiolica craft during the Renaissance was the factor of technical innovation – a kind of alchemical novelty by which dull clay could be transformed into a shiny and coloured object. It was one of the reasons why rich clients ordered beautiful painted services of maiolica, and why powerful families, such as the Della Rovere and the Este, promoted potters' workshops to be set up in their domains. One sign of the success of the medium was the writing of a treatise about the art of maiolica making: Cipriano Piccolpasso's *Tre Libri dell'arte del vasaio*, conceived for Cardinal François de Tournon in ca. 1556–7.[16] In his text, Piccolpasso repeatedly underlines the amazing nature of the glazing technique, which he reveals as if it was a great trade secret. The emphasis on the 'mysterious' aspect of the craft is apparent from the title page onwards: 'the three books of the potter's art: wherein is treated not only of the practice but in brief of all its secrets, a matter that up today has always been

Figure 12.1 ASF, *Magistrato dei Pupilli*, filza 187, 292. Photo: author.

kept concealed.'[17] From the preparation of the clay, via the different ways of painting the surfaces, through to the making of colours and the methods of firing, the author discusses all the stages of maiolica production. His treatise puts the official seal on maiolica as an art, following the example of the *De la Pirotechnia* by Biringuccio of 1540, dedicated to metals and alloys.

Despite the secrecy and the associated exclusivity, archaeologists have shown that there was a side to production very different from that of the luxurious historiated ceramics, involving pieces that are less ornate, less elegant, often with a composition reduced to a unique figure in a basic landscape, or a few decorative or animal patterns. The development of the printing industry and technical improvements in the manufacture of ceramics allowed maiolica painters to renew their visual repertoire and to offer a wide-ranging clientele access to the pictorial and ornamental innovations of the Renaissance. This type of maiolica was often produced in series for people with

lower incomes, who could, in this way, buy for a modest price a plate showing a saint, or a vase with ornamental patterns, with a sheen imitating precious metal. A document dated to the Quattrocento demonstrates this adaptation to a large customer base. The painter Maestro Gentile Fornarini, *maiolicaro* from Faenza,[18] left behind a book of accounts, which documents all his business: the decoration of plates of different sizes, ceramics in different shapes (*tazze* and *scodelle*, for example, but also decorative vases, with or without handles, with or without lids), at different prices rates, increasing according to the care bestowed on the painted patterns.

We can ask ourselves if these ceramics were specifically created for the lower classes and, consequently, if this kind of maiolica classifies as a 'popular art'. Virginia Nixon has outlined the essential features of 'popular art' as follows:

> As popular art is usually defined by art historians as art that can be and is bought by the lower ranks of ordinary people, in one very obvious sense works of popular art must differ from those made for wealthier clients, for they have to be affordable by the popular classes. Thus their production typically involves cheaper materials and shorter production time. However it is not only in production and materials that elite works differ from popular ones.[19]

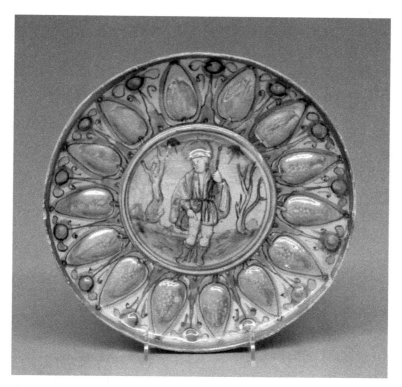

Figure 12.2 Gubbio, Bowl with Saint Roch, ca. 1535–40, lustred tin-glazed ceramic, New York, Metropolitan Museum of Art (accession number: 81.3.1). Image in the public domain.

Thus, a 'popular art' is one that is manufactured for and bought by the lower classes, made of cheaper materials and in a reduced time of production compared to similar arts made for the elite. It also differs from upmarket arts in its external features, showing perhaps a simplified iconography with a less intricate message. Serial maiolica making conforms to both these criteria. Serial production would see more wares produced in a shorter amount of time, and allowed craftsmen to save money on the salary-to-output ratio of their workshop and on materials such as wood for firing. Simultaneously, it used designs based on successful engravings that were simplified in their iconography and meaning, for example, by lifting a single figure out off a narrative subject, reducing what was originally a *historia* to a simple *ornamentum*.

A representative example is the serial production of bowls and dishes created in Gubbio, in the first half of the sixteenth century (Figures 12.2 and 12.3). These lustred bowls have a moulded relief decoration to imitate embossed metalwork, typical of the production created in the workshop of Maestro Giorgio Andreoli between the 1520s and the 1540s.[20] The centre is like a medallion, bearing the single figure of a

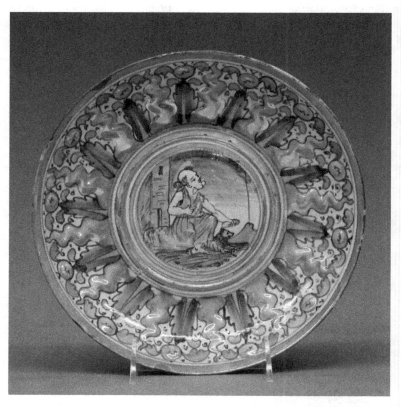

Figure 12.3 Gubbio, Bowl with Saint Jerome, ca. 1530, lustred tin-glazed ceramic, New York, Metropolitan Museum of Art (accession number: 53.225.73). Image in the public domain.

saint, rendered sketchily – Saint Roch, standing in a rudimentary landscape with two little bushes, on the one dish (Figure 12.2), and Saint Jerome with his lion, kneeling in an elementary desert, in the other (Figure 12.3). Such ceramics, present in many collections,[21] showing the Virgin Mary, or saints such as Jerome, Francis of Assis, Roch, John the Baptist, Sebastian or Mary Magdalen, may have been popular objects of private devotion for modest households, perhaps even bought as local pilgrims' souvenirs.

A second example concerns serial productions in the workshops of Deruta.[22] I have found more than fifty Deruta ceramics showing an armed warrior on horseback. These pieces can be distinguished from each other only by the ornamental decoration on the rims, which consists of either scale patterns, foliate designs, stylized plants and flowers or leaves and scrolls. This set reflects the tastes for chivalric literature at all levels of society.[23] Another serial production consists of plates inspired by paintings by Perugino and Pinturicchio, as it were a way for lower-class clients to have at home a miniature copy of a masterpiece, perhaps once again to aid domestic devotion. An example is a dish from the Metropolitan Museum in New York, within the centre an angel inspired by Perugino's fresco of God the Father with Angels in the Collegio del Cambio in Perugia (Figure 12.4).[24] The *maiolicaro* supplemented the praying angel with a book on the left and a little church on the right.

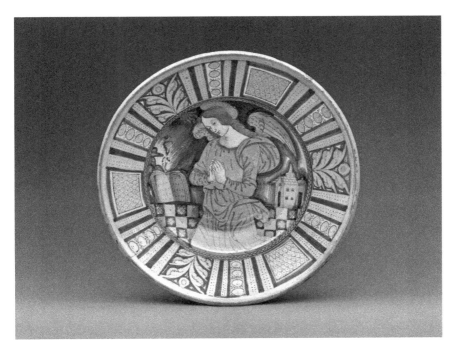

Figure 12.4 Deruta, Dish with an angel, ca. 1510–30, lustred tin-glazed ceramic, New York, Metropolitan Museum of Art (accession number: 65.6.12). Image in the public domain.

Thus, Italian maiolica became a substitute for painting, both functional and decorative, exhibited in large numbers on the *credenze* of princes and *condottieri*, but also as an *unicum* on the wall of a lower-class interior, providing the latter with a little window onto the world of the Italian Renaissance. Perhaps it goes too far to label maiolica as the silverware of poor people, or the painting of the lower classes, but this brief analysis has shown that Italian tin-glazed ceramics found a widespread use as decorative objects, and could be found equally in common households as in luxurious *palazzi*. We can study maiolica as an artistic medium reflecting the tastes of many layers of society in the Cinquecento. The surviving evidence from painting may not tell us much about this aspect, but the study of archival data, from Florence in particular, allows for a more detailed socio-economic and cultural analysis of the context of the medium. The importance of this kind of study for the 'decorative arts' cannot be understated. The ways in which these arts have been collected and exhibited has sometimes led to a biased view. It will be especially important to use the new tools of the Digital Humanities to create a virtual space in which data from archives, visual evidence and actual objects are collated, presenting information on the context of objects, their presentation, function and status as collectors' items, to clarify relationships between the different arts, and perhaps to show objects in reconstructed virtual Italian interiors of the Cinquecento, from poor to rich. Such an internet resource would demonstrate, among other things, how the medium of maiolica came in a range of products, from everyday items to luxurious works of art.

Ordinary objects for priceless lighting

Copper-alloy candlesticks in medieval and early modern England

Anne-Clothilde Dumargne

As Daniel Smail has pointed out recently, past standards of living and social status have too often been defined by opposing the rich to the poor, that is, those who possessed everything to those who owned nothing.[1] Recent research by socio-economic historians, however, together with a growing interest in the study of material culture, has shown that wealth cannot be characterized solely by a quantitative assessment of luxury goods. Objects could be valuable in different ways, which all have to be considered.[2] Research on post-mortem inventories (a crucial and widely acknowledged tool for the study of material culture, often providing remarkably detailed pictures of people's living environments) has tended to focus on the most apparent and obvious signs of wealth: exceptional objects, exotic or foreign items, articles of great value. Beds, linens, clothes, precious-metal tableware and jewellery are well-known material expressions of social privilege, used by elites to assert their social position.

By contrast, the presence or absence of ordinary objects in households, their daily use and the consequences of owning these objects in the context of social history have rarely been investigated.[3] Utilitarian utensils are assumed to have been routinely present in households, but how did their owners choose them from among the broad range of items available? What were the terms used to describe them, and what the criteria used to assess their value? Most importantly, what do the sources tell us about how people perceived these objects? This chapter is derived from an interdisciplinary project studying medieval and early modern copper-alloy candlesticks.[4] Lighting is referred to only occasionally in studies about medieval and early modern daily life;[5] yet, as the project has shown, a modest item such as the candlestick can reveal information about the relationships between material culture, consumption habits and social trends. The main purpose of the project, in fact, has been to use candlesticks to gauge the living standards of their owners and learn about the customs of people from diverse socio-economic backgrounds. The project is based on a sequential analysis of 1137 English urban and rural inventories from York, Southampton, Surrey, Oxfordshire and

Bristol, dating from the fourteenth to the seventeenth centuries, supplemented with iconographic and archaeological evidence.[6]

Post-mortem inventories provide us with hard data regarding the presence of candlesticks in households, informing us about the relevant terminology, about location within the household and about issues of valuation. Yet, they cannot be interpreted as reliable snapshots of everyday life.[7] The list of the deceased's goods was generally not exhaustive, omitting items that were judged to be of little importance or value.[8] The very making of an inventory was a socially selective practice, which came at a cost that not everyone could afford. The study of the lower classes through this type of source is therefore biased. Nonetheless, post-mortem inventories are the written sources in which candlesticks are mentioned most often, and they remain valuable resources for outlining the connections between objects and owners.

The study of candlesticks through inventories faces several difficulties. The first one concerns an issue of terminology. Medieval and early modern inventories systematically use the generic Latin term *candelabrum* for different objects, without distinguishing between forms, while in practice, there was a wide range of utensils used for lighting, including sconces, lanterns, lamps and chandeliers. A similar problem regards the materials of which the candlesticks are made. Only 35 per cent of the inventories examined in the context of the aforementioned project record the material of candlesticks, and only 14 per cent detail their shape. The extent of the project, however, involving 1137 inventories, means that there is a sizeable quantity of usable data regardless of these low percentages.

From a morphological point of view, mobile candlesticks from the period under investigation can be classified into two categories according to the fixing device for the combustible material. There were candlesticks with a spike (pricket candlesticks) and candlesticks with a socket. Written sources do not tell us why two of these different fixing devices existed. There is an assumption in the historiography that the socket replaced the spike over time.[9] The material examined here does not support this assumption, as there is only one single mention of a 'candlestick & two sockets' in an inventory of the goods of Thomas Boselie from 1587,[10] and one single reference to 'three sticking candlesticks' from 1675.[11]

Documentary and iconographic sources confirm, however, that the introduction of the socket was influenced by both social and economic factors. As early as the thirteenth century, there were three main types of combustible material used for artificial lighting:[12] olive or walnut oil for lamps,[13] beeswax for candles and tallow for candles. Research has shown that beeswax, as an expensive core material, was used almost exclusively in churches and by aristocratic elites.[14] Tallow candles, by contrast, were financially more accessible to the lower social classes. The candlesticks with a spike were better suited for fixing rigid beeswax candles than for the softer tallow candles. Thus, craftsmen may have introduced the socket candlestick to cater to a larger demographic; it was a morphological adaptation to a new pattern of consumption.

The distinction between pricket candlesticks used for beeswax candles and socket candlesticks used for tallow candles was not absolute, as it is not uncommon to find examples of the use of tallow for candlesticks with spikes in church accounts or inventories.[15] Medieval and early modern iconography similarly provides evidence of

pricket candlesticks in households,[16] as well as socket candlesticks on church altars.[17] Nonetheless, although light remained an obvious manifestation of social distinction, there can be no doubt that as a commodity, it was made more accessible to the less privileged in the form of tallow candles, and it is likely that in this context, socket candlesticks began to compete with spike candlesticks on the market.

Archaeological finds of socket candlesticks date back to the fourteenth century, while the first iconographic evidence is from the fifteenth century (Figure 13.1). The introduction of the socket candlestick accompanied a development in the ownership of candlesticks, from exclusive use by the church to their widespread introduction in secular households.[18] During the fourteenth century, candlesticks were certainly present in wealthy households in France. Bernard Garnier, a merchant, had six small brass candlesticks (*sex candelabra parva erea*) in 1346.[19] Isabelle Malet, a burgher of Douai, owned eight brass candlesticks in 1359.[20] There are eighteen references to copper-alloy candlesticks in the thirty-six inventories from the city of Dijon drawn up between 1390 and 1399, and they are mainly found among the burghers and merchants.[21] From the fifteenth century, however, the presence of candlesticks is also documented in non-elite households.

Archaeology on its own does not allow us to determine the diffusion of candlesticks, owing to the limited number of actual finds, which often lack historical context. Even with candlesticks found or documented in a specific environment, there is often still

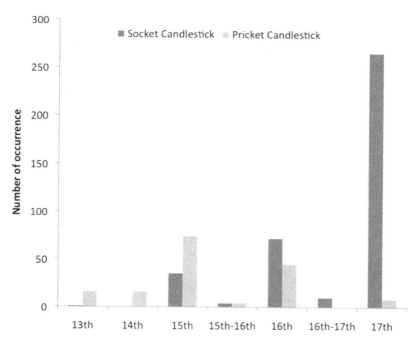

Figure 13.1 Number of iconographic representations of candlesticks per century, pricket versus socket candlesticks (total = 550). Source: A.-C. Dumargne.

an ambiguity regarding their use: a candlestick in a church may have been used for domestic lighting purposes by clerics, while a candlestick in a secular household could have been intended for private devotional practices. For instance, the inventory of the canon Thomas Morton, dated to 1449, includes 'eleven latten candle-sticks of which three are for wax'.[22] The inventory does not specify if the candlesticks intended for wax had a spike or a socket, yet the presence of wax is perhaps suggestive of the rank and role of the canon in society; the evidence does not tell us, however, whether the candlesticks were intended for secular use or for the canon's private rituals.

It is tempting to assume that the social ownership of light was ubiquitous in medieval and early modern houses, as the only method to dispel the darkness of the night.[23] It is therefore surprising that the post-mortem inventories examined here reveal that the presence of candlesticks was not a given in either urban or rural households (Figure 13.2). Inventories alone cannot answer the question whether the absence of candlesticks in some houses was a choice, or depended on the social position of the household. Other types of sources shed an interesting light on this issue. French poems on household goods, so-called dits',[24] tell us about the types of objects that were considered basic equipment for a medieval domestic interior.[25] In the oldest such poems, composed in the thirteenth century, candlesticks are not mentioned, unlike pots, kettles or pans, which are described in detail.[26] Candlesticks are included in the fourteenth-century *le Dit de menage* by Eustache Deschamp,[27] but not systematically in other poems from the same period, or even of a later date.

Iconography, too, provides information about the standard utensils of everyday life. For instance, Hans Paur's depiction of a household, dated to the end of the fifteenth century, seems particularly evocative (Figure 13.3). In the centre of the engraving, a wealthy married couple are seated in a landscape, while the surrounded frame contains all the objects required for the couple to set up their home, including candlesticks at

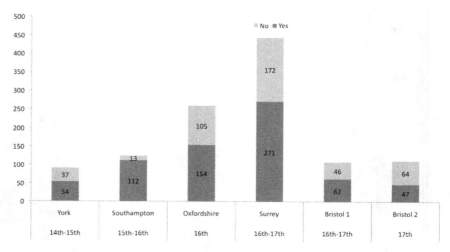

Figure 13.2 Proportion of English inventories in which candlesticks are present (total no. of inventories = 1137). Source: A.-C. Dumargne.

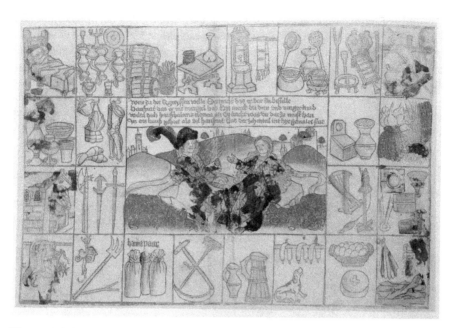

Figure 13.3 Hans Paur, *Household Utensils Required for Married Life*, printed at Nuremberg, ca. 1475, Munich, Staatliche Graphische Sammlung, inv. 118321. Photo out of copyright (The Warburg Institute, Photographic Collection).

the top left. The presence of armour, a horse and several weapons, however, suggests that this particular couple were well off.

These sources indicate that candlesticks were commonplace domestic utensils from at least the fourteenth century onwards. It is not clear, though, if they were regarded as indispensable. One example suggests that not all household goods had the same status in the domestic space. The will of Annys Dayer, written in 1581 after the inventory of her estate was drawn up, mentions a bequest to her granddaughter consisting of 'all the necessities available in the form of a cauldron, pot, brass laver and posnet, a broach, pothooks and a gridiron with hooks', plus other items such as a 'table, trestles, a form and a cupboard; cooking equipment consisted of the 4 best platters, 2 pottingers, a chafing dish, salt cellar, canstyke and saucer'.[28] Here, candlesticks are referred to, but they are clearly not listed among the essential goods.

Moreover, there is no obvious correlation between the number of candlesticks registered in inventories and the number of rooms in the corresponding houses. Conclusions must be drawn with caution, as sometimes rooms that did not contain objects, or rooms that contained only objects that did not belong to the deceased, were deliberately omitted from the inventory. Conversely, items that were made part of a bequest were sometimes not included in the household inventory. Elizabeth Morley and John Weaste, each from Southampton, bequeathed one and four candlesticks to their children, respectively, but these items did not appear in their inventories.[29] Nonetheless, the documentary evidence is strangely inconsistent. For example, the

inventory of John Staveley, a grocer from Southampton, records only one candlestick for fourteen rooms, despite a fortune valued at more than £315.[30] On the other hand, the husbandman Richard Collins, from Oxfordshire, whose fortune exceeded £119, owned eight candlesticks for sixteen rooms in 1587.[31] And the widow Alice Note from Southampton possessed seven candlesticks for only two rooms.[32]

The low number of candlesticks registered in some spacious houses must have been insufficient to light the interior. Of course, candlesticks were movable items, so they may simply have been carried around in the house. Another solution could be the use of devices to increase the brightness of a light source, as documented in iconography (Figure 13.4). A candle could be placed in front of a reflective object, generally a brass plate.[33] The description of a 'skryne [screen] candlestick' in the 1558 inventory of the merchant Raffe Alporte might correspond to this type of lighting device.[34]

In most inventories, we find candlesticks registered in specific rooms: the main hall, the kitchen or a storeroom, particularly the buttery, with regional variations. In York and Oxfordshire, candlesticks were mostly recorded in the hall. In Southampton, on

Figure 13.4 Anonymous, *Annunciation* (detail), fifteenth century, Paris, Musée des Arts Décoratifs, inv. PE 224. Photo: author.

the other hand, the buttery was the preferred location. In Surrey, candlesticks were kept in the kitchen in rural households, but in the hall in urban ones. In Bristol, finally, they were mainly part of the inventory of the kitchen. The hall was the principal room of English houses during the medieval period; it served to eat, to sleep and even to cook.[35] The increasing number of candlesticks recorded in kitchens during the sixteenth century probably corresponds to a progressive specialization of the function of rooms in this period.[36] The presence of candlesticks in storerooms may imply an incidental use of the items inside the house. It is important to note that candlesticks were rarely recorded in several different rooms within one household. This could mean that they were systematically stored in the same places, but also that they may have been moved during the making of the inventory, and grouped together with other similar utensils.

Given the random presence of candlesticks in English households between the fourteenth and the seventeenth centuries, a lack of candlesticks cannot be interpreted as a sign of poverty; they could be absent even from the richest houses.[37] Inventories give indications of the value of candlesticks, but these indications have to be treated with caution. In the first place, the valuations were often low compared to actual sale prices. For example, in the 1402 inventory John of Scardeburgh, four bronze candlesticks were valued together at 10d, but the items were later sold for 1s (twice the valuation) on the second-hand market.[38] Secondly, appraisers rarely recorded the value of items separately. Candlesticks were mostly valued together with other copper-alloy utensils.[39] Only 26 per cent of the inventories examined here present usable data concerning the value of copper-alloy candlesticks. For other materials the percentages are even lower. There are a mere twenty-five instances of tin candlesticks with individual valuations, two of silver candlesticks, one of an iron candlestick and three of wooden candlesticks. While this lack of per item valuations makes it difficult to present a reliable scale of the value of candlesticks according to materials, it is clear that the price of any single candlestick was not prohibitive.

The appraisal of candlesticks was based on the weight of the metal: the heavier the item, the larger its content of metal, and the higher its value. Among the inventories examined here, only seven from the sixteenth and seventeenth centuries list both the weight of candlestick and the corresponding price per pound of metal. These examples, though rare, reveal that there was a standard price of brass, ranging between 6d and 9d per pound. Despite the existence of such standards, the logic behind most appraisals remains unclear. Price differences do not seem to relate to the type of alloy used. Latten, bronze and brass candlesticks often had equivalent values. Some older candlesticks were appraised as highly as new ones; this may be explained by the weight of the objects, but it was probably not the only reason.

The inventories examined here contain different qualifiers that were applied to candlesticks, which distinguish between forms and types, as well as provide indications of how candlesticks were perceived and, consequently, what gave them value. Donald Spaeth has pointed out that the way goods were valued depended a lot on the 'style' of the appraisers and on the way objects were perceived.[40] Mary Beaudry has called such qualifiers a 'principle of categorization', expressing a cultural significance.[41] The appraisals of candlesticks described with qualifiers have therefore been compared to determine the role and importance of the criteria used by the appraisers. From the

entire corpus of inventories, thirty-seven qualifiers were extracted and classified into four thematic categories (Figure 13.5).

Inventories from urban areas (especially Southampton and Bristol), which also had the richest inhabitants, have the largest number of qualifiers, including frequent qualitative and morphological characterizations. Many descriptions reflect the poor

Characterization	Modifiers	York	Southampton	Oxfordshire	Surrey	Bristol	Total
Qualitative	bad		1				1
	broken	2	2				4
	fair					1	1
	gilt	3					3
	good		1				1
	great		5		2		7
	lesser		1				1
	old		8		15	9	32
	ordinary					1	1
	well		1				1
	white		3		2		5
	worn					1	1
Locative	Flanders		2				2
	for the altar	1					1
	nurse (nursing)					4	4
	shop			1	·	9	10
Functional	a bottom of		1	1			2
	hand					2	2
	skryne (screen ?)				1		1
	socket			1			1
	sticking					1	1
	wax	1				1	2
	water					1	1
	writing		1				1
Morphological	bell	2	7		2	7	18
	big					1	1
	flat		1				1
	high					1	1
	large	3			1	1	5
	litlle (*parvo, parvis*)		6	2	2	3	13
	low		1				1
	middle					2	2
	small	2	4	4	3	6	19
	twist					1	1
	wire					2	2
	with flowers	4					4
Total		18	45	9	28	54	154

Figure 13.5 Descriptors of candlesticks in English inventories (total = 154 descriptors). Source: A.-C. Dumargne.

state in which items were found in medieval and early modern interiors: often they were 'broken', 'worn' and, in particular, 'old'. Positive qualifiers occur more rarely, with candlesticks being described as 'fair', 'good' or more frequently 'great'. It is difficult to determine if such qualifiers were chosen by the appraisers themselves, in consultation with the owner, in accordance with established practice, or as a rhetorical flourish.

There is no obvious connection between qualifiers and appraisals. In some cases, there appears to be an internal hierarchy within the inventory based on the qualifiers used, as in the 1558 inventory of Nicholas Myssick:[42]

- iij Flannders candlesticks : 3s.
- ij bell candlesticks : 2s. 4d.
- iij smeller bell candellstykes : 12d.
- ij olde candlesticks : 4d.

Here, aesthetic considerations seem to be the decisive factor in determining the price. Yet, it is much more difficult to explain the price difference between '6 broken bell candle-sticks of latten of a sort' valued at 4s and '6 broken bell candle-sticks of latten', valued at 2s in an inventory from 1494.[43] Sometimes, objects with positive and negative qualifiers were even grouped together: in the 1564 inventory of John Lughting '1 hele candlesticke & 2 brocken' were valued together at 16d, while in the 1558 inventory of John Elyn '12 kanstekes goat & bayd' were appraised at 5s.[44]

To sum up, the inventories examined here reveal that the valuation of candlesticks eludes normative categorization. Each inventory had its own internal logic of valuation, guided by the price standard of the weight of the metal, but ultimately depending on the discretion and expertise of the appraisers. The logic of valuation must also have been determined by the intended fate of objects: the valuation will not have been the same for goods coveted by the family or goods intended to be sold in auction.[45] The use of qualifiers must have been related to the internal valuation systems of the inventories; they were possibly used specifically for objects intended to have a second life, to be redistributed on another market, perhaps even in another form.[46]

Economic historians have used post-mortem inventories to try and establish whether poverty or wealth translated themselves into the presence or absence of certain goods in households.[47] Yet, such attempts are plagued by difficulties, such as the definition of the phrase 'luxury goods', or the construction of an index to determine living standards.[48] A man considered rich by the time of his death had not necessarily been rich for his entire life, and vice versa. In addition, the link between social status, indices of wealth and the content of households is ambiguous. Persons practising the same job could have radically different fortunes. For example, two bakers in Southampton left behind fortunes of £40 and more than £103, respectively; and two merchants from the same city had an even wider gap between them: 5s. 10d versus more than £2061.

The inventory evidence suggests that owners considered copper-alloy utensils partly as a monetary reserve, which may explain the presence of candlesticks in large numbers in some interiors. The most striking examples are provided by some Dutch inventories from Deventer from the fifteenth century.[49] The 1476 inventory of Clawes

Tyminck lists, in copper alloy, 18 candlesticks, 2 lanterns, 19 jars, 13 kettles, 10 basins, 47 ewers and 36 dishes; the 1477 inventory of Herman de Leyle, 15 candlesticks, 10 pots of copper, 7 kettles, 43 ewers of 4 different types and 87 pieces tableware of tin. Copper-alloy candlesticks were regularly bequeathed, not only as household equipment but also as part of a dowry that was returned to the widow.[50] Some testators pledged them to others during their lifetime, such as the clerk John Dye, whose will of 1573 listed the household utensils he bequeathed to his niece, including two good candlesticks, pledged before his death.[51] Each candlestick represented a quantity of metal that could if necessary be recycled. This must have been why in 1586, William Kytchiner bequeathed to his wife, among more than thirty copper-alloy utensils, 'the very worst latten candlestick'.[52] The fact that copper-alloy candlesticks represented a financial investment is reflected in iconography, which demonstrates that they were put on display during meals or in the bedroom, and not only in the richest households.[53]

In short, the examination of a large corpus of English post-mortem inventories from the late Middle Ages and the early modern period reveals that copper-alloy candlesticks had multivalent social and cultural meanings, translated into different conceptions of their value. Two types of candlesticks can be distinguished on the basis of the device for affixing the candle: pricket and socket candlesticks. While the former were an established commodity, craftsmen gradually introduced the latter in response to a growing secular use of less expensive tallow candles. Their increasing numbers in households show that copper-alloy candlesticks changed from elite objects in the fourteenth to essential utensils in the fifteenth century.

Yet, candlesticks were never ubiquitous even in the richest houses. There, their absence must have been a matter of choice and cannot be explained from their relatively low value. Their disproportionate numbers in other households, by contrast, suggest that candlesticks, like other copper-alloy utensils, were also seen as a durable financial investment, the material of which could be recycled to regain their value. This function meant that their position in houses was ultimately not permanent, and they circulated on markets and between households through bequests. On the other hand, as a store of wealth, copper-alloy candlesticks could be modest items of conspicuous consumption.

Burning issues

Political iconography on Dutch firebacks

Lucinda Timmermans

Genre paintings of the Dutch Golden Age give an impression of seventeenth-century interiors in Holland. Several of these paintings – for example by Jan Steen (1626–79) and Pieter de Hooch (1629–84) – show inhabitants eating, drinking and working around a fireplace. On closer inspection, a black relief can be detected against the back wall of some of the fireplaces. These are the so-called Dutch firebacks, of which a large number has survived. What was their actual connection with Holland, and where were they produced? Who decorated their fireplaces with such firebacks, and which messages were conveyed through their iconography? This chapter will discuss these issues using mainly examples from the rich collections of the Rijksmuseum in Amsterdam.

Sand-mould casting was introduced in Europe around 1500, which gave a boost to the iron production in several European regions.[1] Certain early manufactories started to produce cast-iron firebacks, which could be installed against the back wall of fireplaces. These iron screens not only protected the wall against the flames but also reflected the warmth of the fire, which made the room around the fireplace much warmer. Sometimes, the fireback was complemented by a cast-iron floor panel on feet. Few of these floor panels survive today, but they are documented in inventories, and they are also present in the fireplaces of contemporary doll's houses.[2] Most households had only one or two fireplaces, which were used for cooking and to heat the principal room of the house.

The production of the firebacks was related to that of the decorated side panels of cast-iron stoves. Such stoves, now mostly dismantled, were often installed in rooms without a fireplace, as archival research in the Dutch city of Leiden has brought to light.[3] Some painters appear to have had stoves in their studios, in accordance with the advice by the Dutch art theorists Willem Goeree (1635–1711) and Samuel van Hoogstraten (1627–78). In their books, of 1668 and 1678 respectively, they advised painters to make use of a stove while they were drawing or painting after models, especially nude models, because a stove would spread the warmth more evenly throughout the room than a fireplace.[4] An additional advantage was the absence of

smoke and soot. Therefore, it is not surprising that other house owners installed stoves in libraries and studies, to make sure their books and paperwork were kept dry.[5]

Stoves and fireplaces were clearly luxurious items. In 1644, the average amount of fireplaces per household in Leiden was just over two.[6] In wealthier households, however, this number could rise to no fewer than fifteen. It is known that, by the middle of the seventeenth century, the price of a cast-iron stove was between 10 and 14 guilders – an amount for which the average skilled craftsman had to work three to four weeks. It can only be assumed that the firebacks, by comparison, were less expensive; not only were they smaller, but they also survive in large quantities. Unfortunately, we do not have systematic data regarding their prices. They are registered only occasionally in inventories, and rarely valued – mainly because firebacks, being fixed to the wall, were not seen as movable property, but as part of the building.

To produce cast-iron firebacks – and also stove panels – craftsmen made use of carved wooden templates – the master copies of the designs.[7] These templates were modelled identically to the eventual firebacks; they were pushed into a mixture of sand and clay to form the negative sand mould. Melted iron was poured into this temporary negative mould, and after the iron had cooled down and hardened, the fireback was ready for use. Afterwards, the template could be reused; for protection of the wood, it was often coated with a red paint layer.[8] Since many of the firebacks and stove panels were richly decorated, the wooden templates of the sixteenth century were often made by sculptors. One of the earliest references to them is in an account of 1523–4, recording a commission from the carver of Wetzlar to carve the Nassau escutcheon for an iron stove.[9] The German craftsman Philipp Soldan (ca. 1500 to after 1569), who also sculpted stone doorways and gravestones, designed many wooden templates for stove panels, which were still reproduced even by the end of the seventeenth century.[10]

In later times, too, sculptors were asked to produce wooden templates for firebacks. King Louis XIV of France (1638–1715) commissioned designs for the firebacks in his palaces and castles from the same sculptors who made the sculptures for the garden of Versailles.[11] In the Dutch city of Gouda, the sculptor Jan Gijselingh the Younger (1650–1718), who was responsible for the sculptures in and on the town hall, also designed a fireback with the coat of arms of the city for this building. And in 1754, the sculptor Theodor Nadorp carved a template for a fireback with a coat of arms to be used in the iron foundry of Ulft in the Netherlands; it was intended for Johan Baptist von Hohenzollern-Sigmaringen (1728–1781), Count of Van den Bergh.[12] Most carvers of templates have remained anonymous, however, despite the large numbers of their designs, reflected in the various iconographies that can still be seen today.

Many of the later firebacks were cast from one complete template, such as an early eighteenth-century example, which shows a peasant couple sitting in front of a fireplace.[13] The joint in the wood of this template has opened up after intensive use; it has become more visible over time, and has left a trace in a surviving cast-iron fireback made from its imprint. The example also demonstrates that the wooden moulds were revised over the years. The wooden template shows the remains of an inscription referring to the year 1709, which once decorated the top of the fireplace. On the cast made from the mould, only the uneven surface reminds the viewer of this discarded

original date. And after the surviving cast was made, the wooden mould was cut short at the bottom, probably to remove some damage.[14]

But for most of the earlier firebacks – and again also for stove panels – two or more templates were used in combination. This meant that designs could be varied by combining different moulds. Two firebacks bearing the same image of Caritas, the personification of charity, form a good example (Figures 14.1 and 14.2). The decorative frames surrounding the central image on each fireback are completely different. The frame of the first fireback, dated 1653, is much wider than that of the second, and has a different pattern. Clearly, the responsible iron worker used one template for the central panel of Caritas, and another one for the frame. Furthermore, on firebacks that were signed, separate stamps were used for the initials of the signature, presumably the initials of either the caster or the owner of the iron foundry. Often, such initials appear to have been stamped into the sand mould separately from the main templates of the picture and the frame.

The designs of the wooden templates are thought to have been copied from or inspired by prints, especially in the case of biblical subjects.[15] In many instances,

Figure 14.1 German (?), fireback with Caritas, 1653, cast iron, 120 × 86 cm, Amsterdam, Rijksmuseum (BK-KOG-1418). Photo: Rijksmuseum.

Figure 14.2 German (?), fireback with Caritas, 1650–1700, cast iron, 100 × 70 cm, Amsterdam, Rijksmuseum (BK-BFR-125). Photo: Rijksmuseum.

there is indeed a close correspondence between surviving prints and firebacks, but sometimes there is a looser relationship, suggesting perhaps merely a standardized way of representing the same iconography. Therefore, it is difficult to determine if the woodcarver made use of a print as a model, or that he was simply following a well-known tradition to tell the story. Some firebacks and stove panels bear inscriptions explaining the iconography, but at a time when few people were literate, the images themselves had to adhere to established patterns in order to be recognizable.

Today, firebacks surviving in the Netherlands are labelled as 'Dutch'. This does not necessarily mean that they were actually manufactured in the Netherlands. Little is known about local iron foundries and their production. In 1687, one Johannes Verbeeck filed for a patent on – among other things – *kachelplaten* (stove panels).[16] It is not clear if he intended to cast these in the Netherlands or elsewhere. The Dutch merchant Louis de Geer (1587–1652) owned iron foundries in Sweden, which could have produced stove panels and firebacks.[17] Many scholars believe that the earlier firebacks were cast in Germany, where there were many iron foundries in the hands of aristocratic families.[18] Later, firebacks were also produced in Wallonia, in iron foundries owned by

prominent local families and important abbeys.[19] From the eighteenth century, there is evidence that iron foundries in the eastern part of the Netherlands, for example, in Ulft, were turning out firebacks. Yet, regardless of the places of their casting, the large surviving numbers in the Netherlands and their often typically Dutch iconography indicate that firebacks were designed and produced for a specific Dutch market.

The vast majority of the stove panels bear biblical and religious images.[20] Since stove panels and firebacks were produced according to the same method, and presumably also by the same foundries, it would have been reasonable to expect the same iconography on firebacks. This is not the case, however. Only a small group of firebacks are adorned with saints and scenes from the Old and New Testaments. More commonly, the images on Dutch firebacks are related to Dutch history, historical figures and events, such as the capture of a Spanish treasure fleet by the Dutch admiral Piet Hein (1577–1629) in 1628.[21]

A frequent iconography is that of the personification of the Dutch Republic with the Dutch lion in the Garden of Holland (Figure 14.3), accompanied almost invariably by the inscriptions 'PRO PATRIA' and 'HOLLANDIA'. Surviving firebacks with related iconographies can be found not only in museums, castles and historical residences in the Netherlands but also in collections elsewhere in Europe and beyond. A fragment of such a fireback was found during excavations of the farm 'De Vlackte', or 'The Flatts', near Fort Orange, on the west side of the Hudson. Most likely, it was brought there from Holland by the owner the farm, Arent van Corlaer (1619–67), who worked for the West Indian Company.[22]

Most of these firebacks were produced in the first-half of the seventeenth century, and their nationalistic theme is clearly related to the Eighty-Years War, fought between the Netherlands and Spain between 1568 and 1648. In 1555, Philip II (1527–98), son of the Holy Roman Emperor Charles V (1500–58), became the ruler of the Netherlands, and a year later he also became king of Spain. Tensions between the two dominions under Philip's reign were stirred up due to the Reformation, resulting in the Iconoclasm of 1566 and the start of the Eighty Years War two years afterwards.

Under the leadership of William I of Nassau (1533–84), prince of Orange, the Dutch provinces signed the Pacification of Ghent in 1576, in an attempt to rid themselves of the Spanish domination. Given that the Dutch revolt was in full swing during the last decade of the sixteenth century, it is interesting to find the coat of arms of Charles V on a fireback of 1596, and that of Philip II on a fireback dated 1592 (Figure 14.4).[23] The coat of arms of Phillip II is surrounded by a chain with the escutcheons of the Seventeen Dutch Provinces, or the Spanish Netherlands as they were called. These firebacks must have been made for supporters of the Spanish cause.

The Eighty-Years War ended with the Peace of Münster, an event that was the subject of many prints, and also of some paintings and firebacks. The majority of the firebacks portraying this event show the Personification of Peace in the centre, holding a palm branch in her hand, accompanied by the inscription 'Pax', and in many cases also by the date of the conclusion of the peace, 24 October 1648.[24]

The Nassau family remained popular during the seventeenth century, and their portraits and coats of arms were reproduced on firebacks. In particular the image of William III (1650–1702) appears to have been popular. Referred to as William of

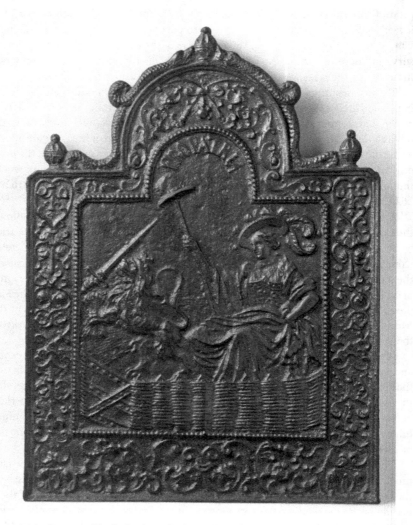

Figure 14.3 German (?), fireback with the Personification of the Dutch Republic and the Dutch lion in the enclosed Garden of Holland, 1650–1700, cast iron, 105 × 75 cm, Amsterdam, Rijksmuseum (BK-KOG-1056). Photo: Rijksmuseum.

Orange, he was the Stadtholder of the Seven Provinces of the Netherlands from 1672, and became King of England, Scotland and Ireland after the Glorious Revolution of 1689. The majority of the firebacks bearing his portrait, however, are dated 1696: the year he was appointed Stadtholder of the Dutch territory of Drenthe.[25] In the meantime, William's coronation in 1689 boosted trade between the Netherlands and Britain, including in firebacks. In 1695, no fewer than 1516 firebacks were imported from Holland into England.[26]

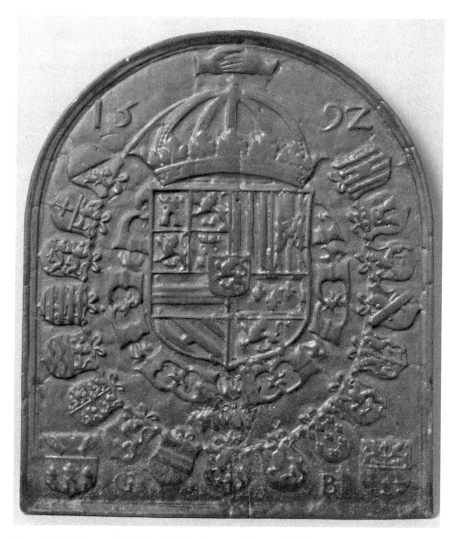

Figure 14.4 German (?), fireback with the coat of arms of Philip II, 1592, cast iron, 74 × 61 cm, Amsterdam, Rijksmuseum (BK-NM-191). Photo: Rijksmuseum.

The portrayal of rulers on firebacks was not restricted to the Netherlands. The Rijksmuseum owns a fireback bearing the likeness of Louis XIV of France.[27] He is shown as a young man, accompanied by the inscription 'LVDOVICVS XIV/FRANCIA ET NAVARRA/ [REX CHRISTIANISSIMVS]', and is surrounded by four medallions with a star, a dove and two dolphins, respectively. He is flanked by a caduceus, the symbol of Mercury, the God of Trade, on the left, and a bow and arrows, the symbol of war, on the right.

Rulers aside, the crests and coats of arms of prominent civic families were depicted on firebacks, too. These could be simple, or more elaborate, such as the fireback with

the coat of arms of Joan Huydecoper (1625–1704), dated 1647 (Figure 14.5). The arms bear a crest with a centaur with bow and arrows; they are framed by trophies on the left and right and ornaments in the auricular style in the top and bottom corners.[28] This fireback may have been a custom-made design for the home of the Huydecoper family. It is not, however, unique; there is at least one other copy.[29]

There are many firebacks showing a prince of Orange on horseback, or the coats of arms of members of the Nassau family. Firebacks with these subjects could have been commissioned by the Nassaus themselves, to adorn their fireplaces, or perhaps be as gifts to friends or supporters. For example, a fireback from the Royal Palace in Leeuwarden shows the coats of arms of Prince Hendrik Casimir II (1657–96), the

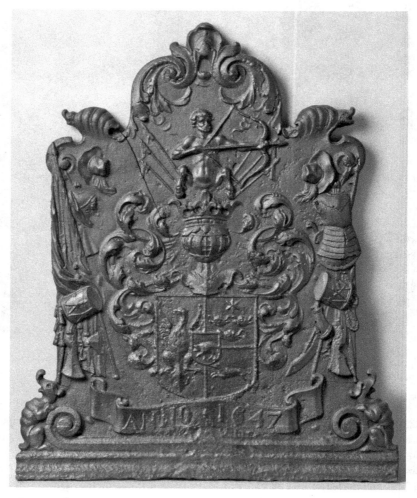

Figure 14.5 German (?), fireback with the coat of arms of Joan Huydecoper, 1647–60, cast iron, 110 × 90 cm, Amsterdam, Rijksmuseum (BK-1978-19). Photo; Rijksmuseum.

Stadtholder of Friesland and Groningen and his wife Henriëtte Amalia van Anhalt-Dessau (1666–1726).[30] Yet, the large quantity of surviving firebacks with imagery linked to the Nassau family suggests that they were produced for a wider group of individual customers, perhaps to show their loyalty.

Since a fireback would have been fixed against the back wall of a fireplace, and could not easily be removed, it may seem a dangerous medium for political propaganda, especially at a time of war. Of course, when the fireplace was not in use, the fireback could be hidden from view by a vase of flowers or a cloth.[31] A safe choice of decoration would have been a reference to a peace treaty, such as the Peace of Nijmegen, which ended the Franco-Dutch war of 1678–9, and the Peace of Rijswijk, which marked the end of the Nine Years' War; both were commemorated on firebacks.

A fireback from the period of the Eighty-Years War, dated 1619, contains what was perhaps a subtle and learned protest against foreign oppression (Figure 14.6). Its decoration consists of two tiers. The lower tier has three portrait medallions of unknown sitters. The upper tier has three full-length figures identified by inscriptions – two exemplary characters from Roman History, and one from the Old Testament: Publius Horatius Cocles, an officer in the army of the Roman Republic who single-handedly defended a bridge against Etruscan invaders; Gaius Mucius Scaevola, a Roman youth who also distinguished himself in the Etruscan wars; and Samson, the legendary biblical fighter against the Philistines. All three men were resisting foreign oppressors, just like the supporters of the Nassau family were resisting dominance by Spain. The various elements of the decoration of this fireback appear to have been cast from separate templates, which suggest it was a bespoke design for a specific customer.

Given the fact that almost every single household had at least one fireplace, it is reasonable to assume that most households would have been fitted with at least one decorated fireback. The large quantity of the surviving firebacks would support this assumption. Unfortunately, little is known about who owned most of the specific surviving copies, but in a few cases we have information regarding their origins. For instance, the Museum Rotterdam owns two firebacks stemming from two Dutch farms. The first is plain, with only a decorated upper border with two putti carrying a crown.[32] Farms did not have only sober firebacks, however, because the second one in the Museum Rotterdam is lavishly adorned with a representation of the Parable of the Wise and the Foolish Virgins.[33] Since the farm in question dates back to the seventeenth century, it is possible that the fireback was installed at the time when the farm was built.

Firebacks made for government institutions could be plain, too. Two firebacks originally installed in the building of the Admiralty of Rotterdam must have formed sober ornaments in their respective rooms.[34] They do not show images of sea battles or admirals, but once again have only decorated upper borders, each with two little angels holding a laurel wreath. Perhaps this is an understated reference to the victories of the Admiralty fleet. By contrast, Johanna Maria Tromp (1644–1717) paid tribute to her father, the famous Admiral Maarten Harpertszoon Tromp (1598–1653), by having a fireback fitted that shows him in the guise of Neptune riding two seahorses.[35] It was listed in the inventory of Johanna's manorial estate, called Elsbos, near the Dutch village of Nuland.

Figure 14.6 German (?), fireback with Publius Horatius Cocles, Gaius Mucius Scaevola, and Samson, 1619, cast iron, 88 × 61 cm, Amsterdam, Rijksmuseum (BK-NM-11188). Photo: Rijksmuseum.

Another fireback that once decorated a government institution, in this case an orphanage combined with a home for the elderly, shows Caritas, like the examples discussed earlier. At first glance, the iconography of charity would seem appropriate for such an organization, which took care of helpless infants and senior citizens. This charitable institution, however, was only founded in 1825. Until that time, the building housed the Dutch West Indian Company, and was called the 'West-Indisch Huis'. If the

fireback with the image of Caritas was already in use at that time, it would be an ironic twist, as the Dutch West Indian Company is mainly known for their uncharitable slave trade. Nonetheless, the Company associated itself with this particular virtue: one of their ships was in fact named 'Caritas'.

In short, the production process of cast-iron firebacks and stove panels was similar, but where stoves were luxury items decorated with biblical and religious images, firebacks appear to have been less expensive, more common and adorned with scenes related to Dutch politics and history. The crests and coats of arms and portraits of politically important families and figures were reproduced, as well as contemporary events such as the capture of the Spanish treasure fleet or the Peace of Münster. Firebacks were fixed against the wall inside fireplaces and could not easily be removed, which would have made them dangerous vehicles for political messages, and sometimes these are conveyed in a discrete form. Firebacks appear to have been present in many households of all social classes, from farms to palaces and government institutions. Occasionally, their iconography seems to have been designed for specific customers, but the vast majority of the images were of a more generic type. It is to be hoped that further research will result in a more detailed knowledge of the market for firebacks, and the preference for these political charged iconography that they display.

Visual pedagogy

The use of woodcuts in early modern Lutheran and Catholic catechisms

Ruth Atherton

Catechesis as a method of religious instruction has existed since the beginning of the Christian church. However, prior to the Reformation, high illiteracy rates and the predominance of Latin-language texts restricted the accessibility of educational material. During the sixteenth century, the whole laity became the focus of religious instruction: across Europe, catechisms increasingly were printed in the vernacular, and were often illustrated with woodcuts of varying size and number. The laity comprised adults and children, the literate and illiterate, the rich and the poor. The catechisms therefore needed to include material that was suitable for this broad spectrum of knowledge and education, resulting in the publication of catechisms with different levels of doctrinal content and complexity. Small catechisms were aimed at children and 'simple folk'; intermediate catechisms were directed towards advanced pupils or educated adults; and large catechisms were intended as resources to support clergy and schoolteachers in the delivery of religious instruction to their parishioners or pupils.

In each case, the laity remained the ultimate target audience. The laity were not all educated in theology; indeed, many were barely educated at all. It was not plausible to expect an ordinary German to grasp complex doctrinal matters that even highly trained theologians struggled to comprehend fully. Catechisms, therefore, taught the basics of the faith, and their material was intended to be simple and easy to understand. Current scholarship suggests catechisms imparted knowledge that 'separated a true Christian from a false Christian,'[1] and argues they were designed to resolve the religious, political and social challenges caused by the development of rival confessions.[2] The examination of a sample of woodcuts in this chapter, however, suggests that catechisms did not function at a high confessional level and supports Ulinka Rublack's caution that religion 'is not defined by a fixed set of beliefs and ideas; it rests on their diverse social interpretations'.[3] Drawing on a range of images from Lutheran and Catholic catechisms, I will argue that, although catechisms were attached to confessional churches, their differing visual content impacted the homogeneity of their messages across geographically diverse readerships.

In 2004, Keith Moxey commented that the significance of woodcuts for sixteenth-century German society has been overlooked.[4] As Ruth Slenczka notes, even the famed artwork of Lucas Cranach has been perceived as lacking any independent agenda and serving only an illustrative purpose.[5] Bridget Heal, however, argues that catechetical woodcuts were 'as important as texts' in teaching the laity what it meant to be a Lutheran.[6] Lee Palmer Wandel suggests that images could be used to teach what words alone could not, and Henk van den Belt's analysis of woodcuts illustrating the Decalogue concludes that images contained messages that were independent of the text.[7] These findings touch on an inherent historiographical problem regarding woodcuts. The suggestion has been that their purpose was solely to provide visual reiterations of printed lessons, intended to aid the learning of the illiterate.[8] Yet, woodcuts could cloud messages conveyed by the printed word, or alternatively, they could strengthen lessons that resonated particularly with specific authors or their intended readership. Moreover, occupying a position that does not adhere to modern distinctions between high and low art, or high and low culture, catechetical woodcuts can contribute to our understanding of how popular religion was perceived and represented in educational material, and how local print cultures responded to popular demonstrations of piety and devotional practices. In a broader sense, they were part of a market of imagery that catered not strictly for the poor but certainly for broad layers of society.

German book illustration began in Bamberg in the 1460s and approximately one-third of books printed before 1500 included images, a proportion increasing further still with the onset of the Reformation.[9] During the 1520s, however, images became a progressively contentious issue, with the reformer Andreas Bodenstein von Karlstadt arguing, in 1522, that the laity 'learn nothing of salvation from them'.[10] Luther agreed to some extent, asserting in a sermon delivered in Meresburg in 1545 that 'Christ's kingdom is a hearing-kingdom, not a seeing-kingdom; for the eyes do not lead and guide us to where we know and find Christ, but rather the ears must do this'.[11] Nonetheless, in Luther's thought, images played a vital role in the dissemination of religious knowledge, and in 1525, he proclaimed that pictures are useful 'for the sake of remembrance and better understanding'.[12] The pedagogical benefits of images had been recognized in the early medieval church, with Pope Gregory the Great likening images to books for the illiterate.[13] In 1563, the Council of Trent affirmed the use of holy images, declaring that from them 'great profit is derived', although 'all superstition should be removed from their use'.[14] Numerous Lutheran and Catholic catechisms published throughout the sixteenth century included woodcuts, many of which shared similar biblical or contemporary themes. Yet, the degree of authorial authority over these images, their purpose and their reception remain far from clear.

It was not unusual for the printer to have a say regarding the inclusion of woodcuts.[15] Heal notes that the prefaces to Luther's *Small* and *Large Catechism* did not provide any justification for using woodcuts, in contrast to that of his prayer book, indicating that the images were added at the behest of the printer.[16] For his 1589 edition of the *Small Catechism* published in Antwerp, the Jesuit Peter Canisius corresponded with the publisher, Christopher Plantin, and provided a brief text to accompany each image, inferring that he must have seen or been given details of the woodcuts.[17] Such authorial control over the use of woodcuts was not guaranteed. Printers and publishers knew

their markets and produced books that they believed would sell.[18] As Pettegree notes, author and printer relations could become very tense if the former came to believe that the printer was more concerned with profit than with the purity of the words or the aesthetics of their products.[19]

In the printers' defence, the cost of publishing books was high, meaning it was crucial to target market preferences.[20] Likewise, commissioning woodblocks was expensive, leading to the creation of images that were designed to be versatile and reuseable.[21] A consequence of this versatility of woodcuts is that their meaning could be open to interpretation. For example, Alison Stewart notes that Sebald Beham's peasant festival woodcuts can be interpreted in diverse ways depending on the context in which they appeared, and Moxey's analysis of depictions of mercenaries illustrates how they could be used to personify imperial power and nationalist sentiment, but also to represent drunkenness and people unworthy of respect.[22] Political, social and cultural landscapes informed the understanding of woodcuts, resulting in a single image being read in multiple ways.[23]

Some artists lent their services to both Catholic and Protestant publications. For instance, Sebald Beham was patronized by both Lutherans and Catholics,[24] and Hans Holbein provided Bible illustrations for Luther's German translation as well as for the Vulgate and Erasmus's Bible editions.[25] David Price suggests that Holbein's art was designed to transcend 'the textual and confessional heterogeneity of the Bible'.[26] In his study of the visual arts and the church, John Dillinberger notes that images created by Cranach and Dürer, despite being both associated with Luther, did not translate into artwork that 'really came to understand the central theological shift that created the Protestant Church'.[27] Likewise, in his discussion of the religious position of Reformed artists in the sixteenth century, James Tanis concludes that there is no 'guarantee of the religious orientation of a given artwork'.[28] Iconographic conventions as well as the personal outlooks of the artist, their understanding of doctrinal shifts and the localized context in which they appeared all impacted the messages woodcuts conveyed.

A final consideration is how authors and printers intended images to be read. Van den Belt suggests that the Old Testament stories illustrating the Decalogue in Luther's catechisms reflect strongly his identification of the Law with the Old Testament and notes that they mostly represent examples of 'punished disobedience'.[29] For instance, in the 1530 edition of Luther's *Large Catechism*, the first and second commandments are illustrated with a woodcut depicting the stoning of a blasphemer (Leviticus 24).[30] By contrast, in the catechism by Luther's follower, Andreas Osiander, published in Nuremberg in 1533, the woodcut marking the second commandment shows Christ on the Cross surrounded by a peasant and a mercenary playing dice, a man yelling at his dogs and a man appearing to argue with a tithe collector;[31] only in the distant background, a man wields a slab over a kneeling figure – a reference to the stoning of the blasphemer (Figure 15.1).[32] With regard to *Kermis* (church festival) woodcuts printed in sixteenth-century Nuremberg, Stewart questions whether the inclusion of groups of people playing skittles or becoming inebriated indicates specific objections to the celebrations by the city elites.[33] She points out how, in 1525, the city council accused feast days – including *Kermis* – of leading 'to the highest dishonour of God's

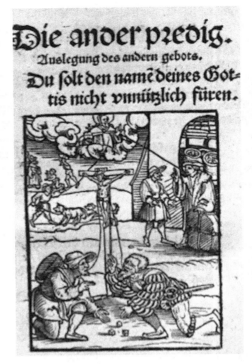

Figure 15.1 German, second commandment, from Andreas Osiander, *Catechismus oder Kinderpredig . . .* (Nuremberg: Johann Petreium, 1533), Biiia, Munich, Bayerische Staatsbibliothek, Res/Hom. 276, fol. Q8v. Image in the public domain.

holy word because [they] were cause for . . . blasphemy, drunkenness, anger, lust, adultery, strife, manslaughter, brawls and other public and sinful vices'.[34] In Osiander's woodcut, several of these sins are in fact depicted: Christ on the Cross in the middle of the image is ignored and dishonoured by the gambling, angry and resentful figures surrounding him. The biblical reference to the stoning of the blasphemer that featured so prominently in Luther's catechism is relegated to the background, with the emphasis being placed on sins that were immediately problematic to the authorities in Nuremberg and undoubtedly in other German cities.

The remainder of this chapter will discuss two case studies that further illustrate the versatility and ambiguity of woodcuts in catechisms. The first of these explores the visual presentation of penance in the German-language catechisms of Martin Luther, Andreas Osiander and Philip Melanchthon. In 1520, Luther rejected the sacramental status of penance, concluding in the *Babylonian Captivity of the Church* that 'the sacrament of penance . . . lacks the visible sign and divine institution'.[35] Nonetheless, penance continued to be seen by Lutherans as a method by which to moderate the outward excesses of society. The medieval process of penance comprised four parts: contrition, confession, absolution and satisfaction. A crucial part of achieving forgiveness was the annual confession to the priest of all transgressions committed

over the year, and the subsequent performance of an imposed penance, or satisfaction, to repay the debt accrued by the individual.

This temporal punishment was made possible by virtue of the power of two keys, which, wielded by the priest, allowed the penitent to suffer the punishment for their transgressions here on earth, rather than to suffer it after death.[36] It was the control over these keys, as proclaimed by the Gospel, that enabled the church to assume authority in spiritual and temporal affairs, and on which they based their prerogative to forgive and retain sins. There was not a uniform theology of the keys until the late medieval period, and, as Rittgers notes, there was discord between the spiritual and secular estates regarding temporal authority in the high and late Middle Ages.[37] The debate regarding the extent of spiritual authority was not resolved by the onset the Reformation, when Luther rejected the idea that the clergy had the authority to affect an individual's temporal standing (the large ban), and argued that they could only restrict access to communion (the small ban).[38]

Luther's reconceptualization of the ecclesiastical office resulted in a radically different role and image of the pastor. While priests traditionally were cast as judges in the absolving of sins, Luther saw pastors more as servants of the laity and, crucially, he taught that private confession of sins should be a voluntary, albeit beneficial, process. This view was compounded in his *Treatise on the Keys* (1530), as well as in his catechisms.[39] Yet, the 1530 edition of Luther's *Large Catechism* printed in Wittenberg by Georg Rhau included a woodcut depicting a traditional scene of private confession, with a seated pastor listening to the confession of a bareheaded layman kneeling in front of him (Figure 15.2).[40] The image was similar to those depicting confession in the later Middle Ages, with a seated confessor and a kneeling penitent.[41] By emphasizing continuities with medieval Christianity, it softened Luther's transformation of the process of confession and forgiveness at a time when he was trying to disassociate himself from fanatical sects in the wake of the Peasants' War.

In Luther's *Large Catechism* of 1540, however, again printed by Georg Rhau, the image had changed: Christ, standing in front of a group of men, presents two keys to a barefooted man standing in ordinary clothes – his disciple, Peter (Figure 15.3).[42] The handing of the keys to Peter reflected Luther's opinion that they were given for the benefit of the whole of the Christian community.[43] The new image corresponds to changes in Luther's theological focus, which were driven by discord within the Lutheran faith. During the 1530s, Luther and his fellow Wittenberg theologians were involved in extensive correspondence with Nuremberg preachers and the city council over the practice of private confession and the use of general confession and absolution. Luther did not reject private confession but argued it was voluntary and was not to be intrusive. The confessor, in Luther's eyes, did not grant absolution, he merely conveyed God's forgiveness to the penitent.

Andreas Osiander, Nuremberg's leading preacher, was a strong advocate of private confession.[44] In his catechism, he questioned how an individual could truly know that they had been forgiven and argued that such knowledge could only come from God who 'does not speak to us down from heaven; [instead] he has left the keys of heaven and commanded the power to forgive sins to the ministers of the church'.[45] He argued that 'the reason and source of the entire preaching office and the keys of the

Figure 15.2 German, a short exhortation on penance, from Martin Luther, *Deudsch Catechismus* (Wittemberg: Georg Rhau, 1530), 167, Berlin, Staatsbibliothek. Image in the public domain.

kingdom of heaven . . . [are] . . . so that we can be certain that we have forgiveness of sin, and all that the holy Gospel brings with it, as often as we require it'.[46] Osiander's textual defence of clerical authority was reinforced by the woodcut that framed his catechetical sermon on the keys. It depicts a pastor holding a key in his left hand, while pronouncing forgiveness on a kneeling layman with his right (Figure 15.4). The cleric is holding only one key: the city council had already managed to wrestle control of the binding key – much to Osiander's dismay – so this remaining key probably represents the loosing key, which was used to forgive sinners.[47]

On the instruction of the city magistrates, the 1533 church order, to which Osiander's catechism originally was appended, had removed any reference to the pastor laying his hands on the confessant when pronouncing absolution.[48] Osiander co-authored the church order and complied with this request, but in September 1533, he declared that 'absolution with the laying of hands is not a sign of loosing but is the loosing itself'.[49] The woodcut printed in his catechism correlates with this view and the standing pastor can be interpreted as demonstrating Osiander's rejection of clerical subservience to the confessant. In early medieval acts of contrition, the priest demonstrated his superiority by standing over the kneeling penitent who, after acknowledging his sinful nature, begged the priest to act as an intercessor with God.[50] Thus, while Luther's 1530 catechetical image of confession appealed to imagery of the later Middle Ages,

Figure 15.3 German, a short exhortation on penance, from Martin Luther, *Deudsch Catechismus* (Wittemberg: Georg Rhau, 1540), on CLXXXa, Munich, Bayerische Staatsbibliothek, VD16 L 4343. Image in the public domain.

Osiander's woodcut mirrored the physical positions of the confessor and penitent of an older Christianity in order to support his defence of clerical authority.

Whether the choice of woodcuts was intentional on the part of Luther and Osiander is difficult to ascertain, but the visual messages conveyed by these woodcuts could have been understood by those familiar with the teachings of Osiander and Luther, whether literate or illiterate. This was perhaps recognized: the woodcut supporting clerical use of the keys is missing from the edition of Osiander's catechism published by Georg Rhau in Wittenberg in 1533, although the text remained unchanged.[51] Given the disagreement between Luther and Osiander regarding clerical authority and the power of the keys, it is probably not a coincidence that this particular woodcut was not replicated in the Wittenberg edition.[52]

On the other hand, an edition of Melanchthon's catechism printed by Hans Guldenmundt in Nuremberg in 1544 included a woodcut representing confession similar to that in Osiander's catechism (Figure 15.5).[53] The textual content of Melanchthon's catechism differed from Osiander's instructions by moderating the role of pastors in the forgiveness of sins. Melanchthon taught that 'confession to and before the pastor . . . is not necessary' but 'if your brother comes to you and says "I am repentant", you should forgive him'.[54] By contrast, Osiander's catechisms taught that 'one should seek forgiveness of sins and receive it from the ministers of the church to whom Christ has given and promised the keys' and reiterated the power of the

Figure 15.4 German, pastor holding a key pronouncing forgiveness on a layman, from Andreas Osiander, *Catechismus oder Kinderpredig*... (Nuremberg: Johann Petreium, 1533), 262, Munich, Bayerische Staatsbibliothek, Res/Hom. 276, fol. Q8v. Image in the public domain.

minister to forgive or retain sins throughout the sermon.[55] Melanchthon focused on the need for the repentant sinner to have faith in the forgiveness of God and taught that the forgiveness proclaimed by the pastor originates with God. Osiander did not allege otherwise, and Melanchthon agreed with the benefits of private confession, but the two disagreed on the limits of clerical authority. Significantly, the woodcut in Melanchthon's catechism is somewhat incongruous with, albeit not entirely removed from, the textual lesson.

There is scope for much more study, but the removal of the woodcut depicting confession in Osiander's Wittenberg edition and the changing image in Luther's editions indicates that printers at times considered carefully the visual content of woodcuts, while the example from Melanchthon's catechism illustrates that woodcut images could emphasize messages that were incongruous with the text.

The second case study examines the pictorial representation of the Mass in the catechisms of Peter Canisius to demonstrate how the choice of image could impact the textual message. The Eucharist played a vital role in the lives of early modern Christians.[56] Participation in this sacrament was not to be taken for granted, treated lightly or undertaken in haste. Indeed, such was its importance to Christians that no

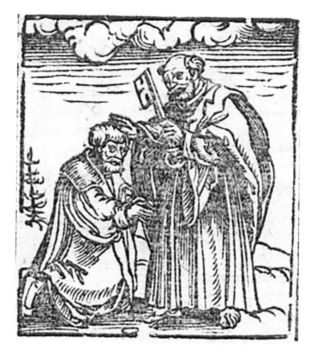

Figure 15.5 German, on absolution, from Philip Melanchthon, *Catechismus. . .* (Nürnberg: Hans Guldenmundt, 1544), 145, Sachsen-Anhalt, Universitäts- und Landesbibliothek, VD16 M2643. Image in the public domain.

other sacrament was the focus of as much debate during the Reformation.[57] One of the most visible areas of contention was offering communion in both kinds to the laity, which Catholic doctrine rejected. The rejection or acceptance of communion in two kinds increasingly became seen as a confessional marker during the second half of the sixteenth century, although after the growth of Lutheranism within the Empire and beyond, receiving communion in two kinds became a normal feature of worship for many loyal Catholics living in bi-confessional areas.[58]

Peter Canisius wrote his catechisms while witnessing the spread of Lutheranism first-hand. He produced three different catechisms, which were aimed at different audiences, and they initially appeared in both Latin and German, with the Latin editions being designed for an international or a better-educated audience. Canisius's catechisms became the most popular and widely available Catholic catechisms in sixteenth-century Germany and, by his death in 1597, at least 357 editions had appeared.[59] In 1575, a Latin edition of Canisius's *Small Catechism* was published in Antwerp, a city outside of the Holy Roman Empire, which had a significant Lutheran presence.[60] Intriguingly, the catechism includes a woodcut depicting the priest offering both the host and the chalice to the kneeling laity (Figure 15.6).[61] Although the chalice may have been used to contain wafers that were being distributed by the priest, there is sufficient ambiguity to suggest that communion in both kinds is being offered to the laity in this scene.

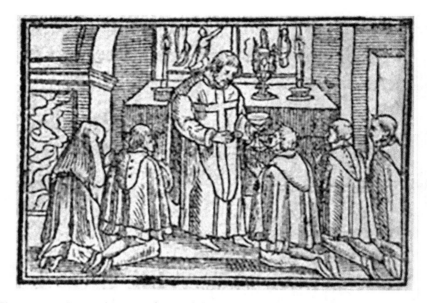

Figure 15.6 German, priest offering chalice and wafer to a congregation, from Petro Canisio, *Institvtiones Christianae Pietatis sev Parvvs Catechismvs Catholicorvm* (Antwerp: Johann Bellerus, 1575), 40, Augsburg, Staats-und-Stadtbibliothek. Image in the public domain.

This image did not appear in any of Canisius's vernacular catechisms. Indeed, in a German-language edition published in Dillingen in 1575, five woodcuts portraying communion are included, but they do not depict the laity being offered communion in both kinds. In one woodcut, replicated four times, a priest holds up the consecrated host, while another dispenses the bread to a kneeling parishioner.[62] The second woodcut shows a kneeling layman gazing at the Host as it is raised aloft by the priest while a chalice sits on the altar.[63] Why, then, does an image depicting the chalice being proffered to the laity appear in the Antwerp Latin version?

Victoria Christman's study on religious heterodoxy has revealed that several Antwerp printers produced works for multi-confessional clients and markets.[64] Yet, the publisher of Canisius's 1575 Latin catechism, Jean Belere, printed solely Catholic works.[65] This makes the choice of woodcuts used in the catechism even more intriguing. Essentially, a Catholic printer chose an image that promoted communion in both kinds to be used in a Catholic catechism, despite the Council of Trent's ruling against the practice in 1562. Guido Marnef notes that in between the orthodox Catholics and resolute Protestants in Antwerp, there existed a broad, religiously heterogeneous middle group, which included Catholics who sympathized with Protestant ideas but did not formally break with the Roman faith.[66] During the 1570s, there was a drive to reconcile Protestants to Catholicism, and in 1570, after the proclamation in Antwerp of a papal pardon, over 14,000 people returned to the Catholic fold.[67] It is possible, therefore, that the image depicting communion in both kinds in Canisius's catechism

was an acknowledgement of a devotional practice in Antwerp that had developed as a result of Catholic sympathy towards Protestant ideas, or was intended to encourage the reconciliation of wavering Protestants.

A different message was conveyed in Canisius's 1563 and 1566 German-language *Large Catechism* published in Cologne. In these editions, woodcuts depict angels looking upwards towards the Host, housed in a monstrance (Figure 15.7). The oval image is framed with a Latin inscription reading '[T]he bread I will give is my flesh which I give for life: he that eateth of this bread shall live forever'.[68] Janis Gibbs has demonstrated that, despite Cologne priding itself on being a 'holy city', there was a growing concern regarding the orthodoxy of its citizens, with the 1560s witnessing increasing efforts by the city council to root out heresy.[69] Although communion in both kinds had been permitted in some German dioceses by Pope Pius IV in 1564, receiving communion in both kinds was regarded as a 'mark of alien belief, and of separation from their sacred community' in Cologne.[70] In the Cologne catechisms, Canisius's woodcut avoids the controversy surrounding communion in both kinds, instead reflecting the ongoing ritual practice of worship.

The difference between the woodcuts in these Latin and German Catholic catechisms is striking. The woodcuts support different aspects of the faith, with Latin editions illustrating doctrinal aspects and German versions supporting ritual expressions of piety. These different messages could be problematic for confessional homogeneity. The question of audience and the textual content of the catechisms becomes significant here. In the Latin *Small Catechism*, intended for an educated or international audience, Canisius taught that a believer receives the whole of Christ under one species – the bread – but he did not forbid the lay chalice directly.[71] This allowed for the reception

Figure 15.7 German, angels adoring the host, from Peter Canisius, *Catholischer Catechismus oder Sumārien Christlicher Lehr* (Cologne: Maternus Cholinus, 1563), 160, Munich, Bayerische Staatsbibliothek, VD16 C750. Image in the public domain.

of communion in both kinds to be depicted visually in a mixed confessional city such as Antwerp. In the German *Large Catechism*, intended primarily for the clergy to teach the laity, Canisius emphasized communion in one kind. He expressed astonishment towards those who conspired with the 'despisers of the Church' regarding communion in both kinds, and taught that the fruits of the sacrament are available only to those who 'persist in the unity of the Church', while those who insisted on 'the external signs of the sacrament' would make themselves unworthy partakers and would not receive its fruits.[72] Again, however, he did not expressly forbid communion in two kinds. Cologne resisted communion in both kinds, so the choice of woodcut used in editions published there focused on devotional aspects of the Eucharist, communicating Canisius's preference for communion in one kind clearly and without contradiction.

Catechetical instruction was designed for the laity but, in viewing the catechisms primarily as tools of the church and state, the influence of this audience is overlooked. Here, it has been argued that the intended audience could impact the visual content of catechetical instruction. Reversely, authorial and secular objectives could be presented visually in order to influence the behaviour of the lay audience. Catechisms were designed to educate an audience of differing intellectual abilities and theological knowledge, and with different lived experiences of their faith. Woodcuts could reflect these disparities, and in so doing, they illustrate the problematic nature of viewing catechisms as methods by which to establish confessional homogeneity. If the meaning of the catechism text could be altered by the accompanying image, the printer's role in the creation of confessional identities becomes significant, especially if the choice of woodcuts represents a conscious reflection of local religious feeling and practice. The transmission of knowledge in early modern Europe remains a fruitful area of study, and this chapter has sought to demonstrate the importance of investigating both the methods of religious instruction and the intended audience of this education.

Shakespeare's picture of 'We Three'

An image for illiterates?

M. A. Katritzky

I first came to the 'We Three' tradition not through images but through texts.[1] Notably, I was intrigued by a reference in *Twelfth Night* that has been scrutinized by generations of Shakespeare scholars; yet by no means fully satisfied by their explanations.[2] The text of *Twelfth Night*, first performed in 1602, was only posthumously published, in the 1623 First Folio. In the scene in question, Sir Toby Belch and Sir Andrew Aguecheek are joined in a room by Feste the clown, prompting the following exchange:

> *Sir Andrew*: Here comes the fool, i' faith.
> *Clown*: How now, my hearts? Did you never see the picture of 'we three'?
> *Sir Toby*: Welcome, ass.[3]

The eighteenth-century Shakespeare scholar Edmond Malone explains this as follows:

> I believe Shakspeare had in his thoughts a common sign, in which two wooden heads are exhibited, with this inscription under it: '*We three* loggerheads be.' The spectator or reader is supposed to make the third. The clown means to insinuate, that Sir Toby and Sir Andrew had as good a title to the name of *fool* as himself.[4]

Loyalty to Malone's suggestion remains surprisingly persistent. Margaret Farrand Thorp excludes the picture of 'We Three' from her introductory list of 'allusions to twelve actual concrete pictures and carvings' in Shakespeare's plays. She barely expands on Malone, her later discussion merely suggesting that the images which most often inspired Shakespeare were non-elite: 'those of "monsters," of tavern signs, broadsides, painted walls, and painted cloths', without referring to specific 'We Three' pictures.[5] More recently, art historians have been linking the formula's visual record with Shakespeare, or the wider literary tradition.[6]

Remaining unconvinced that Shakespeare's primary source here is a tavern sign, I take as a more reliable gloss for Shakespeare's 'picture of we three' a description by the London-based Netherlandish merchant and economist Gerard de Malynes. In 1623,

he referred to 'the picture of two fooles, deriding one another, made by our moderne Paynters, with an inscription: *Wee are three*, meaning the looker on for [the missing] one'.[7] This chapter will consider what Shakespeare meant by this 'picture of we three' and what its relevance to the poor and illiterate may have been; it will address these enquiries in the light of the social mobility of a long-standing tradition of closely linked folly-related formulaic sayings. Although this formula may be typified by the phrase 'We three', the number 'three' is not fixed. Two, three, four or seven are all popular variants. The given number is always one more than depicted (Figures 16.1–16.6, 16.8, 16.9).

The 'We Three' tradition underlies a persistent and widespread pan-European emblematic visual formula informing numerous text-image influences and interdependencies. It is manifest in elite *imprese* and emblem books, friendship albums and secular decorations at court, such as painted ceilings or stone reliefs, but also in a rich variety of popular art, at least some of which was specifically manufactured for the poor. This includes not only cheap print but also carved wooden biscuit moulds, painted earthenware dishes, trade tokens and other modest household objects

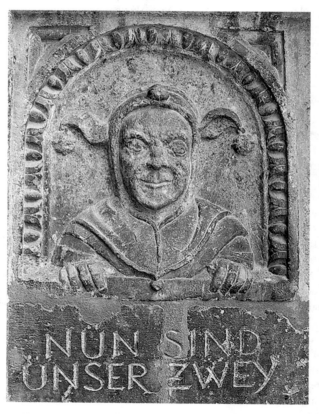

Figure 16.1 Wolfgang Wahlberger, *Nun sind unser zwey* (Now we are two), 1618, stone relief, Nördlingen (Bavaria), Town Hall. Image in the public domain.

Figure 16.2 German, *Vnser sind drei* (We are three), wooden biscuit mould, early seventeenth century, Basel, Historisches Museum. © Basel, Historisches Museum (photo: N. Jansen).

bearing images aimed at amusing and diverting the economically and educationally disadvantaged. The tradition drew on the late medieval Germanic genre of folly literature (Narrenliteratur) and its associated images, enriching the works of early modern artists with meaningful complexity (and persisting into our own century as a trivial visual joke). With reference to some key examples of 'We Three' representations, I will here consider two early images in the tradition (Figures 16.1 and 16.2), before focusing on a group of prints explicating this tradition's challenging and ridiculing of illiterates (Figures 16.3–16.5), and concluding with cases here identified, presented and examined as examples of cross-cultural retrofitting, aimed specifically at non-elite consumers of visual culture (Figures 16.6–16.9).

A stone relief of 1618 (Figure 16.1) suggests telling links between the 'We Three' tradition and the poor. Set into the wall of a Bavarian town hall, it is strategically positioned, immediately to the right of the entrance to the town's official Narrenhäusl, or Fools' Hut. This one-man early modern municipal dungeon was not used for elite transgressors. Its main purpose was to provide a secure short-term lockup cell for socially disadvantaged trouble makers: vagrants, petty criminals and the drunk and disorderly. The carving depicts a single fool's head above the wry motto 'now we are two'. In confronting onlookers with this particular, simple, combination of image and text, it acts as a mocking warning to those tempted to antisocial behaviour, and

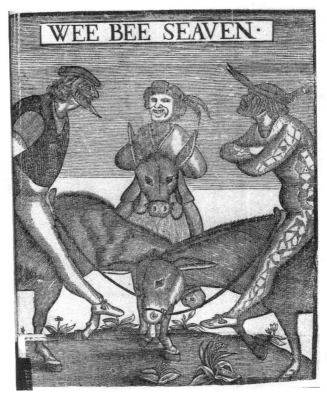

Figure 16.3 English, *Wee bee seaven*, ca. 1654, woodcut, title-page illustration to the anonymous pamphlet *Tvrne over behold and wonder*, London, British Library. Image published with permission of ProQuest.

humiliatingly brands those already behind its door as complete fools, in a succinct way immediately understandable to both the literate and the illiterate.

The 'We Three' tradition's earliest explicit images tend to depict one fool, or at most two. They draw heavily on the medieval convention of alluding to the spectator or reader's folly, in depictions of fools or court jesters, by seemingly reflecting the viewer in the fool's mirror or folly-stick. The layered religious connotations of medieval fool iconography, with or without mirrors or folly-sticks, reference Old and New Testament biblical passages such as 'The fool hath said in his heart, *There is* no God',[8] or 'For if any be a hearer of the word, and not a doer, he is like unto a man beholding his natural face in a glass. For he beholdeth himself, and goeth his way, and straightway forgetteth what manner of man he was'.[9] A painted statuette depicted in Willem II van Haecht's 1628 painting, *The Cabinet of Cornelis van der Geest* (Rubenshuis, Antwerp), may convey such connotations. Van Haecht's painting depicts elite art collectors surrounded by elite works of art. Incongruously, a painted statuette on the left-hand table represents a court fool. He holds a folly-stick in his left hand and points at his own face with his

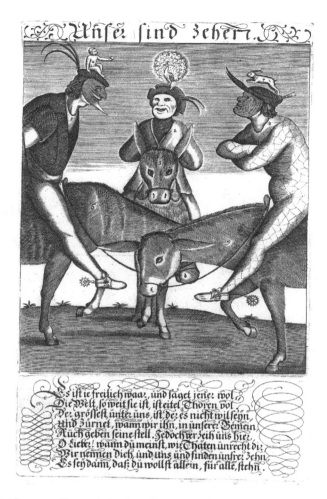

Figure 16.4 German, *Unser sind zehen* (We are ten), ca. 1700, engraving, Nürnberg, Germanisches Nationalmuseum (HB 17862a). Photo: Germanisches Nationalmuseum.

right hand. Here, I believe, van Haecht is conveying complex, lightly coded, allusions in the 'We Three' tradition, to the pretensions of his wealthy patron, who profited from the family business of his spice merchant parents Jacques and Marguerite Pepersack,[10] while rejecting their unaffected, descriptive surname in favour of one with more elite connotations.

Modest artefacts in this tradition include English press-moulded dishes[11] and trade tokens,[12] as well as domestic equivalents of the grand and artistically ambitious Teutonic biscuit moulds bearing classical, heraldic and religious, but also popular motifs, manufactured for collection by the elite,[13] or for use in commercial bakeries.[14] It is illuminating to consider a seventeenth-century circular wooden biscuit mould

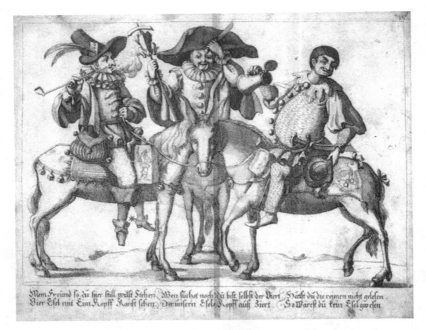

Figure 16.5 German, *Mein Freünd so du hier still wilst stehen* (My friend, if you want to stop and stand here), seventeenth century, engraving, Oxford, Ashmolean Museum, Douce Portfolio 142, no. 294. Photo: Ashmolean Museum.

in the Basle Historical Museum (Figure 16.2)[15] from the perspective of a childhood recollection of the Basle physician Felix Platter (1536–1614). Finances always remained an issue with his parents, who overcame poverty-stricken backgrounds to raise their family in adequate circumstances. The recollection, one of several imprecisely datable episodes woven together into a single coherent narrative by Valentin Lötscher's editorial rearrangements of Platter's childhood memories, records his mother's anger after he returned, aged about ten, from Basle's annual fair, having squandered a coin he had been tasked with spending on a useful dagger, on a doll and other foolish trinkets. Fairground trinkets that caught Platter's interest as a child included biscuit moulds:

> At the Basle Fair, someone was selling moulds of the type used for pressing out gingerbread biscuits, on a stall on the Cornmarket. Being eager to examine these artistic objects, I stood there and touched one, at which the old wretch ripped the wooden mould from my hand and threw it so hard at my face that I thought he had knocked my teeth out, grabbed back the mould and threw it high over all the stalls that had been set up. He chased after me as I ran away, returning home with a thick lip. My mother was angry with the trader, went down in the morning, reprimanded him as an old degenerate. He replied with insults, wanted to be paid for his mould, which broke when he threw it.[16]

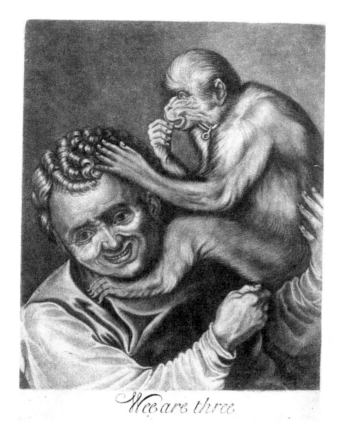

Figure 16.6 English, after Annibale Carracci, *Wee Are Three*, early eighteenth century, mezzotint, London, British Museum (BM.2010,7081.343). @ British Museum.

Around a decade later, on 27 October 1557, twenty-year-old Felix hid for three hours in the bitterly cold attic of his future father-in-law, in order to be the first to greet his fiancé Madlen Jeckelmann with the traditional Basle cry of 'kromen mir' ('Give me a fairing!'), when the city's bells announced the fair's official opening at midday, and to exchange gifts when she in turn emerged from her hiding place.[17] This was the Basle custom of exchanging gifts on the first day of the annual fair, and modest wooden biscuit moulds, of the type depicted in Figure 16.2, represented one of a whole host of attractively decorated little household goods on offer to local people for exactly this purpose.

The earliest images in the 'We Three' tradition date to around the 1590s. They include not only cheap prints but also coloured friendship album drawings recording the standard highlights of early modern Northerners' Italian travels, including two that show a pair of fighting fools, directly recalling the above-quoted description by Gerard de Malynes.[18] One defining characteristic of 'We Three' images is that they require an explanatory text to explicate their link to the 'We Three' theme. Like emblems, they are

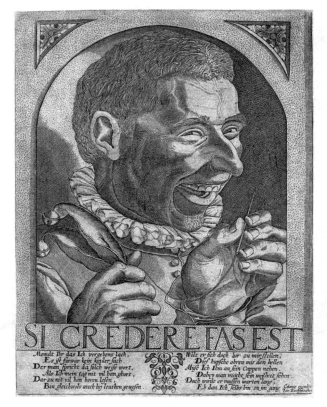

Figure 16.7 Matthias Quad (published by Johann Bussemacher), *Si credere fas est* (You don't say!), ca. 1588, London, British Museum (BM.1874,1010.237). @ British Museum.

only fully accessible to those at least moderately literate. In fact, at least one group of compositionally related prints in this tradition does explicitly mock illiterates.

The Thames bargeman-turned-celebrity 'water-poet' John Taylor identified with, and wrote for, non-elites. His cordial relations with many of the players and writers who habitually crossed the Thames, to frequent London's South Bank theatres, are a characteristic feature of his carefully cultivated literary image. His awareness of the 'We Three' formula is demonstrated in his lengthy poem of 1622, on the two leather wine bottles he formerly collected as toll from ships entering London:

> Plaine home-spun stuffe shall now proceed from me,
> Much like vnto the Picture of wee Three [. . .]
> My bottles and my selfe did oft agree,
> Full to the Top, all merry came Wee three [. . .]
> And to close vp this point, I say in briefe,
> Who byes it is a Begger, or a Thiefe,

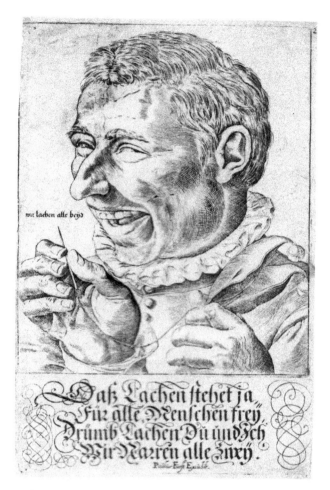

Figure 16.8 Paulus Fürst of Augsburg (after Matthias Quad), *Wir lachen alle beijd* (We are both laughing), ca. 1640, engraving, Nürnberg, Germanisches Nationalmuseum (HB 16702, Kapsel 1293). Photo: Germanisches Nationalmuseum.

> Or else a Foole, or to make all agree,
> He may be Foole, Thiefe, Begger, All the Three.
> So you false Bottles, to you both adieu,
> The Thames for mee, not a Denier for you.[19]

Confirming the 'We Three' connection, Taylor's *marginalium* notes that 'b: The picture of 2. fooles, & the third looking on, I doe fitly compare with the two black Bottles and my selfe'.

Taylor crossed the channel more than once to visit his brother William, one of a troupe of professional English musicians and actors based at the North German court

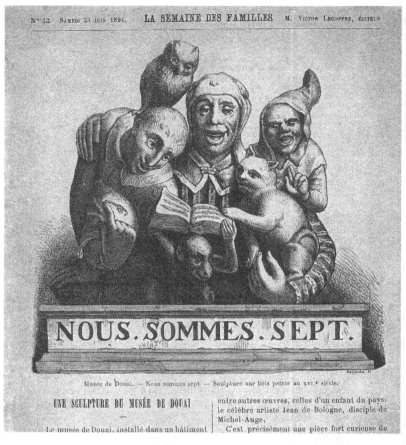

Figure 16.9 French, *Nous sommes sept* (We are seven), pre-1550 (carving) and post-1660 (paintwork, including inscription). The original painted carving depicted in this engraving is in Douai (Musée de la Chartreuse). Photo: Musée de la Chartreuse.

of Bückeburg. William accompanied John to a Habsburg court festival at Prague, and introduced him to expatriate English performers, including the troupe leader Thomas Sackville, with whom the brothers stayed in Wolfenbüttel in September 1620.[20] Evidence suggesting that John Taylor knew European popular prints in the 'We Three' tradition comes from a lost publication, *Wee bee seaven*, known from a Stationer's Register entry of 8 March 1637, identifying him as its author.[21] This was reissued as the anonymous pamphlet *Tvrne over behold and wonder*, of which the British Library copy is dated 'March 3 1654' in manuscript.[22] Its unsophisticated verses directly address semi-illiterate readers:

[. . .] And this much may be learn'd in Natures schoole
Tis better to be Borne than made a foole.

Thus every man that lives one way or other
Doth make our number seaven, and proves our Brother;
[. . .] The Race of man to folly being subject,
And in one Poynt or other Fortunes abject.
For why if any men have Earthly Rest,
Tis onely We that are Right fooles profest.
Thus welcome Brother whosoere thou art
If thou will make us seaven, weele take thy part.

The title-page woodcut *Wee bee seaven* (Figure 16.3) is one of a large subgroup of 'We Seven' and 'We Ten' variants, in the 'We Three' tradition, including French, German, Italian and multilingual prints, of which three are here reproduced (Figures 16.3–16.5).[23] They depict three foolish types, with or without foolish animals or birds perched on their heads, riding three foolish mounts – asses or donkeys, often sharing one head. A German-language 'We Four' print is a late variant explicitly ridiculing illiterates, aimed at those who need to have it spelled out to them in wearisome detail that they themselves are the missing fool (Figure 16.5). Its text targets those for whom reading was a slow and laborious task generally undertaken only out loud, in company, and directly addresses educationally disadvantaged readers. Having informed the reader that the image depicts four asses with one head, the text labels the reader a fool by identifying him as the missing fourth ass, an animal strongly associated with folly and foolishness. For good measure, the text mocks its reader even further, by pointing out that if he had not read it, then he would have been spared the embarrassment of being branded an ass:

My friend if you want to stop and stand here
You can see four asses with one head
Who are you looking for? You yourself are the fourth
Who completes our asses' heads
And if you hadn't read out these verses
You wouldn't have been an ass.[24]

Surprisingly, numerous images were retrospectively brought into the 'We Three' tradition, either through compositionally close variants or through modification of the original image. A widely circulated print by Jacques Callot forms the basis for a 'We are Four' image in a coloured friendship album drawing of 1643.[25] The title-page print of Pieter Jansz. Quast and Hendrijk Hondius's print series of 1638, *De vijf zintuigen* (The Five Senses), was the compositional source for another album picture, one of 1696 by the professional artist Gregorius Schünemann, in the album of his respected patron, the Basle goldsmith Johann Heinrich Schrotberger.[26] Quast's original print shows a fool with a marotte that closely resembles him, holding a scroll reading *Vijf sinen te koop* (Five senses for sale). In Schünemann's version, the scroll spells 'unser sind 3' (We are three). Schünemann has also added four couplets of accompanying verse, which conclude by directly addressing their reader and drawing him into the band of fools: 'Look, you are our third!'[27]

A category of retrofitted images much more economically significant than such friendship album drawings aimed at targeting a new market of poorer and less sophisticated purchasers, by appropriating the 'We Three' tradition to refresh and recycle older images. One example is an early eighteenth-century English mezzotint, *Wee are three* (Figure 16.6), based directly or via an intermediate image, on a painting of ca. 1588–90 by Annibale Carracci (1560–1609), depicting a monkey balanced on the shoulder of a young man, whose hair he is picking through for nits.[28] This elite painting entered the Uffizi Gallery via the Medici family collections. The print coarsens every aspect of its composition, flattening Carracci's subtle psychological and physical interplay between ape and human, to produce an easily read variant with one clear narrative, deliberately designed for consumption by the educationally disadvantaged.

The previous examples focus on prints influencing drawings, and on a painting (directly or indirectly) influencing a print. More usually, prints directly influenced prints. The single laughing fool of Matthias Quad's print of ca. 1588, *Si credere fas est* ('You don't say!' Figure 16.7), berates his reader for his foolish talk and offers to sew asses' ears onto his cap. Some half-century later, by virtue of a replacement text and new caption: *We are both laughing*, Paulus Fürst's derivative reverse engraving of ca. 1640 draws Quad's laughing fool into the 'We Three' tradition (Figure 16.8). Within the 'We Three' context, Quad's distinctive head is also recycled in *Novs soms cinq*, a print featuring four half-length figures with a French text,[29] itself based on an earlier 'We Three' version, known by at least two variants, one with a German, and the other with a bilingual German and French text.[30] *Novs soms cinq* flanks its foolish couple with two fools, the one on the right closely based on Quad's.

My concluding examples appear to have been brought into the 'We Three' tradition through direct modification of the original image. They include a variant of *Head of a reveler*, an undated engraving signed in the plate by the Netherlandish artist Philips Galle (1537–1612).[31] The variant, which modifies the original engraver's plate with the addition of four rhyming couplets, has been published as 'an anonymous German engraving of c.1600', and interpreted as a complex example of the 'We Three' tradition.[32] I read the variant rather as an unproblematic image in the 'We three' tradition, with the reader supplying the missing second fool.[33]

Another example probably best explained by direct modification is provided by the only picture widely referred to in the context of Shakespearean occurrences of the 'We Three' tradition, the Shakespeare Birthplace Trust's painted panel *Wee three Loggerh[ea]ds*. There are no published instances of the term 'loggerhead' in the 'We Three' tradition from Shakespeare's lifetime, and our knowledge of the precise textual history of *Twelfth Night*, the only Shakespeare play whose connection to the 'We Three' tradition is universally recognized, does not predate its posthumous first publication in 1623. The Stratford painting shows two court fools, one holding a folly-stick. Its composition draws heavily on the influential early sixteenth-century Northern iconographic traditions of fools and folly, typified by prints such as Heinrich Vogtherr the Elder's *Court Fool* of ca. 1540,[34] which also influenced 'We Three' images such as the Basle biscuit mould (Figure 16.2). Some specialists question the Stratford painting's traditional dating to the reign of James I, dating it instead to the reign of Charles I,[35] or even later, to ca. 1650.[36] As they note, the original paint surface of *Wee three Logger-h[ea]ds*

shows evidence of later over-painting. This points to a likely dual dating of image and text, supporting the traditional dating of the Stratford painting, supplemented with a later inscription situating it directly within the 'We Three' tradition.[37]

The final example is even more problematic. This worm-damaged and fragile woodcarving, the sole image of multiple foolish characters associated with the *We three* tradition habitually dated by specialists to well before 1600 (Figure 16.9),[38] was found in a Picardian monastery. Its back is untreated, strengthened with a modern support and fitted with a modern hanging hook; its front carries a single badly discoloured layer of paint over a thick white preparatory layer, and covered by various partial layers of varnish. It shows six figures on a wooden plinth: three humans, an owl and a cat, all singing to notes in a music book supported by a monkey. Specialists variously date this carving, now in Douai, to either the thirteenth,[39] the thirteenth or fourteenth,[40] the early fourteenth,[41] the fifteenth or sixteenth,[42] probably the early sixteenth[43] or the sixteenth century.[44] They cite the painted inscription on its plinth, 'Nous sommes sept', as proof that it was created in the 'We Three' tradition before 1600. The comic choir was a popular late medieval composition. Examples outside the 'We Three' tradition include certain works by and after Hieronymus Bosch, and an unpainted English carved wood misericord depicting two fools playing two cats as bagpipes.[45] My own detailed examination of the Douai carving confirms that, excluding its modern support, the wood of its figural group and plinth is all of a comparable venerable age, and that all its paintwork (plinth inscription included) was applied at around one date. Furthermore, it highlights previously unnoticed discrepancies between the cut of the costume, which is compatible with that of the medieval fool, and its style of colouration, some of which is not. The decoration of the distinctive jacket of the Douai carving's central figure resembles that worn by the *commedia dell'arte* inspired stage clown in a late seventeenth-century engraving by Nicolas Bonnart, none of whose hand-coloured examples, however, feature the distinctive Douai colour scheme.[46]

Early 'We Two' and 'We Three' images, such as the Nördlingen stone relief (Figure 16.1) or the Basle biscuit mould (Figure 16.2), represent a transitional phase connecting the late medieval trope of the single fool and his folly-stick or mirror with the increasingly elaborate 'We Three' iconography from the seventeenth century onwards, depicting as many as seven, or even nine, 'foolish' animals and humans (Figures 16.3–16.5). Many images are imported into the 'We Three' tradition by adaptation (Figures 16.6–16.9). The paintwork of the Douai carving (Figure 16.9) challenges specialists with the enigma of an image conceived and created by its original sculptor in the *We three* tradition decades, perhaps centuries, before any of this tradition's other known images of multiple fools. My examination of the original confirms that the Douai carving itself is medieval, and suggests that it is in fact yet another example of an image modified and refreshed with reference to the 'We Three' tradition, and that its paintwork considerably postdates its late medieval woodwork. If Bonnart's widely circulated late seventeenth-century print (or a variant) influenced the carving's painter, then all its paintwork – including its painted inscription – postdates the mid-seventeenth century.

Once the 'We Three' iconography multiplied the predictable single fool, with or without folly-stick, of early images (Figures 16.1–16.2), its message could no longer be conveyed purely visually. Explanatory text became obligatory, turning these images into

emblems, and providing rich opportunities to mock those who struggled to read their text (Figure 16.4). During the early modern period, the 'We Three' tradition continually drew on and fed into traditions that were both medieval and contemporary, popular and elite, secular and religious; inhabiting a network of transnational cultural interchanges with complex intertwined textual and iconographic strands. Printmakers and others appropriated existing images outside the tradition to tweak and repackage them into the 'We Three' tradition, specifically to appeal to a new market of less economically and educationally advantaged consumers (Figures 16.6, 16.8 and 16.9). This process of what I define as cross-cultural retrofitting is here situated as a significant, previously under-recognized trend in the 'We Three' tradition. In a very real sense, images in the 'We Three' tradition include a significant category of art for the poor.

Notes

Introduction

1 Aby Warburg, Christopher D. Johnson and Claudia Wedepohl, 'From the Arsenal to the Laboratory', *West 86th* 19, no. 1 (Spring–Summer 2012): 106–24, esp. 115–16.
2 Donald Brown, *Human Universals* (New York: McGraw Hill, 1991).
3 William Morris, 'The Art of the People', in *Hopes and Fears for Art* (London: Ellis & White, 1882), 38–70, esp. 58.
4 Charles L. Hutchinson, 'The Democracy of Art', *The American Magazine of Art* 7, no. 10 (August 2016): 397–400, esp. 397.
5 A. H. Church, *English Earthenware* (London: Chapman & Hall, 1884), 11; R. L. Hobson, *A Guide to the English Pottery and Porcelain in the Department of British and Mediaeval Antiquities* (British Museum; Oxford: Oxford University Press, 1910), 5 (both cited by Jacqui Pearce in this volume).
6 See, indicative, Tom Nichols, *The Art of Poverty: Irony and Ideal in Sixteenth-Century Beggar Imagery* (Manchester and New York: Manchester University Press, 2007); Tom Nichols (ed.), *Others and Outcasts in Early Modern Europe. Picturing the Social Margins* (Aldershot: Ashgate, 2001); Peter van der Coelen, Alexandra van Dongen, Friso Lammertse, Lucinda Timmermans and Matthias Ubl, *De ontdekking van het dagelijks leven. Van Bosch tot Bruegel* (exhibition catalogue; Rotterdam: Museum Boymans-Van Beuningen, 2015).
7 The rhetorical 'no' is from Marina Belozerskaya, *Luxury Arts of the Renaissance* (Los Angeles: The J. Paul Getty Museum, 2005), 5: 'There is no such thing as poor man's art in the Renaissance.' The exhibition *At Home in Renaissance Italy*, held at the Victoria & Albert Museum in 2006, took the cautious approach; it included a few relevant objects and an admission that we know relatively little on the subject. Marta Ajmar-Wollheim and Flora Dennis (eds), *At Home in Renaissance Italy* (exhibition catalogue; London: V&A Publications, 2006). Samuel Cohn points out that documents reveal there to have been more art among people of lower classes than we might have guessed. See S. Cohn, 'Renaissance Attachment to Things: Material Culture in Last Wills and Testaments', *Economic History Review* 65, no. 3 (2012): 984–1004.
8 Pierre Bourdieu, *Distinction: A Social Critique of the Judgement of Taste* (New York and London: Routledge, 1984).
9 Virginia Nixon, 'Producing for the People: Late Medieval Assumptions about the Process of Reading Art Works', in *Le petit peuple dans l'Occident medieval*, ed. P. Boglioni, R. Delort and C. Gavard (Paris: Éditions de la Sorbonne, 2002), 617–31.
10 Martin Ravillion, *The Economics of Poverty. History, Measurement, and Policy* (Oxford: Oxford University Press, 2016).
11 See, indicative, Bronislav Geremek, *Poverty: A History* (Oxford: Oxford University Press, 1974); Michel Mollat, *Les Pauvres au Moyen âge. Étude sociale* (Paris: Hachette, 1978); Robert Jutte, *Poverty and Deviance in Early Modern Europe* (Cambridge: Cambridge University Press, 1994); Ph. Braunstein, 'La pauvreté au quotidian.

Apports et limites des sources médiévales', in *Les niveaux de vie au Moyen Âge. Mesures, perceptions et représentations, Actes du colloque international de Spa, 21-25 octobre 1998*, ed. J.-P. Sosson, C. Thiry and S. Thonon (Louvain-La-Neuve: Bruylant-Academia, 1999), 91–103; C. Gavard, 'Le petit peuple au Moyen Âge. Conclusions', in *Le petit peuple dans l'Occident médiéval, Actes du Congrès international, Université de Montréal, 18-23 octobre 1999*, ed. P. Boglioni, R. Delort and C. Gauvard (Paris: Publications de la Sorbonne, 2002), 707–22; A. Scott and C. Kosso (eds), *Poverty and Prosperity in the Middle Ages and Renaissance* (Turnhout: Brepols Publishers, 2012); and D. Smail, 'La culture matérielle des pauvres à Lucques au XIVe siècle', in *La culture matérielle. Un objet en question*, ed. L. Bourgeois, D. Alexandre-Bidon, L. Feller, P. Mane, C. Verna and M. Wilmart (Caen: Presses Universitaires de Caen, 2018), 203–13.

12 A useful summary can be found in Christopher Dyer, 'Poverty and Its Relief in Late Medieval England', *Past and Present* 216 (August 2012): 41–78. See also Marjorie Keniston McIntosh, *Poor Relief in England, 1350-1600* (Cambridge: Cambridge University Press, 2011).

13 http://www.unesco.org/new/en/social-and-human-sciences/themes/international-migration/glossary/poverty/ (accessed 11 June 2019).

14 https://blogs.worldbank.org/developmenttalk/international-poverty-line-has-just-been-raised-190-day-global-poverty-basically-unchanged-how-even (accessed 11 June 2019).

15 https://researchbriefings.parliament.uk/ResearchBriefing/Summary/SN07096 (accessed 11 June 2019).

16 R. A. Goldthwaite, *The Building of Renaissance Florence: An Economic and Social History* (Baltimore and London: Johns Hopkins University Press, 1980), 348.

17 Ibid., 430 and 436–7: an unskilled worker earned 9.9 silver *soldi* per day at a conversion rate of 77:1 for the gold florin in 1400 (32 florins a year at full employment in a working year of 250 days), and 9.3 *soldi* per day at a conversion rate of 140:1 in 1500 (17 florins a year at full employment). The inflation of the silver *lira* between 1400 and 1500 meant that nominal wages dropped compared to the value of the gold florin, but their purchasing power in terms of everyday goods did not diminish as significantly.

18 D. Herlihy and C. Klapisch-Zuber, *Les Toscans et leurs familles. Une Étude du catasto florentin de 1427* (Paris: Presses de la Fondation nationale des Sciences politiques, 1978), 250–1.

19 Economic historian Peter Spufford states that it has been 'estimated that a quarter of the inhabitants [of late medieval cities] . . . were normally destitute. . . . This is not very different from the 30 per cent or so below the poverty line in less developed countries today.' P. Spufford, *Power and Profit: The Merchant in Medieval Europe* (London: Thames & Hudson, 2002), 88.

20 The Florentine *catasto* officials assessed income as a fixed return (7 per cent) on assets. See Raymond De Roover, *The Rise and Decline of the Medici Bank* (Cambridge, MA: Harvard University Press, 1963), 25. By this standard, the curve of income distribution in Florence would be shaped identically to the Lorenz curve of asset distribution drawn by Herlihy and Klapisch-Zuber (see above, note 17). Within the curve, only people with non-zero assets would have had a non-zero income – the segment of the curve between 40 per cent and 100 per cent of

the population on the horizontal axis. One-third of this non-zero income curve (equivalent to 60 per cent of the median) corresponds roughly to 70 per cent of the population on the horizontal axis (a group that owned a total of just 10 per cent of total assets).

21 Goldthwaite argues that skilled workers in the building industry 'could remove themselves from the poverty level if they could work full time'. A skilled construction worker earned 16.2 *soldi* per day in 1400 (more than twice as much as an unskilled labourer) and 14.5 *soldi* per day in 1500 (ca. 1.5 times as much as an unskilled labourer); see Goldthwaite, *The Building of Renaissance Florence*, 348 and 437–38.

22 G. Brucker (ed.), *The Society of Renaissance Florence: A Documentary Study* (Toronto: University of Toronto Press, 1998), 214–16.

23 See the discussion in Herlihy and Klapisch-Zuber, *Les Toscans et leurs familles*, 250–1.

24 Brucker, *The Society of Renaissance Florence*, 216.

25 Leopold D. Ettlinger, *Antonio and Piero Pollaiuolo* (Oxford: Phaidon and New York: Dutton, 1978), 29.

26 Ronald Lightbown, *Sandro Botticelli* (London: Elek, 1978), vol. 1, 15.

27 As based on Giorgio Vasari, *Le vite de' più eccellenti pittori scultori e architettori. Nelle redazioni del 1550 e 1568*, ed. R. Bettarini and P. Barocchi, 6 vols (Florence: S.P.E.S., 1966-present).

28 A recent and successful example of a survey of Renaissance art remaining within the traditional framework is J. T. Paoletti and G. M. Radtke, *Art in Renaissance Italy* (London: Laurence King Publishing, 1997). Course books on Renaissance art adopting a wider range of different approaches were published by the Open University under the title *Renaissance Art Reconsidered* in 2007. See Carol M. Richardson, Angeliki Lymberopoulou and Kim Woods (eds), *Making Renaissance Art* (London and New Haven: Yale University Press, 2007); Carol. M. Richardson (ed.), *Locating Renaissance Art* (London and New Haven: Yale University Press, 2007); Carol M. Richardson and Kim Woods (eds), *Viewing Renaissance Art* (London and New Haven: Yale University Press, 2007).

29 M. Belozerskaya, *Rethinking the Renaissance. Burgundian Arts across Europe* (Cambridge: Cambridge University Press, 2002); Belozerskaya, *Luxury Arts of the Renaissance*.

30 Ajmar-Wollheim and Dennis, *At Home in Renaissance Italy*.

31 In 1990, Hans Belting argued that the Middle Ages only knew functional images and the notion of 'art' only arose in Italy from the fourteenth century onwards. See Hans Belting, *Bild und Kult. Eine Geschichte des Bildes vor dem Zeitalter der Kunst* (Munich: Beck, 1990). An early exhibition project to follow Belting's line is Henk van Os, *The Art of Devotion the late Middle Ages in Europe, 1300-1500* (exhibition catalogue; London, Merrell Holberton, 1994). See also, indicative, Richard Marks, *Image and Devotion in Late Medieval England* (Stroud: Sutton Publishing Ltd, 2004).

32 Anabel Thomas, *The Painter's Practice in Renaissance Tuscany* (Cambridge and New York: Cambridge University Press, 1995), 310.

33 Ajmar-Wollheim and Dennis, *At Home in Renaissance Italy*, 28–9 and 369 (cat. no. 263).

34 Van der Coelen et al., *De ontdekking van het dagelijks leven*.

35 On this work, see Mark. A. Meadow, *Pieter Bruegel the Elder's* Netherlandish Proverbs *and the Practice of Rhetoric* (Zwolle: Waanders, 2002).

36 Walter S. Gibson, *Pieter Bruegel and the Art of Laughter* (Berkeley and Los Angeles:
 University of California Press, 2006), 73–4 observes that 'Bruegel's known patrons
 . . . seem to have been wealthy men who were prominent in public life. They included
 Cardinal Granvelle. . . . Another patron was Niclaes Jonghelink, a very well-to-do
 Antwerp businessman.'

37 Thorstein Veblen classified the education in taste as an essential part of the
 'conspicuous consumption' of the rich. See Thorstein Veblen, *The Theory of the Leisure
 Class*, ed. R. Lechakman (New York: Penguin, 1994 [first edition published 1898]).
 Bourdieu classifies education as non-economic capital, but highlights its importance
 in social distinction between rich and poor. See Bourdieu, *Distinction*.

38 In 1831, the site of the National Gallery in London was deliberately chosen at the
 newly created Trafalgar Square, because it provided access in equal measure to
 the West End rich and the East End poor. See Neil MacGregor, 'A Pentecost in
 Trafalgar Square', in *Whose Muse? Art Museums and the Public Trust*, ed. James Cuno
 (Princeton and Cambridge: Princeton University Press, 2004), 30.

39 The idea that the peasants are ignoring the tree shrine comes from F. Grossman,
 Pieter Bruegel: Complete Edition of the Paintings (London: Phaidon 1973), 201, and has
 since been popularized in other publications and on the internet, including https://en
 .wikipedia.org/wiki/The_Peasant_Dance (accessed 4 August 2019). For an alternative
 reading, see Stephanie Porras, 'Rural Memory, Pagan Idolatry: Pieter Bruegel's Peasant
 Shrines', *Art History* 34, no. 3 (June 2011): 486–509.

40 The sixteenth-century Netherlandish art theorist, Karel van Mander, commented on
 Brueghel's accuracy in rendering peasant costumes. See Gibson, *Pieter Bruegel and the
 Art of Laughter*, 99. On Brueghel and rural material culture, see also Van der Coelen
 et al., *De ontdekking van het dagelijks leven*.

41 J. van der Stock, *Printing Images in Antwerp: The Introduction of Printmaking in a City.
 Fifteenth Century to 1585* (Rotterdam: Sound & Vision Interactive, 1998), 118.

42 John Munro, 'Money, Wages, and Real Incomes in the Age of Erasmus: The
 Purchasing Power of Coins and of Building Craftsmen's Wages in England and the
 Southern Low Countries, 1500 – 1540', in *The Correspondence of Erasmus*, vol. 12,
 Letters 1658 – 1801, ed. Alexander Dalzell and Charles G. Nauert (Toronto: University
 of Toronto Press, 2003), 551–699, table 13.

43 The reproductive nature of printmaking, in fact, put the entirety of this art form
 on the wrong side of the equation of Walter Benjamin's famous argument about
 'The Work of Art in the Age of Mechanical Reproduction', that is with the 'soul-less'
 output of machinery rather than the inspired intellectual creations of individual
 artists, casting doubt on whether printing is indeed fully deserving of being called
 an 'art'. While popular in the discourse of art in the twentieth century, Benjamin's
 thesis is of limited validity for historical application; Peter Parshall has argued that
 it is a 'complex, somewhat uncharacteristic, sometimes frustratingly contradictory'
 argument that is by and large 'responding to contemporary events'. See Peter
 Parshall, 'The Modern Historiography of Early Printmaking', *Studies in the History
 of Art* 75 (2009): 9–15, esp. 12. We could add to this point that if used historically,
 Benjamin's distinction inevitably becomes one between elite production for those who
 could afford distinctive pieces by highly rated masters and those whose purse only
 allowed them access to works of a serialized and therefore less expensive process of
 manufacture.

44 Peter Schmidt, 'The Multiple Image: The Beginnings of Printmaking, between Old
 Theories and New Approaches', in *Origins of European Printmaking: Fifteenth-Century*

Woodcuts and Their Public, ed. Peter Parshall and Rainer Schoch (New Haven and London: Yale University Press, 2005), 37–56, esp. 41.

45 On the beginnings of upmarket glass production, see Luke Syson and Dora Thornton, *Objects of Virtue: Art in Renaissance Italy* (Los Angeles: The J. Paul Getty Museum, 2001).

46 Stephanie Porras, 'Producing the Vernacular: Antwerp, Cultural Archaeology and the Bruegelian Peasant', *Journal of Historians of Netherlandish Art* 3, no. 1 (2011): https://jhna.org/articles/producing-vernacular-antwerp-cultural-archaeology-bruegelian-peasant/ (accessed 7 August 2019).

47 See https://collections.museumoflondon.org.uk/online/object/34860.html (accessed 7 August 2019).

48 Felix Platter, *Tagebuch* (Basel and Stuttgart: Schwabe, 1976), 106, as cited by M. A. Katritzky in this volume. The original German term used by Platter is 'kunststuck', which at the very least would seem to indicate an object made with a degree of artifice.

Chapter 1

1 K. I. Bos, et al. 'Pre-Columbian Mycobacterial Genomes Reveal Seals as a Source of New World Human Tuberculosis', *Nature* 514, no. 7523 (2014): 494–7. To be sure, the old view was already contested, as with Massimo Livi-Bacci, *Conquest: The Destruction of the American Indios* (Cambridge: Polity Press, 2008), however, not with the epidemical record now being constructed from phylogenetic sequencing.

2 Here, much more has been achieved for the early modern period in the north of Europe. For the late Middle Ages the investigation has been with possessions in general; see Maria Serena Mazzi, 'Gli inventari dei beni: storia di oggetti e storia di uomini', *Società e storia* 7 (1980): 203–14; Maria Serena Mazzi and Sergio Raveggi, 'Masserizie contadine nella prima metà del quattrocento: alcuni esempi del territotio fiorentino e pistoiese', in *Civiltà ed economia agricola in Toscana nei secc. XIII-XV: Problemi della vita delle campagne nel tardo medioevo (Pistoia, 21-24 aprile 1977)* (Pistoia: Centro italiano di studi di storia e d'arte Pistoia, 1981), 169–97; Maria Serena Mazzi and Sergio Raveggi, *Gli uomini e le cose nelle campagne fiorentine* (Florence: L.S. Olschki, 1983). For the early modern period, see Isabella Palumbo-Fossati, 'L'interno della casa dell'artigiano e dell'artista nella Venezia del Cinquecento', *Studi veneziani* 8, n. s. (1966): 109–53; Barbara Bettoni, *I beni dell'agiatezza: stili di vita nelle famiglie bresciane dell'età moderna* (Milan: FrancoAngeli, 2005); Alessandra Tessari, *Trasferimenti patrimoniali e cultura materiale nella Puglia del primo Settecento: Monopoli 1721-1740* (Bari: Cacucci, 2007); Renata Ago, Bradford Bouley, Corey Tazzara and Paula Findlen, *Gusto for Things: A History of Objects in Seventeenth-Century Rome* (Chicago: University of Chicago Press, 2013). On inventories north of the Alps, see Stana Nenadic, 'Middle-Rank Consumers and Domestic Culture in Edinburgh and Glasgow 1720–1840', *Past and Present* 145 (1994): 122–56; and Inneke Baatsen, *A Bittersweet Symphony: The Social Recipe of Dining Culture in Late Medieval and Early Modern Bruges (1438-1600)* (PhD thesis, University of Antwerp, 2016).

3 Archivio di Stato di Firenze (hereafter, ASF), *Diplomatico* (hereafter, *Dipl.*), S. Maria Nuova, 21 September 1323.

4 ASF, Dipl., Ospedale di Santa Maria Nuova, 24 August 1368. For an excellent description of late medieval testamentary art commissions, primarily from Lucca, as legally binding contracts, see Michele Bacci, '*Pro remedio animae': Immagini sacre e pratiche devozionali in Italia centrale (secoli XIII e XIV)* (Pisa: GISEM – edizioni ETS, 2000), especially chapters IV, 'Immagini come strumenti di salvezza: opere d'arte e lasciti testamentari', 227–328; and V, 'Dalle volontà testamentarie all'opera finita', 329–430.

5 ASF, Dipl., Olivetani di Arezzo, 1348 (day and month not specified). For the increase in deathbed commissions and their penetration down the social ladder, see Samuel Cohn, 'Piété et commande d'oeuvres d'art après la Peste Noire', *Annales: Histoire, Sciences sociales* 51, no. 3 (1996): 551–73.

6 In 1412, a week's salary for an unskilled worker was 10 *soldi*, the equivalent of around 12 florins a year. See Gene Brucker, *The Civic World of Early Renaissance Florence* (Princeton: Princeton University Press, 1977), 322. In 1385, the annual salary of the Lucchese doctor Coluccino Bonavia was 40 florins. See *Il Memoriale di Iacopo di Coluccino Bonavia Medico Lucchese (1373-1416)*, ed. Pia Pittino Calamari, in *Studi di Filologia Italiana*, 24 (1966): 55–428, esp. 209.

7 ASF, *Notarile antecosimiano* (hereafter, Not. antecos.), 5880, 131r, 23 August 1371. His largest gift, of only six itemized bequests, amounted to a mere 10 lire, and the dowries bequeathed to his three daughters were extraordinarily small, 1 florin a piece.

8 Archivio di Stato di Perugia, *Notarile Protocolli,* 22, 110r-v, 26 June 1400.

9 Despite the specificity of chosen saints and other characteristics of their planned compositions found in many of these post-mortem commissions, I have found only one artist named, Giotto di Bondone, in the long will of the *'Discretus vir' Ricchuccius filius quondam Puccii* from the Florentine parish of Santa Maria Novella, redacted in 1312. In fact, Ricchuccius mentioned Giotto twice, once in a gift to supply oil annually to illuminate a painting by Giotto in the parish 'populo' of Santa Maria Novella as opposed to the sections reserved for the Dominican friars, and then as a commission for 'a beautiful panel painting' executed by the 'egregum pictorem' from whom this testator had previously commissioned in the Dominican friary at Prato; ASF, *Dipl.*, Santa Maria Novella, 15 June 1312.

10 Evidence of increases in land ownership in nearby villages by artisans or even several disenfranchised workers in the wool industry can be seen in notarial books such as those of the Mazzetti family from 1348 to 1426 in villages around Sesto; see Samuel Cohn, *Creating the Florentine State: Peasants and Rebellion, 1348-1434* (Cambridge: Cambridge University Press, 1999), 102–4.

11 In late medieval Tuscany, an ironmonger was a craftsman or a small shopkeeper and in Florence, a minor guildsman.

12 ASF, Dipl., Archivio Generale, 13 October 1416.

13 Archivio Capitolare, Arezzo, Testamenta Ser Johanne Cecchi, 3r, 6 January 1389.

14 Archivio di Stato, Perugia, Pergamene, Monte Morciano, 335, 29 July 1411.

15 ASF, Not. antecos., 20833, n. p., 11 July 1348.

16 Emmanuel Le Roy Laduire, *Les paysans de Languedoc,* 2 vols (Paris: S.E.V.P.E.N, 1966).

17 See for instance David Herlihy, 'Santa Maria Impruneta: A Rural Commune in the Late Middle Ages', in *Florentine Studies: Politics and Society in Renaissance Florence*, ed. Nicolai Rubinstein (London: Faber, 1968), 246–76, esp. 276; Richard A. Goldthwaite, 'I prezzi del grano a Firenze dal XIV al XVI secolo', *Quaderni Storici* 28 (1975): 5–36; Richard A. Goldthwaite, *The Economy of Renaissance Florence* (Baltimore: Johns Hopkins University Press, 2009); Christopher Dyer, *Standards of*

Living in the Later Middle Ages: Social Change in England c.1200-1520 (Cambridge: Cambridge University Press, 1989); David Herlihy, *The Black Death and the Transformation of the West*, ed. Samuel Cohn (Cambridge, MA: Harvard University Press, 1997), chapter 2: 'The New Economic and Demographic System', 39–57.

18 Guido Alfani and his équipe, based at Bocconi University, Milan, funded by a European Research Council grant, on pre-industrial inequalities in Europe 'EINITE', November 2012–16; see, for instance, Guido Afani, 'Economic Inequality in Northwestern Italy: A Long-Term View (Fourteenth to Eighteenth Centuries)', *The Journal of Economic History* 75, no. 4 (2015): 1058–96; Guido Alfani and Wouter Ryckbosch, 'Growing Apart in Early Modern Europe? A Comparison of Inequality Trends in Italy and the Low Countries, 1500–1800', *Explorations in Economic History* 62 (2016): 143–53; and Guido Alfani and Matteo Di Tullio, *The Lion's Share: Inequality, Poverty and the Fiscal State in Preindustrial Europe* (Cambridge: Cambridge University Press, 2019).

19 For the period from 1910 to 2010, see Thomas Piketty, *Capital in the Twenty-first Century*, trans. Arthur Goldhammer (Cambridge, MA: Harvard University Press, 2014). The next longest period we know of in the West when the gap between rich and poor narrowed was from ca. 1911 to 1973.

20 My samples, in Samuel Cohn, *The Cult of Remembrance and the Black Death: Six Renaissance Cities in Central Italy* (Baltimore: Johns Hopkins University Press, 1992), comprised six cities and totalled 3,226 testaments. For the present study, however, I was unable to review the evidence from Siena that I had collected in the early 1980s, because those files had become corrupted and were no longer readable.

21 See note 16 and Susan Mosher Stuard, *Gilding the Market: Luxury and Fashion in Fourteenth-Century Italy* (Philadelphia: University of Pennsylvania Press, 2006).

22 In composing charts 1.1 and 1.2, various terms had to be operationally defined. First, art was seen with requests to (a) construct chapels, monumental graves, monasteries, churches or hospitals; (b) paintings which described the figures to be included and details of composition; (c) priestly vestments, altar cloths, grave stones, coats of arms, candles and candleholders, but only if figures were specified to be embroidered, sculpted or painted. Second, elites are defined as possessing family names or titles 'Dominus' ('Messer') or 'Ser' (unless a parish priest), along with the children or wives of men so identified. In addition, certain occupations such as iudex, canonicus, mercator and upper-guild professions were considered as elite indications. Third, commoners were defined as those identified by occupations that designated crafts or trades as with masons, carpenters, cobblers, butchers, skilled and lesser-skilled occupations in textiles, or who came from villages and were identified by only a single patronymic. The grey region of testamentary commissioners of art, who possessed neither these elite nor commoner tags decreased from over 50 per cent before 1325 to 23 per cent by the last quartile of this analysis, 1401–25. The left y-axis of these graphs indicates the percentage of commissioners who fall into one of three social categories – elites, commoners or the 'grey area', probably indicative of the middling sorts. The right y-axis indicates the percentages of testators who in a given period and of a social category commissioned works of art. I have used percentages instead of raw numbers because of the variations in the numbers of testators for each of the ten time periods selected in these charts. For the raw numbers divided by city state, period and social category, see Tables 1.1 and 1.2.

23 The numbers of commissions were calculated as any testator who instructed at least one commission or by the total number of commissions within a time period.

Testators who made more than one commission in their wills were almost exclusively the elites or the grey area of non-elites. Nonetheless, whether by the number testators who made at least one commission or by the total number of commissions, the trends appear much the same; see Tables 1.1 and 1.2.

24 Goldthwaite, 'I prezzi del grano'; and Charles de la Roncière, *Florence: Centre économique régional au XIVe siècle (1280-1360)* (Aix-en-Provence: S.O.D.E.B, 1976).

25 See Michele O'Malley, *The Business of Art: Contracts and the Commissioning Process in Renaissance Italy* (New Haven and London: Yale University Press, 2005).

26 Samuel Cohn, 'Rich and Poor in Western Europe, c. 1375-1475: The Political Paradox of Material Well-Being', in *Approaches to Poverty in Medieval Europe: Complexities, Contradictions, Transformations, c. 1100–1500*, ed. Sharon Farmer (Turnhout: Brepols, 2016), 145–73. For a parallel decline in artisans' rights and guild privileges in London, see Caroline Barron, 'Ralph Holland and the London Radicals, 1438–1444', in *The English Medieval Town: A Reader in English Urban History 1200–1540*, ed. R. C. Holt and G. Rosser (London: Longman, 1990), 160–83; Gwyn A. Williams, *Medieval London: From Commune to Capital* (London: Athlone Press, 1963); and Samuel Cohn, *Popular Protest in Late Medieval English Towns* (Cambridge: Cambridge University Press, 2013), 44–59. The historiography on the Tumulto dei Ciompi is vast, see for instance, Richard Trexler, 'Follow the Flag: The Ciompi Revolt Seen from the Streets', *Bibliothéque d'Umanisme et Renaissance* XLVI (1984): 357–92; Alessandro Stella, *La révolte des Ciompi. Les hommes, les lieux, le travail* (Paris: Editions de l'Ecole des Hautes Etudes en Sciences Sociales, 1993); Ernesto Screpanti, *L'angelo della liberazione nel tumulto dei Ciompi: Firenze, giugno-agosto 1378* (Siena: Protagon, 2008); Samuel Cohn, *Lust for Liberty: The Politics of Social Revolt in Medieval Europe, 1200-1425* (Cambridge, MA: Harvard University Press, 2006), 58–62 and 268–9; and for an extended biograpaphical analysis, Franco Franceschi, 'I "Ciompi" a Firenze, Siena, e Perugia', in *Rivolte urbane e rivolte contadine nell'Europa del Trecento: un confronto*, ed. Monique Bourin, Giovanni Cherubini and Giuliano Pinto (Florence: Firenze University Press, 2008), 277–303.

27 For northern and central Italy, a similar decline can be seen in popular protest from the 1370s on, see Cohn, *Lust for Liberty*, 225–7.

28 Neri di Bicci, *Le ricordanze (10 marzo 1453 – 24 aprile 1475)*, ed. Bruno Santi (Pisa: Marlin, 1976). For a social analysis of his patrons, see Dale Kent, *Cosimo de' Medici and the Florentine Renaissance: The Patron's Oeuvre* (New Haven and London: Yale University Press, 2000), 111–16; for a more thorough investigation of these accounts, see Megan Holmes, 'Neri di Bicci and the Commodification of Artistic Values in Florentine Painting (1450-1500)', in *The Art Market in Italy, 15th-17th Centuries*, ed. M. Fantoni et al. (Modena: Franco Cosimo Panini, 2003), 213–23.

29 Fredrika Jacobs, *Votive Panels and Popular Piety in Early Modern Italy* (Cambridge: Cambridge University Press, 2013); and Megan Holmes, 'Miraculous Images in Renaissance Florence', *Art History* 34 (2011): 432–65.

30 George R. Bent, *Public Art and Visual Culture in Early Republican Florence* (Cambridge: Cambridge University Press, 2016), 24; Richard Trexler, *Public Life in Renaissance Florence* (New York: Academic Press, 1980), 68–9; Peter Humfrey, and Richard MacKenney, 'The Venetian Trade Guilds as Patrons of Art in the Renaissance', *The Burlington Magazine* 128, no. 998 (1986): 317–30; Max Seidel, 'The Social Status of Patronage and its Impact on Pictorial Language in Fifteenth-Century Siena', in *Italian altarpieces, 1250-1550: Function and Design*, ed. E. Borsook and F. Superbi

Gioffredi (Oxford: Clarendon Press, 1994), 119–29. On the civic committees that supervised public projects and judged competitions such as the 1420 competition between Filippo Brunelleschi, Lorenzo Ghiberti and others for the reliefs on Florence's baptismal doors, see Margaret Haines, 'Brunelleschi and Bureaucracy: The Tradition of Public Patronage at the Florentine Cathedral', *I Tatti Studies in the Italian Renaissance* 3 (1989): 89–125. At least by the fifteenth century, these committees were almost exclusively composed of merchants and upper guildsmen.

31 On Lazzaro Bracci's testament of 1410, commission, and conflict with the Franciscans, see Cohn, *The Cult of Remembrance*, 151–2 and 312, which also points to other literature on Bracci, especially Eve Borsook, *The Mural Painters of Tuscany from Cimabue to Andrea del Sarto*, 2nd edn (Oxford: Oxford University Press, 1980), 92–3.

32 ASF, Diplomatico Archivio Generale, 1417.vi.19.

33 See Marcia Hall, *Renovation and Counter-Reformation: Vasari and Duke Cosimo in Santa Maria Novella and Santa Croce, 1565-1577* (Oxford: Oxford University Press, 1979).

34 Filippo Moisé, *Santa Croce di Firenze: Illustrazione storico-artistica* (Florence: At the author's expense, 1845), 73.

35 See Paul Hills, 'The Renaissance Altarpiece: A Valid Category?' in *The Altarpiece in the Renaissance*, ed. P. Humfrey and M. Kemp (Cambridge: Cambridge University Press, 1990), 34–48.

36 Cited by Henk van Os, 'Painting in a House of Glass: The Altarpieces of Pienza', *Simiolus* 17, no. 1 (1987): 23–38, esp. 27. Martin Wackernagel, *The World of the Florentine Renaissance Artist: Projects and Patrons, Workshop and Art Market*, trans. Alison Luchs (Princeton: Princeton University Press, 1981 [Leipzig, 1938]), called this cleaning of ecclesiastical space from the clutter of column paintings and other small works of art along with 'trophies and personal memorabilia' 'the spirit of a new Renaissance ideal' (242). Yet, despite this cleansing, Wackernagel concluded: 'Only this much might still be added: the general artistic conditions of the Renaissance period in Florence were fundamentally determined by the existence of an uncommonly strong, multifaceted demand for art and an equally extensive body of patrons, encompassing all social levels.' However, he provides no statistics to substantiate this claim, nor even examples of artisan patrons or others further down the social ladder from those with prominent Florentine family names.

Chapter 2

1 Robert Jutte, *Poverty and Deviance in Early Modern Europe* (Cambridge: Cambridge University Press, 1994); Bronislav Geremek, *Poverty: A History* (Oxford: Oxford University Press, 1974).

2 For a recent discussion of these 'rural paintings': Tom Nichols, 'Jacopo Bassano, Regionalism, and Rural Painting', *Oxford Art Journal* 41, no. 2 (2018): 147–70.

3 Tom Nichols, *The Art of Poverty: Irony and Ideal in Sixteenth-Century Beggar Imagery* (Manchester: Manchester University Press, 2007), 49–57.

4 From the translation given in Brian Pullan, 'The Famine in Venice and the New Poor Law 1527-9', *Bolletino dell'istituto di storia della società e dello stato veneziano* 5–6 (1963–4): 153.

5 Beverley Louise Brown and Paola Marini (eds), *Jacopo Bassano c. 1510-1592* (Fort Worth: Kimbell Art Museum, 1993), cat. no. 47.

6 Tom Nichols, 'Saint Barnabé guérissant un malade de Véronèse et les images vénitiennes de la pauvreté et de la maladie', in *Venise et Paris, 1500-1700: La Peinture Vénitienne de la Renaissance et sa Réception en France: Actes des Colloques de Bordeaux et de Caen (24-25 Février 2006, 6 Mai 2006)*, ed. Michel Hochmann (Geneva: Droz, 2011), 63–82.

7 Cesare Ripa, *Iconologia* (Rome: Lepido, 1593), 499–500.

8 Matt. 25.34-36.

9 Nichols, *Art of Poverty*, 16–32.

10 Manfred Wundram and Thomas Pape, *Andrea Palladio 1508-80: Architect between Renaissance and Baroque* (Cologne: Taschen, 1992), 64–73.

11 On the special role of visual imagery of St Roch in Venice, see Philip Cottrell, 'Poor Substitutes: Imaging Disease and Vagrancy in Renaissance Venice', in *Others and Outcasts in Early Modern Europe: Picturing the Social Margins*, ed. Tom Nichols (Aldershot: Ashgate, 2007), 64–7.

12 On the symbolism of dead twigs in Flemish art: Dirk Bax, *Hieronymus Bosch: His Picture-Writing Deciphered*, trans. M.A. Bax-Botha (Rotterdam: A.A. Balkema, 1979), 16–17; Nichols, *Art of Poverty*, 52–3.

13 Nichols, 'Jacopo Bassano, Regionalism, and Rural Painting', 166–7.

14 Rocco Benedetti described some works that Bassano displayed on the Rialto bridge in Venice in 1571 as 'pastorali'. See Rocco Benedetti, *Raggualgio delle Allegrezze, Solenità, e Feste fatte in Venetia per la felice Vittoria al Clariss. Sig. Girolamo Diedo, digniss. Consigliere di Corfù* (Venice: Perchacchino, 1571), unpaginated. For the idea that many of Bassano's rural works followed examples of sixteenth-century Christianized pastoral poetry see Roger W. Rearick, 'From Arcady to the Barnyard', in *The Pastoral Landscape: Selected Papers*, ed. John Dixon Hunt (Washington DC: National Gallery of Art, 1992), 137–59.

15 Fernando Checa, *Felipe II: Mecenas de las artes* (Madrid: Nerea, 1992), 286.

16 Giorgio Vasari, *Le vite dei piu ecellenti pittori, scultori ed architettori*, ed. Gaetano Milanesi (Florence: G. C. Sansoni, 1878–85), vol. 7, 455; Raffaello Borghini, *Il Riposo* (Florence: Giorgio Mariscotti, 1584), 563.

17 A similar point has been made about the burial of human staffage in idealizing English paintings of the eighteenth and nineteenth centuries: John Barrell, *The Dark Side of the Landscape: The Rural Poor in English Painting 1730-1840* (Cambridge: Cambridge University Press, 1980).

18 For the idea that Bassano's rural paintings were initially made with local Bassanese patrons in mind see Michelangelo Muraro (ed.), *Il libro secondo di Francesco e Jacopo Bassano* (Bassano del Grappa: G. B. Verci, 1992), 50–1.

19 Nichols, 'Jacopo Bassano, Regionalism, and Rural Painting', 151–3.

20 Daniele Beltrami, *Saggi di storia dell'agricoltura nella Reppublica di Venezia durante l'età moderna* (Venice: Istituto per la collaborazione culturale, 1955), 41–3; Ugo Tucci, 'L'Ungheria e gli approvvigionamenti Veneziani del bovini nel Cinquecento', in *Rapporti veneto-ungheresi all'epoca del Rinascimento*, ed. Tibor Klaniczay (Budapest : Akadémiai Kiadó, 1975), 153–71.

21 See the discussions in Sheila McTighe, 'Perfect Deformity, Ideal Beauty and the *Imaginaire* of Work: The Reception of Annibale Carracci's *Arti di Bologna*', *Oxford Art Journal* 16, no. 1 (1993): 75–91; Sean Shesgreen, *Images of the Outcast: The Urban Poor in the Cries of London* (Manchester: Manchester University Press, 2002).

22 Agostino Valier, *Rhetorica ecclesiastica* (Venice: Andrea Bocchino e fratelli, 1570), 116. For a negative/satirical reading of Bassano's peasants, quoting many other sixteenth-century sources, see Bernard Aikema, *Jacopo Bassano and His Public: Moralising Pictures in an Age of Reform ca. 1535-1600* (Princeton: Princeton University Press).

Chapter 3

1 Patricia Fortini Brown, *Venetian Narrative Painting in the Age of Carpaccio* (New Haven: Yale University Press, 1988).

2 For the paintings themselves and the *Scuola* in general, I make extensive use of Guido Perocco, *Carpaccio in the Scuola di S. Giorgio degli Schiavoni* (*Carpaccio: Le pitture alla Scuola di S. Giorgio degli Schiavoni*), trans. Brenda Balich (Treviso: Canova, 1975). This essay refers to the 'Scuola degli Schiavoni', but other authors call it the 'Scuola di San Giorgio degli Schiavoni'. The structure today is technically a church and still belongs to the *scuola* which was founded in 1451, whose official name is now the *Scuola Dalmata dei Ss. Giorgio e Trifone*.

3 Jacobus de Voragine, *Legenda Aurea*, ed. Alessandro e Lucetta Vitale Brovarone (Torino: Einaudi, 1995). The notable exception is the painting of *Saint Augustin's Vision of St Jerome* (long interpreted as *St Jerome in his Study*), which is not based on the *Legenda Aurea*. See Helen Roberts, 'St. Augustine in "St. Jerome's Study": Carpaccio's Painting and its Legendary Source', *Art Bulletin* 41 (1959): 283–97.

4 The *Bucchia Manuscript*, Venice, *Biblioteca Nazionale Marciana*, It. XI, 196 (=7577), produced in Cattaro (Kotor, Montenegro) in 1466. See also Susy Marcon, 'Un manoscritto cattarino del 1466 e l'eridità belliniana lungo le sponde dell'Adriatico', *Rivista di Storia della Miniatura* 4 (1999): 121–34.

5 See Bruno Crevato-Selvaggi, Jovan Martinović and Daniele Sferra, *L'Albania veneta: la Serenissima e le sue popolazioni nel cuore dei Balcani* (Milan: Biblion, 2012).

6 For Tryphon and his church see Miloš Milošević, *Osamsto (800) godina Katedrale Sv. Tripuna u Kotoru (1166-1966)* (Kotor: Štamparsko A. Paltašić, 1966).

7 Vittorio Sgarbi, *Carpaccio*, trans. Jay Hyams (New York: Abbeville Press, 1994), 136–9.

8 Fortini Brown, *Venetian Narrative* Painting, 289, summarizes the views of two eminent Venetian art historians on the *Saint Tryphon*:

> [Rodolfo] Pallucchini dated [it] before the other works [in the Scuola degli Schiavoni] on the basis of similarities between its architecture and that of the St Ursula cycle. As far as execution is concerned, it is the weakest of the group, a circumstance that caused [Terisio] Pignatti and others to place it after the other works, as evidence of Carpaccio's declining powers. [. . .] As Pignatti himself allows, the rather mediocre execution could well have been the responsibility of the workshop.

9 The *scuole*, large and small, including the Scuola degli Schiavoni, are described at www.churchesofvenice.co.uk (accessed 4 September 2019).

10 Ibid. For the special case of the Scuola degli Schiavoni, see Perocco, *Carpaccio in the Scuola di S. Giorgio degli Schiavoni*, 42–4.

11 The history of the priory is discussed in a book produced by the successor of the Knights Hospitaller. See Sovrano Militare Ordine di Malta (SMOM), Gran Priorato di Lombardia e Venezia, *Lungo il tragitto crociato della vita* (Venice: Marsilio, 2000).

12 Ibid., 68–87.

13 The map can be accessed at Venice Project Center, http://cartography.veniceprojectcen ter.org.

14 The painting and its history are discussed in SMOM, *Lungo il tragitto*, 88–90.

15 Perocco, *Carpaccio in the Scuola di S. Giorgio degli Schiavoni*, 29–31. Depictions of a younger Michiel, identifiable both by his Hospitaller garments and distinctive long hair, are also found in two narrative paintings, one by Carpaccio himself and another by Gentile Bellini, done in the last decade of the Quattrocento for the Scuola Grande di San Giovanni Evangelista, now in the Gallerie dell'Accademia. Ibid., 17, 30.

16 This is discussed in detail in Perocco, *Carpaccio in the Scuola di S. Giorgio degli Schiavoni*, 46, endnote 18.

17 Pompeo Molmenti and Gustav Ludwig, *The Life and Works of Vittore Carpaccio*, trans. Robert H. Hobart Cust (London: John Murray, 1907), 111–41.

18 Sgarbi, *Carpaccio*, 110–11.

19 See note 3 in this chapter.

20 The crusaders were fixated on the royal lineage of Christ, as is evident from the following passage from a fourteenth-century work by the Venetian crusader Marino Sanuto Torsello, the *Liber secretorum fidelium crucis*: 'With what voice can I describe the glory of that manger? In which wrapped in swaddling clothes the infant cried, who made the stars, and at this stupendous miracle the angels cried out, the shepherds ran to see, the star shone above, Herod was terrified, Jerusalem disturbed. O Bethlehem, city of David! Glorified by the birth of the true David.' Marino Sanuto Torsello, *The Book of Secrets of the Faithful of the Cross* (= *Liber secretorum fidelium crucis*), trans. Peter Locke, *Crusade Texts in Translation* 21 (Farnham: Ashgate, 2011).

21 It is interesting to note that the city in the background in Mantegna's *Agony in the Garden*, which is often, as on the National Gallery website, identified as a Jerusalem filled with Roman monuments, could in fact refer to Constantinople. It includes a stadium, thought to be inspired by the Colosseum, which could actually be the Hippodrome, with next to it an equestrian statue on a column that could be the equestrian statue of Justinian, which Mehmet II *Fatih* ordered to be destroyed immediately after the conquest. Three crescent moons mounted atop towers further seem to suggest that this could be Constantinople after Islamic conquest. For an example of the conventional reading, see https://www.nationalgallery.org.uk/paint ings/andrea-mantegna-the-agony-in-the-garden (accessed 6 September 2018).

22 L. A. Mayer, *Mamluk Costume* (Geneva: A. Kundig, 1952).

23 Robert Irwin, *The Middle East in the Middle Ages: The Early Mamluk Sultanate, 1250-1382* (Carbondale: Southern Illinois University Press, 1986).

24 Using costume, physiognomy and grooming, Carpaccio reveals himself as a consummate visual ethnographer, accurately representing the ruling elites of the Mamluk Sultanate, with all their ethnic diversity and socio-religious differentiation. Paintings such as this one have led many to ask whether Carpaccio visited the East. I would hold that the intellectual author of this painting could only have been someone with an extensive personal knowledge of the Levant and the Mamluk Sultanate, such as a Knight of Rhodes.

25 Augusto Gentili, *Le storie di Carpaccio: Venezia, i Turchi, gli Ebrei* (Venice: Marsilio Editore, 1996), 47–90.

26 Perocco, *Carpaccio in the Scuola di S. Giorgio degli Schiavoni*, 38–41 and Figs. 13, 20.

27 Ibid., 40–1.

28 This was the Veneto-Italian name for present-day Shkodër in northern Albania, from whence the Boiana River flows out of Skadar Lake on its way to the Adriatic.

29 Perocco, *Carpaccio in the Scuola di S. Giorgio degli Schiavoni*, 12.

30 Ibid., 15.

31 Ibid., 14–19. The first election of officers is found in the scuola's *Mariegola*, while the *Catastico* preserves information on ordinary members.
32 Ibid., 31–5.
33 Ibid., 143–65.
34 Ibid., 153 and Figs. 105, 106. See also http://www.treccani.it/enciclopedia/aliense_%28Enciclopedia-Italiana%29/ (accessed 5 September 2019).
35 Ibid., 162 and Figs. 114, 116, 117. See also http://www.treccani.it/enciclopedia/andrea-michieli_(Dizionario-Biografico) (accessed 5 September 2019)
36 Ibid., 150 and Figs. 110, 111.
37 Ibid., 160 and Fig. 115.
38 Ibid., 160 and Fig. 113.

Chapter 4

1 I would like to thank the editor Rembrandt Duits, who also is my life companion, for giving me the opportunity to participate in the pioneering conference of which these proceedings form the published record.
2 Sophia Kalopissi-Verti, 'Collective Patterns of Patronage in the Late Byzantine Village: The Evidence of Church Inscriptions', in *Donation et Donateurs dans la monde byzantin. Acts du colloque international de l'Université de Fribourg 13-15 mars 2008*, ed. Jean-Michel Spieser and Élisabeth Yota (Paris: Desclée de Brouwer, 2012), 125–40, esp. 126 and note 10.
3 Ibid., 130.
4 Patricia Fortini Brown, 'The Venetian Loggia. Representation, Exchange, and Identity in Venice's Colonial Empire', in *Viewing Greece: Cultural and Political Agency in the Medieval and Early Modern Mediterranean*, ed. Sharon E. J. Gerstel (Turnhout: Brepols, 2016), 206–35, esp. 213.
5 For a concise summary on the history of Crete under the Venetians, see Chryssa Maltezou, 'The Historical and Social Context', in *Literature and Society in Renaissance Crete*, ed. David Holton (Cambridge: Cambridge University Press, 1991), 17–47. On the exploitation of Cretan agricultural products, see Angeliki Lymberopoulou, 'Fourteenth-Century Regional Cretan Church Decoration: The Case of the Painter Pagomenos and his Clientele', in *Towards Rewriting? New Approaches to Byzantine Archaeology and Art*, ed. Piotr Ł. Grotowski and Sławomir Skrzyniarz (Warsaw: Neriton, 2010), 159–75, esp. 163–4, and the discussion in the following.
6 Angeliki Lymberopoulou, *The Church of the Archangel Michael at Kavalariana: Art and Society on Fourteenth-Century Venetian-Dominated Crete* (London: Pindar Press, 2006), 217.
7 Saint Nicholas replaces Saint John the Baptist in the Deesis in the conch of the sanctuary apse, which further underlines the desire of the congregation to place their hope of salvation in his saintly hands; ibid., Fig. 107.
8 On the painter, see Alexandra Sucrow, *Die Wandmalereien des Ioannes Pagomenos in Kirchen der ersten Hälfte des 14. Jahrhunderts auf Kreta* (Berlin: s.n., 1994); Lymberopoulou, *Kavalariana*, 10–14; Lymberopoulou, 'Regional Cretan Church Decoration', 159–75; Vasiliki Tsamakda, *Die Panagia-Kirche und die Erzengelkirche in Kakodiki. Werkstattgruppen, kunst- und kulturhistorische Analyse byzantinischer Wandmalerei des 14. Jhs. auf Kreta* (Vienna: Verlag der Österreichischen Akademie der Wissenschaften, 2012), 104–31.

9 If Konstantinos had been a member of the Sarakinopoulos family more senior than
 Demetrios (father, older brother), he would probably have been named first in the
 inscription. The most likely option is that Konstantinos was either a younger brother,
 a son or a paternal cousin of Demetrios. See Lymberopoulou, *Kavalariana*, 208–9.

10 The inscription reads:

> This holy and revered church of the saint and wonder-working and *myrovlytis* [i.e.
> sweetly perfumed] Nikolaos of Maza was painted with the contributions and labour
> of Demetrios Sarakinopoulos and Konstantinos Raptis for one half, Konstantinos
> Sarakinopoulos, Georgios Mavromatis, the priest Michael and of all the people of the
> village of Maza. The Lord knows their names. It was completed by the hand of the sinner
> Ioannis Pagomenos in the year 6834 [=AD 1325/6].

See Lymberopoulou, *Kavalariana*, 175–7.

11 The inscription at Maza avoids a specific 'class-distinction', examples of which can be
 found outside the island. Examples in Cyprus and in the Peloponnese explicitly refer to
 'common people': on Cyprus, see Sophia Kalopissi-Verti, 'The Murals of the Narthex:
 The Paintings of the Late Thirteenth and Fourteenth Centuries', in *Asinou Across Time:
 The Architecture and Murals of the Panagia Phorbiotissa, Cyrpus*, ed. Annemarie Weyl
 Carr and Andréas Nikolaïdès (Washington DC: Harvard University Press, 2012), 115–
 210, esp. 176–9; on the Peloponnese, see Sophia Kalopissi-Verti, *Dedicatory Inscriptions
 and Donor Portraits in Thirteenth-Century Churches of Greece* (Vienna: Verlag der
 Österreichischen Akademie der Wissenschaften, 1992), 65–6 (no. 17).

12 The inscription reads:

> . . . and most sacred (church) of the Great martyr Georgios with great labour and pains
> Manouel Skordilis and his wife and his children and Fimis Skordilis, Kali Vlastoudena
> and her children and Anna Tzinaropoli and her children, Manouel Faropoulos and his
> wife and his children, by Kalinikos the monk, Gerasimos Fourogiorgis and other people
> whose names are known to the Lord. Amen. / . . . poulas and her children. / In the year
> 6822 [=AD 1313/14], Indiction 12, by my hand, Ioannis Pagomenos.

See Lymberopoulou, *Kavalariana*, 171–3.

13 The inscription reads:

> The Holy church of the great martyr Hagios Georgios Anydriotis was renovated
> and painted with the contributions and labour of the priest Nestor protopapas,
> the monk Ysagias, of Marina, Georgios Amageremos and his wife and his children,
> Georgios Mamos and his wife and his children, Kapadokis Papadopoulos and his
> wife and his children, Georgios Papadopoulos and his wife and his children, Ioannis
> Papadopoulos and his wife and his children, Kalos Papadopoulos and his children,
> Georgios Meropoulos and his wife, Pougis Meropoulos and his wife and his children,
> Gianitzis Skatalis and his children, Kalos and his children, Leon Amagerep(tos), Kostas
> Gianakopoulos, Eirini Anifatou and her children, Kostas Louginos and his wife and his
> children, Kamisas Michalis, Pelagia of Thodororakopoulos, Ioannis Makrikokalos and
> his wife and his children, Georgios Skordilis and his children, Alexis Stratigis and his
> wife and his children. / It was painted by the hand of the sinner Ioannis Pagomenos in
> the month of May 21st (?), in the year 6831 [=AD 1323], Indiction 4. / Ioannis Thlouvos,
> Thodoros Papadopoulos and his wife and his children.

See Lymberopoulou, *Kavalariana*, 174–5.

14 The inscription reads:

> The holy and revered church of the most holy Theotokos the Virgin Mary was painted
> with the expenses and contributions of Nikephoros protopapas and his wife, Ioannis the
> priest Nomikos and his wife and his children, Nikitas Kalamaris and his wife, Nikolas

Amagereptos and his wife, Skordilis Mousogianis Patzos Gerardon, Nikolaos Partzalis, Gerardon Kalinikos and his children, Michael Raptopoulos and his sister, Nikolas Ochtokefalos, Georgios Koukomaris, Georgios Kopeton and his family, Stefanos Kipro . . . , Marinon Vaptaka . . . and . . . opoulos, Achladis Kalogeros, Sgourogianis with her family and her children. . . . Kouka with his family, all of the Stefanades with their family, all of the Exelouriki with their family and their children, Sgouros Ioannis Sgourogianis, Michael Lafragis, Ioannis, Michael Kalamaris, Nikolaos Papadopoulos, Andreas Salivaras, Ioannis Raptopoulos, Georgios . . . with the wife . . . Georgios Therianos with . . . / The present church was completed by the hand of the sinner Ioannis who happened to be the/a painter Pagomenos, in the year 6840 [=AD 1331/2] on Friday.

See Lymberopoulou, *Kavalariana*, 177–9 and 171, note 89 (for the translation as 'the/a'); Tsamakda, *Kakodiki*, 37–44.

15 See Lymberopoulou, *Kavalariana*, 179–81. The question who wrote these inscriptions is unresolved. We can only assume that it was the painter himself if he was literate, or else either the village priest or a notary could have written down the names for the painter to copy them in the dedicatory inscription.

16 Sharon Gerstel, 'Hearing Late Byzantine Painting', in *The Post-1204 Byzantine World: New Approaches and Novel Directions, Papers from the 51st Spring Symposium of Byzantine Studies, University of Edinburgh 13-15 April 2018*, ed. Niels Gaul, Mike Carr and Yannis Stouraitis (London and New York: Routledge, forthcoming).

17 '*Aionia gar i mnimi auton*', appears, for example, at the end of the dedicatory inscription in the Church of the Archangel Michael at Kapetaniana, Monofatsi, Herakleion (Map 4.1), dated ca. 1430; see Giuseppe Gerola, *Monumenti Veneti dell' Isola di Creta*, volume 4 (Venice: R. Istituto *veneto di* scienze, lettere ed arti, 1932), 568 (no. 9).

18 Charalambos Gasparis, 'Venetian Crete: The Historical Context', in *Hell in the Byzantine World: A History of Art and Religion in Venetian Crete and the Eastern Mediterranean*, vol. 1, ed. Angeliki Lymberopoulou (Cambridge: Cambridge University Press, forthcoming [2020]), section 2.2.

19 Kalopissi-Verti, *Dedicatory Inscriptions*, 67–9, Fig. 34; Kalopissi-Verti, 'Collective Patterns', 129–31.

20 Kalopissi-Verti, *Dedicatory Inscriptions*, 71–5, Figs 37–39; Kalopissi-Verti, 'Collective Patterns', 129–31.

21 Other inscriptions referring to property can be found in ibid, 69–71 (no. 20), and 76–7 (no. 24).

22 His name is mentioned in line 3, while his contribution in lines 6–7; see Kalopissi-Verti, *Dedicatory Inscriptions*, 67 and 68 respectively.

23 Andrea Mattiello, 'Latin Basilissai in Palaiologan Mystras: Art and Agency', unpublished PhD thesis (University of Birmingham, Centre for Byzantine, Ottoman and Modern Greek Studies: 2018), vol. 1, 264 and note 64. During the period the church was decorated, the term 'nomisma' (gold coin) refers invariably to an *yperpyron* (lit. 'highly refined'), introduced in 1092 by the emperor Alexios I and in use until the mid-fourteenth century: Kalopissi-Verti, *Dedicatory Inscriptions*, 68–9; Philip Grierson, *Byzantine Coinage* (Washington DC: Dumbarton Oaks, 1999), 56. 'Gold ducats' in general refer to Venice's *ducatus aureus*, which was created in 1284–85. In Palaiologan times, the silver Venetian ducat was adopted under the name 'basilicon', see Grierson, *Byzantine Coinage*, 53 and 55. It would, thus, seem that between 1278 and 1343 the two monetary units are comparable (allowing for inflation).

24 Gerola, *Monumenti*, vol. 4, 449–51 (no. 24) (dates it 1462); Ioannis Spatharakis, *Dated Byzantine Wall Paintings of Crete* (Leiden: Alexandros Press, 2001), 215–16 (no.

71) (dates it 1470). It should be noted that while both authors record the church as dedicated to the Holy Fathers, its inscription as transcribed by Gerola mentions Saint John the Hermit as its patron saint.

25 Giuseppe Gerola, *Monumenti Veneti Nell'Isola di Creta*, vols. 1–3 (Venice, 1905–1917), vol. 2, 172 and 174–5, where the author declares the churches as 'insignificant' ('insignificanti') and hence not worthy of detailed description.

26 Ibid., 172.

27 David Jacoby, 'Social Evolution in Latin Greece', in *A History of the Crusades*, ed. H. W. Hazard and N. P. Zacour (Madison: University of Wisconsin Press, 1989), vol. 6, 205–6.

28 For the Church of the Saviour: Gerola, *Monumenti*, vol. 4, 465 (no. 45); for the Church of the Holy Apostles: ibid., 466–7 (no. 47).

29 'omofylon Christianon': ibid., 568 (no. 9).

30 Ανδρέας Ξυγγόπουλος, 'Περί μίαν Κρητικήν Τοιχογραφίαν', *Κρητικά Χρονικά* 12 (1958): 335–42; Maria Vassilaki Mavrakakis, 'Western Influences on the Fourteenth Century Art of Crete', *Jahrbuch der Österreichischen Byzantinistik* 32, no. 5 (1982): 305–11, esp. 304. See also Angeliki Lymberopoulou, 'Regional Byzantine Monumental Art from Venetian Crete', in *Byzantine Art and Renaissance Europe*, ed. Angeliki Lymberopoulou and Rembrandt Duits (Farnham: Ashgate, 2013), 61–100, esp. 65.

31 See, indicative, essays in A. Lymberopoulou and R. Duits, *Byzantine Art and Renaissance Europe*; and in Angeliki Lymberopoulou, ed., *Cross-Cultural Interaction between Byzantium and the West, 1204-1669. Whose Mediterranean is it anyway?* (London and New York: Routledge, 2018).

32 Ιωάννα Χριστοφοράκη, 'Χορηγικές Μαρτυρίες στους Ναούς της Μεσαιωνικής Ρόδου (1204-1522)', *Η Πόλη της Ρόδου από την Ίδρυσή της μέχρι την Κατάληψη από τους Τούρκους (1530)*, 2, (Athens: s.n., 2000), 429–48, esp. 463.

33 Ibid., 464.

34 Lymberopoulou, 'Regional Byzantine Monumental Art', 92–5 (as in note 30).

35 Gasparis, 'Venetian Crete'.

36 Sally McKee, 'The Revolt of St Tito in Fourteenth-Century Venetian Crete: A Reassessment', *Mediterranean Historical Review* 9 (1994): 173–204.

37 Flaminius Cornelius, *Creta Sacra, sive de episcopis utriusque ritus Graeci et Latini in insula Cretae* (Venice: Pasquali, 1755), vol. 2, 349.

38 Χαράλαμπος Γάσπαρης, 'Μαλεβίζι. Το όνομα, η αμπελοκαλλιέργεια και τα κρασιά στον 13ο και 14ο αιώνα', *Μονεμβάσιος Οίνος – Μονοβασ(ι)ά – Malvasia*, ed. Ηλίας Αναγνωστάκης (Athens: Εθνικό Ίδρυμα Ερευνών, Ινστιτούτο Βυζαντινών Ερευνών, 2008), 147–58; Benjamin Arbel, 'Venice's Maritime Empire in Early Modern Period', in *A Companion to Venetian History*, ed. Eric R. Dursteler (Leiden and Boston: Brill, 2014), 229–31; Angeliki Panopoulou, 'Working Indoors and Outdoors: Female Labour, Artisanal Activity and Retails Trade in Crete (14th-16th Centuries)', in *Women and Monasticism in the Medieval Eastern Mediterranean: Decoding a Cultural Map*, ed. Eleonora Kountoura Galake and Ekaterini Mitsiou (Athens: National Hellenic Research Foundation, 2019), 207–32, esp. 230.

39 Lymberopoulou, 'Regional Cretan Church Decoration', 163 (as in note 5).

40 Ibid.

41 Gerola, *Monumenti*, vol. 4, 460 (no. 37).

42 See Panopoulou, 'Working Indoors and Outdoors', 225 and note 68. On the winning of salt by Venice in general, see J. C. Hocquet, *Le sel et la fortune de Venise*, vol. 1 *Production et monopole* (Lille: Presses Universitaires de Lille, 1982, 2nd ed.); on Crete

in the seventeenth century, see M. Αρακαδάκη, 'Οι αλυκές της Ελούντας μέσα από τις επιστολές του Zeno (1640-1644)', in *Το αλάτι και οι αλυκές ως φυσικοί πόροι κι εναλλακτικοί πόλοι τομικής ανάνπτυξης* (Mytilini: s.n., 2002), 102–15.

43 On the term 'tourma' (the byzantine 'thema' – district) see Χαράλαμπος Γάσπαρης, 'Από τη βυζαντινή στη βενετική τούρμα. Κρήτη, 13ος-14ος αι.', *Σύμμεικτα* 14 (2001): 167–228.

44 Gerola, *Monumenti* vol. 4, 435–6 (no. 7); Spatharakis, *Dated Wall Paintings*, 116–18 (no. 41). According to the dedicatory inscription the 'district' of Kitiros included the villages of Kitiros, Chasi, Rogozo, Hagios Konstantinos, Sklavopoula, Kalami and the metochi (dependency) of Moustaki (the names of at least two further villages are illegible).

45 This is made explicit in the church at Kitiros, which includes, within its iconographic programme, a prominent and eye-catching representation of hell; see Lymberopoulou, 'Regional Byzantine Monumental Art', 81–90 and Fig. 3.8 (as in note 30). The preoccupation of the Orthodox congregation with the salvation of their immortal souls is supported by evidence provided in Cretan wills; see Angeliki Lymberopoulou, '"*Pro anima mea*", but do not touch my icons: Provisions for private icons in wills from Venetian-Dominated Crete', *The Kindness of Strangers: Charity in Pre-Modern Mediterranean*, ed. Dionysios Stathakopoulos (London: King's College, 2007), 71–89, esp. 76–8 (donations towards wall paintings).

46 See, indicative, Paul Underwood, *The Kariye Djami* (New York: Pantheon Books, 1966).

Chapter 5

1 Michel Mollat, *The Poor in the Middles Ages: An Essay in Social History*, trans. Arthur Goldhammer (New Haven and London: Yale University Press, 1986), 5–6.

2 For the semantic development of 'poverty' and the 'poor', see ibid, 1–5. Poverty defined in terms of 'quasi-religious or theological concepts' is observed by Tom Nichols, *The Art of Poverty: Irony and Ideal in Sixteenth-Century Beggar Imagery* (Manchester and New York: Manchester University Press, 2007), 9 and 14 n. 23.

3 A social history of art that asks what images are meant to do for their viewers. For example, from emotional responses to the formal properties of images, as pioneered by David Freedberg, *The Power of Images: Studies in the History and Theory of Response* (Chicago: University of Chicago, 1989) or in terms of their miraculous properties which gain prestige through multiplication and replication or by means of their antiquity which counters aesthetic judgements that form the basis of connoisseurship. For example, Frederika Jacobs, *Votive Panels and Popular Piety in Early Modern Italy* (New York: Cambridge University Press, 2013); Megan Holmes, *The Miraculous Image in Renaissance Florence* (New Haven and Yale: Yale University Press, 2013); Gervase Rosser and Jane Garnett, *Spectacular Miracles: Transforming Images in Italy, from the Renaissance to the Present* (London: Reaktion, 2013); Lisa Pon, *A Printed Icon in Early Modern Italy: The Madonna di Forli* (New York: Cambridge University Press, 2015). What is yet to be fully considered is the relationship of the image to its landscape or environment in terms of space and the passage of time. Albrecht Classen identifies this lacuna and has opened up new dialogues, including the significance of the mountains, see n. 5 in this chapter.

4 Relationality provides ontological, theoretical and epistemological interventions that can help us understand poverty, see Sarah Elwood, Victoria Lawson and Eric Sheppard, 'Geographical Relational Poverty Studies', *Progress in Human Geography* 41, no. 6 (2016): 745–65.

5 Albrecht Classen, 'Introduction', in *Rural Space in the Middle Ages and Early Modern Age: The Spatial Turn in Premodern Studies*, ed. Albrecht Classen (Berlin and Boston: De Gruyter, 2012), 3. Classen quotes Noel Castree on the concept of 'placeness' from his 'Differential Geographies: Place, Indigenous Rights and "Local Resources"', *Political Geography* 23 (2004): 133–67; 138, n. 7. Classen has also edited a volume on urban space, *Urban Space in the Middle Ages and Early Modern Age* (Berlin and New York: Walter de Gruyter, 2002). The spatial turn began with Cassirer and Mumford, gaining new momentum with Foucault and especially Henri Lefebvre with his *The Production of Space* (1974), whereby space equals a mode of existence of social relations.

6 Erwin Poeschel, *Die Kunstdenkmäler des Kantons Graubünden*, vol. 7, *Chur und der Kreis Fünf Dörfer* (Basel: Verlag Birkhauser, 1948), 16–17.

7 For the spread of the church in this locality from the early Middle Ages, see Randon Jerris, 'Cult Lines and Hellish Mountains: The Development of Sacred Landscape in the Early Medieval Alps', *Journal of Medieval and Early Modern Studies* 32, no. 1 (2002): 85–108, esp. 87–92. For data on ecclesiastical foundations and clergy in the bishopric of Chur see, Ludwig Schmugge, 'Das Bistum Chur im Spätmittelalter: aus der Sicht des "gemeinen Mannes"', in *Studien zur Geschichte des Bistums Chur (451-2001)*, ed. Michael Durst (Freiburg: Universitätsverlag, 2002), 59–81, esp. 60–1; and Immacolata Saulle Hippenmeyer, *Nachbarschaft, Pfarrei und Gemeinde in Graubünden 1400-1600* (Chur: Desertina, 1997).

8 For the organization of the family in the Alps, see Dionigi Albera, *Au fil des générations: Terre, pouvoir et parenté dans l'Europe alpine, XIV-XX siècles* (Grenoble: Presses universitaires de Grenoble, 2011).

9 See Yoshihisa Hattori, 'Community, Communication and Political Integration in the Late Medieval Alpine Regions. Survey from a Comparative Viewpoint', in *Communities and Conflicts in the Alps from the Late Middle Ages to Early Modernity*, ed. Marco Bellabarba, Hannes Obermair and Hito Sato (Trento and Bologna: Società editrice il Mulino; Berlin: Duncker & Humblot in Kommission, 2015), 13–38, esp. 19–22.

10 For a full discussion of St Maria Magdalena and its decoration, see Joanne W. Anderson, *Moving with the Magdalen: Late Medieval Art and Devotion in the Alps* (New York and London: Bloomsbury Visual Arts, 2019), 49–76. See also Joanne W. Anderson, 'Arming the Alps with Art: Saints, Knights and Bandits on the Early Modern Roads', in *Travel and Conflict in the Early Modern World*, ed. Gabor Gelleri and Rachel Willie (New York and London: Routledge, forthcoming 2020).

11 Historisch-Antiquarische Gesellschaft von Graubünden (ed.), *BU*, vol. 2 (1200-1272) (Chur: Bischofberger, 1947), 35 and nr. 516: 'in villa Usces curtem unam'. The term *villa* can also refer to smaller autonomous peasant farms; see Randold Head, *Early Modern Democracy in the Grisons: Social Order and Political Language in a Swiss Mountain Canton* (New York: Cambridge University Press, 2002). The earliest surviving wooden houses in Switzerland are to be found in Schwyz (e.g. Haus Nideröst of 1176 and Haus Bethlehem of 1287) and Morschach (Haus Tennen of 1341); these were affordable only for those who worked the land, gave military service and held administrative posts in urban centres; see Georges Descoudres,

'Quantensprung als Diskontinuität. Wohnhäuser des 12. bis 14. Jahrhunderts in der Innerschweiz', *Mitteilungen der Arbeitsgemeinschaft für Archäologie des Mittelalters und der Neuzeit* 17 (2006): 79–85 and 'Bauholz und Holzbau im Mittelalter', *Der Geschichtsfreund: Mitteilungen des Historischen Vereins Zentralschweiz* 161 (2008): 47–62.

12 See Barbara Orland, 'Alpine Milk: Dairy Farming as a Pre-modern Strategy of Land Use', *History and Environment* 10, no. 3 (2004): 327–64, 341, for the prosperity indicator. Cattle were grazed on Alpine meadows of varying elevations during the summer months; agrarian practices were limited by 'a combination of altitudinal belt, varying terrains and difficult climatic conditions' (334). Lowlanders (breeders, traders and dairymen) could own the cattle and rent the land from highlanders on a seasonal basis, allowing for more cows. For highlanders, by contrast, the number of cows owned was restricted by grazing rights on common meadows and by accommodation requirements during the winter months in certain regions.

13 Settlements in the Swiss Grisons typically carry dual nomenclature, indicating usage of Rhaeto-Romansch, an official language alongside German and Italian.

14 See Erwin Poeschel, *Die Kunstdenkmäler des Kantons Graubünden*, vol. 2, Herrschaft, Prätigau, Davos, Schanfigg, Churwalden, Albulatal (Basel: E. Birkhäuser & CIE. A. G., 1937), 390–3. The wall paintings were restored in 1955. After 1590, the church was reformed and in 1620 it separated from the parish church in Bergün/Bravuogn.

15 The polygonal apse and enlarged bell tower with spire were added in 1500. There are no surviving traces of earlier decoration in the apse.

16 Fresco painting was cheaper than sculpture, textiles or metalwork, the cost of works in this geographic area at this time being linked to materials used and time spent on delivering the final product rather than necessarily the reputation of the artist. Migrant workshops would have required lime, water and sand for making the plaster in addition to organic pigments for painting. Other costs included board and lodgings. See also n. 28.

17 See Saulle Hippenmeyer, *Nachbarschaft, Pfarrei und Gemeinde*; and Emanuele Curzel, 'Alpine Village Communities, Ecclesiastic Institutions, and Clergy in Conflict: The Late Middle Ages', in *Communities and Conflicts in the Alps* (Berlin: Duncker & Humblot GmbH, 2015), 91–100, esp. 95. See also Anderson, *Moving with the Magdalen*, 169–71 for a further example in Ossana in Trentino.

18 Curzel, 'Alpine Village Communities', 93.

19 See Jürg Simonett, 'Stugl/Stuls', in *Historiches Lexikon der Schweiz*, https://hls-dhs-dss.ch/de/articles/008995/2012-07-03/ (accessed 15 May 2019); forty-two residents are recorded in 1900 and today the village is in decline.

20 A recent scientific study suggests that living conditions in a rural Swiss village during the medieval/early modern period were comparable to other rural and urban environments, meaning that they were no worse off in terms of health, see Joke Somers, Christine Kathryn Cooper, Amelie Alterauge and Sandra Lösch, 'A Medieval/Early Modern Alpine Population from Zweisimenn, Switzerland: A Comparative Study of Anthropology and Palaeopathology', *International Journal of Osteoarchaeology* (July 2017): https://doi.org/10.1002/oa.2607.

21 A priest probably performed the mass there once a month.

22 The Premonstratensian convent of St Luzi is first recorded in 1149. The Dominican convent of St Nicolai was founded towards the end of the 1200s, see Linus Bühler, *Chur im Mittelalter: von der karolingischen Zeit bis in die Anfänge des 14. Jahrhunderts* (Chur: Kommissionsverlag Bndner Monatsblatt, 1995), 35.

23 Ibid., 180–91. It also looked after day labourers, servants and journeymen.

24 Bühler, *Chur im Mittelalter*, 63–122 for the Chur economy, esp. 67–8 for the cereal economy and 107–22 for market and trade. The number of markets in Chur is queried, a matter complicated by terminology in the documents. A weekly market had existed since 1300. Tradable commodities from 1300 from the area included cattle for milk products (mainly cheese), lard, goats and wool, also slaughter cattle, grain, wine, salt and spices. Fabric and textiles were also traded (109). More exotic products were brought in from the fairs in Champagne and the trading centres of Venice, Genoa and Pisa (119).

25 Bühler, *Chur im Mittelalter*, estimates between 1,000 and 1,500, this is set in a comparative context, see 59–60. The data is after H. C. Peyer, 'Zurich im Fruh- und Hochmittelalter', in *Zurich von der Urzeit bis zum Mittelalter*, ed. Emilt Vogt et al. (Zurich, 1971), 165–235, esp. 217; and Richard Laufner, 'Das Rheinische Stadtewesen im Hochmittelalter', in *Die Städte Mitteleuropas im 12. und 13. Jahrhundert*, ed. Wilhelm Rausch (Linz: Archiv Stadt Linz, 1963), 27–40, esp. 27–31. Chur's population was predominantly commercial by the fifteenth century.

26 The 'chapel' is not situated in a discreet architectural setting within the cathedral, rather the space is designated a chapel by virtue of its altar and baptismal function.

27 Inevitably, there is a delicate interplay between quantity of artworks, the cost of their execution in terms of materials and labour, the number of patrons involved in a commission, which can be sizeable, and the local availability of artists (other factors aside).

28 For the migration of the Venetan style to Bozen and its subsequent diffusion in the late fourteenth century, see Tiziana Franco, 'Tra Padova, Verona e le Alpi. Sviluppi della pittura nel secondo Trecento', in *Trecento. Pittori gotici a Bolzano*, ed. Andrea De Marchi et al. (Bolzano: TEMI Editrice, 2002), 149–65. For travel in the Alps, see Guido Castelnuovo, 'Strade, passi, chiuse nelle Alpi del basso medioevo', in *Il Gotico nelle Alpi 1350-1450*, ed. Enrico Castelnuovo and Francesca de Gramatica (Trento: Castello del Buonconsiglio. Monumenti e collezioni provinciali, 2002), 61–78.

29 For discussion of migratory workshop typologies in the Alps, see Anderson, *Moving with the Magdalen*, 165–9.

30 A place to stay and sustenance was probably also provided, though perhaps not as part of a prior contract that established the terms that would bring the artist from his home residence to the temporary one, as discussed in the context of fifteenth-century documented Italian commissions, see Michelle O'Malley, *The Business of Art: Contracts and the Commissioning Process in Renaissance Italy* (New Haven and London: Yale University Press, 2005), 82–3. Patronage and payment in rural pre-Alpine Trentino are analysed by Silvia Vernaccini, *Baschenis de Averaria. Pittori itineranti nel Trentino* (Trento: TEMI Editrice, 1989), esp. 37–45. She notes that the costs for materials and stipends for the helpers and assistants were borne by the patron. The master of the workshop, who belonged to a large family enterprise specializing in 'pitture povere', was paid for the time he spent on the commission (42).

31 See Enrico Castelnuovo and Carlo Ginzburg, 'Centro e periferia', in *Storia dell'arte italiana*, 1, *Materiali e problemi*, vol. 1, *Questione e metodi*, ed. Giovanni Previtali (Turin: Einaudi, 1979), 283–352, esp. 326–8. The 1970s saw a groundswell of interest in the theoretical model developed by political geography and subsequently applied to historical disciplines, including art history.

32 See Yoshihisa Hattori, 'Community, Communication and Political Integration', 13–38, esp. 13–22 for structure and communication in communities, and the case study on the Grisons.

33 Johann Rudolf Rahn, *Geschichte der Bildenden Künste in der Schweiz von den
Ältesten Zeiten bis zum Schlusse des Mittelalters* (Zürich: Hans Staub, 1876), v and
3: '*Die Schweiz ist arm an höheren Werken der bildenden Kunst [.] Das Ganze
der schweizerischen Denkmäler bietet ein Bild voller Widersprüche, aus dem nur
schwer und nach längerer Umschau der Hinblick auf festere Richtungen und die
mannigfaltigen Einflüsse sich öffnet, die von hüben und drüben zusammentrafen und
seit der romanischen Epoche der Kunst unseres Landes ein völlig kosmopolitisches
Gepräge aufdrückten. [. . .] Nicht im Gebirge, dessen Schönheit alljährlich den Zug der
Fremden herbeilockt, hat das Mittelalter die Zeugen seiner Kunst hinterlassen. Selten
auch da, wo jetzt Handel und Wandel ihre Mittelpunkte finden. Dort nicht, weil die
Rauheit der Natur und die Bedürfnisslosigkeit ihrer Bewohner eine künstlerische Blüthe
verhinderten [. . .]*.'

Chapter 6

1 This chapter is derived from my book in preparation, the research for which I
completed at the University of California, Santa Barbara, United States. I am grateful
for the insightful guidance of the late Robert Williams, and I am indebted to Claudia
Moser, Robert W. Gaston, Peter Howard, Anne Dunlop and Megan Cassidy-Welch, all
of whom have provided invaluable feedback on my work. This project was supported
in part by the University of California Office of the President MRPI funding MR-15-
328710. My research was also made possible by a Medieval Academy of America
Dissertation Grant; by the Albert and Elaine Borchard Foundation European Studies
Fellowship; and by financial support from the University of California, Santa Barbara,
United States. Many thanks to Mandragora for permission to reprint published
transcriptions of Santa Maria delle Carceri's two miracle books.
2 Previous scholarship addressing *Santa Maria delle Carceri* is vast and tends to focus
on the architecture of Giuliano da Sangallo's church: most notably, Piero Morselli and
Gino Corti, *La Chiesa di Santa Maria delle Carceri in Prato: contributo di Lorenzo de'
Medici e Giuliano da Sangallo alla progettazione* (Prato: Società pratese di storia patria,
1982); Claudio Cerretelli, *La Basilica di Santa Maria delle Carceri a Prato* (Florence:
Mandragora, 2009). Paul Davies also has published several essays based on his PhD
thesis: Paul Davies, *Studies in the Quattrocento Centrally Planned Church* (unpublished
PhD thesis, University of London, 1992); see also his essays cited throughout this
chapter. Recent work on the cult gives greater attention to ritual practices: Robert
Maniura, *Art and Miracle in Renaissance Tuscany* (Cambridge: Cambridge University
Press, 2018); Cecilia Hewlett, 'Rural Pilgrims and Tuscan Miracle Cults', in *Studies on
Florence and the Italian Renaissance in Honour of F. W. Kent*, ed. Cecilia Hewlett and
Peter Howard, Europa Sacra 20 (Turnhout: Brepols, 2016), 339–58; Roslyn Halliday,
Santa Maria delle Carceri: Politics and Devotion in Renaissance Prato (unpublished
MA thesis, Clayton: Monash University, 2016). Megan Holmes discusses how the
Florentine elite appropriated the cult in Prato as well as other miraculous images
located throughout Tuscany. Megan Holmes, *The Miraculous Image in Renaissance
Florence* (New Haven: Yale University Press, 2013), 115–19. Other work on the
fresco concerns object agency: Christopher J. Nygren, 'Metonymic Agency: Some
Data on Presence and Absence in Italian Miracle Cults', *I Tatti Studies in the Italian
Renaissance* 22, no. 2 (2019): 209–37; Robert Maniura, 'Agency and Miraculous
Images', in *The Agency of Things in Medieval and Early Modern Art: Materials, Power*

and *Manipulation*, ed. Grażyna Jurkowlaniec, Ika Matyjaszkiewicz and Zuzanna Sarnecka (New York: Routledge, 2017), 63–72.

3 My interest in exploring the importance of 'place' in religious sites stems from Robert W. Gaston's essays: Robert W. Gaston, 'Sacred Place and Liturgical Space: Florence's Renaissance Churches', in *Renaissance Florence: A Social History*, ed. Roger J. Crum and John T. Paoletti (New York: Cambridge University Press, 2006), 331–52; Ibid., 'Introduction: Some Meditations on Space and Place in Recent Florentine Art History', *Melbourne Art Journal* 9, no. 10 (2007): 8–13.

4 Paul Davies, 'The Early History of S. Maria delle Carceri in Prato', *Journal of the Society of Architectural Historians* 54, no. 3 (September 1995): 326–35.

5 F. W. Kent, 'Prato and Lorenzo de' Medici', in *Communes and Despots in Medieval and Renaissance Italy*, ed. John E. Law and Bernadette Paton (Burlington: Ashgate, 2010), 203–6.

6 A fifteenth-century miracle book states that every Pratese church under his jurisdiction – with the exception of *Santa Maria delle Carceri* – rendered a tribute to Carlo. 'Prato, Biblioteca Roncioniana, ms. 86 (Q.II.6)', in *Santa Maria delle Carceri a Prato: Miracoli e devozione in un santuario Toscano del Rinascimento*, ed. Anna Benvenuti (Florence: Mandragora, 2005), 122. For Carlo's struggle over the cult, see Maniura, *Art and Miracle*; Davies, 'Early History'; Halliday, *Santa Maria delle Carceri*.

7 Renzo Fantappiè, 'Una cintura di lana finissima di Prato', in *Legati da una cintola: l'Assunta di Bernardo Daddi e l'identità di una città*, ed. Cristina Gnoni Mavarelli (Florence: Mandragora, 2017), 30–9. Much has been written on the relic of the Virgin's belt in Prato. As a starting point, see Andrea De Marchi and Cristina Gnoni Mavarelli, eds, *Legati da una cintola: l'Assunta di Bernardo Daddi e l'identità di una città* (Florence: Mandragora, 2017); Aldo Capobianco, ed., *La Sacra Cintola nel Duomo di Prato* (Florence: Claudio Martini, 1995).

8 'ms. 86', 104–32; Isabella Gagliardi, 'I miracoli della Madonna delle Carceri in due codici della Biblioteca Roncioniana di Prato', in *Santa Maria delle Carceri a Prato: miracoli e devozione in un santuario toscano del Rinascimento*, ed. Anna Benvenuti (Florence: Mandragora, 2005), 97–8.

9 Guizzelmi, 'Prato, Biblioteca Roncioniana, ms. 87', in *Santa Maria delle Carceri a Prato: Miracoli e devozione in un santuario toscano del Rinascimento*, ed. Anna Benvenuti (Florence: Mandragora, 2005), 135–53; Maniura, *Art and Miracle*, 107–8. For Lorenzo degli Olbizi's poem, see Marco Villoresi, *Versi per la Madonna delle Carceri di Prato: un poemetto e quattro laudi*, Biblioteca dell'Archivio storico pratese 18 (Prato: Società pratese di storia patria, 2011).

10 '*inmediate, messa che fu decta croce, tucto el popolo vi gittò de' sassi, et non vollono avere tanta pazienza che ve gli gittassi decto messer Nicholò né el gonfalonieri né gl'Otto: questo volle el popolo dimostrare come n'era padrone, et non altra persona, come dicono le bolle*'. 'ms. 86', 124. The translation is mine, but my interpretation of this section of the text is partially indebted to Davies, 'Early History', 329. See also Maniura, *Art and Miracle*, 103–4.

11 *Inventario della Sagrestia e per l'altare dell'opera della Vergine Maria delle Carcere*, 1488–1510, MS 2304, Patrimonio Ecclesiastico fonds, Archivio di Stato, Prato, Italy; Marco Ciatti, 'Doni e donatori del Santuario di Santa Maria delle Carceri di Prato nei suoi inventari 1488–1510', *Prato storia e arte* 59 (1981): 14–44.

12 Hewlett, 'Rural Pilgrims', 349–58; Cecilia Hewlett, *Rural Communities in Renaissance Tuscany: Religious Identities and Local Loyalties* (Turnhout: Brepols, 2008), 197–209.

13 My calculation of the total number of miracles counts the stories duplicated in both texts once. 'ms. 86', 104–21; Guizzelmi, 'ms. 87', 137–52.

14 Miracles 94, 105, 34 in 'ms. 86', 113, 114, 107.

15 '*avendo a guadagnare con le braccia per vivere*', '*fu libero et sano*'. Miracle 103 in ibid., 114.

16 The use of this phrase was not unique to *Santa Maria delle Carceri*. In his miracle book for the Virgin's girdle, Guizzelmi occasionally referred to recipients of the relic's miracles as 'freed'. See, for instance, miracle 22. Giuliano Guizzelmi, *Historia della Cinctola della Vergine Maria: testo quattrocentesco inedito*, ed. Cesare Grassi (Prato: Società pratese di storia patria, 1990), 143–4.

17 '*Iesù . . . / . . . volesti per la tua bontade, / sol per cavarci di prigione scura*'. Lorenzo degli Olbizi, '*Miracoli della Vergine delle Carceri*', in Villoresi, *Versi per la Madonna delle Carceri di Prato*, 53, lines 1–6.

18 Guizzelmi, 'ms. 87', 135; Claudio Cerretelli, 'Da oscura prigione a tempio di luce: La costruzione di Santa Maria delle Carceri a Prato', in *Santa Maria delle Carceri a Prato: miracoli e devozione in un santuario toscano del Rinascimento*, ed. Anna Benvenuti (Florence: Mandragora, 2005), 48; Cerretelli, *La Basilica di Santa Maria delle Carceri*, 13.

19 Guy Geltner, *The Medieval Prison: A Social History* (Princeton: Princeton University Press, 2008), 20, 52–3; 59–60; Geltner, 'Isola non isolata: Le Stinche in the Middle Ages', *Annali di Storia di Firenze* III, no. 3 (2008): 19.

20 Cerretelli, 'Da oscura prigione', 47, 89 n. 15; Maniura, *Art and Miracle*, 95–7. The oil painting surrounding the miracle-working image conceals the inscription.

21 See note 19.

22 For examples of charitable practices involving prisoners, see John Koenig, 'Prisoner Offerings, Patron Saints, and State Cults, at Siena and Other Italian Cities from 1250 to 1550', *Bullettino senese di storia patria* 108 (2001): 222–96; Nicholas Terpstra, 'Confraternal Prison Charity and Political Consolidation in Sixteenth-Century Bologna', *Journal of Modern History* 66, no. 2 (1994): 217–48.

23 Guizzelmi, 'ms. 87', 136.

24 '*ongni superfluità et bruttura di decta Terra*'; '*che poche persone, mai per tal luogho passavano*'. 'ms. 87', 136.

25 Enrico Fiumi, *Demografia, movimento urbanistico e classi sociali in Prato: dall' eta comunale ai tempi moderni* (Firenze: Olschki, 1968), 517.

26 Guido Pampaloni, 'La povertà a Prato nella seconda metà del Quattrocento', in *Aspects of Poverty in Early Modern Europe*, ed. Thomas Riis (Odense: Odense University Press, 1986), 109–13.

27 Ibid., 110–16; Guido Pampaloni, 'Popolazione e società nel centro e nei sobborghi', in *Prato: Storia di una città*, ed. Fernand Braudel and Elena Fasano Guarini (Prato: Comune di Prato, Le Monnier, 1986), 361–93, esp. 375–9, 388–90.

28 Pampaloni, 'Popolazione e società', 375.

29 'ms. 86', 124; Davies, 'Early History', 327–9. For the widespread practice of preserving the sanctity of a miracle-working site, see Paul Davies, 'La santita' del luogo e la chiesa a pianta centrale nel Quattro e nel primo Cinquecento', in *La chiesa a pianta centrale: tempio civico del Rinascimento*, ed. Bruno Adorni (Milano: Electa, 2002).

30 For Lorenzo de' Medici's involvement in the church's construction, see Davies, 'Early History', 327, 329–32; Cerretelli, 'Da oscura prigione', 54–62; Holmes, *The Miraculous Image in Renaissance Florence*, 115–19; Morselli and Corti, *La Chiesa di Santa Maria delle Carceri*, esp. 16, 19–24.

31 '*discese dal muro, spichossi visibile et adorò per noi pregando et ponendo in terra questo vil luogo di Carcere el suo figluolo sanctissimo*'. 'ms. 86', 104.

32 Cyril Gerbron, 'Christ Is a Stone: On Filippo Lippi's "Adoration of the Child" in Spoleto', *I Tatti Studies in the Italian Renaissance* 19 (2016): 257–84, esp. 273.

33 'in tal l[uo]go la Madre piatosa Vergine Maria, la sua mano della gratia al bisognoso aperta et distesa, et a' poveri allarghate le braccia della sua Misericordia, dicendo: 'Venite a mme voi tucti che siete afatichati et io vi farò salvi'. ms. 86', 104.

34 Katherine T. Brown, *Mary of Mercy in Medieval and Renaissance Italian Art: Devotional Image and Civic Emblem* (New York: Routledge, 2017).

35 *Capitoli dell'Opera di Santa Maria delle Carceri*, 1484, MS 57, Archivio Antico Comunale fonds, Archivio di Stato, Prato; documents 9, 10, 11, 13 in Appendix 6 of Davies, 'Quattrocento Centrally Planned Church', 389–91.

36 Giuseppe Bologni, *Gli Antichi Spedali della 'Terra Di Prato'*, vol. 2 (Signa: Masso delle Fate Edizioni, 1994), 167.

37 Giulio Paolucci and Giuliano Pinto, 'Gli "Infermi" della Misericordia di Prato (1401-1491)', in *Società del bisogno: Povertà e assistenza nella Toscana medievale*, ed. Giuliano Pinto (Florence: Salimbeni, 1989).

38 Guizzelmi, *Historia della Cinctola*.

39 See miracles 7, 11, 14, 23 in ibid., 113–14, 120–2, 126–7, 144–6.

40 For Guizzelmi's textual sources, see Maniura, *Art and Miracle*, 73–4, 80.

41 Claudio Cerretelli, 'La Pieve e la Cintola: le trasformazioni legate alla reliquia', in *La Sacra Cintola nel Duomo di Prato*, ed. Aldo Capobianco (Prato: C. Martini, 1995), 79–161, esp. 89–90.

42 Mayu Fujikawa, 'Florence's Territorial Hegemony in the Eyes of Foreign Dignitaries: The Cappella della Sacra Cintola in Santo Stefano, Prato', in *The Chapels of Italy from the Twelfth to the Eighteenth Centuries: Art, Religion, Patronage, and Identity*, ed. Lilian H. Zirpolo (Woodcliff Lake: WAPACC Organization, 2010), 177–207; Renato Piattoli, 'Per la storia della Cappella del Sacro Cingolo nella prima metà del '400', *Archivio storico pratese* 10 (1931–1932): 70–2.

43 Fujikawa, 'Florence's Territorial Hegemony', 178, 180–1.

44 Maniura, *Art and Miracle*, 70–1. For a detailed description of the ostension ceremony, see Jean K. Cadogan, 'The Chapel of the Holy Belt in Prato: Piety and Politics in Fourteenth-Century Tuscany', *Artibus et Historiae* 30, no. 60 (2009): 107–14.

45 Alick McLean, *Prato: Architecture, Piety, and Political Identity in a Tuscan City-State* (New Haven: Yale University Press, 2008), 181–4.

46 Our evidence for a more immediate experience of the sacred object concentrates on the first years of the cult, and it is possible that access to the image was restricted over time; the cult's immediate success, however, suggests that its promoters were responding to a widespread need.

47 Ciatti, 'Doni e donatori', 24, 36, citing *Inventario*, 6v; Megan Holmes, 'Miraculous Images in Renaissance Florence', *Art History* 34, no. 3 (2011): 439–41.

48 'ms. 86', 121–6.

49 'volse gl'ochi et mutossi di colore'. Ibid., 122.

50 Five documented transfigurations suggest that the fresco was uncovered during the confraternities' offices. Ibid., 123–4, 126. Although the confraternity of the Archangel Raphael said weekly offices at the Chapel of the Sacred Belt, the relic presumably remained hidden in the altar during these rituals. *Capitoli della Compagnia di San Raffaello Arcangelo in S. Agostino*, 1512-1779, MS 276, Biblioteca Roncioniana, Prato, 5v.

51 degli Olbizi, '*Miracoli della Vergine*', 64, 67–8, 70; miracles 14, 20, 35, 110 in 'ms. 86', 105–6, 107, 115. Guizzelmi, 'ms. 87', 139, 141; Maniura, *Art and Miracle*, 113–14.

52 See miracles 14, 20, 27, 31, 32, 36 in 'ms. 86', 105–7. Guizzelmi, 'ms. 87', 139–41, 143–4, 147–8; Maniura, *Art and Miracle*, 112–13; Maniura, 'Image and Relic in the Cult of Our Lady of Prato', in *Images, Relics, and Devotional Practices in Medieval and*

Renaissance Italy, ed. Sally J. Cornelison and Scott Bradford Montgomery (Tempe: Arizona Center for Medieval and Renaissance Studies, 2006), 193–212.

53 See, for instance, the case studies in Jane Garnett and Rosser Gervase, 'Miraculous Images and the Sanctification of Urban Neighborhoods in Post-Medieval Italy', *Journal of Urban History* 32, no. 5 (July 2006): 729–40.

Chapter 7

1 Peter Parshall and Rainer Schoch, *Origins of European Printmaking: Fifteenth-Century Woodcuts and Their Public* (New Haven: Yale University Press, 2005), 60.
2 Richard Marks, *Image and Devotion in Late medieval England* (Stroud: Sutton Publishing Ltd, 2004), 18.
3 Jennifer Lee, 'Material and Meaning in Lead Pilgrims' Signs', *Peregrinations: Journal of Medieval Art and Architecture* 2, no. 3 (2009): 152–69, https://digital.kenyon.edu/per ejournal/vol2/iss3/7/ (accessed 6 December 2018).
4 www.finds.org.uk (accessed 5 November 2018).
5 John Schofield, Lyn Blackmore and Jacqui Pearce, with Tony Dyson, *London's Waterfront 1100-1666: Excavations in Thames Street, London, 1974-84* (Oxford: Archaeopress Publishing, 2018), xvii.
6 Ibid., 308.
7 Ibid., 309.
8 Geoff Egan and Frances Pritchard, *Dress Accessories: Medieval Finds from Excavations in London* 3 (Norwich: The Stationery Office, 1991), 3.
9 Jennifer Lee, 'Medieval Pilgrims' Badges in Rivers: The Curious History of a Non-theory', *Journal of Art Historiography* 11 (2014): https://arthistoriography.files.wor dpress.com/2014/11/lee.pdf (accessed 6 December 2018).
10 Egan and Pritchard, *Dress Accessories*, vii.
11 Schofield et al., *London's Waterfront*, 312–13.
12 Sarah Blick, 'Popular and Precious: Silver Gilt & Silver Pilgrim Badges', *Peregrinations: Journal of Medieval Art and Architecture* 2, no. 1 (2005): https://digital.kenyon.edu/per ejournal/vol2/iss1/7/ (accessed 6 December 2018).
13 Blick, 'Popular and Precious'.
14 Brian Spencer, *Pilgrim Souvenirs and Secular Badges: Medieval Finds from Excavations in London* 7 (Woodbridge: Boydell Press, 2010), 10.
15 Hazel Forsyth with Geoff Egan, *Toys, Trifles & Trinkets: Base Metal Miniatures from London 1200 to 1800* (London: Unicorn Press, 2005), 56.
16 Daniel Berger, 'Herstellungstechnik hoch- und spätmittelalterlicher Kleinobjekte aus Zinn' ('Production processes of small pewter objects in the High and Late Middle Ages'), in *Heilig en Profaan 3* (Langbroek: Stichting Middeleeuwse Religieuze en Profane Insignes, 2012), 39–55.
17 Museum of London object number: 8906.
18 Museum of London object number: BOY86[1487]<1291>.
19 Annemarieke Willemsen and Marlieke Ernst, *Hundreds of . . . Medieval Chic in Metal: Decorative Mounts on Belts and Purses from the Low Countries, 1300-1600* (Zwolle: Stichting Promotie Archeologie, 2012), 126.
20 Colin Torode, 2017, personal communication.
21 Herbert Maryon, *Metalwork and Enamelling*, 5th edn (New York: Dover, 1971), 203.
22 Spencer, *Pilgrim Souvenirs and Secular Badges*, 9.
23 Ashmolean Museum object number: 1997.20. Available online: http://collections.ashmolean.org/object/334603 (accessed 5 November 2018).

24	Spencer, *Pilgrim Souvenirs and Secular Badges*, 14.

25	Denis Bruna, *Saints et Diables au Chapeau. Bijoux oubliés du Moyen Age* (Paris: Seuil, 2007), 52.

26	Jos Koldeweij, '"Shameless and naked images": Obscene Badges as Parodies of Popular Devotion', in *Art and Architecture of Late Medieval Pilgrimage in Northern Europe and in the British Isles*, ed. Sarah Blick and Rita Tekippe (Leiden: Koninklijke Brill NV, 2005), 493–510, esp. 497.

27	Diana Webb, *Pilgrims and Pilgrimage in the Medieval West* (London: I. B. Tauris, 2001), 131.

28	Esther Cohen, 'In Haec Signa: Pilgrim Badge Trade in Southern France', *Journal of Medieval History* 2 (1976): 193–214, esp. 196.

29	Peter Murray Jones, 'Amulets: Prescriptions and Surviving Objects from Late Medieval England', in *Beyond Pilgrim Souvenirs and Secular Badges: Essays in honour of Brian Spencer*, ed. Sarah Blick (Oxford: Oxbow, 2007), 92–107, esp. 101.

30	Brian Spencer, *Medieval Pilgrim Badges from Norfolk* (Norfolk: Norfolk Museums Service, 1980), 10.

31	Christopher Dyer, *Standards of Living in the Later Middle Ages: Social Change in England c. 1200-1520* (Cambridge: Cambridge University Press, 1989), 227.

32	Ibid., 173.

33	Ibid., 170.

34	Ibid., 79.

35	Anonymous, *The Prologue; Or, the Merry Adventure of the Pardoner and Tapster at the Inn at Canterbury*, 171–7, http://sites.fas.harvard.edu/~chaucer/canttales/gp/bery npro.html (accessed 5 November 2018)

36	Geoffrey Chaucer, *Canterbury Tales*, Ellesmere MS (Henry E. Huntington Library and Art Gallery, San Marino, USA, 1400–1410): f. 138 & f. 34v.

37	Kate M. Warren, *Langland's Vision of Piers the Plowman: An English Poem of the Fourteenth Century Done into Modern Prose* (London: T. Fisher Unwin, 1889), 82–3.

38	John Gough Nichols, *Pilgrimages to Saint Mary of Walsingham and Saint Thomas of Canterbury by Desiderius Erasmus: Newly Translated, with an Introductions and Illustrative Notes*, 2nd edn (London: John Murray, 1875), 1–2.

39	Jennifer Lee, 'Searching for Signs: Pilgrims' Identity and Experience made Visible in the Miracula Sancti Thomae Cantuariensis', in *Art and Architecture of Late Medieval Pilgrimage in Northern Europe and in the British Isles*, ed. Sarah Blick and Rita Tekippe (Leiden: Koninklijke Brill NV, 2005), 473–91, esp. 484–5.

40	Edwin A. Abbott, *St. Thomas of Canterbury: His Death and Miracles*, 2 (London: Adam and Charles Black, 1898), 70.

41	Museum of London object number: TL74[2532]<1671>.

42	Brian Spencer, *Pilgrim Souvenirs and Secular Badges: Salisbury Museum Medieval Catalogue, Part 2* (Over Wallop: Salisbury and South Wiltshire Museum, 1990), 19.

43	Museum of London object numbers: 86.202/3 and 80.65/9.

44	Spencer, *Pilgrim Souvenirs and Secular Badges*, 103.

45	Museum of London object numbers: A24766/6 and 81.490/11.

46	Thames foreshore find from Billingsgate (private collection); Museum of London object number: BWB83[155]<76>. A badge from the same mould as that in the private collection is in the Neish Pewter Collection at the Stirling Smith Art Gallery & Museum. Patricia Neish, *The Neish Pewter Collection* (Stirling: Stirling Smith Art Gallery & Museum, 2018), 184.

47	Spencer, *Pilgrim Souvenirs and Secular Badges*, 94.

48 Peter R. G. Hornsby, Rosemary Weinstein and Ronald F. Homer, *Pewter: A Celebration of the Craft 1200-1700* (London: Historical Publications Ltd., 1989), 15.
49 Museum of London object number: 97.95/1.
50 Spencer, *Pilgrim Souvenirs and Secular Badges*, 93.
51 British Library, Harley MS 5102, f. 32.
52 Museum of London object number: 86.202/17.
53 Dublin, Trinity College Library, MS E. I. 40, f. 38r.
54 Spencer, *Pilgrim Souvenirs and Secular Badges*, 175.
55 Museum of London object numbers: 84.394; 78.84/7; 78.84/19.
56 Spencer, *Pilgrim Souvenirs and Secular Badges*, 131.
57 Ibid., 151.
58 Ibid., 149.
59 For example, Museum of London object number: 75.1/3.
60 Museum of London object number: 80.150/8.
61 Brian Spencer, 'King Henry and the London Pilgrim', in *Collectanea Londiniensia. LAMAS Special Paper* 2, ed. Joanna Bird, High Chapman and John Clark (London: London and Middlesex Archaeological Society, 1978), 248.
62 Blick, 'Popular and Precious', no page number.
63 New Bedford Free Public Library, Mss 015, 1912.005, f. 29 v.
64 Museum of London object number: 83.367.
65 Spencer, *Pilgrim Souvenirs and Secular Badges*, 165.
66 Bruna, *Saints et Diables*, 101.
67 Ibid., 108–9.
68 Anthony Mackinder, *Roman and Medieval Revetments on the Thames Waterfront: Excavations at Riverbank House, City of London, 2006-9, MOLA Archaeology Studies Series 33* (London: Museum of London Archaeology, 2015), 94–6.
69 Mackinder, *Roman and Medieval Revetments*, 96.
70 Bruna, *Saints et Diables*, 91.
71 David S. Areford, *The Viewer and the Printed Image in Late Medieval Europe* (Farnham: Ashgate Publishing Ltd, 2010), 12.
72 Hans Belting, *Likeness and Presence: A History of the Image before the Era of Art*, trans. Edmund Jephcott (Chicago: The University of Chicago Press, 1990), 220.
73 Spencer, *Pilgrim Souvenirs and Secular Badges*, 252.
74 Museum of London object number: 2002.89.
75 Spencer, *Pilgrim Souvenirs and Secular Badges*, 252.
76 Megan H. Foster-Campbell, 'Pilgrimage through the Pages: Pilgrims' Badges in Late Medieval Devotional Manuscripts', in *Push Me, Pull You: Imaginative and Emotional Interaction in Late Medieval and Renaissance Art*, 1, ed. Sarah Blick and Laura D. Gelfand (Leiden: Koninklijke Brill NV, 2011), 227–76, esp. 240.
77 National Library of the Netherlands, The Hague, KB, 77 L 60, f. 98.
78 Hanneke van Asperen, 'A Pilgrim's Additions: Traces of Pilgrimage in the *Belles Heures* of Jean de Berry', *Quaerendo* 38 (2008): 175–94, esp. 176.
79 Foster-Campbell, 'Pilgrimage through the Pages', 227–8.
80 van Asperen, 'A Pilgrim's Additions', 181.
81 Ibid., 182.
82 Brian Spencer, 'Medieval Pilgrim Badges', in *Rotterdam Papers: A Contribution to Medieval Archaeology* (Rotterdam: J.G.N. Renaud, 1968), 137–53, esp. 144.
83 Peter Cardwell, 'Excavation of the Hospital of St Giles by Brompton Bridge, North Yorkshire', *Archaeological Journal* 152 (1995): 109–245, esp. 201.

84 Spencer, *Pilgrim Souvenirs and Secular Badges*, 18.

85 http://www.kunera.nl, catalogue number 03899 (accessed 6 December 2018).

86 Museum of London object number: 94.102.

87 Spencer, 'King Henry', 237.

88 Museum of London object number: BC72[55]<1555>.

89 Sarah Blick, 'Reconstructing the Shrine of St Thomas Becket, Canterbury Cathedral', in *Art and Architecture of Late Medieval Pilgrimage in Northern Europe and in the British Isles*, ed. Sarah Blick and Rita Tekippe (Leiden: Koninklijke Brill NV, 2005), 407–41, esp. 406.

90 Annemarieke Willemsen, '"Man is a sack of muck girded with silver": Metal Decoration on Late-Medieval Leather Belts and Purse from the Netherlands', *Medieval Archaeology* 56 (2012): 171–202, esp. 199.

Chapter 8

1 This chapter is part of my forthcoming PhD Thesis, with the preliminary title *Artisan Dress in Denmark 1550-1650*. The research for it was carried out as part of the 'Refashioning the Renaissance' project, funded generously by the European Research Council (ERC) under the European Union's Horizon 2020 research and innovation programme (grant agreement No 726195).

2 Michael Dupont, *Helsingør Skifteprotokol 1571-1582* (Copenhagen: Selskabet for Udgivelse af Kilder til Dansk Historie, 2014), 209–10: 'nogenn sølff whare, spennde oc skeder'.

3 Dupont, *Helsingør Skifteprotokol*, 210.

4 See, for instance, Carole Collier Frick, *Dressing Renaissance Florence: Families, Fortunes, and Fine Clothing* (Baltimore: Johns Hopkins University Press, 2006); Elizabeth Currie, 'Clothing and a Florentine Style, 1550–1620', *Renaissance Studies* 23, no. 1 (2009): 33–52; Elizabeth Currie, *Fashion and Masculinity in Renaissance Florence* (London and New York: Bloomsbury Academic, 2016); Susan J. Vincent, *Dressing the Elite: Clothes in Early Modern England* (Oxford and New York: Berg Publishers, 2003).

5 For Italy: Patricia Allerston, 'Clothing and Early Modern Venetian Society', *Continuity and Change* 15, no. 3 (2000): 367–90; Paula Hohti, 'Dress, Dissemination, and Innovation: Artisan Fashions in Sixteenth- and Early Seventeenth-Century Italy', in *Fashioning the Early Modern: Dress, Textiles, and Innovation in Europe, 1500-1800*, ed. Evelyn Welch (Oxford: Oxford University Press and Pasold Research Fund, 2017); and especially the ongoing 'Refashioning the Renaissance' project at http://refashioningrenaissance.eu. For England: John Styles, *The Dress of the People: Everyday Fashion in Eighteenth-Century England* (New Haven and London: Yale University Press, 2007). For Germany: Ulinka Rublack, *Dressing Up: Cultural Identity in Renaissance Europe* (Oxford: Oxford University Press, 2011). For Scandinavia: Camilla Luise Dahl, 'Dressing the Bourgeoisie: Clothing in Probate Records of Danish Townswomen, ca. 1545–1610', *Medieval Clothing and Textiles* 12 (2016): 131–93; Camilla Luise Dahl, 'Klædt i Rigets – Stand, Status og National Identitet Udtrykt i Borgerskabets Dragt i Reformationstidens Danmark-Norge og Sverige' (Oslo: Forelæsningsserien Norsk institutt for bunad og folkedrakt, Norsk folkemuseum, 2015); Eva I Andersson, 'Swedish Burghers' Dress in the Seventeenth Century', *Costume* 51, no. 2 (2017): 171–89; Eva I. Andersson, 'Women's Dress in Sixteenth-Century Sweden', *Costume* 45

(2011): 24–38; Charlotte Rimstad, 'Dragtfortællinger fra Voldgraven: Klædedragten i 1600-Tallets København, Baseret På Arkæologiske Tekstiler fra Københavns Rådhusplads' (PhD Thesis, University of Copenhagen, Copenhagen, 2018); Vivi Lena Andersen, 'Mellem Brosten, Knyst, Skolæst og Mode. Sko fra 1300-1800 fra Arkæologiske Udgravninger i København' (PhD Thesis, University of Copenhagen and Museum of Copenhagen, Copenhagen, 2016).

6 Grete Jacobsen, *Kvinder, Køn og Købstadslovgivning 1400-1600* (Copenhagen: Det Kongelige bibliotek and Museum Tusculanums forlag, 1995), 99; Ole Degn and Inger Dübeck, *Håndværkets Kulturhistorie. Håndværket i Fremgang. Perioden 1550-1700*, vol. 2 (Copenhagen: Håndværkerrådets Forlag, 1983), 11–13. In this chapter, I use the term 'Denmark' to refer to the Kingdom of Denmark, which in the sixteenth and most of the seventeenth centuries included Skåne (until 1658), Blekinge and Halland (until 1645). I have chosen not to include other provinces ruled by the Danish king, including the Kingdom of Norway together with the Faroe Islands, Iceland, Greenland and the duchies Schleswig and Holstein in what is now northern Germany.

7 Camilla Luise Dahl and Piia Lempiäinen, 'The World of Foreign Goods and Imported Luxuries: Merchant and Shop Inventories in late 17th-Century Denmark-Norway', in *Fashionable Encounters: Perspectives and Trends in Textile and Dress in the Early Modern Nordic World*, ed. Tove Engelhardt Mathiassen et al. (Oxford: Oxbow Books, 2015), 11.

8 On the use of inventories, Giorgio Riello, 'Things Seen and Unseen: The Material Culture of Early Modern Inventories and Their Representation of Domestic Interiors', in *Early Modern Things: Objects and Their Histories, 1500-1800*, ed. Paula Findlen (Basingstoke: Routledge, 2013), 125–50; Jan Kuuse, 'The Probate Inventory as a Source for Economic and Social History', *Scandinavian Economic History Review* 22, no. 1 (1974): 22–31. Other inventory based dress studies are Daniel Roche, *The Culture of Clothing: Dress and Fashion in the Ancien Regime* (Cambridge: Cambridge University Press, 1996), Isis Sturtewagen, *All Together Respectable Dressed: Fashion and Clothing in Bruges during the Fifteenth and Sixteenth Centuries* (PhD Thesis, University of Antwerp, 2016).

9 Dahl, 'Dressing the Bourgeoisie', 133; no inventories from Norway survive from this period.

10 Dahl, 'Dressing the Bourgeoisie', 133–4.

11 HBS: 1592-1598, 521v: 'Vndvigt fra for Jørren Skinder, Hand haffde stuckett och får gjord'.

12 Dahl, 'Dressing the Bourgeoisie', 133–4.

13 HBS:1628-1631, 364r: '1 Mørckebruun bomsies kledning med 2 Rad stickninng, 1 par soertte kledis buxer med 3 Raed Snoerrer, 1 bomsies troye, 1 par Indsprengt kirsei buxer'. The cloths are not described in detail, but they are probably of wool. https://mothsordbog.dk/ordbog?select=Klæde,e&query=klæde (accessed 13 February 2019).

14 HBS:1628-1631, 364r: '1 hatt, 1 gammell hatt, 1 gammell foederitt hue, 1 gammell Natthue, 2 Blaae strømper, 2 huide hoser, 1 par handshe'. https://mothsordbog.dk/ordbog?aselect=Klæde-byrste&query=klædebørste (accessed 2 October 2018).

15 HBS:1628-1631, 364v: '2 Gamle skiortter, 2 Linnhoesser, 3 gamle Ruekrauffuer'.

16 HBS:1628-1631, 364r, In 1683, one ell was 62.81 cm. The currency in this period included the rigsdaler, mark, ort and skilling.

17 Troels Lund, *Dagligt Liv i Norden i det Sekstende Aarhundrede*, vol. 2 (Copenhagen and Kristiania: Gyldendalske Boghandel and Nordisk Forlag, 1914, 4th edn), 174–5.

According to Lund, the custom of making gifts of stained-glass panels was common when a new house was built, and according to him the example discussed here is representative of this custom.

18 Camilla Luise Dahl, 'Skifter fra Kalundborg 1541-1658', no. 11: 'Dend sorte leertrøie, 2 sorte engelst boxer'. https://ctr.hum.ku.dk/research-programmes-and-projects/previ ous-programmes-and-projects/earlymodern/postdocproject/extracts/skifter_fra_kalu ndborg_udvalg.docx.pdf (accessed 15 September 2019).

19 Literature on archological finds from Copenhagen includes Andersen, Mellem Brosten, Rimstad, 'Dragtfortællinger Fra Voldgraven', 10–12, Charlotte Rimstad, 'Hgåndtryk fra fortiden. Om strikkede handsker og vanter fra 1600-tallet', *Dragtjournalen* 11, no. 15 (2017): 69–74; Maj Ringgaard, '*To par strixstrømper oc en nattrøie naccarat'. Filtede og strikkede tekstiler fra omkring år 1700, fundet i Københavnske byudgravninger – og sammenhænge mellem tekstilers farve og bevaring* (PhD Thesis, University of Copenhagen, Copenhagen, 2010); Maj Ringgaard, 'Hosekoner Og Sålede Strixstrømper', *Dragtjournalen* 8, no. 11 (2014): 4–12; Lise Warburg, 'Strik i de Københavnske jordfund', in *Textila tekniker i nordisk tradition. Rapport från nordiskt symposium om textila tekniker*, ed. Bengt Wittgren (Uppsala: Etnologiska Institutionen 1986), 79–93.

20 Rimstad, 'Dragtfortællinger fra Voldgraven', 10–12, 403.

21 Leon Jespersen, 'At Være, at Ville og at Have. Træk af Luksuslovgivningen i Danmark i 15- 1600-Tallet', *Temp. Tidsskrift for Historie* 1, no. 1 (2010): 31–6.

22 https://kalkarsordbog.dk/ordbog?aselect=Garnete&query=garnidt, https://ordnet.dk/ ods/ordbog?entry_id=6014615 &query=garnet (accessed 7 January 2019).

23 V. A. Secher, *Forordninger, Recesser og Andre Kongelige Breve, Danmarks Lovgivning Vedkommende 1558-1660*, vol. 3, *1596-1621* (Copenhagen: G.E.C Gad Nielsen & Lydiche, 1891), 210–13;
http://kalkarsordbog.dk/ordbog?entry_id=67137002&query=perlelad&hi=perlelad (accessed 7 January 2019).

24 Eva I. Andersson, 'Foreign Seductions: Sumptuary Laws, Consumption and National Identity in Early Modern Sweden', in *Fashionable Encounters: Perspectives and Trends in Textile and Dress in the Early Modern Nordic World*, ed. Tove Engelhardt Mathiassen et al. (Oxford: Oxbow Books, 2014), 15–29, esp. 28.

25 I use the English phrase 'town books' collectively for the Danish terms *stadsbøger, rådstueprotokoller, bytingsprotokoller*, and *rådstuedombøger*. Published town books include Einar Bager, *Malmø Stadsbog 1549-1559. Rådstuerettens, Bytingets og Toldbodrettens Protokol* (Copenhagen: Selskabet for udgivelse af kilder til dansk historie, 1972); Erik Kroman, *Malmø Rådstueprotokol (Stadsbok) 1503-1548* (Copenhagen: Selskabet for Udgivelse af Kilder til Dansk Historie, 1965); Leif Ljungberg and Einar Bager, *Malmø Tingbøger 1577-83 og 1588-90* (Copenhagen: Selskabet for Udgivelse af Kilder til dansk Historie, 1968); Erik Kroman, *Ribe Rådstuedombøger 1527-1576 og 1580-1599* (Copenhagen: Selskabet for Udgivelse af Kilder til dansk Historie, 1974); Karen Hjorth and Erik Kroman, *Helsingør Stadsbog 1554-1555, 1559 -1560 og 1561-1565. Rådstueprotokol og Bytingbog* (Copenhagen: Selskabet for Udgivelse af Kilder til Dansk Historie, 1981); and Erik Kroman, *Helsingør Stadsbog 1549-1556. Rådstueprotokol og Bytingbog* (Copenhagen: Selskabet for Udgivelse af Kilder til Dansk Historie, 1971).

26 *Lybke* probably refers to the German town of Lübeck.

27 Kroman, *Helsingør Stadsbog 1549-1556*, 52–3.

28 See also Beverly Lemire, 'The Theft of Clothes and Popular Consumerism in Early Modern England', *Journal of Social History* 24, no. 2 (1990): 255–76; Vibe Maria Martens, 'The Theft of Fashion: Circulation of Fashionable Textiles and Garments in 18th-Century Copenhagen', in *Fashionable Encounters: Perspectives and Trends in Textile and Dress in the Early Modern Nordic World*, ed. Tove Engelhardt Mathiassen et al. (Oxford: Oxbow Books, 2014), 157–71.

29 Lou Taylor, *Establishing Dress History* (Manchester: Manchester University Press, 2004), 4–6.

30 W. R. Prior, 'Et Engelsk Rejseindtryk Af Danmark Fra 1593', *Fra Arkiv Og Museum* 5 (1912-1915): 45–58.

31 Fynes Morrison, *An Itinerary Containing His Ten Yeeres Travell through the Twelve Dominions of Germany, Bohmer- Land, Sweitzerland, Netherland, Denmarke, Poland, Italy, Turkey, France, England, Scotland & Ireland*, vol. 4 (Glasglow: James MacLehose and Sons, 1908), 215.

32 Julius Clausen and P. Fr. Rist, *Det Store BIlager I Kjøbenhavn 1634* (Copenhagen: Gyldendalske Boghandel and Nordisk Forlag, 1914), I–XIX.

33 Ibid., 15: 'Allevegne ser man det fineste Linned, og jeg undrede mig over selv i Barberernes Bod at finde fine og kostbare Haandklæder til Brug for Haandværkere og Daglejere, skøndt der ingen Overflod der i Landet er paa Hør og Hamp. I intet andet Land har jeg set saa store og smukke Sengelagener som her'.

34 The German style also dominated dress in Sweden, Andersson, 'Foreign Seductions', 24–5.

35 HBS:1632-1635, 9r: '5 shiorter, 8 sky kraffuer, 2 tørrekleder, 3 pudes vor, 1 par hórgarns lagen, 8 pd Hørgarn, 1 bloegarns dug, 1 par bloegarns lagen, 21 pd bloegarn' *Blågarn* is coarse linen made from the waste fibres of spinning: https://mothsordbog.dk/ordbog?query=blår (accessed 9 February 2019).

36 The diary is transcribed and published by Torben Bill-Jessen and Lone Hvass.

37 Torben Bill-Jessen and Lone Hvass, *Liv Og Død, Tro, Håb Og Mirakler i 1600-Tallets Helsingør* (Helsingør: Helsingør Kommunes Museer, 2017), 48: 'med en høj top for[an] i panden var ret lige som et halvt rundt cirkel som skulle være lignet [ligne] som et af hine staaktraadsbøjler de sætte i for panden og har igennem øren.'

38 Hans Nielsøn, *Sørglig Spectacel oc Vndertegn* (Copenhagen: Henrich Waldkirch, 1625), 4: 'høj bred rund Bue aff Kiød, noget I Høyden spizactig, eller med Staaltraae opreiste Sørgehatte, och andre saadanne forargelige Huer som nu aff Quindekiønet Adel oc V-adel, Fattig oc Riig, fast vbetenctet oc modvilligen imod mange saadanne Guds vredis Tegn oc daglig Formaning Brugis'.

39 Nielsøn, *Sørglig Spectacel*, 5–7.

Chapter 9

1 The research for this article has been carried out as part of the 'Refashioning the Renaissance' Project. The project has received funding from the European Research Council (ERC) under the European Union's Horizon 2020 research and innovation programme (grant agreement No. 726195).

2 See Charles Eastlake, in Angela Maddock, 'Folds, Scissors and Cleavage in Giovanni Battista Moroni's *Il Tagliapanni*', in *The Erotic Cloth: Seduction & Fetishism in Textiles*,

ed. Alice Kettle and Lesley Millar (London and New York: Bloomsbury, 2018), 25–36, esp. 28.

3 Archivio di Stato di Siena (henceforth referred to as ASS), Lira 111-113 (1509).

4 For the economic and social status of Italian artisans, see Paula Hohti, 'Conspicuous Consumption and Popular Consumers: Material Culture and Social Status in Sixteenth-Century Siena', *Renaissance Studies* 24, no. 5 (2010): 654–70, esp. 657; and of tailors, Paula Hohti Erichsen, *Artisans, Objects, and Everyday Life in Renaissance Italy* (Amsterdam: Amsterdam University Press, 2020), Chapter 3.

5 For the sumptuary laws of 1548, see ASS, *Quattro Censori* 1, 'Statuti degli sforgi e altre provvisioni'. The subsequent laws are found in ASS, *Balìa* 830, 'Libro dei bandi', c. 246r- (1576), c. 321r- (1588), c. 326r- (1589), and in ASS, *Regolatori* 76, c. 99 v- (1594).

6 See, for example, ASS, *Balìa* 830, 246r (1576).

7 In 1588, a ban was issued against the use of *pavonazzo* and black with purple undertones by anyone who did not belong to the governing class (*uomini di reggiemento*). See G. Calvi, 'Abito, genere, cittadinanza nella Toscana moderna (secoli XIV-XVII)', *Quaderni Storici* 110 (2002): 477–503, 501, note 28. The law was repeated in 1599: 'Il color nero o almeno il pavonazzo pareve da proibirsi in tutto alle donne non riseduti o non marinate a riseduti', ASS, *Balìa* 830, 342r (1599).

8 For transcription, see Renato Lugarini, 'Il ruolo degli "statuti delli sforgi" nel sistema suntuario senese', *Bullettino senese di storia patria* 54 (1997): 403–22, at 416–17.

9 See the discussion in Carole Frick, *Dressing Renaissance Florence: Families, Fortunes and Fine Clothing* (Baltimore and London: Johns Hopkins University Press, 2005), 149–57.

10 See the statutes of *Quattro Censori* of 1548, transcribed in Lugarini, 'Il ruolo degli "statuti"', 414–18.

11 ASS, *Balìa* 830, 246r- (1576).

12 ASS, *Bicccherna* 1082, 'Marcatura dei vesti' (1561).

13 Giovanbattista di Girolamo Fideli, designated as *sarto* (tailor), is found in ASS, *Biccherna* 1084 (1576), 55r. For his economic level and background, see ASS, *Lira* 132, Città (1548) and ASS, *Lira* 243, *Denunzia*, c. 1784-85 (1548).

14 Elizabeth Currie, *Fashion and Masculinity in Renaissance Florence* (London and New York: Bloomsbury, 2016).

15 Calvi, 'Abito, genere, cittadinanza', 492–5; Paula Hohti, 'Dress, Dissemination, and Innovation: Artisan Fashions in Sixteenth- and Early Seventeenth-Century Italy', in *Fashioning the Early Modern: Creativity and Innovation in Europe, 1500-1800*, ed. Evelyn Welch (Oxford: Pasold and Oxford University Press, 2016), 143–65, esp. 157.

16 The case is recorded in ASS, *Quattro Censori* 2, c. 119r: 'La moglie di Girolamo Salvestri calzolaro a san Marco per haver portato un rete con frontale doro filato e rosetta contra la forma della legge si domanda del quattro'.

17 ASS, *Biccherna* 1084 (1562), 61v.

18 Elizabeth Currie, 'Fashion Networks: Consumer Demand and the Clothing Trade in Florence from the Mid-sixteenth to Early Seventeenth Centuries', *Journal of Medieval and Early Modern Studies* 39, no. 3 (2009): 483–509.

19 Evelyn Welch, 'Art on the Edge: Hair and Hands', *Renaissance Studies* 23, no. 3 (2008): 241–68; Timothy McCall, 'Material Fictions of Luxury in Sforza Milan', and Paula Hohti, 'Cheap Magnificence? Imitation and Low-Cost Luxuries in Renaissance Italy', in *Luxury and the Ethics of Greed in Early Modern Italy*, ed. Catherine Kovesi (Turnhout: Brepols, forthcoming January 2019), 239–76 and 277–97.

20 Ulinka Rublack and Maria Hayward (eds), *The First Book of Fashion: The Books of Clothes of Matthäus & Veit Konrad Schwartz of Augsburg* (London and New York: Bloomsbury, 2015).

21 Ulinka Rublack, *Dressing Up: Cultural Identity in Renaissance Europe* (Oxford: Oxford University Press, 2011).

22 Hohti, 'Dress, Dissemination, and Innovation', 152–8. See also the forthcoming ERC-Refashioning the Renaissance database, recording artisan dress from Siena, Florence and Venice, 1550–1650 at http://refashioningrenaissance.eu.

23 Elizabeth Currie has argued that tailors began to propose new styles actively rather than simply making garments according to models provided by their clients in the sixteenth century. See Elizabeth Currie, 'Diversity and Design in the Florentine Tailoring Trade, 1550-1620', in *The Material Renaissance*, ed. Michelle O'Malley and Evelyn Welch (Manchester: Manchester University Press, 2007), 154–73, esp. 163–5. For a discussion of the status of artisans in early modern Europe, see also Margaret Pappano and Nicole R. Rice (eds), 'Medieval and Early Modern Artisan Culture', *Special Issue, Journal of Medieval and Early Modern Studies* 43, no. 3 (2013): 480–1.

24 Currie, 'Diversity and Design', 157–8; Monica Cerri, 'Sarti toscani nel seicento: Attività e clientela', in *Le trame della moda*, ed. Anna Giulia Cavagna and Grazietta Butazzi (Rome: Bulzoni, 1995), 421–33, 423.

25 For his inventory and shop, see ASS, *Curia del Placito* 733, no. 273 (1549). His wealth is recorded in ASS, *Lira* 132 (1548), 82v. For discussion, see Hohti Erichsen, *Artisans, Objects, and Everyday Life in Renaissance Italy*, Chapter 3.

26 By the end of the sixteenth century, black had become the most important colour of rank and power. For a discussion of black, see Currie, *Fashion and Masculinity*, 98–108; and for the different types of black and their creation and meanings, Susan Kay-Williams, *The Story of Colour in Textiles: Imperial Purple to Denim Blue* (London and New York: Bloomsbury, 2013).

27 Cited in Patricia Fortini Brown, *Art and Life in Renaissance Venice* (London: Laurence King Publishing, 1997), 149.

28 ASS, *Curia del Placito* 279 (1637), 109v: Inventory of the shoemaker Giovanni di Pavolo.

Chapter 10

1 The first version of this chapter was presented at the Symposium *The Art of the Poor in the Middle Ages and Renaissance*, held at the Warburg Institute, London, 14–15 June 2018. I would like to thank the audience for their comments.

2 V. Sekules, 'Religious Politics and the Cloister Bosses of Norwich Cathedral', *Journal of the British Archaeological Association* 159, no. 1 (2006): 284–306.

3 Tord Harlin and Bengt Z. Nordström, *Härkebergas rika skrud: möte med målaren Albertus Pictor* (Enköping: Enköpings kyrkliga samfällighet, 2003).

4 A. Schneider, 'Archaeology of Music in Europe', in *The Garland Encyclopedia of World Music*, ed. T. Rice, J. Porter and C. Goertzen (London: Routledge, 2017), 34–45.

5 Cajsa Lund, 'The Archaeomusicology of Scandinavia', *World Archaeology* 12, no. 3 (1981): 246–5.

6 G. Kolltveit, *Jew's Harps in European Archaeology* (Oxford: Archaeopress, 2006).

7 Nicholas J. Conard, Maria Malina and Susanne C. Münzel, 'New Flutes Document the Earliest Musical Tradition in Southwestern Germany', *Nature* 460 (August 2009): 737–40.

8 F. Anoyanakis, *Greek Folk Musical Instruments* (Athens: National Bank of Greece, 1979).

9 F. Crane, *Extant Medieval Musical Instruments: A Provisional Catalogue by Types* (Iowa City: University of Iowa Press, 1972); an updated version with extended bibliography by J. G. Hurst has been issued.

10 D. Hakelberg, 'A Medieval Wind Instrument from Schlettwein, Thuringia', *Historic Brass Society Journal* 7 (1995): 185–96.

11 If King David played any chordophone, it would most likely have been the lyre.

12 C. Page, 'German Musicians and Their Instruments: A 14th-Century Account by Konrad of Megenberg', *Early* music 10, no. 2 (1982): 192–200. See also S. Kruiger (ed.), *Konrad von Megenberg. Werke. Ökonomik* (*Monumenta Germaniae historica. Staatsschriften späteren Mittelalters* III/5, 1–2), (Stuttgart: Hiersemann Vlg., 1973 and 1977).

13 A. F. W. Bentzon, *The Launeddas: A Sardinian Folk-music instrument* (Copenhagen: Akademisk forlag, 1969).

14 E. Hickmann and R. Eichmann (eds), *Symposium Musikarchäologische Quellengruppen. Bodenurkunden, mündliche Überlieferung, Aufzeichnung* (International Study Group on Music Archaeology) (Rahden, Westfalia: M. Leidorf, 2004).

15 There is some debate as to whether the *tibia utricularius*, played by Nero (not the lyre!), was in fact a type of early bagpipe, as suggested by the first century AD writer Dio Chrysostom.

16 David Munrow, *Instruments of the Middle Ages and the Renaissance* (London: Oxford University Press, 1976); J. Montagu, *The World of Medieval & Renaissance Musical Instruments* (New York: Overlook Press, 1976).

17 Johannes de Grocheio, *Ars Musicae*, ed. and trans. Constant J. Mews, John N. Crossley, Catherine Jeffreys, Leigh McKinnon and Carol J. Williams (Kalamazoo: Medieval Institute Publications, 2011).

18 '*Quia interdum peregrini quando vigilant in ecclesia Beate Marie de Monte Serrato volunt cantare et trepudiare, et etiam in platea de die, et ibi non debeant nisi honestas ac devotas cantilenas cantare, idcirco superius et inferius alique sunt scripte. Et de hoc uti debent honeste et parce, ne perturbent perseverantes in orationibus et devotis contemplationibus.*'

19 Timothy McGee, *Medieval Instrumental Dances* (Bloomington and London: Indiana University Press, 2014).

Chapter 11

1 A. H. Church, *English Earthenware* (London: Chapman & Hall, 1884), 11.

2 R. L. Hobson, *A Guide to the English Pottery and Porcelain in the Department of British and Mediaeval Antiquities: British Museum* (Oxford: Oxford University Press, 1910), 5.

3 W. B. Honey, 'Foreword', in Bernard Rackham, *Medieval English Pottery*, 2nd edn (London: Faber & Faber, 1972), v.

4 Rackham, *Medieval English Pottery*, 1.

5 Ibid., 2–3.

6 J. E. Pearce, A. G. Vince and M. A. Jenner, *A Dated Type-Series of London Medieval Pottery, Part 2: London-Type Ware*, London Middlesex Archaeological Society Special Paper 6 (London: London Middlesex Archaeological Society, 1985), 127.

7 For example, Pearce et al., *London-Type Ware*, 27–8, figs 10–24, pls I–IV.

8 G. C. Dunning, 'Pottery', in J. B. Ward Perkins, *London Museum Medieval Catalogue* (London: HMSO, 1954), 212.

9 Ibid., 212.

10 Pearce et al., *London-Type Ware*.
11 J. Pearce and A. Vince, *A Dated Type-Series of London Medieval Pottery, Part 4: Surrey Whitewares*, London Middlesex Archaeological Society Special Paper 4 (London: London Middlesex Archaeological Society, 1988).
12 J. Pearce, A. Vince and R. White, 'A Dated Type-Series of London Medieval Pottery Part 1: Mill Green Ware', *Transactions of the London Middlesex Archaeological Society* 33 (1982): 214–65.
13 Pearce and Vince, *Surrey Whitewares*, 82.
14 For example, Pearce et al., *London-Type Ware*, 29–31, figs 41–4, 55; Pearce and Vince, *Surrey Whitewares*, 35–8.
15 Pearce and Vince, *Surrey Whitewares*, 20, figs 12; fig. 56, nos 28–32; figs 57–9.
16 For example, see Rackham, *Medieval English Pottery*, col. pl. D; Michael R. McCarthy and Catherine M. Brooks, *Medieval Pottery in Britain AD 900–1600* (Leicester: Leicester University Press, 1988), fig. 127.
17 J. Pearce, 'Adorned with Ferocious Beasts: A Unique Medieval Zoomorphic Jug', in *Hidden Histories and Records of Antiquity': Essays on Saxon and Medieval London for John Clark, Curator Emeritus, Museum of London*, ed. J. Cotton, J. Hall, J. Keily, R. Sherris and R. Stephenson, London Middlesex Archaeological Society Special Paper 17 (London: London Middlesex Archaeological Society, 2014), 140–4.
18 Rackham, *Medieval English Pottery*, col. Pl. B; Pearce and Vince, *Surrey Whitewares*, fig. 71, no. 110.
19 See, for example, a copy of the Kingston-type zoomorphic jug by Leach, ca. 1930, illustrated in Edmund de Waal, *Bernard Leach* (London: Tate Publishing, 2014), pl. 29.
20 Pearce and Vince, *Surrey Whitewares*, fig. 100, nos 384–6.
21 Pearce et al., *London-Type Ware*, figs 74–5.
22 Rackham, *Medieval English Pottery*, col. Pl. F; McCarthy and Brooks, *Medieval Pottery in Britain*, fig. 127, no. 651.
23 Rackham, *Medieval English Pottery*, 11.
24 Pearce et al., *London-Type Ware*, fig. 56; Pearce and Vince, *Surrey Whitewares*, figs 84–6; Pearce et al., 'Mill Green Ware', figs 8–9.
25 Pearce and Vince, *Surrey Whitewares*, fig. 84, nos 212–13; Rackham, *Medieval English Pottery*, pl. 46.
26 M. Hinton, 'Medieval Pottery from a Kiln Site at Kingston upon Thames', *London Archaeology* 3 (1980): 377–83, see fig. 3, no. 28.
27 See, for example, Pearce and Vince, *Surrey Whitewares*, fig. 57, nos 33, 35, 38; Pearce et al., *London-Type Ware*, fig. 12, no. 12, fig. 13, nos 14, 16.
28 R. W. Newell, 'Thumbed and Sagging bases on English Medieval Jugs', *Medieval Ceramics* 18 (1994): 51–8; see, for example, Pearce et al., *London-Type Ware*, figs 48–9; Pearce and Vince, *Surrey Whitewares*, figs 110–11.
29 L. Blackmore and J. Pearce, *A Dated Type-Series of London Medieval Pottery Part 5: Shelly-Sandy Ware and the Greyware Industries*, MOLA Monographs 46 (London: Museum of London, 2010), figs 104–17.
30 For example, Pearce et al., *London-Type Ware*, figs 36–7; Pearce and Vince, *Surrey Whitewares*, figs 79–83.
31 For example, Pearce et al., *London-Type Ware*, 31, fig. 35, nos 113–15, figs 45, 48–9, 88; Pearce and Vince, *Surrey Whitewares*, figs 74–7.
32 J. Pearce, *Pots and Potters in Tudor Hampshire: Excavations at Farnborough Hill Convent, 1968–72* (Guildford Museum, Guildford Borough Council, Museum of London Archaeology Service, 2007), figs 25–8; Pearce and Vince, *Surrey Whitewares*, figs 110–12.

33 Pearce and Vince, *Surrey Whitewares*, fig, 123, no. 556; Rackham, *English Medieval Pottery*, col. Pl. G.
34 Lyn Blackmore, 'Pottery, the Port and the Populace: The Imported Pottery of London 1300–1600 (part 1)', *Medieval Ceramics* 18 (1994): 29–44.
35 Blackmore, *Medieval Ceramics*, 34–5.
36 Ibid., 38–40.
37 Frank Britton, *London Delftware* (London: Jonathan Horne, 1988), 26–9.

Chapter 12

1 The quotation, '*se le cose più rare debbono essere più chare, questi vasi mi sono più chari et più li stimo che se fussino de argento, per esser molto excellenti et rari, come dico, et nuovi a noi altri di qua*', is referred to, among others, in G. Gaye, *Carteggio inedito d'artisti dei secoli XIV-XV-XVI*, III (Florence: G. Molini, 1839), 304; Luca Pesante, 'Vascellarius modernus: l'idea di modernità nelle parole di alcuni contemporanei', in *Atti del XLIII Convegno internazionale della ceramica. La ceramica nei periodi di transizione: novità e persistenze nel Mediterraneo tra XII e XVI secolo: Savona, 28-29 maggio 2010* (Albisola: Centro ligure per la storia della ceramica, 2011), 317–22, esp. 319.
2 For an overview of the different workshops, styles and subjects of Italian tin-glazed ceramics, see the following recent publications, including bibliography: F. Barbe, *Majolique: l'âge d'or de la faïence italienne au XVIᵉ siècle* (Paris: Citadelles & Mazenod, 2016); E. Sani, *Italian Renaissance Maiolica* (London: V&A Museum Publishing, 2012); and Th. Wilson, *Italian Maiolica and Europe: Medieval, Renaissance, and Later Italian Pottery in the Ashmolean Museum* (Oxford: Ashmolean museum, 2017).
3 On excavations of and news about maiolica in Italy, see the half-yearly review of the Museo Internazionale della Maiolica: *Faenza*.
4 Ph. Braunstein, 'La pauvreté au quotidien: apports et limites des sources médiévales', in *Les niveaux de vie au Moyen Âge. Mesures, perceptions et représentations, Actes du colloque international de Spa, 21-25 octobre 1998*, ed. J.-P. Sosson, C. Thiry and S. Thonon (Louvain-La-Neuve: Bruylant-Academia, 1999), 91–103; and C. Gavard, 'Le petit peuple au Moyen Âge: Conclusions', in *Le petit peuple dans l'Occident médiéval, Actes du Congrès international, Université de Montréal, 18-23 octobre 1999*, ed. P. Boglioni, R. Delort and C. Gauvard (Paris: Publications de la Sorbonne, 2002), 707–22.
5 I would like to thank Carmen Ravanelli-Guidotti for the generous sharing of her research on this topic, specifically her paper about the representation of maiolica in paintings.
6 On the frescoes of the Palazzo Te, see J. Koering, *Le Prince en représentation. Histoire des décors du palais ducal de Mantoue au XVIᵉ siècle* (Arles: Actes Sud, 2013).
7 Oxford, Bodleian Library, Douce 219, fol. 145v-146r: https://digital.bodleian.ox.ac.uk/inquire/p/d10d6ac6-7c2f-42e3-8076-ca721aa86138 (accessed 20 December 2018).
8 On the place of maiolica in the Italian art market, see R. Goldthwaite, 'The Economic and Social World of Italian Renaissance Maiolica', *Renaissance Quarterly* 42 (1989): 1–32. For a general overview of the Italian Renaissance art market, see R. Goldthwaite, *Wealth and the Demand for Art in Italy, 1300-1600* (Baltimore: Johns Hopkins University Press, 1993); Guido Guerzoni, *Apollo and Vulcan: The Art Markets in Italy, 1400-1700* (East Lansing: Michigan State University Press, 2011).
9 On the Medici ceramics, see M. Spallanzani, *Ceramiche alla Corte dei Medici nel Cinquecento* (Modena: F.C. Panini, 1994).

10 Archivio di Stato di Firenze, *Mediceo del Principato*, 537, c.258, cited in ibid., 157.

11 ASF, *Mediceo del Principato*, 537, c.258, cited in ibid., 157–8.

12 The transcription of the document reads: '*2 bacini / 2 mescirobe / 2 cantini grandi et 2 brocche per acqua / per lavare mane / 2 rinfrescatoi a canti / 10 piatti grandi / 25 piatti alla franzese / 30 piatti per savore / 80 piatti da tenere inanzi / 40 piatti cupi / 12 tazze sanza piede / 12 scodelle con li orechii / 6 tazze piccole / 24 scodelle tonde / 2 bagaglie da bere acqua / 6 orciolini da olio e aceto / 2 porta pane / 6 vasetti varii per acqua / 4 saliere / 24 tazze da frutte con il piede / 6 bossoli da pepe / 4 fiasche grande / 4 candellieri / 307*'.

13 To put this price in perspective: in Florence around 1500, a servant earned about 30 lire per month, and income from which only few ceramics could be bought.

14 At the time of writing, I had only just started this survey, which I will probably have to complete as a post-doc.

15 ASF, *Magistrato dei Pupilli*, filza 187, 292.

16 The manuscript is in London, National Art Library, MSL/1861/7446. For a transcription and translation of the manuscript, see R. Lightbown and A. Caiger-Smith (eds), *The Three Books of the Potter's Art: Wherein Is Treated not Only of the Practice Thereof but in Brief of All Its Secrets, a Matter that up to this Very Day has Always been Kept Concealed by the cavaliere Cipriano Piccolpasso of Castel Durante* (Vendin-le-Vieil: La Revue de la céramique et du verre, 2007).

17 '*Li tre libri dell'arte del vasaio, nei quai si tratta non solo la pratica ma brevemente tutti gli secreti di essa cosa che per sino al di d'oggi è stata sempre tenuta ascosta*'. See above, note 16.

18 M. Lama, *Il libro di conti di un maiolicaro del Quattrocento* (Faenza: Fratelli Lega, 1939).

19 V. Nixon, 'Producing for the People: Late Medieval Assumptions about the Process of Reading Art Works', in *Le petit peuple dans l'Occident medieval*, ed. P. Boglioni, R. Delort and C. Gavard (Paris: Éditions de la Sorbonne, 2002), 617–31, esp. 617.

20 On these ceramics and the production of the workshop in Gubbio, see Barbe, *Majolique*, 78–87; and Th. Wilson, *Maiolica: Italian Renaissance Ceramics in the Metropolitan Museum* (New Haven and London: Yale University Press, 2016), 218–37.

21 For other examples of this type of bowl, see F. Barbe and C. Ravanelli-Guidotti (eds), *Forme e 'diverse pitture' della maiolica italiana. La collezione delle maioliche del Petit Palais della Città di Parigi* (Venice: Marsilio Editori, 2006), 186–8; and Wilson, *Maiolica*, 236–7.

22 On the production of Deruta, see Barbe, *Majolique*, 88–95; and C. Fiocco and G. Gherardi, *La Ceramica di Deruta dal XIII al XVIII secolo* (Perugia: Volumnia, 1994).

23 One chapter of my PhD dissertation will focus on this serial production. For some examples of this type of iconography, see J. Poole, *Italian Maiolica and Incised Slipware in the Fitzwilliam Museum Cambridge* (Cambridge: Cambridge University Press, 1995), 199–202; and Th. Wilson, *Ceramic Art of the Italian Renaissance* (London: British Museum Publications, 1987), 102.

24 For further information, see Wilson, *Maiolica*, 244–5.

Chapter 13

1 D. Smail, 'La culture matérielle des pauvres à Lucques au XIV^e siècle', in *La culture matérielle. Un objet en question*, ed. L. Bourgeois, D. Alexandre-Bidon, L. Feller, P. Mane, C. Verna and M. Wilmart (Caen: Presses Universitaires de Caen, 2018), 203–13.

2 L. Bourquin, 'Les objets de la vie quotidienne dans la première moitié du XVIᵉ siècle à travers cent inventaires après-décès parisiens', *Revue d'Histoire Moderne et Contemporaine* 36 (1989): 465–86.

3 D. Roche, *Histoire des choses banales: Naissance de la consommation dans les sociétés traditionnelles (XVIIᵉ-XIXᵉ siècle)* (Paris: Fayard, 1997). A. Appadurai, *The Social Life of Things: Commodities in Cultural Perspective* (New York: Cambridge University Press, 1986) remains an essential work of reference.

4 This chapter is based on my interdisciplinary PhD project defended at the University of Paris Saclay – Versailles Saint-Quentin-en-Yvelines and funded by the Foundation of Cultural Heritage Science (EUR-17-EURE-0021). I warmly thank Dr Rembrandt Duits for inviting me to the conference *The Art of the Poor in the Late Middle Ages and Renaissance* at the Warburg Institute on 14 and 15 June 2018, during which elements of Chapter 5 of my PhD thesis were presented.

5 Unlike light in the religious context. For the medieval period, see M. Zannettacci Stephanopoli, 'La lumière naturelle dans l'habitation médiévale', in *Le soleil, la lune et les étoiles au Moyen Âge* (Aix-en-Provence: Presses universitaires de Provence, 1983), 451–65; Y. Esquieu, 'L'Éclairage', in *Cent maisons médiévales en France*, ed. J.-M. Pesez and Y. Esqiueu (Paris: Monographie du CRA, 1998), 97–107; L. Chrzanovski and P. Kaiser, *Dark Ages? Licht im Mittelalter [Publikation des Historischen Museums Olten und der International Lychnological Association zur gleichnamigen Ausstellung und zum Kongress in Olten]* (Milan: Et, 2007); and G. Egan, 'Lighting Equipment', in G. Egan, *The Medieval Household: Daily Living c. 1150-c.1450, Medieval Finds from Excavations in London* (London: Museum of London, 2010), 127–51. For the early modern period, see A. Pardailhé-Galabrun, *La naissance de l'intime: 3000 foyers parisiens, XVIIᵉ-XVIIIᵉ siècles* (Paris: Presses Universitaires de France, 1988), 341–8; and N. Courtin, *L'Art d'habiter à Paris au XVIIᵉ siècle. L'ameublement des hôtels particuliers* (Dijon: Faton, 2011), 232–41.

6 The corpus is based on inventories published in M. A. Havinden, *Household and Farm Inventories in Oxfordshire, 1550-1590* (London: The Majesty's stationery office, 1965); E. Roberts and K. Parker, *Southampton Probate Inventories, 1447-1575* (Southampton: University Press, 1992); E. George and S. George, *Bristol Probate Inventories, Part I, 1542-1650* (Bristol: Bristol Record Society, 2002); E. George and S. George, *Bristol Probate Inventories, Part II, 1657-1689* (Bristol: Bristol Record Society, 2005); P. M. Stell, *Probate Inventories of the York Diocese, 1350-1500* (York: York Archaeological Trust, 2006) and D. M. Herridge, *Surrey Probate Inventories, 1558-1603* (Woking: Surrey record Society, 2005).

7 A. Schuurman A. Van der Houde, *Probate Inventories: A New Source for the Historical Study of Wealth, Material Culture and Agricultural Development. Papers Presented at the Leeuwenborch Conference (Wageningen, 5-7 May 1980)* (Wageningen: Brill Hes & De Graaf, 1980); M. Baulant, A. J. Schuurman and P. Servais, *Inventaires après-décès et ventes de meubles. Apports à une histoire de la vie économique et quotidienne, XIVᵉ-XIXᵉ siècle. Actes du séminaire tenu dans le cadre du 9ème Congrès international d'histoire économique de Berne (1986)* (Louvain-la-Neuve: Academia, 1988).

8 L. Orlin, 'Fictions of the Early Modern English Probate Inventory', in H. Turner, *The Culture of Capital: Property, Cities, and Knowledge in Early Modern England* (New York: Routledge, 2002), 51–83.

9 H. Havard, 'Chandelier', in *Dictionnaire de l'ameublement et de la décoration depuis le XIIᵉ siècle jusqu'à nos jours* (Paris: Ancienne Maison Quentin, 1894), 734–55, esp. 749.

10 Havinden, *Household and Farm Inventories in Oxfordshire*, no. 170.

11 George and George, *Bristol Probate Inventories, Part II*, no. 47.

12 L. Chrzanovski, *De Prométhée à la Fée Electricité: Pour une sociologie de l'éclairage à travers les âges, les croyances et les continents* (Cluj-Napoca: Académie Roumaine, 2013), 27–42; and L. Chrzanovski and M. Martiniani-Reber, *À la tombée de la nuit: Art et histoire de l'éclairage* (exhibition catalogue; Geneva: Musées d'art et d'histoire, 2011), 41–56.

13 Olive oil has remained the preferred combustible in the Mediterranean area from classical Antiquity. In the religious context, it is used in ritual, for anointments, baptism and the holy chrism. See C. Vincent, *Fiat lux: Lumière et luminaires dans la vie religieuse du XIII^e au XVI^e siècle* (Paris: Cerf, 2004), 66–7; and D. Iancu-Agou, 'Les juifs, l'olivier et l'huile d'olive en Provence médiévale, d'après les registres notariés aixois de la fin du XV^e siècle', in *L'huile d'olive en Méditerranée: Histoire, anthropologie, économie de l'Antiquité à nos jours* (Aix-en-Provence: Institut de recherches et d'études sur le monde arabe et musulman, 1985), 133–46.

14 J. Duguet, 'Notes sur l'utilisation de la cire (XI^e–XVII^e siècles)', *Roccafortis: Bulletin de la Société de géographie de Rochefort* 3 (1998): 265–9.

15 For example, one inventory from the church of Wycombe, dated 1552, mentions '*ij Candilsticke to sett talowe candell in*'. F. Eeles, *The Edwardian Inventories for Buckinghamshire* (London: Longmans, Green and Company, 1908), 144.

16 See, for example, the miniature in *Mare Historiarum*, Paris, BnF, Latin 4915, fol. 82**r**; or the one in Vienna, Österreichische Nationalbibliothek, inv. cod. 2773, fol. 18r.

17 See, for example, *Attavante Missel*, Lyon, Bibliothèque Municipale, Ms 5123, fol. 432v; Annoymous, *Mass of St Gregory*, Tours, Musée des Beaux-Arts, inv. 1963-2-25; or Anonymous, *Mass of St Gregory*, Friser, church.

18 Their introduction was gradual, as shown by the archaeological discoveries dated to the thirteenth and fourteenth centuries from nineteen castles in central and southern Germany and northern Switzerland. The study shows that only four non-ferrous metal candlesticks were present in these aristocratic castles, while five out of nineteen castles had iron lamps and ten of them had ceramic lamps. See C. Krauskopf, 'Just Noble Things? Studies on the Material Culture of 13th and 14th Century Nobility', in *Château et Peuplement : actes du colloque international de Voiron [28 août-4 septembre 2004]*, ed. P. Ettel, A.-M. Flambard-Héricher and T. McNeill (Caen: Publications du CRAHM, 2006), 195–204.

19 L. Ripert, M. Zerner and C. Barnel (eds), *Matériaux pour l'étude de la vie domestique et de la culture matérielle en Provence aux derniers siécles du Moyen Âge* (Nice: Université de Nice, 1993), 52.

20 J.-P. Deregnaucourt, 'L'inventaire après décès d'Ysabel Malet, bourgeoise douaisienne, en 1359. Document pour servir à l'histoire de la vie quotidienne de la bourgeoisie médiévale', in *Revue du Nord* 64 (1982): 707–30, esp. 719.

21 G. Ferrand, *Les inventaires après décès de la ville de Dijon à la fin du Moyen Âge. 1390-1459* (Toulouse: Presses Universitaires du Midi, 2017).

22 Stell, *Probate Inventories of the York Diocese*, no. 35.

23 Archaeological finds have demonstrated that only the rich had windows, and that wall openings were rare, apart from the main door, to minimize heat loss. See J. -P. Leguay, *Vivre en ville au Moyen Âge* (Paris: Éditions Jean-Paul Gisserot, 2006).

24 U. Nyström, *Poèmes français sur les biens d'un ménage depuis l'Oustillement au villain du XIIIe siècle jusqu'aux Controverses de Gratien du Pont* (Paris: Imprimerie de la Société de littérature finnoise, 1940), 279–88. Other medieval historians have worked on the 'dits' and on the interest of lists in medieval literature; see M. Jeay, *Le commerce*

des mots: L'usage des listes dans la littérature médiévale (XIIe-XVe siècles) (Geneva: Droz, 2006).

25 On essential possessions of daily life as mentioned in fables, M. -T. Lorcin and D. Alexandre-Bidon, *Le quotidien au temps des fabliaux. Textes, images, objets* (Paris: Espaces médiévaux, 2003).

26 M.-T. Lorcin, 'De l'Oustillement au villain ou l'inventaire sans raton laveur', *Revue Historique* 10 (1985): 321–39, esp. 335, v.60-71.

27 Nyström, *Poèmes français sur les biens d'un ménage*, 93–106.

28 Herridge, *Surrey Probate Inventories*, 162.

29 Roberts and Parker, *Southampton Probate Inventories*, nos 83 and 96.

30 Ibid., no. 62.

31 Havinden, *Household and Farm Inventories in Oxfordshire*, no. 171.

32 Roberts and Parker, *Southampton Probate Inventories*, no. 50.

33 For other examples, see the sixteenth-century panel by Jan van Dornicke in Baltimore, Walters Art Gallery (inv. 37.779), or one of the seven deadly sins by Bosch in the Museo del Prado (inv. P02822).

34 Roberts and Parker, *Southampton Probate Inventories*, no. 32.

35 A statistical study on Kent in the seventeenth century shows that most halls contained utensils related to the preparation of meals and items related to bedding. See M. Overton, J. Whittle, D. Darron and A. Hann, *Production and Consumption in English Households, 1600-1750* (London: Routledge, 2004), 126, table 6.4. The same is true for York in the fifteenth and sixteenth centuries, where inventories include weapons, and also suggest a storage function. See L. J. Howarth Liddy, *Domestic Objects in York, c. 1400-1600* (PhD dissertation, University of York, 2015), 69.

36 Especially with the appearance of separate kitchens. See S. Pennell, 'Pots and Pans History: The Material Culture of the Kitchen in Early Modern England', in *Journal of Design History* 11 (2016): 201–16; and idem, *The Birth of the English Kitchen, 1600-1850* (London: Bloomsbury, 2016).

37 D. Smail, 'Les biens comme otage. Quelques aspects du processus de recouvrement des dettes à Lucques et à Marseille à la fin du Moyen Âge', in *Objets sous contraintes. Circulation des richesses et valeur des choses au Moyen Âge*, ed. L. Feller and A. Rodríguez López (Paris: Publications de la Sorbonne, 2018), 365–83, 203.

38 All values are expressed in pounds sterling (£), shillings (*solidus* = s) and pence (*denaridus* = d); £ 1 = 20 s = 240 d. See P. Spufford, *Handbook of Medieval Exchange* (London: Offices of the Royal Historical Society; Distributed by Boydell & Brewer, 1986), lx. Stell, *Probate Inventories of the York Diocese*, no. 7.

39 Different local and regional customs and terminology may have affected the writing of inventories. See D. Spaeth, 'Orderly Made: Re-Appraising Household Inventories in Seventeenth-Century England', *Social History* 41, no. 4 (2016): 417–35, esp. 423.

40 Ibid., 422 and 434.

41 M. Beaudry, 'Words for Things: Linguistic Analysis of Probate Inventories', in M. Beaudry, *Documentary Archaeology in the New World* (Cambridge: Cambridge University Press, 1988), 43–50. Similar but less well-developed conclusions (mainly concerning colour) can be found in M. Baulant, 'Nécessité de vivre et besoin de paraître. Les inventaires et la vie quotidienne', in *Inventaires après-décès et ventes de meubles: Apports à une histoire de la vie économique et quotidienne, XIVᵉ-XIXᵉ sicle. Actes du sminaire tenu dans le cadre du 9me Congrès international d'histoire économique de Berne (1986)* (Louvain-la-Neuve: Academia, 1988), 9–17; and, regarding household linen, in Bourquin, 'Les objets de la vie quotidienne', 469–71.

42 Roberts and Parker, *Southampton Probate Inventories*, no. 49.

43 Stell, *Probate Inventories of the York Diocese*, no. 80.

44 Roberts and Parker, *Southampton Probate Inventories*, nos 39 and 68.

45 Daniel Smail has pointed out that 'it is more than likely that long-lived goods [. . .] were valued for the memories'. See D. Smail, *Legal Plunder: Households and Debt Collection in Late Medieval Europe* (Cambridge: Harvard University Press, 2016), 44. Aso L. Feller, 'Culture matérielle et Histoire Économique', in *La culture matérielle. Un objet en question. Anthropologie, archéologie et histoire. Actes du Colloque international organisé à Caen, 9-10 octobre 2015* (Caen: Presses Universitaires de Caen, 2018), 161–74, esp. 167.

46 Daniel Smail has shown, based on surveys of materials regarding Lucca and Marseille, that certain types of objects, including those made of reusable materials, such as metal, were more likely than other goods to be seized during debt collection or at forced household auctions. See Smail, *Legal Plunder*; also Smail, 'Les biens comme otage', and Smail, 'La culture matérielle des pauvres à Lucques'.

47 The essential bibliography includes C. Dyer, 'Furnishings of Medieval English Peasant Houses: Investment, Consumption and Life Style', in *Pautas de Consumo y niveles de vida en el mundo rural medieval. Coloquio internacional di Valencia, 18–20 September 2008*, ed. A. Furio and F. Garcio-Oliver (Valencia: University of Valentcia Press, 2008), 1–13; P. Goldberg, 'The Fashioning of Bourgeois Domesticity in Later Medieval England: A Material Culture Perspective', in *Medieval Domesticity. Home, Housing and Household in Medieval England*, ed. M. Kowaleski and P. J. P. Goldberg (Cambridge, 2008), 124–44; N. Coquery, 'La diffusion des biens à l'époque modern: Une histoire connectée de la consommation', *Histoire urbaine* 30 (2011): 5–20; and G. Hansen, S. Ashby and I. Baug, 'Everyday Products in the Middle Ages: Crafts, Consumption and the Individual in Northern Europe c. AD 800-1600. An introduction', in G. Hansen, *Everyday Products in the Middle Ages: Crafts, Consumption and the individual in Northern Europe* (York: Oxbow Books, 2015), 1–10.

48 For a recent definition of luxury goods in the Middle Ages, see Feller, 'Culture matérielle et Histoire Économique'.

49 B. Dubbe, *Huusraet: Het stedelijk woonhuis in de Bourgondische tijd* (Hoorn: Uitg. Polder Vondsten, 2012), 237.

50 C. Barnel and H. Bresc, 'La maison et la vie domestique: L'apport des inventaires', in *Matériaux pour l'étude de la vie domestique et de la culture matérielle en Provence aux derniers siècles du Moyen Âge*, ed. L. Ripert, M. Zerner and C. Barnel (Nice: Université de Nice, 1993), 7–27, esp. 9. An example is John Vybard's will of 1558, in which he bequeathed to his wife 'all the goods she brought to me', including bedding, a trestle table, a little cupboard and pewter candlesticks. Roberts and Parker, *Southampton Probate Inventories*, no. 54.

51 G. Piccope, *Lancashire and Cheshire Wills and Inventories, 1542-1696* (Manchester: Chetham Society, 1860), 5.

52 Herridge, *Surrey Probate Inventories*, no. 224.

53 For some examples, see BnF, Français 81, fol. 203; BnF, Français 288, fol. 228, and BnF, Français 9087, fol. 1r.

Chapter 14

1 I would like to thank Tonny Beentjes of the University of Amsterdam for sharing his knowledge about the origins of sand casting in Northern Europe.

2 Jet Pijzel-Dommisse, *Het Hollandse pronkpoppenhuis. Interieur en huishouden in de 17de en 18de eeuw*, (Amsterdam: Uitgevery Wbooks, 2000), 145.

3 C. Willemijn Fock, 'Verwarmd door de Bijbel: de ijzeren kachel in het zeventiende-eeuwse Nederlandse interieur', *Antiek: Tijdschrift voor liefhebbers en kenners van oude kunst en kunstnijverheid* 31, no. 10 (1997): 465–75.

4 Willem Goeree, *Inleydinge tot de al-ghemeene teycken-konst* (Middelburgh: Wilhelmus Goeree, 1668), 34; Samuel van Hoogstraaten, *Inleyding tot de hooge schoole der schilderkonst. Anders de zichtbaere werelt: verdeelt in negen leerwinkels, yder bestiert door eene der zanggodinnen* (Rotterdam: Fransois van Hoogstraaten, 1678), 294.

5 Fock, 'Verwarmd door de Bijbel', 465–75.

6 Ibid., 462.

7 For the earliest firebacks in Great Britain, actual objects appear to have been used to create their decorations, such as ropes, firedogs and daggers, which were pushed into the sand mould. See Jeremy Hodgkinson, *British Cast-Iron Firebacks of the 16th to mid 18th Centuries* (Worth: Hodgers Books, 2010), 57–73; and Jeremy Hodgkinson, 'Pre-Restoration Iron Firebacks', *Journal of Antique Metalware Society* 20 (June 2012): 2–5.

8 F. van Molle and L. Baeyens, 'Achttiende-eeuwse haardplaatmodellen in het Maasland: Bijdrage tot de studie van de oude haardplaten', *Antiek: Tijdschrift voor liefhebbers en kenners van oude kunst en kunstnijverheid* 7, no. 5 (1972–73): 361.

9 Albrecht Kippenberger, *Die Kunst der Ofenplatten, dargestellt an der Sammlung des Vereins Deutscher Eisenhüttenleute in Düsseldorf* (2. Neubearbeitete und erweiterte Auftrage) (Düsseldorf: Stahleisen, 1973), 5. It is interesting to note that Wetzlar is situated near Dillenburg and Siegen, two places where members of the Nassau family lived.

10 Albrecht Kippenberger, *Philipp Soldan zum Frankenberg: ein hessischer Bildhauer des 16ten Jahrhunderts, Meister der Ofenplatten* (Wetzlar: Scharfes Druckereien, 1926); Kirsten Hauer and Friedhelm Krause, *Philipp Soldan: Bildhauer der Reformation* (Petersberg: Michael Imhof Verlag, 2017).

11 Molle and Baeyens, 'Achttiende-eeuwse haardplaatmodellen in het Maasland', 357.

12 Wim Meulenkamp, 'Een vroege gietijzeren grafplaat: een kindergraf uit 1756 in de Hervormde kerk van Waardenburg', in *Lood om oud ijzer*, ed. Tim Graas (Soesterberg: Aspekt/SKKN, 1998), 58–9; Annemarie Kutsch Lojenga-Rietberg, *Huis Bergh: kasteel-kunst-geschiedenis* ('s-Heerenbergh: Stichting Huis Bergh, 2000), 144.

13 Rijksmuseum, inv. no. BK-18335. On the wooden model, see Molle and Baeyens, 'Achttiende-eeuwse haardplaatmodellen in het Maasland', 364, Fig. 9.

14 Molle and Baeyens, 'Achttiende-eeuwse haardplaatmodellen in het Maasland', 363–5.

15 Wolfgang Herskamp, *Die Eiserne Bibel: Alte Ofen- und Kaminplatten im Rheinland mit Bildern zur Bibel nach Holzschnitten und Kupferstichen der Meister des 15. bis 17. Jahrhunderts* (Aachen: Helios, 2007).

16 B. de Kock, 'Haardplaten', *Oud Nederland* 4 (1950): 179.

17 Louis de Geer owned virtually all the iron foundries in Sweden around the middle of the seventeenth century, mainly to produce artillery. In 1634, he bought the canal house 'Huis met de hoofden' on the Keizersgracht in Amsterdam, and built a new, marble fireplace in the large backroom. See Luc Panhuysen, 'Wapenhandelaar Louis de Geer (1587-1650): de Dertigjarige Oorlog was een zegen voor zijn portemonnee', *Historisch Nieuwsblad* 6 (2007) (online publication: https://www.historischnieuwsbl ad.nl/nl/artikel/6949/wapenhandelaar-louis-de-geer-1587-1650.html, consulted on 23 July 2019).

18 Erich Schmitt, *Pfälzische Ofenplatten* (München: DT Kunstverlag, 1968), 10.

19 Molle and Baeyens, 'Achttiende-eeuwse haardplaatmodellen in het Maasland', 356.

20 For an overview of the themes, see Karlheinz von den Driesch, *Handbuch der Ofen-, Kamin- und Takenplatten im Rheinland* (Köln: Rheinland-Verlag, 1990).

21 Rijksmuseum, inv. nos BK-BFR-216 and BK-BFR-390.

22 For the fragment of the fireback, see: https://www.newnetherlandinstitute.org/history-and-heritage/digital-exhibitions/arent-van-curler-and-the-flatts/the-artifacts/, consulted on 23 July 2019.

23 Rijksmuseum, inv. no. BK-BFR-19.

24 Rijksmuseum, inv. nos BK-BFR-297 and BK-16017.

25 Rijksmuseum, inv. no. BK-1977-129.

26 In 1560, only sixty firebacks were imported from Antwerp into England. See Hodgkinson, *British Cast-Iron Firebacks*, 47 and 50.

27 Rijksmuseum, inv. no. BK-BFR-314.

28 On the auricular style, see Reinier Baarsen, *Kwab: Ornament as Art in the Age of Rembrandt* (Amsterdam: Rijksmuseum, 2018).

29 Museum Rotterdam, inv. no. 15224.

30 Fries Museum, inv. no. M00031B. Hendrik Casimir II and Amalia van Anhalt-Dessau used to live in this palace.

31 H. J. Zantkuil, *Bouwen in Amsterdam: het woonhuis in de stad* (Amsterdam: Uitgeverij Architectura & Natura, 1993), 358; Willemijn Fock (ed.), *Het Nederlandse interieur in beeld 1600-1900* (Zwolle: Waanders, 2001), 43.

32 Museum Rotterdam, inv. no. 15218.

33 Museum Rotterdam, inv. no. 15213.

34 Rijksmuseum, inv. Nos BK-NM-8656-A and BK-NM-8656-B.

35 A similar fireback can be found in the collection of the Rijksmuseum, inv. no. BK-18329.

Chapter 15

1 Lee Palmer Wandel, *Reading Catechisms, Teaching Religion* (Leiden: Brill, 2016), 353.

2 Robert James Bast, *Honor Your Fathers: Catechisms and the Emergence of a Patriarchal Ideology in Germany, 1400-1600* (Leiden: Brill, 1997), 231.

3 Ulinka Rublack, *Reformation Europe* (Cambridge: Cambridge University Press, 2005), 11.

4 Keith Moxey, *Peasants, Warriors, and Wives: Popular Imagery in the Reformation* (Chicago: University of Chicago Press, 2004), 1.

5 Ruth Slenczka, 'Cranach als Reformator neben Luther', in *Der Reformator Martin Luther 2017: Eine wissenschaftliche und gedenkpolitische Bestandsaufnahme*, ed. Heinz Schilling (Berlin: Walter de Gruyter GmbH, 2014), 133–58, esp. 135.

6 Bridget Heal, 'Visual and Material Cultures', in *The Oxford Handbook of the Protestant Reformations*, ed. Ulinka Rublack (Oxford: Oxford University Press, 2017), 606.

7 Lee Palmer Wandel, 'Catechisms: Teaching the Eye to Read the World', in *Illustrated Religious Texts in the North of Europe, 1500-1800*, ed. Feike Dietz, Adam Morton, Lien Roggen and Els Stronks (Farnham: Ashgate, 2014), 53–76, esp. 62; Henk van den Belt, 'The Law Illuminated: Biblical Illustrations of the Commandments in Lutheran Catechisms', in *The Ten Commandments in Medieval and Early Modern Culture*, ed. Youri Desplenter, Jürgen Pieters and Walter Melion, (Leiden: Brill, 2017), 196–218, esp. 216.

8 Belt, 'The Law Illuminated', 203.

9 Daniela Laube, 'The Stylisitc Development of German Book Illustration, 1460-1511', in *A Heavenly Craft: The Woodcut in Early Printed Books*, ed. Daniel De Simone (New York: George Braziller Inc., 2004), 47–71, esp. 49.

10 Andreas Karlstadt, *Von abthung der Bylder / Und das keyn Betdler unther den Christen seyn soll* (Wittenberg: Nickell Schyrlentz, 1522), Ba.

11 'Predigt in Meresburg gehalten', in *D. Martin Luthers Werke, kritische Gesammtausgabe [hereafter, WA]*, 128 vols (Weimar: H. Böhlau, 1883–1929), 51, 11. Cited in Bridget Heal, *A Magnificent Faith: Art and Identity in Lutheran Germany* (Oxford: Oxford University Press, 2017), 22.

12 Heal, *Magnificent Faith*, 28; *D. Martin Luthers Werke*, vol. 1, 82–3.

13 Peter van Dael, 'Two Illustrated Catechisms from Antwerp by Petrus Canisius', in *Education and Learning in the Netherlands, 1400-1600: Essays in Honour of Hilde de Ridder-Symoens*, ed. Koen Goudriaan, Jaap Moolenbroek and Ad Tervoort, (Leiden: Brill, 2004), 277–96, esp. 281.

14 J. Waterworth (ed.), *The Canons and Decrees of the Sacred Oecumenical Council of Trent* (London: Burns and Oates, Ltd., 1848).

15 Van Dael, 'Two Illustrated Catechisms', 281.

16 Heal, *Magnificent Faith*, 34.

17 Jeffrey Chipps Smith, *Sensuous Worship: Jesuits and the Art of the Early Catholic Reformation in Germany* (Princeton: Princeton University Press, 2002), 19.

18 Jan-Dirk Müller, 'An Information Revolution', in *A New History of German Literature*, ed. David E. Wellbery and Judith Ryan (Cambridge, MA: Belknap Press, 2004), 183–93, esp. 190.

19 Andrew Pettegree, 'Print Workshops and Markets', in *The Oxford Handbook of the Protestant Reformations*, ed. Ulinka Rublack (Oxford: Oxford University Press, 2017), 374.

20 Andrew Pettegree, *Reformation and the Culture of Persuasion* (Cambridge: Cambridge University Press, 2005), 138.

21 Ibid., 121.

22 Alison G. Stewart, 'Sebald Beham. Entrepreneur, Printmaker, Painter', *Journal of Historians and Netherlandish Art* 4, no. 2 (Summer 2012): 1–26, esp. 16; Moxey, *Peasants, Warriors, and Wives*, 72–89.

23 Stewart, 'Sebald Beham', 16.

24 Ibid., 11.

25 David H. Price, 'Hans Holbein the Younger and Reformation Bible Production', *Church History* 86 (2017): 998–1040, esp. 999.

26 Ibid., 999–1000.

27 John Dillinberger, *A Theology of Artistic Sensibilities: The Visual Arts and the Church* (Wipf and Stock: Eugene, 1986), 54.

28 James R. Tanis, 'Netherlandish Reformed Traditions in the Graphic Arts, 1550-1630', in *Seeing Beyond the Word. Visual Arts and the Calvinist Tradition*, ed. Paul Corby Finney (Grand Rapids: William B. Edermans Publishing Company, 1999), 369–96, esp. 374.

29 Belt, 'Law Illuminated', 200.

30 Martin Luther, *Deudsch Catechismus. Gemehret mit einer newen vorrhede / und vermanunge zu der Beicht* (Wittemberg: Georg Rhau, 1530), unpaginated.

31 Woodcuts illustrating the Decalogue were provided by Erhard Schön according to Veronika Thum, *Die Zehn Gebote für die ungelehrten Leut': der Dekalog in der*

Graphik des späten Mittelalters und der frühen Neuzeit (Munich: Dt Kunstverlag, 2006), 221.

32 Andreas Osiander, *Catechismus oder Kinderpredig / Wie die in meinernedigen herrn / Margraven zu Brandēburg / uñ ein Erbarn Raths der stat Nürmberg oberkait uñ gepieten / allent halbē gepredigt werdē/ Den Kindern uñ jungen leutē zu sonderm nuz also in Schrifft verfaßt* (Nuremberg: Johann Petreium, 1533), Biiia.

33 Alison Stewart, 'Paper Festivals and Popular Entertainment: The Kermis Woodcuts of Sebald Beham in Reformation Nuremberg', *Sixteenth Century Journal* 24 (1993): 301–50, esp. 330–1.

34 Ibid., 331.

35 *WA*, vol. 6, 572.

36 Ibid., 378.

37 Ronald K. Rittgers, *The Reformation of the Keys* (Cambridge, MA: Harvard University Press, 2004), 30.

38 Ibid., 62.

39 Martin Luther, *Von den Schlüsseln* (Wittemberg: Hans Lufft, 1530).

40 Martin Luther, *Deudsch Catechismus* (Georg Rhau: Wittemberg, 1530), 167.

41 See Hans Folz, *U wissen sei allen christen die zu der oster-/lichen zeit nach ordennung der kirchen wil / len haben mit rew peicht und pus sich beraiten / . . .* (Nuremberg: Hanse Folcze, 1479).

42 Martin Luther, *Deudsch Catechismus: Auffs new Corrigirt und gebessert* (Wittenberg: George Rhaw, 1540), CLXXXa.

43 Herbert David Rix, *Martin Luther: The Man and the Image* (New York: Irvington Publishers, Inc., 1983), 112.

44 Rittgers, *Reformation of the Keys*, 47–79.

45 Osiander, *Catechismus oder Kinderpredig*, 276.

46 Ibid., 278.

47 Rittgers, *Reformation of the Keys*, 114–37.

48 Ibid., 135.

49 *Andreas Osiander d.A., Gesamtausgabe*, 10 vols, ed. Gerhard Müller and Gottfried Seebaß (Gütersloh: Gütersloher Verlagshaus, 1975–1999), 5, 489.

50 Sarah Hamilton, *The Practice of Penance, 900-1050* (Woodbridge: The Boydell Press, 2001), 112.

51 Andreas Osiander, *Catechismus odder Kinderpredigt / Wie die inn meiner gnedigen herrn/ Marggrauen zu Brandenburg/ vnd eins Erbarn Raths der Stat Nuermberg oberkeit vnd gepieten/ allenthalben gepredigt werden* (Wittemberg: Georgen Rhaw, 1533).

52 It is unclear whether Rhau had access to the original woodblocks used in the Nuremberg edition of Osiander's catechism, although Rhau certainly borrowed woodcuts on other occasions: see Andrew Pettegree, *Broadsheets: Single-Sheet Publishing in the First Age of Print* (Leiden: Brill, 2017), 125.

53 Philip Melanchthon, *Catechismus / Das ist / ein Kinderlehr / Herrn Philippi Melanthonis, auß dem Latein ins Deütsch gebracht / durch Gaspar Bruschen Poeten* (Nürnberg: Hans Guldenmundt, 1544), 145.

54 Ibid., 146a–147.

55 Osiander, *Catechismus oder Kinderpredig*, 274.

56 See Jourden Travis Moger, *Priestly Resistance to the Early Reformation* (Brookfield: Pickering & Chatto, 2014), esp. chapter six, 101–24.

57 Palmer Wandel, *Reading Catechisms*, 262.
58 David M. Luebke, *Hometown Religion: Regimes of Coexistence in Early Modern Westphalia* (Charlottesville: University of Virginia Press, 2016), 93.
59 Paul Begheyn, 'The Catechism (1555) of Peter Canisius, the Most Published Book by a Dutch Author in History', *Quaerendo* 36 (2006): 51–84, esp. 61; Wolfgang Nastainczyk, 'Die Katechismen des Petrus Canisius. Ein Aufbruch', in *Petrus Canisius: Zu seinem 400. Todestag am 21. Dezember 1997*, ed. Karl Hillerbrand (Würzburg: Generalvikariat der Diözese Würzburg, 1998), 49–70, esp. 49.
60 Petro Canisio, *Institvtiones Christianae Pietatis sev Parvvs Catechismvs Catholicorvm* (Antwerp: Johann Bellerus, 1575).
61 Ibid., 40, 46; Palmer Wandel, 'Catechisms', 72.
62 Peter Canisius, *Betbůch vnd Catechismus. Nach rechter Catholischer form vnnd weiß jetzt zum sechßten mal in Truck außgangen* (Dillingen: Sebald Mayer, 1575), 95, 170a, 179a.
63 Ibid., 112a.
64 Victoria Christman, *Pragmatic Toleration: The Politics of Religious Heterodoxy in Early Reformation Antwerp, 1515-1555* (Rochester: University of Rochester Press, 2015), 69.
65 As revealed by the Universal Short Title catalogue accessed at ustc.ac.uk.
66 Guido Marnef, 'The Changing Face of Calvinism in Antwerp, 1555-1585', in *Calvinism in Europe, 1540-1620*, ed. Andrew Pettegree, Alastair Duke and Gillian Lewis (Cambridge: Cambridge University Press, 1994), 153–9, esp. 150.
67 Guido Marnef, 'Protestant Conversions in an Age of Catholic Reformation: The Case of Sixteenth-Century Antwerp', in *The Low Countries as a Crossroads of Religious Belief*, ed. Arie-Jan Gelderblom, Jan L. de Jong and Marc van Vaeck (Leiden: Brill, 2004), 33–47, esp. 35. Ibid.
68 Peter Canisius, *Catholischer Catechismus oder Sumärien Christlicher Lehr* (Cologne: Maternus Cholinus, 1563), 160; Peter Canisius, *Catholischer Catechismus oder Sumärien Christlicher Lehr* (Cologne: Maternus Cholinus, 1569), 194.
69 Janis M. Gibbs, 'Immigration and Civic Identity in Sixteenth-Century Cologne', in *Ideas and Cultural Margins in Early Modern Germany: Essays in Honour of H.C. Erik Midelfort*, ed. Marjorie Elizabeth Plummer and Robin Barnes (Farnham: Ashgate, 2009), 58–61.
70 Ibid., 61.
71 Canisius, *Institvtiones*, 48–9.
72 Canisius, *Catholischer Catechismus* (1563), 182.

Chapter 16

1 My thanks to Rembrandt Duits for inviting me to present this work at the conference *The Art of the Poor* at the Warburg Institute, London, on 14–15 June 2018; to my chair, Angeliki Lymberopoulou; and to the participants for helpful discussions. Also to Malcolm Jones (personal communications 2018); and, for inviting presentations and/or publications, to Edmund King (IES, University of London, 4 February 2013); Rob Henke, Eric Nicholson, and my friends and colleagues in Theater Without Borders (NYU Florence, 23–27 May 2009); Margaret Shewring and Jim Davis (CEMS, University of Warwick, 23 February

2009); Birgit Ulrike Münch, Natalia Filatkina, and Ane Kleine-Engel (University of Trier, 28–29 November 2008); Otto G. Schindler and Brigitte Marschall (University of Vienna, 10–14 May 1998). For supporting this research, my thanks to The Open University (FASS) for research funding, and to the Librarians and Fellows of the Herzog August Bibliothek. Illustrations are by permission of the curators and librarians of the Historisches Museum Basel (Natascha Jansen, Fig. 2: © Historisches Museum, Basel. Photo: N. Jansen), Musée de la Chartreuse Douai (Anne Labourdette and Colin Colson, Fig. 9), the British Library (Chris Rawlings and Ashley Horn, Fig. 3: © British Library Board, image produced by ProQuest as part of Early English Books Online. *www.proquest.com*) and British Museum London (Elizabeth Bray, Figs 6 & 7: © British Museum), Germanisches Nationalmuseum Nürnberg (Bianca Slowik, Figs 4 & 8: © Germanisches Nationalmuseum), and Ashmolean Museum Oxford (Sibyl Searle, Fig. 5: image © Ashmolean Museum, University of Oxford).

2 See M. A. Katritzky, 'Shakespeare's "portrait of a blinking idiot"': Transnational reflections', in *Transnational Mobilities in Early Modern Theater*, ed. Robert Henke and Eric Nicholson (Farnham: Ashgate, 2014), 157–75, esp. 164–6.

3 G. Blakemore Evans and J. J. M. Tobin (eds), *The Riverside Shakespeare* (Boston: Houghton Mifflin, 1997, 2nd ed.), *Twelfth Night*, II.iii.15-18.

4 Edmond Malone, *The Plays and Poems of William Shakespeare* (London: H. Baldwin, 1790) (10 vols), IV, 33.

5 Margaret Farrand Thorp, 'Shakespeare and the Fine Arts', *Publications of the Modern Language Association* 46, no. 3 (1931): 672–93, esp. 678.

6 Notably: Eddie de Jongh and G. Luijten, *Mirror of Everyday Life: Genreprints in the Netherlands 1550–1700* (Amsterdam: Rijksmuseum, 1997); Sheila O'Connell, *The Popular Print in England 1550–1850* (London: British Museum, 1999); Gregory Davies and Alison Stewart, 'Head of a Jester', *Print Quarterly* 19, no. 2 (2002): 170–4.

7 Gerard Malynes, *The Center of the Circle of Commerce, or A Refutation of a Treatise Intitled The Circle of Commerce, or The Balance of Trade, Lately Published by E[dward] M[isselden]* (London: William Iones, 1623), 5.

8 Psalm 53, v.1; Ecclesiastes offers further key passages in this respect.

9 General Epistle of James, 1:23-24.

10 Charles M. Peterson, 'The Five Senses in Willem II van Haecht's Cabinet of Cornelis van Der Geest', *Intellectual History Review* 20, no. 1 (2010): 103–21, 118.

11 S[amuel] M[alkin] (1668-1741), *Wee Three Logerheads*, early eighteenth-century inscribed press-moulded slipware dish, Cambridge, Fitzwilliam Museum; see R. G. Cooper, *English Slipware Dishes 1650–1850* (London: Alec Tiranti, 1968), plate 260. Also *We three loggerheads*, inscribed Staffordshire slipware earthenware plaque dated 1829, made in Buckley, North Wales (art market, London 1.11.2006, Bonhams Sale 13634, no. 329A).

12 Including one of 1665 inscribed 'We are three' and 'St Tulis St'; see William Rendle, 'Tooley Street Tailors', *Notes and Queries*, S.7-V (1888): 13–14. Also, an octagonal Essex halfpenny of 1668 with the inscription 'Wee are 3'; see Edwin Hollis, 'The Shropshire "Loggerheads"', *Notes and Queries* 161 (1931): 377.

13 Several of the thirty-two examples inventoried in 1521 by the Frankfurt silk merchant Claus Stalburg (1469–1521) are now in the Historisches Museum, Frankfurt; see F. Bothe, *Frankfurter Patriziervermögen im 16ten Jahrhundert* (Berlin: Alexander Duncker, 1908), 113–15.

14 Commemorative portraits produced on the deaths of the professional gingerbread bakers (Lebküchner) Hanns Buel (d. 7 November 1520) and Hanns Stüber (d. 6 April 1624) depict Buel in his bakery with around a dozen richly carved wooden biscuit moulds of various sizes, and Stüber standing in a doorway holding one extremely large wooden gingerbread mould (coloured drawings, *Hausbüchern der Nürnberger Zwölfbrüderstiftungen*, Amb. 317.2°, folios 11ᵛ, 99ʳ, Stadtbibliothek Nürnberg).

15 Werner Mezger, *Narrenidee und Fastnachtsbrauch. Studien zum Fortleben des Mittelalters in der europäischen Festkultur* (Konstanz: Universitätsverlag, 1991), 69–71, plate 19; Otto G. Schindler, 'Eselsritt und Karneval. Eine Kremser "Komödiantenszene" aus 1643 in Callots Manier', *Maske und Kothurn* 39, no. 3 (1998): 7–42, esp. 9, plate 3.

16 Felix Platter, *Felix Platter Tagebuch (Lebensbeschreibung) 1536–1567*, ed. Valentin Lötscher (Basle and Stuttgart: Schwabe, 1976), 78–9 (ca 1545), and 105–6 (ca 1546–47): 'In der Baselmäs hatt einer model, wie man in die lebküchen druckt, feil, by der Gelten auf eim tisch. Ich stůndt darby, wie ich auch gern kunststuck zesehen begiirig, růrt eins an; so zert der alt lur mir daß höltzen model uß der handt, würft mirs ins angesicht, daß ich meint, er hette mir die zän ußgeschlagen, erwütsch das model und würf es überalle aufgeschlagene hüslin uß, er lauft mir noch, ich entran, kam heim mit eim geschwullenen mul. Mein můter was erzürnt über den kremer, gieng morndes hinab, schalt in ein alten brauchfüler, er gab böse wort, wolt, man solt im daß model zalen, so von dem wurf zerbrochen.'

17 Platter, *Tagebuch*, 280, 312–13 (April and 27 October 1557, Paris, Basle).

18 *Unser sein dreij* (The fighting fools Hoggig and Boggig), ca. 1590, coloured drawing, friendship album, Württembergisches Landesbibliothek, Stuttgart, Cod. don. 899 fol. 148r; see M. A. Katritzky, 'The Picture of We Three: A Transnational Visual and Verbal Formula before, during and after the Lifetime of Shakespeare', in *Formelhaftigkeit in Text und Bild*, ed. Birgit Ulrike Münch, Natalia Filatkina and Ane Kleine-Engel (Wiesbaden: Reichert, 2012), 223–44, fig. 3a; and Katritzky, 'Shakespeare's "portrait of a blinking idiot"', fig. 9.3b. Also *Unser sünd drey*, 1624, coloured drawing, friendship album, Hannover, Historisches Museum; see M. A. Katritzky, '"Unser sind drey": The Quacks of Beer, Printz and Weise', *Maske und Kothurn* 48, nos. 1–4 (2002): 117–42, fig. 1; Katritzky, 'The Picture of We Three', fig. 3b.

19 John Taylor, *Taylors farevvell, to the Tovver-bottles* (Dort [=London: Augustine Matthewes], 1622), Sigs. A2r-v and final page.

20 John Taylor, *Three Weekes, Three Daies, and Three Houres Observations and Travel, from London to Hambvrgh in Germanie* (London: George Gibbs, 1617), Sigs. E3r-e4v; John Taylor, *Taylor His Trauels: From the Citty of London in England, to the Citty of Prague in Bohemia* (London: Henry Gosson, 1620), Sigs. B4r-v. On the seventeenth-century German literary impact of 'We Three', see Katritzky, '"Unser sind drey"'; and Katritzky, 'The Picture of We Three'.

21 Bernard Capp, *The World of John Taylor the Water-Poet 1578–1653* (Oxford: Clarendon Press, 1994), 204; O'Connell, *The Popular Print*, 233, n. 139.

22 [John Taylor,] *Tvrne over Behold and Wonder* (Layghten Buzzard: Tom Ladle [1654]); *Catalogus Bibliothecæ Musei Britannici: Librorum impressorum, qui in Museo Britannico adservantur, catalogus, VII [TAB-ZYT]* (London: G. Woodfall, 1819): 'Turn over, Behold and Wonder. 4° [1654.]'; Malcolm Jones, 'The English Broadside Print c.1550–c.1650', in *A New Companion to English Renaissance Literature and Culture*, ed. Michael Hattaway (Chichester: Wiley-Blackwell, 2010), 503.

23 See also Giuseppe Caletti ('Il Cremonese', 1600-60), *Noi siamo sette (contate bene)*, etching, London, British Museum (1932-7-9-16). German, *Unser seindt zehen*, ca 1700, engraving, Nürnberg, Germanisches Nationalmuseum (HB 17862b); see Katritzky, '"Unser sind drey"', Fig. 2. Jakob van der Heyden, *Unser sind siben / Novs sommes sept*, ca 1635, London, British Museum (1880-0710-841); see Katritzky, 'Shakespeare's "portrait of a blinking idiot"', Fig. 9.3c. French, *Novs sommes sept*, seventeenth century, Windsor, Royal Collection, Dutch Drolls, f.17r, no. 22; see Katritzky, 'The Picture of We Three', Fig. 4b. English (published in London), *We are seven*, coloured engraving, ca 1700, London, British Museum (1999-0328-7); see Katritzky, 'Shakespeare's "portrait of a blinking idiot"', Fig. 9.3d.

24 'Mein Freünd so du hier still wilst stehen / Vier Esel mit Eim Kopff kanst sehen / Wen suchst noch? du bist selbst der Viert / Der unsern Esels-Kopff auß ziert/Hättst du die reimen nicht gelesen / So Wärest du kein Esel gwesen.'

25 *Nostrum suunt quaduor*, 1643, friendship album drawing, Nürnberg, Germanisches Nationalmuseum, Hs. 137.321, fol. 53r; see Lotte Kurras, *Zu gutem Gedenken, Kulturhistorische Miniaturen aus Stammbüchern des Germanischen Nationalmuseums* (München: Prestel, 1987), 59; Otto G. Schindler, 'Zur Kremser "Komödiantenszene" im Stammbuch des Malergesellen Ferdinand Simmerl (1643)', *Unsere Heimat. Zeitschrift für Landeskunde in Niederösterreich* 68 (1997): 100–12, esp. 101-3; idem, 'Eselsritt', 7–42, Figs 1–3.

26 A reversed English copy bears the text: *Five senses to be sold*, see London, British Museum (S.6734).

27 'Sie du sind unser drey'. Gregorius Schünemann, *Unser sind 3*, 1696, friendship album drawing, Basel, Historisches Museum Basel (Inv. No. 1926.77, ff.23–24).

28 The British Museum possesses a study drawing for this painting (Ff,2.115), which is, however, too different from the painting to be the direct source of the print.

29 French, *Novs soms cinq*, ca 1600, engraving, Oxford, Ashmolean Museum, Douce Collection.

30 German, *Alle Narren lachen, Daß die Zahne krachen*, ca 1600, woodcut, Nürnberg, Germanisches Nationalmuseum (HB24871). French/German, *Novs soms trois. Ey Lieber schaw doch frey, wie Lachen wir all drey*, ca. 1600, woodcut, Paris, *Bibliothèque nationale de France*; see De Jongh and Luijten, *Mirror of Everyday Life*, 23.

31 *Head of a reveler*, ca. 1560, Dresden, Haarlem, Vienna; see Arno Dolders, *The Illustrated Bartsch 56, Netherlandish Artists, Philips Galle* (New York: Abaris, 1987), 495, n. 206, illustrated; Manfred Sellink and Marjolein Leesberg, *The New Hollstein. Dutch and Flemish Etchings, Engravings and Woodcuts 1450–1700: Philips Galle*, Part IV (Rotterdam: Sound & Vision, 2001), n. 563, illustrated.

32 Davies and Stewart, 'Head of a Jester', 170 and 172; this reference thanks to Alison Stewart.

33 Lutz S. Malke, *Narren. Porträts, Feste, Schwankbücher und Spielkarten aus dem 15. bis 17. Jahrhundert* (Berlin: Kunstbibliothek, 2001), 51, 76; Katritzky, 'The Picture of We Three', 229–30 and Fig. 1b.

34 German, *Der Schalksnarr (Dero Narren lache Ich Allen Denn nur Jirn Kolbn thuon gefallen)*, Gotha, Schlossmuseum Schloss Friedenstein, Kupferstichsammlung (Inventar-Nr. 40,18/832, alte Inventar-Nr. Xyl. II. 50).

35 John Southworth, *Fools and Jesters at the English Court* (Thrupp: Sutton, 1998), 150.

36 Malcolm Jones, 'The English print c.1550–1650', in *A Companion to English Renaissance Literature and Culture*, ed. Michael Hattaway (Oxford: Blackwell, 2003), 352–66.

37 This would rule out the Stratford panel as proof for Shakespeare's familiarity with the 'We Three' theme.

38 My thanks, for access to the original, to Anne Labourdette and Colin Colson (Douai, Musée de la Chartreuse), and, for access to relevant publications, to Stewart Tiley and Ruth Ogden (Oxford, St John's College Library).

39 Gustave-Joseph Witkowski, *L'art profane à l'église* (Paris: J. Schemit, 1908), vol. 2, 420, Fig. 512; Dirk Bax, *Hieronymus Bosch: His Picture-writing Deciphered* (Rotterdam: Balkema, 1979), 264, Fig. 111; Yona Pinson, *The Fools' Journey: A Myth of Obsession in Northern Renaissance Art* (Turnhout: Brepols, 2008), 19.

40 Ethan Matt Kavaler, *Pieter Bruegel: Parables of Order and Enterprise* (Cambridge: Cambridge University Press, 1999), 204–5 and Fig. 115.

41 Mezger, *Narrenidee*, 327.

42 E. Gerfue [=Feugère], 'Une sculpture du Musée de Douai', *La semaine des familles* 12 (23 June 1894): 177–8.

43 Malcolm Jones, *The Secret Middle Ages* (Thrupp: Sutton, 2004), 170 and Fig. 8.10.

44 Walter S. Gibson, *Figures of Speech: Picturing Proverbs in Renaissance Netherlands* (Berkeley: University of California Press, 2010), 155–6 and Fig. 81; this reference thanks to Matt Kavaler.

45 Bax, *Hieronymus Bosch*, 263–4. Also, St. Botolph, Boston, reproduced: Christa Grössinger, *The World Upside-Down: English Misericords* (London: Harvey Miller, 1997), 108, Fig. 153.

46 Nicolas Bonnart, *Polichinelle*, from Bonnart's series *Recueil des modes de la cour de France* (ca 1678–93), reproduced: Renzo Guardenti, *Gli Italiani a Parigi. La Comédie Italienne (1660–1697), storia, pratica scenica, iconografia*, 2 vols (Roma: Bulzoni, 1990), vol. 2, 174, Fig. 269.

Bibliography

Abbott, Edwin A. St. *Thomas of Canterbury: His Death and Miracles*, 2. London: Adam and Charles Black, 1898.

Ago, Renata, with Bradford Bouley, Corey Tazzara, and Paula Findlen. *Gusto for Things: A History of Objects in Seventeenth-Century Rome*. Chicago: University of Chicago Press, 2013.

Ahmedaja, Ardian and Gerlinde Haid (eds). *European Voices: Multipart Singing on the Balkans and in the Mediterranean*. Vienna: Böhlau Verlag, 2008.

Aikema, Bernard. *Jacopo Bassano and His Public: Moralising Pictures in an Age of Reform ca. 1535–1600*. Princeton: Princeton University Press, 1996.

Ajmar, Marta and Flora Dennis (eds). *At Home in Renaissance Italy*. London: V&A Publications, 2006 (exhibition catalogue).

Albera, Dionigi. *Au fil des générations: Terre, pouvoir et parenté dans l'Europe alpine, XIV-XX siècles*. Grenoble: Presses universitaires de Grenoble, 2011.

Alfani, Guido. 'Economic Inequality in Northwestern Italy: A Long-Term View (Fourteenth to Eighteenth Centuries)'. *The Journal of Economic History* 75, no. 4 (2015): 1058–96.

Alfani, Guido and Matteo Di Tullio. *The Lion's Share: Inequality, Poverty and the Fiscal State in Preindustrial Europe*. Cambridge: Cambridge University Press, 2019.

Alfani, Guido and Wouter Ryckbosch. 'Growing Apart in Early Modern Europe? A Comparison of Inequality Trends in Italy and the Low Countries, 1500–1800'. *Explorations in Economic History* 62 (2016): 143–53.

Allerston, Patricia. 'Clothing and Early Modern Venetian Society'. *Continuity and Change* 15, no. 3 (2000): 367–90.

Andersen, Vivi Lena. 'Mellem Brosten, Knyst, Skolæst og Mode. Sko Fra 1300–1800 Fra Arkæologiske Udgravninger i København'. PhD thesis, University of Copenhagen and Museum of Copenhagen, Copenhagen, 2016.

Anderson, Joanne W. 'Arming the Alps with Art. Saints, Knights and Bandits on the Early Modern Roads'. In *Travel and Conflict in the Early Modern World*, edited by Gabor Gelleri and Rachel Willie. New York and London: Routledge, forthcoming 2020.

Anderson, Joanne W. *Moving with the Magdalen: Late Medieval Art and Devotion in the Alps*. New York and London: Bloomsbury Visual Arts, 2019.

Andersson, Eva I. 'Foreign Seductions: Sumptuary Laws, Consumption and National Identity in Early Modern Sweden'. In *Fashionable Encounters: Perspectives and Trends in Textile and Dress in the Early Modern Nordic World*, edited by Tove Engelhardt Mathiassen et al., 15–29. Oxford: Oxbow Books, 2014.

Andersson, Eva I. 'Swedish Burghers' Dress in the Seventeenth Century'. *Costume* 51, no. 2 (2017): 171–89.

Andersson, Eva I. 'Women's Dress in Sixteenth-Century Sweden'. *Costume* 45 (2011): 24–38.

Anoyanakis, F. *Greek Folk Musical Instruments*. Athens: National Bank of Greece, 1979.

Appadurai, Arjun. *The Social Life of Things: Commodities in Cultural Perspective*. New York: Cambridge University Press, 1986.

Arakadaki, Maria. (M. Αρακαδάκη). 'Οι αλυκές της Ελούντας μέσα από τις επιστολές του Zeno (1640–1644)'. In *Το αλάτι και οι αλυκές ως φυσικοί πόροι κι εναλλακτικοί πόλοι τομικής ανάνπτυξης*, 102–15. Mytilini: s.n., 2002.

Arbel, Benjamin. 'Venice's Maritime Empire in Early Modern Period'. In *A Companion to Venetian History*, edited by Eric R. Dursteler, 229–31. Leiden and Boston: Brill, 2014.

Areford, David S. *The Viewer and the Printed Image in Late Medieval Europe*. Farnham: Ashgate Publishing Ltd, 2010.

Baarsen, Reinier. *Kwab: Ornament as Art in the Age of Rembrandt*. Amsterdam: Rijksmuseum, 2018.

Baatsen, Inneke. *A Bittersweet Symphony: The Social Recipe of Dining Culture in Late Medieval and Early Modern Bruges (1438–1600)*. PhD thesis, University of Antwerp, 2016.

Bacci, Michele. *"Pro remedio animae": Immagini sacre e pratiche devozionali in Italia centrale (secoli XIII e XIV)*. Pisa: GISEM – edizioni ETS, 2000.

Bager, Einar. *Malmø Stadsbog 1549–1559. Rådstuerettens, Bytingets og Toldbodrettens Protokol*. Copenhagen: Selskabet for udgivelse af kilder til dansk historie, 1972.

Barbe, Françoise. *Majolique: l'âge d'or de la faïence italienne au XVIᵉ siècle*. Paris: Citadelles & Mazenod, 2016.

Barbe, Françoise and Carmen Ravanelli-Guidotti (eds). *Forme e 'diverse pitture' della maiolica italiana. La collezione delle maioliche del Petit Palais della Città di Parigi*. Venice: Marsilio Editori, 2006.

Barnel, Christine and Henri Bresc. 'La maison et la vie domestique: L'apport des inventaires'. In *Matériaux pour l'étude de la vie domestique et de la culture matérielle en Provence aux derniers siècles du Moyen Âge*, edited by L. Ripert, M. Zerner and C. Barnel, 7–27. Nice: Université de Nice, 1993.

Barrell, John. *The Dark Side of the Landscape: The Rural Poor in English Painting 1730–1840*. Cambridge: Cambridge University Press, 1980.

Barron, Caroline. 'Ralph Holland and the London Radicals, 1438–1444'. In *The English Medieval Town: A Reader in English Urban History 1200–1540*, edited by R. C. Holt and G. Rosser, 160–83. London: Longman, 1990.

Bast, Robert James. *Honor Your Fathers: Catechisms and the Emergence of a Patriarchal Ideology in Germany, 1400–1600*. Leiden: Brill, 1997.

Baulant, Michelline. 'Nécessité de vivre et besoin de paraître: Les inventaires et la vie quotidienne'. In *Inventaires après-décès et ventes de meubles. Apports à une histoire de la vie économique et quotidienne, XIVᵉ-XIXᵉ siècle. Actes du séminaire tenu dans le cadre du 9ᵉᵐᵉ Congrès international d'histoire économique de Berne (1986)*, 9–17. Louvain-la-Neuve: Academia, 1988.

Baulant, Michelline, Anton J. Schuurman and Paul Servais. *Inventaires après-décès et ventes de meubles: Apports à une histoire de la vie économique et quotidienne, XIVᵉ-XIXᵉ siècle. Actes du séminaire tenu dans le cadre du 9ᵉᵐᵉ Congrès international d'histoire économique de Berne (1986)*. Louvain-la-Neuve: Academia, 1988.

Bax, Dirk. *Hieronymus Bosch: His Picture-Writing Deciphered*, translated by M. A. Bax-Botha. Rotterdam: A.A. Balkema, 1979.

Beaudry, Mary. 'Words for Things: Linguistic Analysis of Probate Inventories'. In M. Beaudry, *Documentary Archaeology in the New World*, 43–50. Cambridge: Cambridge University Press, 1988.

Begheyn, Paul. 'The Catechism (1555) of Peter Canisius, the Most Published Book by a Dutch Author in History'. *Quaerendo* 36 (2006): 51–84.

Belozerskaya, Marina. *Luxury Arts of the Renaissance*. Los Angeles: The J. Paul Getty Museum, 2005.

Belozerskaya, Marina. *Rethinking the Renaissance: Burgundian Arts across Europe*. Cambridge: Cambridge University Press, 2002.

Belting, Hans. *Bild und Kult. Eine Geschichte des Bildes vor dem Zeitalter der Kunst*. Munich: Beck, 1990.

Belting, Hans. *Likeness and Presence: A History of the Image before the Era of Art*, translated by Edmund Jephcott. Chicago: The University of Chicago Press, 1990.

Beltrami, Daniele. *Saggi di storia dell'agricoltura nella Reppublica di Venezia durante l'età moderna*. Venice: Istituto per la collaborazione culturale, 1955.

Benedetti, Rocco. *Raggualgio delle Allegrezze, Solenità, e Feste fatte in Venetia per la felice Vittoria al Clariss. Sig. Girolamo Diedo, digniss*. Consigliere di Corfù. Venice: Perchacchino, 1571.

Bent, George R. *Public Art and Visual Culture in Early Republican Florence*. Cambridge: Cambridge University Press, 2016.

Bentzon, Andreas F. W. *The Launeddas: A Sardinian Folk-Music Instrument*. Copenhagen: Akademisk forlag, 1969.

Benvenuti, Anna (ed.). *Santa Maria delle Carceri a Prato: Miracoli e devozione in un santuario Toscano del Rinascimento*. Florence: Mandragora, 2005.

Berger, Daniel. 'Herstellungstechnik hoch- und spätmittelalterlicher Kleinobjekte aus Zinn' ('Production processes of small pewter objects in the High and Late Middle Ages'). In *Heilig en Profaan* 3, 39–55. Langbroek: Stichting Middeleeuwse Religieuze en Profane Insignes, 2012.

Bettoni, Barbara. *I beni dell'agiatezza: stili di vita nelle famiglie bresciane dell'età moderna*. Milan: FrancoAngeli, 2005.

Bill-Jessen, Torben and Lone Hvass. *Liv og Død, Tro, Håb og Mirakler i 1600-Tallets Helsingør*. Helsingør: Helsingør Kommunes Museer, 2017.

Blackmore, Lyn. 'Pottery, the Port and the Populace: The Imported Pottery of London 1300–1600 (part 1)', *Medieval Ceramics* 18 (1994): 29–44.

Blackmore, L. and J. Pearce. *A Dated Type-Series of London Medieval Pottery Part 5: Shelly-Sandy Ware and the Greyware Industries*, MOLA Monographs 46. London: Museum of London, 2010.

Blakemore Evans, G. and J. J. M. Tobin (eds). *The Riverside Shakespeare*, 2nd edn. Boston: Houghton Mifflin, 1997.

Blick, Sarah. 'Popular and Precious: Silver Gilt & Silver Pilgrim Badges'. *Peregrinations: Journal of Medieval Art and Architecture* 2, no. 1 (2005): https://digital.kenyon.edu/per ejournal/vol2/iss1/7/

Blick, Sarah. 'Reconstructing the shrine of St Thomas Becket, Canterbury Cathedral'. In *Art and Architecture of Late Medieval Pilgrimage in Northern Europe and in the British Isles*, edited by Sarah Blick and Rita Tekippe, 407–41. Leiden: Koninklijke Brill NV, 2005.

Bologni, Giuseppe. *Gli Antichi Spedali della 'Terra Di Prato'*, vol. 2. Signa: Masso delle Fate Edizioni, 1994.

Borghini, Raffaello. *Il Riposo*. Florence: Giorgio Mariscotti, 1584.

Borsook, Eve. *The Mural Painters of Tuscany from Cimabue to Andrea del Sarto*. Oxford: Oxford University Press, 1980 (2nd edn).

Bos, K. I., et al. 'Pre-Columbian Mycobacterial Genomes Reveal Seals as a Source of New World Human Tuberculosis'. *Nature* 514, no. 7523 (2014): 494–7.

Bothe, F. *Frankfurter Patriziervermögen im 16ten Jahrhundert*. Berlin: Alexander Duncker, 1908.

Bourdieu, P. *Distinction: A Social Critique of the Judgement of Taste*. New York and London: Routledge, 1984.

Bourquin, L. 'Les objets de la vie quotidienne dans la première moitié du XVIᵉ siècle à travers cent inventaires après-décès parisiens'. *Revue d'Histoire Moderne et Contemporaine* 36 (1989): 465–86.

Braunstein, Ph. 'La pauvreté au quotidien: apports et limites des sources médiévales'. In *Les niveaux de vie au Moyen Âge. Mesures, perceptions et représentations, Actes du colloque international de Spa, 21–25 octobre 1998*, edited by J.-P. Sosson, C. Thiry and S. Thonon, 91–103. Louvain-La-Neuve: Bruylant-Academia, 1999.

Britton, Frank. *London Delftware*. London: Jonathan Horne, 1988.

Brown, Beverley Louise and Paola Marini (eds). *Jacopo Bassano c. 1510–1592*. Fort Worth: Kimbell Art Museum, 1993 (exhibition catalogue).

Brown, Donald. *Human Universals*. New York: McGraw Hill, 1991.

Brown, Katherine T. *Mary of Mercy in Medieval and Renaissance Italian Art: Devotional Image and Civic Emblem*. New York: Routledge, 2017.

Brucker, Gene. *The Civic World of Early Renaissance Florence*. Princeton: Princeton University Press, 1977.

Brucker, Gene (ed.). *The Society of Renaissance Florence: A Documentary Study*. Toronto: University of Toronto Press, 1998.

Bruna, Denis. *Saints et Diables au Chapeau. Bijoux oubliés du Moyen Age*. Paris: Seuil, 2007.

Bühler, Linus. *Chur im Mittelalter: von der karolingischen Zeit bis in die Anfänge des 14. Jahrhunderts*. Chur: Kommissionsverlag Bündner Monatsblatt, 1995.

Cadogan, Jean K. 'The Chapel of the Holy Belt in Prato: Piety and Politics in Fourteenth-Century Tuscany'. *Artibus et Historiae* 30, no. 60 (2009): 107–14.

Calvi, G. 'Abito, genere, cittadinanza nella Toscana moderna (secoli XIV-XVII)'. *Quaderni Storici* 110 (2002): 477–503.

Canisius, Peter. *Betbůch vnd Catechismus. Nach rechter Catholischer form vnnd weiß jetzt zum sechßten mal in Truck außgangen*. Dillingen: Sebald Mayer, 1575.

Canisius, Peter. *Catholischer Catechismus oder Sumärien Christlicher Lehr*. Cologne: Maternus Cholinus, 1563.

Canisius, Peter. *Catholischer Catechismus oder Sumärien Christlicher Lehr*. Cologne: Maternus Cholinus, 1569.

Canisius, Peter (Petro Canisio). *Institvtiones Christianae Pietatis sev Parvvs Catechismvs Catholicorvm*. Antwerp: Johann Bellerus, 1575.

Capobianco, Aldo (ed.). *La Sacra Cintola nel Duomo di Prato*. Florence: Claudio Martini, 1995.

Capp, Bernard. *The World of John Taylor the Water-poet 1578–1653*. Oxford: Clarendon Press, 1994.

Cardwell, Peter. 'Excavation of the hospital of St Giles by Brompton Bridge, North Yorkshire'. *Archaeological Journal* 152 (1995): 109–245.

Castelnuovo, Enrico and Carlo Ginzburg, 'Centro e periferia'. In *Storia dell'arte italiana*, 1, *Materiali e problemi*, vol 1, *Questione e metodi*, edited by Giovanni Previtali, 283–352. Turin: Einaudi, 1979.

Castelnuovo, Guido. 'Strade, passi, chiuse nelle Alpi del basso medioevo'. In *Il Gotico nelle Alpi 1350–1450*, edited by Enrico Castelnuovo and Francesca de Gramatica, 61–78. Trento: Castello del Buonconsiglio. Monumenti e collezioni provinciali, 2002.

Castree, Noel. 'Differential Geographies: Place, Indigenous Rights and "Local Resources"'. *Political Geography* 23 (2004): 133–67.

Catalogus Bibliothecæ Musei Britannici: Librorum impressorum, qui in Museo Britannico adservantur, catalogus, VII [TAB-ZYT]. London: G. Woodfall, 1819.

Cerretelli, Claudio. 'Da oscura prigione a tempio di luce: La costruzione di Santa Maria delle Carceri a Prato'. In *Santa Maria delle Carceri a Prato: miracoli e devozione in un santuario toscano del Rinascimento*, edited by Anna Benvenuti, 48. Florence: Mandragora, 2005.

Cerretelli, Claudio. *La Basilica di Santa Maria delle Carceri a Prato*. Florence: Mandragora, 2009.

Cerretelli, Claudio. 'La Pieve e la Cintola: le trasformazioni legate alla reliquia'. In *La Sacra Cintola nel Duomo di Prato*, edited by Aldo Capobianco, 79–161. Prato: C. Martini, 1995.

Cerri, Monica. 'Sarti toscani nel seicento: Attività e clientela'. In *Le trame della moda*, edited by Anna Giulia Cavagna and Grazietta Butazzi, 421–33. Rome: Bulzoni, 1995.

Checa, Fernando. *Felipe II: Mecenas de las artes*. Madrid: Nerea, 1992.

Chipps Smith, Jeffrey. *Sensuous Worship: Jesuits and the Art of the Early Catholic Reformation in Germany*. Princeton: Princeton University Press, 2002.

Christman, Victoria. *Pragmatic Toleration: The Politics of Religious Heterodoxy in Early Reformation Antwerp, 1515–1555*. Rochester: University of Rochester Press, 2015.

Chrystoforaki, Ioanna (Ιωάννα Χριστοφοράκη). 'Χορηγικές Μαρτυρίες στους Ναούς της Μεσαιωνικής Ρόδου (1204–1522)'. In *Η Πόλη της Ρόδου από την Ίδρυσή της μέχρι την Κατάληψη από τους Τούρκους (1530)*, 2, 429–48. Athens: s.n., 2000.

Chrzanovski, L. *De Prométhée à la Fée Electricité: Pour une sociologie de l'éclairage à travers les âges, les croyances et les continents*, 27–42. Cluj-Napoca: Académie Roumaine, 2013.

Chrzanovski, L. and M. Martiniani-Reber. *À la tombée de la nuit*. Art et *histoire de l'éclairage*, 41–56. Exhibition catalogue. Geneva: Musées d'art et d'histoire, 2011.

Chrzanovski, L. and P. Kaiser. *Dark ages? Licht im Mittelalter [Publikation des Historischen Museums Olten und der International Lychnological Association zur gleichnamigen Ausstellung und zum Kongress in Olten]*. Milan: Et, 2007.

Church, A. H. *English* Earthenware. London: Chapman & Hall, 1884.

Ciatti, Marco. 'Doni e donatori del Santuario di Santa Maria delle Carceri di Prato nei suoi inventari 1488–1510'. *Prato storia e arte* 59 (1981): 14–44.

Classen, Albert. *Urban Space in the Middle Ages and Early Modern Age*. Berlin and New York: Walter de Gruyter, 2002.

Classen, Albrecht. 'Introduction'. In *Rural Space in the Middle Ages and Early Modern Age: The Spatial Turn in Premodern Studies*, edited by Albrecht Classen. Berlin and Boston: De Gruyter, 2012.

Clausen, Julius and P. Fr. Rist. *Det Store Bilager I Kjøbenhavn 1634. Memoirer og Breve*. Copenhagen: Gyldendalske Boghandel and Nordisk Forlag, 1914.

Cohen, Esther. 'In Haec Signa: Pilgrim Badge Trade in Southern France'. *Journal of Medieval History* 2 (1976): 193–214.

Cohn, Samuel. *Creating the Florentine State: Peasants and Rebellion, 1348–1434*. Cambridge: Cambridge University Press, 1999.

Cohn, Samuel. *The Cult of Remembrance and the Black Death: Six Renaissance Cities in Central Italy*. Baltimore: Johns Hopkins University Press, 1992.

Cohn, Samuel. *Lust for Liberty: The Politics of Social Revolt in Medieval Europe, 1200–1425*. Cambridge, MA: Harvard University Press, 2006.

Cohn, Samuel. 'Piété et commande d'oeuvres d'art après la Peste Noire'. *Annales: Histoire, Sciences Sociales* 51, no. 3 (1996): 551–73.

Cohn, Samuel. *Popular Protest in Late Medieval English Towns*. Cambridge: Cambridge University Press, 2013.

Cohn, Samuel. 'Renaissance Attachment to Things: Material Culture in Last Wills and Testaments'. *Economic History Review* 65, no. 3 (2012): 984–1004.

Cohn, Samuel. 'Rich and Poor in Western Europe, c. 1375–1475: The Political Paradox of Material Well-Being'. In *Approaches to Poverty in Medieval Europe: Complexities, Contradictions, Transformations, c. 1100–1500*, edited by Sharon Farmer, 145–73. Turnhout: Brepols, 2016.

Conard, Nicholas J., Maria Malina and Susanne C. Münzel, 'New Flutes Document the Earliest Musical Tradition in Southwestern Germany'. *Nature* 460 (August 2009): 737–40.

Cooper, R. G. *English Slipware Dishes 1650–1850*. London: Alec Tiranti, 1968.

Coquery, N. 'La diffusion des biens à l'époque modern: Une histoire connectée de la consommation'. *Histoire urbaine* 30 (2011): 5–20.

Cornelius, Flaminius. *Creta Sacra, sive de episcopis utriusque ritus Graeci et Latini in insula Cretae*. Venice: Pasquali, 1755.

Cottrell, Philip. 'Poor Substitutes: Imaging Disease and Vagrancy in Renaissance Venice'. In *Others and Outcasts in Early Modern Europe: Picturing the Social Margins*, edited by Tom Nichols, 64–7. Aldershot: Ashgate, 2007.

Courtin, N. *L'Art d'habiter à Paris au XVIIᵉ siècle: L'Ameublement des hôtels particuliers*. Dijon: Faton, 2011.

Crane, F. *Extant Medieval Musical Instruments: A Provisional Catalogue by Types*. Iowa City: University of Iowa Press, 1972.

Crevato-Selvaggi, Bruno, Jovan Martinović and Daniele Sferra. *L'Albania veneta: la Serenissima e le sue popolazioni nel cuore dei Balcani*. Milan: Biblion, 2012.

Currie, Elizabeth. 'Clothing and a Florentine Style, 1550–1620'. *Renaissance Studies* 23, no. 1 (2009): 33–52.

Currie, Elizabeth. 'Diversity and Design in the Florentine Tailoring Trade, 1550–1620'. In *The Material Renaissance*, edited by Michelle O'Malley and Evelyn Welch, 154–73. Manchester: Manchester University Press, 2007.

Currie, Elizabeth. *Fashion and Masculinity in Renaissance Florence*. London and New York: Bloomsbury Academic, 2016.

Currie, Elizabeth. 'Fashion Networks: Consumer Demand and the Clothing Trade in Florence from the Mid-Sixteenth to Early Seventeenth Centuries'. *Journal of Medieval and Early Modern Studies* 39, no. 3 (2009): 483–509.

Curzel, Emanuele. 'Alpine Village Communities, Ecclesiastic Institutions, and Clergy in Conflict: The Late Middle Ages'. In *Communities and Conflicts in the Alps*, ed. Marco Bellabarba, Hannes Obermair and Hitomi Sato, 91–100. Berlin: Duncker & Humblot GmbH, 2015.

Dahl, Camilla Luise. 'Dressing the Bourgeoisie: Clothing in Probate Records of Danish Townswomen, ca. 1545–1610'. *Medieval Clothing and Textiles* 12 (2016): 131–93.

Dahl, Camilla Luise. *Klædt i Rigets: Stand, Status og National Identitet Udtrykt i Borgerskabets Dragt i Reformationstidens Danmark-Norge og Sverige*. Oslo: Norsk folkemuseum, 2015.

Dahl, Camilla Luise. *Skifter fra Kalundborg 1541–1658*, https://ctr.hum.ku.dk/research -programmes-and-projects/previous-programmes-and-projects/earlymodern/postd ocproject/extracts/skifter_fra_kalundborg_udvalg.docx.pdf

Dahl, Camilla Luise and Piia Lempiäinen. 'The World of Foreign Goods and Imported Luxuries: Merchant and Shop Inventories in Late 17th-Century Denmark-Norway'. In *Fashionable Encounters: Perspectives and Trends in Textile and Dress in the Early Modern Nordic World*, edited by Tove Engelhardt Mathiassen et al., 1–14. Oxford: Oxbow Books, 2014.

Davies, Gregory and Alison Stewart. 'Head of a Jester'. *Print Quarterly* 19, no. 2 (2002): 170–4.

Davies, Paul. 'The Early History of S. Maria delle Carceri in Prato'. *Journal of the Society of Architectural Historians* 54, no. 3 (September 1995): 326–35.

Davies, Paul. 'La santita' del luogo e la chiesa a pianta centrale nel Quattro e nel primo Cinquecento'. In *La chiesa a pianta centrale: tempio civico del Rinascimento*, edited by Bruno Adorni, 26–35. Milano: Electa, 2002.

Davies, Paul. *Studies in the Quattrocento Centrally Planned Church.* Unpublished PhD thesis, University of London, London, 1992.

De Jongh, Eddie and G. Luijten. *Mirror of Everyday Life: Genreprints in the Netherlands 1550–1700.* Amsterdam: Rijksmuseum, 1997.

De Kock, B. 'Haardplaten'. *Oud Nederland* 4 (1950): 179.

De la Roncière, Charles. *Florence: Centre économique régional au XIVe siècle (1280–1360).* Aix-en-Provence: S.O.D.E.B, 1976.

De Marchi, Andrea and Cristina Gnoni Mavarelli (eds). *Legati da una cintola: l'Assunta di Bernardo Daddi e l'identità di una* città. Florence: Mandragora, 2017.

De Roover, Raymond. *The Rise and Decline of the Medici Bank.* Cambridge, MA: Harvard University Press, 1963.

De Waal, Edmund. *Bernard Leach.* London: Tate Publishing, 2014.

Degn, Ole and Inger Dübeck. *Håndværkets Kulturhistorie. Håndværket i Fremgang. Perioden 1550–1700.* Vol. 2. Copenhagen: Håndværkerrådets Forlag, 1983.

Deregnaucourt, J.-P. 'L'inventaire après décès d'Ysabel Malet, bourgeoise douaisienne, en 1359. Document pour servir à l'histoire de la vie quotidienne de la bourgeoisie médiévale'. *Revue du Nord* 64 (1982): 707–30.

Descoudres, Georges. 'Bauholz und Holzbau im Mittelalter'. *Der Geschichtsfreund: Mitteilungen des Historischen Vereins Zentralschweiz* 161 (2008): 47–62.

Descoudres, Georges. 'Quantensprung als Diskontinuität. Wohnhäuser des 12. bis 14. Jahrhunderts in der Innerschweiz'. *Mitteilungen der Arbeitsgemeinschaft für Archäologie des Mittelalters und der Neuzeit* 17 (2006): 79–85.

Dillinberger, John. *A Theology of Artistic Sensibilities: The Visual Arts and the Church.* Wipf and Stock: Eugene, 1986.

Dolders, Arno. *The Illustrated Bartsch 56, Netherlandish Artists: Philips Galle.* New York: Abaris, 1987.

Dubbe, B. *Huusraet: Het stedelijk woonhuis in de Bourgondische tijd.* Hoorn: Uitg. Polder Vondsten, 2012.

Duguet, J. 'Notes sur l'utilisation de la cire (XIe–XVIIe siècles)'. *Roccafortis: Bulletin de la Société de géographie de Rochefort* 3 (1998): 265–9.

Dunning, G. C. 'Pottery'. In J. B. Ward Perkins, *London Museum Medieval Catalogue*, 212. London: HMSO, 1954.

Dyer, C. 'Furnishings of Medieval English Peasant Houses: Investment, Consumption and Life Style'. In *Pautas de Consumo y niveles de vida en el mundo rural medieval. Coloquio internacional di Valencia, 18–20 September 2008*, edited by A. Furió and F. Garcio-Oliver, 1–13. Valencia: University of Valentcia Press, 2008.

Dyer, C. 'Poverty and Its Relief in Late Medieval England'. *Past and Present* 216 (August 2012): 41–78.

Dyer, C. *Standards of Living in the Later Middle Ages: Social Change in England c.1200–1520*. Cambridge: Cambridge University Press, 1989.

Eeles, F. *The Edwardian Inventories for Buckinghamshire*. London: Longmans, Green and Company, 1908.

Egan, Geoff. 'Lighting Equipment'. In G. Egan, *The Medieval Household: Daily Living c. 1150-c.1450, Medieval Finds from Excavations in London*), 127–51. London: Museum of London, 2010.

Egan, Geoff and Frances Pritchard. *Dress Accessories: Medieval Finds from Excavations in London* 3. Norwich, The Stationery Office, 1991.

Elwood, Sarah, with Victoria Lawson and Eric Sheppard. 'Geographical Relational Poverty Studies'. *Progress in Human Geography* 41, no. 6 (2016): 745–65.

Erwin Poeschel. *Die Kunstdenkmäler des Kantons Graubünden*, vol. 7, *Chur und der Kreis Fünf Dörfer*. Basel: Verlag Birkhauser, 1948.

Esquieu, Y. 'L'Éclairage'. In *Cent maisons médiévales en France*, edited by J.-M. Pesez and Y. Esqiueu), 97–107. Paris: Monographie du CRA, 1998.

Ettlinger, Leopold D. *Antonio and Piero Pollaiuolo*. Oxford: Phaidon and New York: Dutton, 1978.

Fantappiè, Renzo. 'Una cintura di lana finissima di Prato'. In *Legati da una cintola: l'Assunta di Bernardo Daddi e l'identità di una città*, edited by Cristina Gnoni Mavarelli, 30–9. Florence: Mandragora, 2017.

Farrand Thorp, Margaret. 'Shakespeare and the Fine Arts'. *Publications of the Modern Language Association* 46, no. 3 (1931): 672–93.

Feller, L. 'Culture matérielle et Histoire Économique'. In *La culture matérielle. Un objet en question. Anthropologie, archéologie et histoire. Actes du Colloque international organisé à Caen, 9-10 octobre 2015*, 161–74. Caen: Presses Universitaires de Caen, 2018.

Ferrand, G. *Les inventaires après décès de la ville de Dijon à la fin du Moyen Âge. 1390–1459*. Toulouse: Presses Universitaires du Midi, 2017.

Fock, C. Willemijn (ed.). *Het Nederlandse interieur in beeld 1600–1900*. Zwolle: Waanders, 2001.

Fock, C. Willemijn. 'Verwarmd door de Bijbel: De ijzeren kachel in het zeventiende-eeuwse Nederlandse interieur'. *Antiek: Tijdschrift voor liefhebbers en kenners van oude kunst en kunstnijverheid* 31, no. 10 (1997): 465–75.

Folz, Hans. *U wissen sei allen christen die zu der oster-/lichen zeit nach ordennung der kirchen wil / len haben mit rew peicht und pus sich beraiten /…* Nuremberg: Hanse Folcze, 1479.

Forsyth, Hazel, with Geoff Egan. *Toys, Trifles & Trinkets: Base Metal Miniatures from London 1200 to 1800*. London: Unicorn Press, 2005.

Fortini Brown, Patricia. *Art and Life in Renaissance Venice*. London: Laurence King Publishing, 1997.

Fortini Brown, Patricia. 'The Venetian Loggia: Representation, Exchange, and Identity in Venice's Colonial Empire'. In *Viewing Greece: Cultural and Political Agency in the Medieval and Early Modern Mediterranean*, edited by Sharon E. J. Gerstel, 209–35. Turnhout: Brepols, 2016.

Fortini Brown, Patricia. *Venetian Narrative Painting in the Age of Carpaccio*. New Haven: Yale University Press, 1988.

Foster-Campbell, Megan H. 'Pilgrimage through the Pages: Pilgrims' Badges in Late Medieval Devotional Manuscripts'. In *Push Me, Pull You: Imaginative and Emotional*

Interaction in Late Medieval and Renaissance Art, 1, edited by Sarah Blick and Laura D. Gelfand, 227–76. Leiden: Koninklijke Brill NV, 2011.

Franceschi, Franco. 'I "Ciompi" a Firenze, Siena, e Perugia'. In *Rivolte urbane e rivolte contadine nell'Europa del Trecento: un confronto*, edited by Monique Bourin, Giovanni Cherubini and Giuliano Pinto, 277–303. Florence: Firenze University Press, 2008.

Franco, Tiziana. 'Tra Padova, Verona e le Alpi. Sviluppi della pittura nel secondo Trecento'. In *Trecento. Pittori gotici a Bolzano*, edited by Andrea De Marchi et al., 149–65. Bolzano: TEMI Editrice, 2002.

Freedberg, David. *The Power of Images: Studies in the History and Theory of Response.* Chicago: University of Chicago, 1989.

Frick, Carole Collier. *Dressing Renaissance Florence: Families, Fortunes and Fine Clothing.* Baltimore and London: Johns Hopkins University Press, 2005.

Gagliardi, Isabella. 'I miracoli della Madonna delle Carceri in due codici della Biblioteca Roncioniana di Prato'. In *Santa Maria delle Carceri a Prato: miracoli e devozione in un santuario toscano del Rinascimento*, edited by Anna Benvenuti, 97–8. Florence: Mandragora, 2005.

Garnett, Jane and Gervase Rosser, 'Miraculous Images and the Sanctification of Urban Neighborhoods in Post-Medieval Italy'. *Journal of Urban History* 32, no. 5 (July 2006): 729–40.

Gasparis, Charalmabos (Χαράλαμπος Γάσπαρης). 'Από τη βυζαντινή στη βενετική τούρμα. Κρήτη, 13ος-14ος αι.'. *Σύμμεικτα* 14 (2001): 167–228.

Gasparis, Charalmabos (Χαράλαμπος Γάσπαρης). 'Μαλεβίζι. Το όνομα, η αμπελοκαλλιέργεια και τα κρασιά στον 13ο και 14ο αιώνα'. In *Μονεμβάσιος Οίνος – Μονοβασ(ι)ά – Malvasia*, edited by Ηλίας Αναγνωστάκης, 147–58. Athens: Εθνικό Ίδρυμα Ερευνών, Ινστιτούτο Βυζαντινών Ερευνών, 2008.

Gasparis, Charalambos. 'Venetian Crete: The Historical Context'. In *Hell in the Byzantine World: A History of Art and Religion in Venetian Crete and the Eastern Mediterranean*, vol. 1, edited by Angeliki Lymberopoulou. Cambridge: Cambridge University Press, forthcoming 2020.

Gaston, Robert W. 'Introduction: Some Meditations on Space and Place in Recent Florentine Art History'. *Melbourne Art Journal* 9, no. 10 (2007): 8–13.

Gaston, Robert W. 'Sacred Place and Liturgical Space: Florence's Renaissance Churches'. In *Renaissance Florence: A Social History*, edited by Roger J. Crum and John T. Paoletti, 331–52. New York: Cambridge University Press, 2006.

Gavard, C. 'Le petit peuple au Moyen Âge: conclusions'. In *Le petit peuple dans l'Occident médiéval, Actes du Congrès international, Université de Montréal, 18-23 octobre 1999*, edited by P. Boglioni, R. Delort, and C. Gauvard, 707–22. Paris: Publications de la Sorbonne, 2002.

Gaye, G. *Carteggio inedito d'artisti dei secoli XIV-XV-XVI*, 3. Florence: G. Molini, 1839.

Geltner, Guy. 'Isola Non Isolata: Le Stinche in the Middle Ages'. *Annali di Storia di Firenze* 3, no. 3 (2008): 19.

Geltner, Guy. *The Medieval Prison: A Social History*. Princeton: Princeton University Press, 2008.

Gentili, Augusto. *Le storie di Carpaccio: Venezia, i Turchi, gli Ebrei*. Venice: Marsilio Editore, 1996.

George, E. and S. George, *Bristol Probate Inventories*, Part I, *1542–1650*. Bristol: Bristol Record Society, 2002.

George, E. and S. George, *Bristol Probate Inventories*, Part II, *1657–1689*. Bristol: Bristol Record Society, 2005.

Gerbron, Cyril. 'Christ Is a Stone: On Filippo Lippi's "Adoration of the Child" in Spoleto'. *I Tatti Studies in the Italian Renaissance* 19 (2016): 257–84.

Geremek, Bronislav. *Poverty: A History*. Oxford: Oxford University Press, 1974.

Gerola, Giuseppe. *Monumenti Veneti Nell'Isola di Creta*, vols 1–3. Venice: R. Istituto *veneto di* scienze, lettere ed arti, 1905–1917.

Gerola, Giuseppe. *Monumenti Veneti dell' Isola di Creta*, vol. 4. Venice: R. Istituto *veneto di* scienze, lettere ed arti, 1932.

Gerstel, Sharon. 'Hearing Late Byzantine Painting'. In *The Post-1204 Byzantine World: New Approaches and Novel Directions, Papers from the 51st Spring Symposium of Byzantine Studies, University of Edinburgh 13–15 April 2018*, edited by Niels Gaul, Mike Carr and Yannis Stouraitis. London and New York: Routledge, forthcoming.

Gibbs, Janis M. 'Immigration and Civic Identity in Sixteenth-Century Cologne'. In *Ideas and Cultural Margins in Early Modern Germany: Essays in Honour of H.C. Erik Midelfort*, edited by Marjorie Elizabeth Plummer and Robin Barnes, 58–61. Farnham: Ashgate, 2009.

Gibson, Walter S. *Figures of Speech: Picturing Proverbs in Renaissance Netherlands*. Berkeley: University of California Press, 2010.

Gibson, Walter S. *Pieter Bruegel and the Art of Laughter*. Berkeley and Los Angeles: University of California Press, 2006.

Gifford, Paul M. *The Hammered Dulcimer: A History*. Lanham: The Scarecrow Press, 2001.

Goeree, Willem. *Inleydinge tot de al-ghemeene teycken-konst*. Middelburgh: Wilhelmus Goeree, 1668.

Goldberg, P. 'The Fashioning of Bourgeois Domesticity in Later Medieval England: A Material Culture Perspective'. In *Medieval Domesticity: Home, Housing and Household in Medieval England*, edited by M. Kowaleski and P. J. P. Goldberg, 124–44. Cambridge: Cambridge University Press, 2008.

Goldthwaite, Richard A. *The Building of Renaissance Florence: An Economic and Social History*. Baltimore and London: Johns Hopkins University Press, 1980.

Goldthwaite, Richard A. 'The Economic and Social World of Italian Renaissance Maiolica'. *Renaissance Quarterly* 42 (1989): 1–32.

Goldthwaite, Richard A. *The Economy of Renaissance Florence*. Baltimore: Johns Hopkins University Press, 2009.

Goldthwaite, Richard A. 'I prezzi del grano a Firenze dal XIV al XVI secolo'. *Quaderni Storici* 28 (1975): 5–36.

Goldthwaite, Richard A. *Wealth and the Demand for Art in Italy, 1300–1600*. Baltimore: Johns Hopkins University Press, 1993.

Gough Nichols, John. *Pilgrimages to Saint Mary of Walsingham and Saint Thomas of Canterbury by Desiderius Erasmus: Newly translated, with an Introduction and Illustrative Notes*, 2nd edn. London: John Murray, 1875.

Grierson, Philip. *Byzantine Coinage*. Washington, DC: Dumbarton Oaks, 1999.

Grössinger, Christa. *The World Upside-Down: English Misericords*. London: Harvey Miller, 1997.

Grossman, F. *Pieter Bruegel. Complete Edition of the Paintings*. London: Phaidon 1973.

Guardenti, Renzo. *Gli Italiani a Parigi: La Comédie Italienne (1660–1697), storia, pratica scenica, iconografia*. Roma: Bulzoni, 1990 (2 vols).

Guerzoni, Guido. *Apollo and Vulcan: The Art Markets in Italy, 1400–1700*. East Lansing: Michigan State University Press, 2011.

Haines, Margaret. 'Brunelleschi and Bureaucracy: The Tradition of Public Patronage at the Florentine Cathedral'. *I Tatti Studies in the Italian Renaissance* 3 (1989): 89–125.

Hakelberg, D. 'A Medieval Wind Instrument from Schlettwein, Thuringia'. *Historic Brass Society Journal* 7 (1995): 185–96.

Hall, Marcia. *Renovation and Counter-Reformation: Vasari and Duke Cosimo in Santa Maria Novella and Santa Croce, 1565–1577*. Oxford: Oxford University Press, 1979.

Halliday, Roslyn. *Santa Maria delle Carceri: Politics and Devotion in Renaissance Prato*. Unpublished M.A. thesis, Monash University, Clayton, 2016.

Hamilton, Sarah. *The Practice of Penance, 900–1050*. Woodbridge: The Boydell Press, 2001.

Hansen, G., S. Ashby and I. Baug, 'Everyday Products in the Middle Ages: Crafts, Consumption and the Individual in Northern Europe c. AD 800–1600. An introduction', in G. Hansen, *Everyday Products in the Middle Ages: Crafts, Consumption and the Individual in Northern Europe*, 1–10. York: Oxbow Books, 2015.

Harlin, Tord and Bengt Z. Nordström. *Härkebergas rika skrud: möte med målaren Albertus Pictor*. Enköping: Enköpings kyrkliga samfällighet, 2003.

Hattori, Yoshihisa. 'Community, Communication and Political Integration in the Late Medieval Alpine Regions: Survey from a Comparative Viewpoint'. In *Communities and Conflicts in the Alps from the Late Middle Ages to Early Modernity*, edited by Marco Bellabarba, Hannes Obermair and Hito Sato, 13–38. Trento and Bologna: Societa editrice il Mulino; Berlin: Duncker & Humblot in Kommission, 2015.

Haue, Kirsten and Friedhelm Krause. *Philipp Soldan: Bildhauer der Reformation*. Petersberg: Michael Imhof Verlag, 2017.

Havard, H. 'Chandelier'. In *Dictionnaire de l'ameublement et de la décoration depuis le XIIᵉ siècle jusqu'à nos jours*, 734–55. Paris: Ancienne Maison Quentin, 1894.

Havinden, M. A. *Household and Farm Inventories in Oxfordshire, 1550–1590*. London: The Majesty's stationery office, 1965.

Head, Randold. *Early Modern Democracy in the Grisons: Social Order and Political Language in a Swiss Mountain Canton*. New York: Cambridge University Press 2002.

Heal, Bridget. *A Magnificent Faith: Art and Identity in Lutheran Germany*. Oxford: Oxford University Press, 2017.

Heal, Bridget. 'Visual and Material Cultures'. In *The Oxford Handbook of the Protestant Reformations*, edited by Ulinka Rublack, 606. Oxford: Oxford University Press, 2017.

Herlihy, David. 'Santa Maria Impruneta: A Rural Commune in the Late Middle Ages'. In *Florentine Studies: Politics and Society in Renaissance Florence*, edited by Nicolai Rubinstein, 246–76. London: Faber, 1968.

Herlihy, David. *The Black Death and the Transformation of the West*, edited by Samuel Cohn. Cambridge, MA: Harvard University Press, 1997.

Herlihy, David and Christiane Klapisch-Zuber. *Les Toscans et leurs familles. Une Étude du catasto florentin de 1427*. Paris: Presses de la Fondation nationale des Sciences politiques, 1978.

Herridge, D. M. *Surrey Probate Inventories, 1558–1603*. Woking: Surrey Record Society, 2005.

Herskamp, Wolfgang. *Die Eiserne Bibel: Alte Ofen- und Kaminplatten im Rheinland mit Bildern zur Bibel nach Holzschnitten und Kupferstichen der Meister des 15. bis 17. Jahrhunderts*. Aachen: Helios, 2007.

Hewlett, Cecilia. 'Rural Pilgrims and Tuscan Miracle Cults'. In *Studies on Florence and the Italian Renaissance in Honour of F. W. Kent*, edited by Cecilia Hewlett and Peter Howard, 339–58. Europa Sacra 20. Turnhout: Brepols, 2016.

Hickmann, E. and R. Eichmann (eds). *Symposium Musikarchäologische Quellengruppen. Bodenurkunden, mündliche Überlieferung, Aufzeichnung* (International Study Group on Music Archaeology). Rahden, Westfalia: M. Leidorf, 2004.

Hickmann, H. 'The Antique Cross-Flute'. *Acta Musicologica* 24, no. 3/4 (1952): 108–12.

Hills, Paul. 'The Renaissance Altarpiece: A Valid Category?' In *The Altarpiece in the Renaissance*, edited by P. Humfrey and M. Kemp, 34–48. Cambridge: Cambridge University Press, 1990.

Hinton, M. 'Medieval Pottery from a Kiln Site at Kingston upon Thames'. *London Archaeology* 3 (1980): 377–83.

Historisch-Antiquarische Gesellschaft von Graubünden (ed.). *BUB*, vol. 2 (1200-1272). Chur: Bischofberger, 1947.

Hjorth, Karen and Erik Kroman. *Helsingør Stadsbog 1554–1555, 1559—1560 og 1561–1565. Rådstueprotokol og Bytingbog*. Copenhagen: Selskabet for Udgivelse af Kilder til Dansk Historie, 1981.

Hobson, R. L. *A Guide to the English Pottery and Porcelain in the Department of British and Medieaeval Antiquities: British Musuem*. Oxford: Oxford University Press, 1910.

Hocquet, J. C. *Le sel et la fortune de Venice*, vol. 1 *Production et monopole*. Lille: Presses Universitaires de Lille, 1982.

Hodgkinson, Jeremy. *British Cast-Iron Firebacks of the 16th to Mid 18th Centuries*. Worth: Hodgers Books, 2010.

Hodgkinson, Jeremy. 'Pre-Restoration Iron Firebacks'. *Journal of Antique Metalware Society* 20 (June 2012): 2–5.

Hohti, Paula. 'Cheap Magnificence? Imitation and Low-Cost Luxuries in Renaissance Italy'. In *Luxury and the Ethics of Greed in Early Modern Italy*, edited by Catherine Kovesi, 277–97. Turnhout: Brepols, 2019.

Hohti, Paula. 'Conspicuous Consumption and Popular Consumers: Material Culture and Social Status in Sixteenth-Century Siena'. *Renaissance Studies* 24, no. 5 (2010): 654–70.

Hohti, Paula. 'Dress, Dissemination, and Innovation: Artisan Fashions in Sixteenth- and Early Seventeenth-Century Italy'. In *Fashioning the Early Modern: Creativity and Innovation in Europe, 1500–1800*, ed. Evelyn Welch, 143–65. Oxford: Pasold and Oxford University Press, 2016.

Hohti, Paula. 'Dress, Dissemination, and Innovation: Artisan Fashions in Sixteenth- and Early Seventeenth-Century Italy'. In *Fashioning the Early Modern: Dress, Textiles, and Innovation in Europe, 1500–1800*, edited by Evelyn Welch, 143–65. Oxford: Oxford University Press and Pasold Research Fund, 2017.

Hohti Erichsen, Paula. *At Home with Italian Renaissance Artisans*. Amsterdam: Amsterdam University Press, forthcoming 2020.

Hollis, Edwin. 'The Shropshire "Loggerheads"'. *Notes and Queries* 161 (1931): 377.

Holmes, Megan. 'Miraculous Images in Renaissance Florence'. *Art History* 34 (2011): 432–65.

Holmes, Megan. *The Miraculous Image in Renaissance Florence*. New Haven: Yale University Press, 2013.

Holmes, Megan. 'Neri di Bicci and the Commodification of Artistic Values in Florentine Painting (1450-1500)'. In *The Art Market in Italy, 15th–17th Centuries*, edited by M. Fantoni et al., 213–23. Modena: Franco Cosimo Panini, 2003.

Honey, W. B. 'Foreword'. In Bernard Rackham, *Medieval English Pottery*, v. London: Faber & Faber, 1972 (2nd edn).

Hornsby, Peter R. G., Rosemary Weinstein and Ronald F. Homer. *Pewter: A Celebration of the Craft 1200–1700*. London: Historical Publications Ltd., 1989.

Howarth Liddy, L. J. *Domestic Objects in York, c. 1400–1600*. PhD dissertation, University of York, 2015.

Humfrey, Peter and Richard MacKenney. 'The Venetian Trade Guilds as Patrons of Art in the Renaissance'. *The Burlington Magazine* 128, no. 998 (1986): 317–30.

Hutchinson, Charles L. 'The Democracy of Art'. *The American Magazine of Art* 7, no. 10 (August 2016): 397–400.

Iancu-Agou, D. 'Les juifs, l'olivier et l'huile d'olive en Provence médiévale, d'après les registres notariés aixois de la fin du XVᵉ siècle'. In *L'huile d'olive en Méditerranée: Histoire, anthropologie, économie de l'Antiquité à nos jours*, 133–46. Aix-en-Provence: Institut de recherches et d'études sur le monde arabe et musulman, 1985.

Irwin, Robert. *The Middle East in the Middle Ages: The Early Mamluk Sultanate, 1250–1382*. Carbondale: Southern Illinois University Press, 1986.

Jacobs, Frederika. *Votive Panels and Popular Piety in Early Modern Italy*. New York: Cambridge University Press, 2013.

Jacobsen, Grete. *Kvinder, Køn og Købstadslovgivning 1400-1600*. Copenhagen: Det Kongelige bibliotek and Museum Tusculanums forlag, 1995.

Jacobus de Voragine. *Legenda Aurea*, edited by Alessandro e Lucetta Vitale Brovarone. Torino: Einaudi, 1995.

Jacoby, David. 'Social Evolution in Latin Greece'. In *A History of the Crusades*, edited by H. W. Hazard and N. P. Zacour, 175–221. Madison: University of Wisconsin Press, 1989.

Jeay, M. *Le commerce des mots: L'usage des listes dans la littérature médiévale (XIIe-XVe siècles)*. Geneva: Droz, 2006.

Jerris, Randon. 'Cult Lines and Hellish Mountains: The Development of Sacred Landscape in the Early Medieval Alps'. *Journal of Medieval and Early Modern Studies* 32, no. 1 (2002): 85–108.

Jespersen, Leon. 'At Være, at Ville og at Have: Træk Af Luksuslovgivningen i Danmark i 15-1600-Tallet'. *Temp. Tidsskrift for Historie* 1, no. 1 (2010): 31–58.

Johannes de Grocheio, *Ars Musicae*. Edited and translated by Constant J. Mews, John N. Crossley, Catherine Jeffreys, Leigh McKinnon and Carol J. Williams. Kalamazoo: Medieval Institute Publications, 2011.

Jones, Malcolm. 'The English Print c.1550-1650'. In *A Companion to English Renaissance Literature and Culture*, edited by Michael Hattaway, 352–66. Oxford: Blackwell, 2003.

Jones, Malcolm. *The Secret Middle Ages*. Thrupp: Sutton, 2004.

Jutte, Robert. *Poverty and Deviance in Early Modern Europe*. Cambridge: Cambridge University Press, 1994.

Kalopissi-Verti, Sophia. 'Collective Patterns of Patronage in the Late Byzantine Village: The Evidence of Church Inscriptions'. In *Donation et Donateurs dans la monde byzantin. Acts du colloque international de l'Université de Fribourg 13–15 mars 2008*, edited by Jean-Michel Spieser and Élisabeth Yota, 125–40. Paris: Desclée de Brouwer, 2012.

Kalopissi-Verti, Sophia. *Dedicatory Inscriptions and Donor Portraits in Thirteenth-Century Churches of Greece*. Vienna: Verlag der Österreichischen Akademie der Wissenschaften, 1992.

Kalopissi-Verti, Sophia. 'The Murals of the Narthex: The Paintings of the Late Thirteenth and Fourteenth Centuries'. In *Asinou Across Time. The Architecture and Murals of the Panagia Phorbiotissa, Cyrpus*, edited by Annemarie Weyl Carr and Andréas Nikolaïdès, 115–210. Washington, DC: Harvard University Press, 2012.

Karlstadt, Andreas. *Von abthung der Bylder / Und das keyn Betdler unther den Christen seyn soll*. Wittenberg: Nickell Schyrlentz, 1522.

Katritzky, M. A. 'The Picture of We Three: A Transnational Visual and Verbal Formula before, during and after the Lifetime of Shakespeare'. In *Formelhaftigkeit in Text und Bild*, edited by Birgit Ulrike Münch, Natalia Filatkina and Ane Kleine-Engel, 223–44. Wiesbaden: Reichert, 2012.

Katritzky, M. A. 'Shakespeare's "portrait of a blinking idiot": Transnational Reflections'. In *Transnational Mobilities in Early Modern Theater*, edited by Robert Henke and Eric Nicholson, 157–75. Farnham: Ashgate, 2014.

Katritzky, M. A. '"Unser sind drey". The Quacks of Beer, Printz and Weise'. *Maske und Kothurn* 48, nos. 1–4 (2002): 117–42.

Kavaler, Ethan Matt. *Pieter Bruegel: Parables of Order and Enterprise*. Cambridge: Cambridge University Press, 1999.

Kay-Williams, Susan. *The Story of Colour in Textiles: Imperial Purple to Denim Blue*. London and New York: Bloomsbury, 2013.

Keniston McIntosh, Marjorie. *Poor Relief in England, 1350–1600*. Cambridge: Cambridge University Press, 2011.

Kent, Dale. *Cosimo de' Medici and the Florentine Renaissance: The Patron's Oeuvre*. New Haven and London: Yale University Press, 2000.

Kent, F. W. 'Prato and Lorenzo de' Medici'. In *Communes and Despots in Medieval and Renaissance Italy*, edited by John E. Law and Bernadette Paton, 203–6. Burlington: Ashgate, 2010.

Kippenberger, Albrecht. *Die Kunst der Ofenplatten, dargestellt an der Sammlung des Vereins Deutscher Eisenhüttenleute in Düsseldorf*. Düsseldorf: Stahleisen, 1973 (2nd edn, revised and extended).

Kippenberger, Albrecht. *Philipp Soldan zum Frankenberg: ein hessischer Bildhauer des 16ten Jahrhunderts, Meister der Ofenplatten*. Wetzlar: Scharfes Druckereien, 1926.

Koenig, John. 'Prisoner Offerings, Patron Saints, and State Cults, at Siena and Other Italian Cities from 1250 to 1550'. *Bullettino senese di storia patria* 108 (2001): 222–96.

Koering, J. *Le Prince en représentation. Histoire des décors du palais ducal de Mantoue au XVI^e siècle*. Arles: Actes Sud, 2013.

Koldeweij, Jos. '"Shameless and naked images": Obscene Badges as Parodies of Popular Devotion'. In *Art and Architecture of Late Medieval Pilgrimage in Northern Europe and in the British Isles*, edited by Sarah Blick and Rita Tekippe, 493–510. Leiden: Koninklijke Brill NV, 2005.

Kolltveit, G. *Jew's Harps in European Archaeology*. Oxford: Archaeopress, 2006.

Krauskopf, Christof, 'Just Noble Things? Studies on the Material Culture of 13th and 14th Century Nobility', in *Château et Peuplement: actes du colloque international de Voiron [28 août-4 septembre 2004]*, ed. P. Ettel, A.-M. Flambard-Héricher and T. McNeill, 195–204. Caen: Publications du CRAHM, 2006.

Kroman, Erik. *Helsingør Stadsbog 1549–1556. Rådstueprotokol og Bytingbog*. Copenhagen: Selskabet for Udgivelse af Kilder til Dansk Historie, 1971.

Kroman, Erik. *Malmø Rådstueprotokol (Stadsbok) 1503–1548*. Copenhagen: Selskabet for Udgivelse af Kilder til Dansk Historie, 1965.

Kroman, Erik. *Ribe Rådstuedombøger 1527–1576 og 1580–1599*. Copenhagen: Selskabet for Udgivelse af Kilder til dansk Historie, 1974.

Kruiger, S. (ed.). *Konrad von Megenberg. Werke. Ökonomik (Monumenta Germaniae historica. Staatsschriften späteren Mittelalters III/5, 1-2)*. Stuttgart: Hiersemann Vlg., 1973 and 1977.

Kuuse, Jan. 'The Probate Inventory as a Source for Economic and Social History'. *Scandinavian Economic History Review* 22, no. 1 (1974): 22–31.

Lama, M. *Il libro di conti di un maiolicaro del Quattrocento*. Faenza: Fratelli Lega, 1939.

Laube, Daniela. 'The Stylisitc Development of German Book Illustration, 1460–1511'. In *A Heavenly Craft: The Woodcut in Early Printed Books*, edited by Daniel De Simone, 47–71. New York: George Braziller Inc., 2004.

Laufner, Richard. 'Das Rheinische Stadtewesen im Hochmittelalter'. In *Die Städte Mitteleuropas im 12. und 13. Jahrhundert*, edited by Wilhelm Rausch, 27–40. Linz: Archiv Stadt Linz, 1963.

Le Roy Laduire, Emmanuel. *Les paysans de Languedoc*. 2 vols. Paris: S.E.V.P.E.N, 1966.

Lee, Jennifer. 'Material and Meaning in Lead Pilgrims' Signs'. *Peregrinations: Journal of Medieval Art and Architecture* 2, no. 3 (2009): 152–69.

Lee, Jennifer. 'Medieval Pilgrims' Badges in Rivers: The Curious History of a Non-theory'. *Journal of Art Historiography* 11 (2014), https://arthistoriography.files.wordpress.com /2014/11/lee.pdf.

Lee, Jennifer, 'Searching for Signs: Pilgrims' Identity and Experience made Visible in the Miracula Sancti Thomae Cantuariensis'. In *Art and Architecture of Late Medieval Pilgrimage in Northern Europe and in the British Isles*, edited by Sarah Blick and Rita Tekippe, 473–91. Leiden: Koninklijke Brill NV, 2005.

Leguay, J.-P. *Vivre en ville au Moyen Âge*. Paris: Éditions Jean-Paul Gisserot, 2006.

Lemire, Beverly. 'The Theft of Clothes and Popular Consumerism in Early Modern England'. *Journal of Social History* 24, no. 2 (1990): 255–76.

Lightbown, Ronald. *Sandro Botticelli*. London: Elek, 1978.

Lightbown, Ronald and A. Caiger-Smith (eds). *The Three Books of the Potter's Art: Wherein Is Treated not only of the Practice Thereof but in Brief of All Its Secrets, a Matter that Up to This Very Day Has Always Been Kept Concealed by the Cavaliere Cipriano Piccolpasso of Castel Durante*. Vendin-le-Vieil: La Revue de la céramique et du verre, 2007.

Livi-Bacci, Massimo. *Conquest: The Destruction of the American Indios*. Cambridge: Polity Press, 2008.

Ljungberg, Leif and Einar Bager. *Malmø Tingbøger 1577–83 og 1588–90*. Copenhagen: Selskabet for Udgivelse af Kilder til dansk Historie, 1968.

Lojenga-Rietberg, Annemarie Kutsch. *Huis Bergh: Kasteel-kunst-geschiedenis*. 's-Heerenbergh: Stichting Huis Bergh, 2000.

Lorcin, M.-T. 'De l'Oustillement au villain ou l'inventaire sans raton laveur'. *Revue Historique* 10 (1985): 321–39.

Lorcin, M.-T. and D. Alexandre-Bidon. *Le quotidien au temps des fabliaux. Textes, Images, Objets*. Paris: Espaces médiévaux, 2003.

Luebke, David M. *Hometown Religion: Regimes of Coexistence in Early Modern Westphalia*. Charlottesville: University of Virginia Press, 2016.

Lugarini, Renato. 'Il ruolo degli "statuti delli sforgi" nel sistema suntuario senese'. *Bullettino senese di storia patria* 54 (1997): 403–22.

Lund, Cajsa. 'The Archaeomusicology of Scandinavia'. *World Archaeology* 12, no. 3 (1981): 246–65.

Lund, Troels. *Dagligt Liv i Norden i Det Sekstende Aarhundrede*, Vol. 2, 4th edn. Copenhagen and Kristiania: Gyldendalske Boghandel and Nordisk Forlag, 1914.

Luther, Martin. *D. Martin Luthers Werke, kritische Gesammtausgabe*, 128 vols. Weimar: H. Böhlau, 1883–1929.

Luther, Martin. *Deudsch Catechismus. Gemehret mit einer newen vorrhede / und vermanunge zu der Beicht*. Wittemberg: Georg Rhau, 1530.

Luther, Martin. *Deudsch Catechismus: Auffs new Corrigirt und gebessert*. Wittenberg: George Rhaw, 1540.

Luther, Martin. *Von den Schlüsseln.* Wittemberg: Hans Lufft, 1530.

Lymberopoulou, Angeliki. *The Church of the Archangel Michael at Kavalariana. Art and Society on Fourteenth-Century Venetian-Dominated Crete.* London: Pindar Press, 2006.

Lymberopoulou, Angeliki (ed.). *Cross-Cultural Interaction between Byzantium and the West, 1204–1669: Whose Mediterranean Is It Anyway?* London and New York: Routledge, 2018.

Lymberopoulou, Angeliki. 'Fourteenth-Century Regional Cretan Church Decoration: the Case of the Painter Pagomenos and his Clientele'. In *Towards Rewriting? New Approaches to Byzantine Archaeology and Art,* edited by Piotr Ł. Grotowski and Sławomir Skrzyniarz, 159–75. Warsaw: Neriton, 2010.

Lymberopoulou, Angeliki. "'*Pro anima mea*", but do not touch my icons: Provisions for private icons in wills from Venetian-dominated Crete'. In *The Kindness of Strangers: Charity in Pre-Modern Mediterranean,* edited by Dionysios Stathakopoulos, 71–89. London: King's College, 2007.

Lymberopoulou, Angeliki. 'Regional Byzantine Monumental Art from Venetian Crete'. In *Byzantine Art and Renaissance Europe,* edited by Angeliki Lymberopoulou and Rembrandt Duits, 61–100. Farnham: Ashgate, 2013.

Macchiarella, I. 'Harmonizing on the Islands: Overview of the Multipart Singing by Chording in Sardinia, Corsica, and Sicily'. In *European Voices: Multipart Singing on the Balkans and in the Mediterranean,* edited by A. Ahmedaja and Gerlinde Haid, 103–58. Vienna: Böhlau Verlag, 2008.

MacGregor, Neil. 'A Pentecost in Trafalgar Square'. In *Whose Muse? Art Museums and the Public Trust,* edited by James Cuno, 648–62. Princeton and Cambridge: Princeton University Press, 2004.

Mackinder, Anthony. *Roman and Medieval Revetments on the Thames Waterfront: Excavations at Riverbank House, City of London, 2006–9.* MOLA Archaeology Studies Series 33. London: Museum of London Archaeology, 2015.

Maddock, Angela. 'Folds, Scissors and Cleavage in Giovanni Battista Moroni's *Il Tagliapanni*'. In *The Erotic Cloth: Seduction & Fetishism in Textiles,* edited by Alice Kettle and Lesley Millar, 25–36. London and New York: Bloomsbury, 2018.

Malke, Lutz S. *Narren. Porträts, Feste, Schwankbücher und Spielkarten aus dem 15. bis 17. Jahrhundert.* Berlin: Kunstbibliothek, 2001.

Malone, Edmond. *The Plays and Poems of William Shakespeare.* London: H. Baldwin, 1790 (10 vols).

Maltezou, Chryssa. 'The Historical and Social Context'. In *Literature and Society in Renaissance Crete,* edited by David Holton, 17–47. Cambridge: Cambridge University Press, 1991.

Malynes, Gerard. *The Center of the Circle of Commerce, or A Refutation of a Treatise Intitled The Circle of Commerce, or The Balance of Trade, Lately Published by E[dward] M[isselden].* London: William Iones, 1623.

Maniura, Robert. *Art and Miracle in Renaissance Tuscany.* Cambridge: Cambridge University Press, 2018.

Maniura, Robert. 'Image and Relic in the Cult of Our Lady of Prato'. In *Images, Relics, and Devotional Practices in Medieval and Renaissance Italy,* edited by Sally J. Cornelison and Scott Bradford Montgomery, 193–212. Tempe: Arizona Center for Medieval and Renaissance Studies, 2006.

Marcon, Susy. 'Un manoscritto cattarino del 1466 e l'eridità belliniana lungo le sponde dell'Adriatico'. *Rivista di Storia della Miniatura* 4 (1999): 121–34.

Marino Sanuto Torsello. *The Book of Secrets of the Faithful of the Cross* (= *Liber Secretorum Fidelium Crucis*), translated by Peter Locke. *Crusade Texts in Translation* 21. Farnham: Ashgate, 2011.

Marks, Richard. *Image and Devotion in Late Medieval England*. Stroud: Sutton Publishing Ltd, 2004.

Marnef, Guido. 'The Changing Face of Calvinism in Antwerp, 1555–1585'. In *Calvinism in Europe, 1540–1620*, edited by Andrew Pettegree, Alastair Duke and Gillian Lewis, 143–59. Cambridge: Cambridge University Press, 1994.

Marnef, Guido. 'Protestant Conversions in an Age of Catholic Reformation: The Case of Sixteenth-Century Antwerp'. In *The Low Countries as a Crossroads of Religious Belief*, edited by Arie-Jan Gelderblom, Jan L. de Jong and Marc van Vaeck, 33–47. Leiden: Brill, 2004.

Martens, Vibe Maria. 'The Theft of Fashion: Circulation of Fashionable Textiles and Garments in 18th-Century Copenhagen'. In *Fashionable Encounters: Perspectives and Trends in Textile and Dress in the Early Modern Nordic World*, edited by Tove Engelhardt Mathiassen et al., 157–71. Oxford: Oxbow Books, 2014.

Maryon, Herbert. *Metalwork and Enamelling*, 5th edn. New York: Dover, 1971.

Mattiello, Andrea. 'Latin Basilissai in Palaiologan Mystras: Art and Agency'. unpublished PhD thesis, University of Birmingham, Centre for Byzantine, Ottoman and Modern Greek Studies, 2018.

Mayer, L. A. *Mamluk Costume*. Geneva: A. Kundig, 1952.

Mayu Fujikawa, 'Florence's Territorial Hegemony in the Eyes of Foreign Dignitaries: The Cappella della Sacra Cintola in Santo Stefano, Prato'. In *The Chapels of Italy from the Twelfth to the Eighteenth Centuries: Art, Religion, Patronage, and Identity*, edited by Lilian H. Zirpolo, 177–207. Woodcliff Lake: WAPACC Organization, 2010.

Mazzi, Maria Serena. 'Gli inventari dei beni: storia di oggetti e storia di uomini'. *Società e storia* 7 (1980): 203–14.

Mazzi, Maria Serena and Sergio Raveggi. *Gli uomini e le cose nelle campagne fiorentine*. Florence: L.S. Olschki, 1983.

Mazzi, Maria Serena and Sergio Raveggi. 'Masserizie contadine nella prima metà del quattrocento: alcuni esempi del territotio fiorentino e pistoiese'. In *Civiltà ed economia agricola in Toscana nei secc. XIII-XV: Problemi della vita delle campagne nel tardo medioevo (Pistoia, 21-24 aprile 1977)*, 169–97. Pistoia: Centro italiano di studi di storia e d'arte Pistoia, 1981.

McCall, Timothy. 'Material Fictions of Luxury in Sforza Milan'. In *Luxury and the Ethics of Greed in Early Modern Italy*, edited by Catherine Kovesi, 239–76. Turnhout: Brepols, 2019.

McCarthy, Michael R. and Catherine M. Brooks. *Medieval Pottery in Britain AD 900–1600*. Leicester: Leicester University Press, 1988.

McGee, Timothy. *Medieval Instrumental Dances*. Bloomington and London: Indiana University Press, 2014.

McKee, Sally. 'The Revolt of St Tito in Fourteenth-Century Venetian Crete: A Reassessment'. *Mediterranean Historical Review* 9 (1994): 173–204.

McLean, Alick. *Prato: Architecture, Piety, and Political Identity in a Tuscan City-State*. New Haven: Yale University Press, 2008.

McTighe, Sheila. 'Perfect Deformity, Ideal Beauty and the *Imaginaire* of Work: The Reception of Annibale Carracci's *Arti di Bologna*'. *Oxford Art Journal* 16, no. 1 (1993): 75–91.

Meadow, Mark A.. *Pieter Bruegel the Elder's* Netherlandish Proverbs *and the Practice of Rhetoric.* Zwolle: Waanders, 2002.

Melanchthon, Philip. *Catechismus / Das ist / ein Kinderlehr / Herrn Philippi Melanthonis, auß dem Latein ins Deütsch gebracht / durch Gaspar Bruschen Poeten.* Nürnberg: Hans Guldenmundt, 1544.

Meulenkamp, Wim. 'Een vroege gietijzeren grafplaat: een kindergraf uit 1756 in de Hervormde kerk van Waardenburg'. In *Lood om oud ijzer*, edited by Tim Graas, 58–9. Soesterberg: Aspekt/SKKN, 1998.

Mezger, Werner. *Narrenidee und Fastnachtsbrauch. Studien zum Fortleben des Mittelalters in der europäischen Festkultur.* Konstanz: Universitätsverlag, 1991.

Michael Dupont, *Helsingør Skifteprotokol 1571–1582.* Copenhagen: Selskabet for Udgivelse af Kilder til Dansk Historie, 2014.

Milošević, Miloš. *Osamsto (800) godina Katedrale Sv. Tripuna u Kotoru (1166-1966).* Kotor: Štamparsko A. Paltašić, 1966.

Moger, Jourden Travis. *Priestly Resistance to the Early* Reformation. Brookfield: Pickering & Chatto, 2014.

Moisé, Filippo. *Santa Croce di Firenze: Illustrazione storico-artistica.* Florence: At the Author's Expense, 1845.

Mollat, Michel. *The Poor in the Middles Ages: An Essay in Social History*, translated by Arthur Goldhammer. New Haven and London: Yale University Press, 1986.

Molmenti, Pompeo and Gustav Ludwig. *The Life and Works of Vittore Carpaccio*, translated by Robert H. Hobart Cust. London: John Murray, 1907.

Montagu, J. *The World of Medieval & Renaissance Musical Instruments.* New York: Overlook Press, 1976.

Morris, William. 'The Art of the People'. In *Hopes and Fears for Art*, 38–70. London: Ellis & White, 1882.

Morrison, Fynes. *An Itinerary Containing His Ten Yeeres Travell through the Twelve Dominions of Germany, Bohmer- Land, Sweitzerland, Netherland, Denmarke, Poland, Italy, Turky, France, England, Scotland & Ireland*, vol. 4. Glasglow: James MacLehose and Sons, 1908.

Morselli, Piero and Gino Corti. *La Chiesa di Santa Maria delle Carceri in Prato: contributo di Lorenzo de' Medici e Giuliano da Sangallo alla progettazione.* Prato: Società pratese di storia patria, 1982.

Mosher Stuard, Susan. *Gilding the Market: Luxury and Fashion in Fourteenth-Century Italy.* Philadelphia: University of Pennsylvania Press, 2006.

Moxey, Keith. *Peasants, Warriors, and Wives: Popular Imagery in the Reformation.* Chicago: University of Chicago Press, 2004.

Müller, Jan-Dirk. 'An Information Revolution'. In *A New History of German Literature*, edited by David E. Wellbery and Judith Ryan, 183–93. Cambridge: Belknap Press, 2004.

Munro, John. 'Money, Wages, and Real Incomes in the Age of Erasmus: The Purchasing Power of Coins and of Building Craftsmen's Wages in England and the Southern Low Countries, 1500 – 1540'. In *The Correspondence of Erasmus*, vol. 12, *Letters 1658 – 1801*, edited by Alexander Dalzell and Charles G. Nauert, 551–699. Toronto: University of Toronto Press, 2003.

Munrow, David. *Instruments of the Middle Ages and the Renaissance.* London: Oxford University Press, 1976.

Muraro, Michelangelo (ed.). *Il libro secondo di Francesco e Jacopo Bassano.* Bassano del Grappa: G. B. Verci, 1992.

Murray Jones, Peter. 'Amulets: Prescriptions and Surviving Objects from Late Medieval England'. In *Beyond Pilgrim Souvenirs and Secular Badges: Essays in Honour of Brian Spencer*, edited by Sarah Blick, 92–107. Oxford: Oxbow, 2007.

Nastainczyk, Wolfgang. 'Die Katechismen des Petrus Canisius. Ein Aufbruch'. In *Petrus Canisius: Zu seinem 400. Todestag am 21. Dezember 1997*, edited by Karl Hillerbrand, 49–70. Würzburg: Generalvikariat der Diözese Würzburg, 1998.

Neish, Patricia. *The Neish Pewter Collection*. Stirling: Stirling Smith Art Gallery & Museum, 2018.

Nenadic, Stana. 'Middle-Rank Consumers and Domestic Culture in Edinburgh and Glasgow 1720–1840'. *Past and Present* 145 (1994): 122–56.

Neri di Bicci. *Le ricordanze (10 marzo 1453 – 24 aprile 1475)*, edited by Bruno Santi. Pisa: Marlin, 1976.

Newell, R. W. 'Thumbed and Sagging Bases on English Medieval Jugs'. *Medieval Ceramics* 18 (1994): 51–8.

Nichols, Tom. *The Art of Poverty: Irony and Ideal in Sixteenth-Century Beggar Imagery*. Manchester: Manchester University Press, 2007.

Nichols, Tom. 'Jacopo Bassano, Regionalism, and Rural Painting'. *Oxford Art Journal* 41, no. 2 (2018): 147–70.

Nichols, Tom (ed.). *Others and Outcasts in Early Modern Europe: Picturing the Social Margins*. Aldershot: Ashgate, 2001.

Nichols, Tom. 'Saint Barnabé guérissant un malade de Véronèse et les images vénitiennes de la pauvreté et de la maladie'. In *Venise et Paris, 1500–1700: La Peinture Vénitienne de la Renaissance et sa Réception en France: Actes des Colloques de Bordeaux et de Caen (24–25 Février 2006, 6 Mai 2006)*, edited by Michel Hochmann, 63–82. Geneva: Droz, 2011.

Nielsøn, Hans. *Sørglig Spectacel oc Vndertegn*. Copenhagen: Henrich Waldkirch, 1625.

Nixon, Virginia. 'Producing for the People: Late Medieval Assumptions about the Process of Reading Art Works'. In *Le petit peuple dans l'Occident medieval*, edited by P. Boglioni, R. Delort and C. Gavard, 617–31. Paris: Éditions de la Sorbonne, 2002.

Nyström, U. *Poèmes français sur les biens d'un ménage depuis l'Oustillement au villain du XIIIe siècle jusqu'aux Controverses de Gratien du Pont*. Paris: Imprimerie de la Société de littérature finnoise, 1940.

O'Connell, Sheila. *The Popular Print in England 1550–1850*. London: British Museum, 1999.

O'Malley, Michele. *The Business of Art: Contracts and the Commissioning Process in Renaissance Italy*. New Haven and London: Yale University Press, 2005.

Orland, Barbara. 'Alpine Milk: Dairy Farming as a Pre-modern Strategy of Land Use'. *History and Environment* 10, no. 3 (2004): 327–64.

Orlin, L. 'Fictions of the Early Modern English Probate Inventory'. In H. Turner, *The Culture of Capital: Property, Cities, and Knowledge in Early Modern England*, 51–83. New York: Routledge, 2002.

Osiander, Andreas, *Andreas Osiander d.A., Gesamtausgabe*, 10 vols, edited by Gerhard Müller and Gottfried Seebaß. Gütersloh: Gütersloher Verlagshaus, 1975–1999.

Osiander, Andreas. *Catechismus odder Kinderpredigt / Wie die inn meiner gnedigen herrn/ Marggrauen zu Brandenburg/ vnd eins Erbarn Raths der Stat Nuermberg oberkeit vnd gepieten/ allenthalben gepredigt* warden. Wittemberg: Georgen Rhaw, 1533.

Osiander, Andreas. *Catechismus oder Kinderpredig / Wie die in meinernedigen herrn / Margraven zu Brandēburg / uñ ein Erbarn Raths der stat Nürmberg oberkait uñ gepieten / allent halbē gepredigt werdē/ Den Kindern uñ jungen leutē zu sondern nuz also in Schrifft* verfaßt. Nuremberg: Johann Petreium, 1533.

Overton, M., J. Whittle, D. Darron and A. Hann. *Production and Consumption in English Households, 1600–1750*. London: Routledge, 2004.

Page, C. 'German Musicians and their Instruments: A 14th-Century Account by Konrad of Megenberg'. *Early Music* 10, no. 2 (1982): 192–200.

Palmer Wandel, Lee. 'Catechisms: Teaching the Eye to Read the World'. In *Illustrated Religious Texts in the North of Europe, 1500–1800*, edited by Feike Dietz, Adam Morton, Lien Roggen and Els Stronks, 53–76. Farnham: Ashgate, 2014.

Palmer Wandel, Lee. *Reading Catechisms, Teaching Religion*. Leiden: Brill, 2016.

Palumbo-Fossati, Isabella. 'L'interno della casa dell'artigiano e dell'artista nella Venezia del Cinquecento'. *Studi veneziani* 8, n. s. (1966): 109–53.

Pampaloni, Guido. 'La povertà a Prato nella seconda metà del Quattrocento'. In *Aspects of Poverty in Early Modern Europe*, edited by Thomas Riis, 109–13. Odense: Odense University Press, 1986.

Pampaloni, Guido. 'Popolazione e società nel centro e nei sobborghi'. In *Prato: Storia di una città*, edited by Fernand Braudel and Elena Fasano Guarini, 361–93. Prato: Comune di Prato, Le Monnier, 1986.

Panhuysen, Luc. 'Wapenhandelaar Louis de Geer (1587–1650): de Dertigjarige Oorlog was een zegen voor zijn portemonnee'. *Historisch Nieuwsblad* 6 (2007) (on-line).

Panopoulou, Angeliki. 'Working Indoors and Outdoors: Female Labour, Artisanal Activity and Retails Trade in Crete (14th–16th Centuries)'. In *Women and Monasticism in the Medieval Eastern Mediterranean: Decoding a Cultural Map*, edited by Eleonora Kountoura Galake and Ekaterini Mitsiou, 207–32. Athens: National Hellenic Research Foundation, 2019.

Paoletti, J. T. and G. M. Radtke. *Art in Renaissance Italy*. London: Laurence King Publishing, 1997.

Paolucci, Giulio and Giuliano Pinto. 'Gli "Infermi" della Misericordia di Prato (1401–1491)'. In *Società del bisogno: Povertà e assistenza nella Toscana medievale*, edited by Giuliano Pinto. Florence: Salimbeni, 1989.

Pappano, Margaret and Nicole R. Rice (eds). 'Medieval and Early Modern Artisan Culture'. Special Issue, *Journal of Medieval and Early Modern Studies* 43, no. 3 (2013): 480–1.

Pardailhé-Galabrun, A. *La naissance de l'intime: 3000 foyers parisiens, XVIIe-XVIIIe siècles*, 341–348. Paris: Presses Universitaires de France, 1988.

Parshall, Peter, 'The Modern Historiography of Early Printmaking'. *Studies in the History of Art* 75 (2009): 9–15.

Parshall, Peter and Rainer Schoch, *Origins of European Printmaking: Fifteenth-Century Woodcuts and Their Public*. New Haven: Yale University Press, 2005.

Pearce, J. 'Adorned with Ferocious Beasts: A Unique Medieval Zoomorphic Jug'. In *'Hidden Histories and Records of Antiquity': Essays on Saxon and Medieval London for John Clark, Curator Emeritus, Museum of London*, edited by J. Cotton, J. Hall, J. Keily, R. Sherris and R. Stephenson, London Middlesex Archaeological Society Special Paper 17, 140–4. London: London Middlesex Archaeological Society, 2014.

Pearce, J. *Pots and Potters in Tudor Hampshire: Excavations at Farnborough Hill Convent, 1968–72*. Guildford Museum, Guildford Borough Council, Museum of London Archaeology Service, 2007.

Pearce, J. and A. Vince. *A Dated Type-Series of London Medieval Pottery, Part 4: Surrey Whitewares*, London Middlesex Archaeological Society Special Paper 4. London: London Middlesex Archaeological Society, 1988.

Pearce, J., A. Vince and R. White, 'A Dated Type-Series of London Medieval Pottery Part 1: Mill Green Ware'. *Transactions of the London Middlesex Archaeological Society* 33 (1982): 214–65.

Pearce, J. E., A. G. Vince and M. A. Jenner. *A Dated Type-Series of London Medieval Pottery, Part 2: London-Type Ware*, London Middlesex Archaeological Society Special Paper 6. London: London Middlesex Archaeological Society, 1985.

Pennell, S. *The Birth of the English Kitchen, 1600–1850*. London: Bloomsbury, 2016.

Pennell, S. 'Pots and Pans History: The Material Culture of the Kitchen in Early Modern England'. *Journal of Design History* 11 (2016): 201–16.

Perocco, Guido. *Carpaccio in the Scuola di S. Giorgio degli Schiavoni (Carpaccio: Le pitture alla Scuola di S. Giorgio degli Schiavoni)*, translated by Brenda Balich. Treviso: Canova, 1975.

Pesante, Luca. 'Vascellarius modernus: l'idea di modernità nelle parole di alcuni contemporanei'. In *Atti del XLIII Convegno internazionale della ceramica. La ceramica nei periodi di transizione: novità e persistenze nel Mediterraneo tra XII e XVI secolo: Savona, 28–29 maggio 2010*, 317–22. Albisola: Centro ligure per la storia della ceramica, 2011.

Peterson, Charles M. 'The Five Senses in Willem II van Haecht's Cabinet of Cornelis van Der Geest'. *Intellectual History Review* 20, no. 1 (2010): 103–21.

Pettegree, Andrew. *Broadsheets: Single-Sheet Publishing in the First Age of Print*. Leiden: Brill, 2017.

Pettegree, Andrew. 'Print Workshops and Markets'. In *The Oxford Handbook of the Protestant Reformations*, edited by Ulinka Rublack. Oxford: Oxford University Press, 2017.

Pettegree, Andrew. *Reformation and the Culture of Persuasion*. Cambridge: Cambridge University Press, 2005.

Peyer, H. C. 'Zurich im Fruh- und Hochmittelalter'. In *Zurich von der Urzeit bis zum Mittelalter*, edited by Emilt Vogt et al., 165–235. Zurich: Berichthaus, 1971.

Piccope, G. *Lancashire and Cheshire Wills and Inventories, 1542–1696*. Manchester: Chetham Society, 1860.

Pijzel-Dommisse, Jet. *Het Hollandse pronkpoppenhuis: Interieur en huishouden in de 17de en 18de eeuw*. Amsterdam: Uitgeverij Wbooks, 2000.

Piketty, Thomas. *Capital in the Twenty-First Century*, translated by Arthur Goldhammer. Cambridge, MA: Harvard University Press, 2014.

Pinson, Yona. *The Fools' Journey. A Myth of Obsession in Northern Renaissance Art*. Turnhout: Brepols, 2008.

Pittino Calamari, Pia. 'Il Memoriale di Iacopo di Coluccino Bonavia Medico Lucchese (1373–1416)'. *Studi di Filologia Italiana* 24 (1966): 55–428.

Platter, Felix. *Felix Platter Tagebuch (Lebensbeschreibung) 1536–1567*, edited by Valentin Lötscher. Basle and Stuttgart: Schwabe, 1976.

Poeschel, Erwin. *Die Kunstdenkmäler des Kantons Graubünden*, vol. 2, *Herrschaft, Prätigau, Davos, Schanfigg, Churwalden, Albulatal*. Basel: E. Birkhäuser & CIE. A. G., 1937.

Pon, Lisa. *A Printed Icon in Early Modern Italy: The Madonna di Forli*. New York: Cambridge University Press, 2015.

Poole, J. *Italian Maiolica and Incised Slipware in the Fitzwilliam Museum Cambridge*. Cambridge: Cambridge University Press, 1995.

Porras, Stephanie. 'Producing the Vernacular. Antwerp, Cultural Archaeology and the Bruegelian Peasant'. *Journal of Historians of Netherlandish Art* 3, no. 1 (2011) (on-line).

Porras, Stephanie. 'Rural Memory, Pagan Idolatry. Pieter Bruegel's Peasant Shrines'. *Art History* 34, no. 3 (June 2011): 486–509.

Price, David H. 'Hans Holbein the Younger and Reformation Bible Production'. *Church History* 86 (2017): 998–1040.

Prior, W. R. 'Et engelsk Rejseindtryk af Danmark fra 1593'. *Fra Arkiv og Museum* 5 (1912–1915): 45–58.

The Prologue; Or, the Merry Adventure of the Pardoner and Tapster at the Inn at Canterbury. http://sites.fas.harvard.edu/~chaucer/canttales/gp/berynpro.html

Pullan, Brian. 'The Famine in Venice and the New Poor Law 1527-9'. *Bolletino dell'istituto di storia della società e dello stato veneziano* 5–6 (1963–4): 153.

Rackham, Bernard. *Medieval English Pottery*. London: Faber & Faber, 1972 (2nd edn).

Rahn, Johann Rudolf. *Geschichte der Bildenden Künste in der Schweiz von den Ältesten Zeiten bis zum Schlusse des Mittelalters*. Zürich: Hans Staub, 1876.

Ravillion, Martin. *The Economics of Poverty: History, Measurement, and Policy*. Oxford: Oxford University Press, 2016.

Rearick, Roger W. 'From Arcady to the Barnyard'. In *The Pastoral Landscape: Selected Papers*, edited by John Dicon Hunt, 137–59. Washington, DC: National Gallery of Art, 1992.

Rendle, William. 'Tooley Street Tailors'. *Notes and Queries*, S.7-v (1888): 13–14.

Richardson, Carol M. (ed.). *Locating Renaissance Art*. London and New Haven: Yale University Press, 2007.

Richardson, Carol M. and Kim Woods (eds). *Viewing Renaissance Art*. London and New Haven: Yale University Press, 2007.

Richardson, Carol M., Angeliki Lymberopoulou and Kim Woods (eds). *Making Renaissance Art*. London and New Haven: Yale University Press, 2007.

Riello, Giorgio. 'Things Seen and Unseen: The Material Culture of Early Modern Inventories and Their Representation of Domestic Interiors'. In *Early Modern Things : Objects and Their Histories, 1500–1800*, edited by Paula Findlen, 125–50. Basingstoke: Routledge, 2013.

Rimstad, Charlotte. *Dragtfortællinger fra Voldgraven: Klædedragten i 1600-Tallets København, Baseret på Arkæologiske Tekstiler fra Københavns Rådhusplads*. PhD thesis, University of Copenhagen, Copenhagen, 2018.

Rimstad, Charlotte. 'Håndtryk fra fortiden. Om strikkede handsker og vanter fra 1600-tallet'. *Dragtjournalen* 11, no. 15 (2017): 69–74.

Ringgaard, Maj. 'Hosekoner og Sålede Strixstrømper'. *Dragtjournalen* 8, no. 11 (2014): 4–12.

Ringgaard, Maj. 'Silk Knitted Waistcoats: A 17th-Century Fashion Item'. In *Fashionable Encounters: Perspectives and Trends in Textile and Dress in the Early Modern Nordic World*, edited by Tove Engelhardt Mathiassen et al., 73–103. Oxford: Oxbow Books, 2014.

Ringgaard, Maj. *'To par strixstrømper oc en nattrøie naccarat'. Filtede og strikkede tekstiler fra omkring år 1700, fundet i Københavnske byudgravninger – og sammenhænge mellem tekstilers farve og bevaring*. PhD Thesis, University of Copenhagen, 2010.

Ripa, Cesare. *Iconologia*. Rome: Lepido, 1593.

Ripert, L., M. Zerner and C. Barnel (eds). *Matériaux pour l'étude de la vie domestique et de la culture matérielle en Provence aux derniers siècles du Moyen Âge*. Nice: Université de Nice, 1993.

Rittgers, Ronald K. *The Reformation of the Keys*. Cambridge, MA: Harvard University Press, 2004.

Rix, Herbert David. *Martin Luther: The Man and the Image*. New York: Irvington Publishers, Inc., 1983.

Roberts, E. and K. Parker. *Southampton Probate Inventories, 1447–1575*. Southampton: University Press, 1992.

Roberts, Helen. 'St. Augustine in "St. Jerome's Study": Carpaccio's Painting and its Legendary Source'. *Art Bulletin* 41 (1959): 283–97.

Roche, Daniel. *The Culture of Clothing: Dress and Fashion in the Ancien Regime*. Cambridge: Cambridge University Press, 1996.

Roche, Daniel. *Histoire des choses banales. Naissance de la consommation dans les sociétés traditionnelles (XVIIᵉ-XIXᵉ siècle)*. Paris: Fayard, 1997.

Rublack, Ulinka. *Dressing Up: Cultural Identity in Renaissance Europe*. Oxford: Oxford University Press, 2011.

Rublack, Ulinka. *Reformation Europe*. Cambridge: Cambridge University Press, 2005.

Rublack, Ulinka and Maria Hayward (eds). *The First Book of Fashion: The Books of Clothes of Matthäus & Veit Konrad Schwartz of* Augsburg. London and New York: Bloomsbury, 2015.

Sani, E. *Italian Renaissance Maiolica*. London: V&A Museum Publishing, 2012.

Saulle Hippenmeyer, Immacolata. *Nachbarschaft, Pfarrei und Gemeinde in Graubünden 1400–1600*. Chur: Desertina, 1997.

Schindler, Otto G. 'Eselsritt und Karneval. Eine Kremser "Komödiantenszene" aus 1643 in Callots Manier'. *Maske und Kothurn* 39, no. 3 (1998): 7–42.

Schmidt, Peter. 'The Multiple Image: The Beginnings of Printmaking, between Old Theories and New Approaches'. In *Origins of European Printmaking. Fifteenth-Century Woodcuts and Their Public*, edited by Peter Parshall and Rainer Schoch, 37–56. New Haven and London: Yale University Press, 2005.

Schmitt, Erich. *Pfälzische Ofenplatten*. München: DT Kunstverlag, 1968.

Schmugge, Ludwig. 'Das Bistum Chur im Spätmittelalter: aus der Sicht des "gemeinen Mannes"'. In *Studien zur Geschichte des Bistums Chur* (451–2001), edited by Michael Durst, 59–81. Freiburg: Universitätsverlag, 2002.

Schneider, A. 'Archaeology of Music in Europe'. In *The Garland Encyclopedia of World Music*, edited by T. Rice, J. Porter and C. Goertzen, 34–45. London: Routledge, 2017.

Schofield, John, and Lyn Blackmore and Jacqui Pearce, with Tony Dyson. *London's Waterfront 1100–1666: Excavations in Thames Street, London, 1974–84*. Oxford: Archaeopress Publishing, 2018.

Schuurman, A. and A. Van der Houde. *Probate Inventories: A New Source for the Historical Study of Wealth, Material Culture and Agricultural Development*. Papers Presented at the Leeuwenborch Conference (Wageningen, 5–7 May 1980). Wageningen: Brill Hes & De Graaf, 1980.

Scott, A. and C. Kosso (eds). *Poverty and Prosperity in the Middle Ages and Renaissance*. Turnhout: Brepols Publishers, 2012.

Screpanti, Ernesto. *L'angelo della liberazione nel tumulto dei Ciompi. Firenze, giugno–agosto 1378*. Siena: Protagon, 2008.

Secher, V. A. *Forordninger, Recesser Og Andre Kongelige Breve, Danmarks Lovgivning Vedkommende 1558-1660*. vol. 3, *1596–1621*. Copenhagen: G.E.C Gad Nielsen & Lydiche, 1891.

Seidel, Max. 'The Social Status of Patronage and Its Impact on Pictorial Language in Fifteenth-Century Siena'. In *Italian altarpieces, 1250–1550: Function and Design*, edited by E. Borsook and F. Superbi Gioffredi, 119–29. Oxford: Clarendon Press, 1994.

Sekules, V. 'Religious Politics and the Cloister Bosses of Norwich Cathedral'. *Journal of the British Archaeological Association* 159, no. 1 (2006): 284–306.

Sellink, Manfred and Marjolein Leesberg. *The New Hollstein. Dutch and Flemish Etchings, Engravings and Woodcuts 1450–1700: Philips Galle*, Part IV. Rotterdam: Sound & Vision, 2001.

Sgarbi, Vittorio. *Carpaccio*, translated by Jay Hyams. New York: Abbeville Press, 1994.

Shesgreen, Sean. *Images of the Outcast: The Urban Poor in the Cries of London*. Manchester: Manchester University Press, 2002.

Simonett, Jürg. 'Stugl/Stuls'. In *Historiches Lexikon der Schweiz*, https://hls-dhs-dss.ch/de/articles/008995/2012-07-03/

Slenczka, Ruth. 'Cranach als Reformator neben Luther'. In *Der Reformator Martin Luther 2017: Eine wissenschaftliche und gedenkpolitische Bestandsaufnahme*, edited by Heinz Schilling, 133–58. Berlin: Walter de Gruyter GmbH, 2014.

Smail, D. 'La culture matérielle des pauvres à Lucques au XIVᵉ siècle'. In *La culture matérielle. Un objet en question*, edited by L. Bourgeois, D. Alexandre-Bidon, L. Feller, P. Mane, C. Verna and M. Wilmart, 203–13. Caen: Presses Universitaires de Caen, 2018.

Smail, D. *Legal Plunder: Households and Debt Collection in Late Medieval Europe*. Cambridge, MA: Harvard University Press, 2016.

Smail, D. 'Les biens comme otage: Quelques aspects du processus de recouvrement des dettes à Lucques et à Marseille à la fin du Moyen Âge'. In *Objets sous contraintes: Circulation des richesses et valeur des choses au Moyen Âge*, edited by L. Feller and A. Rodríguez López), 365–83. Paris: Publications de la Sorbonne, 2018.

Somers, Joke, with Christine Kathryn Cooper, Amelie Alterauge, and Sandra Lösch, 'A Medieval/Early Modern Alpine Population from Zweisimenn, Switzerland: A Comparative Study of Anthropology and Palaeopathology'. *International Journal of Osteoarchaeology* (July 2017), https://doi.org/10.1002/oa.2607

Southworth, John. *Fools and Jesters at the English Court*. Thrupp: Sutton, 1998.

Sovrano Militare Ordine di Malta (SMOM), Gran Priorato di Lombardia e Venezia. *Lungo il tragitto crociato della vita*. Venice: Marsilio, 2000.

Spaeth, D. 'Orderly Made: Re-appraising Household Inventories in Seventeenth-Century England'. *Social History* 41, no. 4 (2016): 417–35.

Spallanzani, M. *Ceramiche alla Corte dei Medici nel Cinquecento*. Modena: F.C. Panini, 1994.

Spatharakis, Ioannis. *Dated Byzantine Wall Paintings of Crete*. Leiden: Alexandros Press, 2001.

Spencer, Brian. 'King Henry and the London Pilgrim'. In *Collectanea Londiniensia*. LAMAS Special Paper 2, edited by Joanna Bird, High Chapman and John Clark. London: London and Middlesex Archaeological Society, 1978.

Spencer, Brian. 'Medieval Pilgrim Badges'. In *Rotterdam Papers: A Contribution to Medieval Archaeology*, 137–53. Rotterdam: J.G.N. Renaud, 1968.

Spencer, Brian. *Pilgrim Souvenirs and Secular Badges: Medieval Finds from Excavations in London 7*. Woodbridge: Boydell Press, 2010.

Spencer, Brian. *Pilgrim Souvenirs and Secular Badges: Salisbury Museum Medieval Catalogue, Part 2*. Over Wallop: Salisbury and South Wiltshire Museum, 1990.

Spufford, Peter. *Power and Profit: The Merchant in Medieval Europe*. London: Thames & Hudson, 2002.

Stell, P. M. *Probate Inventories of the York Diocese, 1350–1500*. York: York Archaeological Trust, 2006.

Stella, Alessandro. *La révolte des Ciompi: Les hommes, les lieux, le travail*. Paris: Editions de l'Ecole des Hautes Etudes en Sciences Sociales, 1993.

Stewart, Alison G. 'Sebald Beham. Entrepreneur, Printmaker, Painter'. *Journal of Historians and Netherlandish Art* 4, no. 2 (Summer 2012): 1–26.

Stewart, Alison G. 'Paper Festivals and Popular Entertainment: The Kermis Woodcuts of Sebald Beham in Reformation Nuremberg'. *Sixteenth Century Journal* 24 (1993): 301–50.

Sturtewagen, Isis. *All Together Respectable Dressed. Fashion and Clothing in Bruges during the Fifteenth and Sixteenth Centuries*. PhD thesis, University of Antwerp, 2016.

Styles, John. *The Dress of the People. Everyday Fashion in Eighteenth Century England*. New Haven and London: Yale University Press, 2007.

Sucrow, Alexandra. *Die Wandmalereien des Ioannes Pagomenos in Kirchen der ersten Hälfte des 14. Jahrhunderts auf Kreta*. Berlin: s.n., 1994.

Syson, Luke and Dora Thornton. *Objects of Virtue: Art in Renaissance Italy*. Los Angeles: The J. Paul Getty Museum, 2001.

Tanis, James R. 'Netherlandish Reformed Traditions in the Graphic Arts, 1550–1630'. In *Seeing Beyond the Word. Visual Arts and the Calvinist Tradition*, edited by Paul Corby Finney, 369–96. Grand Rapids: William B. Edermans Publishing Company, 1999.

Taylor, John. *Taylor His Trauels: From the Citty of London in England, to the Citty of Prague in Bohemia*. London: Henry Gosson, 1620.

Taylor, John. *Taylors Farevvell, to the Tovver-Bottles*. London: Augustine Matthewes, 1622.

Taylor, John. *Three Weekes, Three Daies, and Three Houres Observations and Travel, from London to Hambvrgh in Germanie*. London: George Gibbs, 1617.

Taylor, John. *Tvrne over Behold and Wonder*. Layghten Buzzard: Tom Ladle, 1654.

Taylor, Lou. *Establishing Dress History*. Manchester: Manchester University Press, 2004.

Terpstra, Nicholas. 'Confraternal Prison Charity and Political Consolidation in Sixteenth-Century Bologna'. *Journal of Modern History* 66, no. 2 (1994): 217–48.

Tessari, Alessandra. *Trasferimenti patrimoniali e cultura materiale nella Puglia del primo Settecento: Monopoli 1721–1740*. Bari: Cacucci, 2007.

Thomas, Anabel. *The Painter's Practice in Renaissance Tuscany*. Cambridge and New York: Cambridge University Press, 1995.

Thum, Veronika, '*Die Zehn Gebote für die ungelehrten Leut': der Dekalog in der Graphik des späten Mittelalters und der frühen Neuzeit*. Munich: Dt Kunstverlag, 2006.

Trexler, Richard. 'Follow the Flag: The Ciompi Revolt Seen from the Streets'. *Bibliothéque d'Umanisme et Renaissance* 46 (1984): 357–92.

Trexler, Richard. *Public Life in Renaissance Florence*. New York: Academic Press, 1980.

Tsamakda, Vasiliki. *Die Panagia-Kirche und die Erzengelkirche in Kakodiki. Werkstattgruppen, kunst- und kulturhistorische Analyse byzantinischer Wandmalerei des 14. Jhs. auf Kreta*. Vienna: Verlag der Österreichischen Akademie der Wissenschaften, 2012.

Tucci, Ugo. 'L'Ungheria e gli approvvigionamenti Veneziani del bovini nel Cinquecento'. In *Rapporti veneto-ungheresi all'epoca del Rinascimento*, edited by Tibor Klaniczay, 153–71. Budapest: Akadémiai Kiadó, 1975.

Underwood, Paul. *The Kariye Djami*. New York: Pantheon Books, 1966.

Valier, Agostino. *Rhetorica ecclesiastica*. Venice: Andrea Bocchino e fratelli, 1570.

Van Asperen, Hanneke. 'A Pilgrim's Additions: Traces of Pilgrimage in the *Belles Heures* of Jean de Berry'. *Quaerendo* 38 (2008): 175–94.

Van Dael, Peter. 'Two Illustrated Catechisms from Antwerp by Petrus Canisius'. In *Education and Learning in the Netherlands, 1400–1600: Essays in Honour of Hilde de*

Ridder-Symoens, edited by Koen Goudriaan, Jaap Moolenbroek and Ad Tervoort, 277–96. Leiden: Brill, 2004.

Van den Belt, Henk. 'The Law Illuminated. Biblical Illustrations of the Commandments in Lutheran Catechisms'. In *The Ten Commandments in Medieval and Early Modern Culture*, edited by Youri Desplenter, Jürgen Pieters and Walter Melion, 196–218. Leiden: Brill, 2017.

Van der Coelen, Peter, with Alexandra van Dongen, Friso Lammertse, Lucinda Timmermans, and Matthias Ubl. *De ontdekking van het dagelijks leven. Van Bosch tot Bruegel*. Rotterdam: Museum Boymans-Van Beuningen, 2015 (exhibition catalogue).

Van der Stock, J. *Printing Images in Antwerp: The Introduction of Printmaking in a City. Fifteenth Century to 1585*. Rotterdam: Sound & Vision Interactive, 1998.

Van Hoogstraaten, Samuel. *Inleyding tot de hooge schoole der schilderkonst. Anders de zichtbaere werelt: verdeelt in negen leerwinkels, yder bestiert door eene der zanggodinnen*. Rotterdam: Fransois van Hoogstraaten, 1678.

Van Molle, F. and L. Baeyens. 'Achttiende-eeuwse haardplaatmodellen in het Maasland: Bijdrage tot de studie van de oude haardplaten'. *Antiek. Tijdschrift voor liefhebbers en kenners van oude kunst en kunstnijverheid* 7, no. 5 (1972–73): 361.

Van Os, Henk. *The Art of Devotion the late Middle Ages in Europe, 1300–1500*. London: Merrell Holberton, 1994 (exhibition catalogue).

Van Os, Henk. 'Painting in a House of Glass: The Altarpieces of Pienza'. *Simiolus* 17, no. 1 (1987): 23–38.

Vasari, Giorgio. *Le vite de' più eccellenti pittori scultori e architettori. Nelle redazioni del 1550 e 1568*, edited by R. Bettarini and P. Barocchi. Florence: S.P.E.S., 1966-present.

Vasari, Giorgio. *Le vite dei piu ecellenti pittori, scultori ed architettori*, edited by Gaetano Milanesi. Florence: G. C. Sansoni, 1878–85.

Vassilaki Mavrakakis, Maria. 'Western Influences on the Fourteenth Century Art of Crete'. *Jahrbuch der Osterreichischen Byzantinistik* 32, no. 5 (1982): 305–11.

Veblen, Thorstein. *The Theory of the Leisure Class*, edited by R. Lechakman. New York: Penguin, 1994.

Vernaccini, Silvia. *Baschenis de Averaria. Pittori itineranti nel Trentino*. Trento: TEMI Editrice, 1989.

Vincent, C. *Fiat lux: Lumière et luminaires dans la vie religieuse du XIIIᵉ au XVIᵉ siècle*. Paris: Cerf, 2004.

Vincent, Susan J. *Dressing the Elite. Clothes in Early Modern England*. Oxford and New York: Berg Publishers, 2003.

Von den Driesch, Karlheinz. *Handbuch der Ofen-, Kamin- und Takenplatten im Rheinland*. Köln: Rheinland-Verlag, 1990.

Wackernagel, Martin. *The World of the Florentine Renaissance Artist: Projects and Patrons, Workshop and Art Market*, translated by Alison Luchs. Princeton: Princeton University Press, 1981.

Warburg, Aby, Christopher D. Johnson and Claudia Wedepohl. 'From the Arsenal to the Laboratory'. *West 86th* 19, no. 1 (Spring–Summer 2012): 106–24.

Warburg, Lise. 'Strik i de Københavnske jordfund'. In *Textila tekniker i nordisk tradition. Rapport från nordiskt symposium om textila tekniker*, edited by Bengt Wittgren, 79–93. Uppsala: Etnologiska Institutionen, 1986.

Warren, Kate M. *Langland's Vision of Piers the Plowman: An English Poem of the Fourteenth Century Done into Modern Prose*. London: T. Fisher Unwin, 1889.

Waterworth, J. (ed.). *The Canons and Decrees of the Sacred Oecumenical Council of Trent*. London: Burns and Oates, Ltd., 1848.

Webb, Diana. *Pilgrims and Pilgrimage in the Medieval West.* London: I. B. Tauris, 2001.

Welch, Evelyn. 'Art on the Edge: Hair and Hands'. *Renaissance Studies* 23, no. 3 (2008): 241–68.

Willemsen, Annemarieke. '"Man is a sack of muck girded with silver": Metal Decoration on Late-medieval Leather Belts and Purse from the Netherlands'. *Medieval Archaeology* 56 (2012): 171–202.

Willemsen, Annemarieke and Marlieke Ernst, *Hundreds of . . . Medieval Chic in Metal: Decorative Mounts on Belts and Purses from the Low Countries, 1300–1600.* Zwolle: Stichting Promotie Archeologie, 2012.

Williams, Gwyn A. *Medieval London: From Commune to Capital.* London: Athlone Press, 1963.

Wilson, Th. *Ceramic Art of the Italian Renaissance.* London: British Museum Publications, 1987.

Wilson, Th. *Italian Maiolica and Europe: Medieval, Renaissance, and Later Italian Pottery in the Ashmolean Museum.* Oxford: Ashmolean museum, 2017.

Wilson, Th. *Maiolica: Italian Renaissance Ceramics in the Metropolitan Museum.* New Haven and London: Yale University Press, 2016.

Witkowski, Gustave-Joseph. *L'art profane à l'église.* Paris: J. Schemit, 1908.

Wright, L. 'The Medieval Gittern and Citole: A Case of Mistaken Identity'. *The Galpin Society Journal* 30 (1977): 8–42.

Wundram, Manfred and Thomas Pape. *Andrea Palladio 1508-80: Architect between Renaissance and Baroque.* Cologne: Taschen, 1992.

Xyngopoulos, Andreas (Ανδρέας Ξυγγόπουλος). 'Περί μίαν Κρητικήν Τοιχογραφίαν'. *Κρητικά Χρονικά* 12 (1958): 335–42.

Zannettacci Stephanopoli, Monique. 'La lumière naturelle dans l'habitation médiévale'. In *Le soleil, la lune et les étoiles au Moyen Âge,* 451–65. Aix-en-Provence: Presses universitaires de Provence, 1983.

Zantkuil, H. J. *Bouwen in Amsterdam: het woonhuis in de stad.* Amsterdam: Uitgeverij Architectura & Natura, 1993.

Index

Note: Page numbers in italics refer to figures.

CPSIA information can be obtained
at www.ICGtesting.com
Printed in the USA
LVHW081340160422
716386LV00010B/490

9 781350 214576